MY LIFE IN A COLUMN

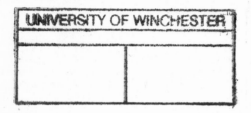

First published in the United States of America in 2011 by
Rizzoli International Publications, Inc.
300 Park Avenue South
New York, NY 10010
www.rizzoliusa.com

© 2011 Tracey Emin

All essays originally published in *The Independent*, 2005–2009

Edited by Alexandra Dugdale

Design by Murray & Sorrell FUEL

2011 2012 2013 2014 / 10 9 8 7 6 5 4 3 2 1

ISBN-13: 978-0-8478-5807-1

Library of Congress Control Number: 2011902337

Printed in Italy

TRACEY EMIN

MY LIFE
IN A
COLUMN

RIZZOLI
NEW YORK

New York · Paris · London · Milan

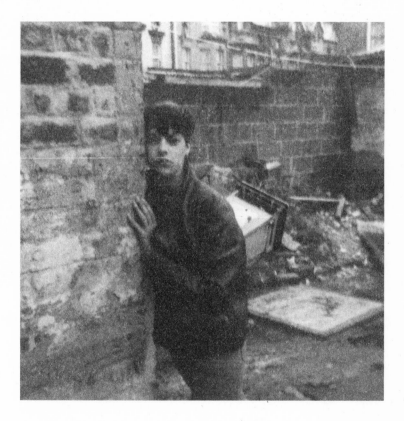

Tracey Emin, 1979

It happened like this…

It was 2005. I was at the Groucho Club getting very drunk with my old friend Simon Kelner. The Groucho Club always has had a very intoxicating atmosphere—slightly heady and persuasive towards the next drink, and the next drink, followed by the next drink.

Simon and I had met when he interviewed me in 1999 for *GQ* magazine. He had just become editor of *The Independent* newspaper. Seven years later he was doing a really good job. With every drink he kept buttering me up saying, "Tracey, you know you're a really good writer. Trace, why don't you come and write for us?"

After singing a few rounds of karaoke with Simon I rolled into an Eritrean taxi and meowed my way home. I woke up at one o'clock in the afternoon, hungover from Hell, my entire face dislodged by about three inches, and I felt very sick. The night started to play itself back in reverse.

Then the phone rang. I leaned over the bed and picked it up. It was Simon. He simply said how great it was I'd agreed to write the column and they looked forward to my first copy at 5 p.m.

That was it, that's how I started. The first column was so bad. I finished the last 300 words on the phone. In fact, the first few months were pretty ropey. It's only when I started to travel a lot that I got into my stride and understood what the column was for— very simply a way into the mind of an artist. It didn't have to be like other columns.

I wrote it almost every week for four years; sometimes it would only take half an hour, other times I would ponder and procrastinate and drive myself insane. One thing is—I'd always spend my whole week thinking about it—not what I was going to write but wondering if what I was witnessing was *columnable*.

I loved writing the column—the excitement of getting it in on time, when my editor Adam would say, "This week's a good one." It was the sort of approval I have always craved. I also knew when I had presented a naff one, but with a column it's judged on the week that it is written and printed—a few dud ones can get through, that's its nature. And that's why this book has the good and the bad. It's a journey of my mind and my life and my reactions to the everyday.

I'd like to thank Simon Kelner and Adam Leigh for all their patience, understanding, and constant encouragement. Alexandra Dugdale for being able to type, from wherever I dictated, from all over the world.

Thanks to *The Independent*—a newspaper that truly is.

15 April 2005

Ring, ring. Who's there? Val Kilmer. Wow, the sex cub hits the West End stage in *The Postman Only Rings Twice*. Me and Val famously smashed furniture together, one late night in the Dorchester hotel. Completely by accident, may I add. And categorically there were no tables involved. Ah, rock 'n' roll.

I am only allowed to go out one night a week now, my rules. You see I just don't trust myself. One moment, there I am merrily having an intellectual conversation; the next, I wake up on the kitchen floor. Red slate tiles can be fine, but never two nights in a row. And then there are the taxi drivers. "Guess who I had in my cab last night?" Every time my period's late I pray my level of unconsciousness was alcohol-induced and not Rohypnol.

It's tricky being single, wild, and female, and it's amazing how, after a certain amount of drunken dysfunctional behaviour, the invitations slowly dry up. There is simply no man out there big enough to scrape me up off the floor and throw me over his shoulder and safely take me home.

I get really scared to go out these days. Only the day before yesterday, two nice young men decided (on seeing me), to cover their faces with masks and put baseball caps on their heads. I started to run, and I could hear the words "Get the lady." The next morning I went to the local police station to report it. Now this actually made me laugh: they asked me if I had seen the youths behaving suspiciously. As I was feeling like an extra from *Assault on Precinct 13*, that

Cherie Blair was at the end of my road having a curry, drumming up support for our MP, Oona King. Shame she wasn't drumming up support for more police in the area. They must be really scared about the challenge from George Galloway for little old Cherie to be hanging around the East End. Doesn't she know it's dangerous out here?

I went out last night (oh, that's two nights this week). I did the Joan Rivers show. That woman is so funny. It's amazing in life what we are given. I was given giant tits and a good visual sense, whereas Joan got so much humour. Every other word, every other sentence is pure wit on the level of genius, and she is such a sprightly little thing. People talk about the work she's had done on her face, but it really suits her. She's one lady who could not be baggy in any sense of the word.

I remember shouting at a boyfriend once who went off to have an affair, that sex with her would be really bulbous. The next time he saw me he told me that at the moment of penetration the word "bulbous" was firmly set in his mind, and he thought, "How the hell did Tracey know that." It's funny, with some men, a hole's a hole. But I can imagine that sometimes it's an empty void of nothingness, shagging someone and there's just nothing there.

I have a really big problem, I cannot have sex with men with little dicks. Oh, I've tried, but I just can't do it. But lots of people do. Thus, I have not had sex for two years. "Hello, how do you do ... My name is Tracey ... How big is your cock?" Never a good opening line. And now that I am only allowed to go out one night a week, my chances of any sexual satisfaction are even more remote.

At the moment I am sitting in bed. It's 3:30 in the afternoon. My glands are swollen and I feel and look like a chipmunk. And I have herpes on my face—smack bang centre of my chin. Stress, stress, stress. Right now I am meant to be at the Chelsea Arts Club at a memorial service, for my dear old friend Bernard Stone. The impresario of Turret Books. Maybe it is just better that I am just sitting at home just thinking of him, maybe just safer for everyone.

It's quite strange being an artist. I live a life of constant contradiction. One is that I have to spend a lot of time alone and I actually enjoy my own company, and the other I need a good flow of stimulation. I do not sit around and wait for the next revelation. Talking of which, Greenbelt, the Christians' answer to Glastonbury, wants to screen my film, *Top Spot*. This pleases me a lot, it's a young people's festival, so lots of young people will get to see my film. The main reason for my art is to communicate.

So here I am communicating my daily thoughts, big, small, important, not important, but mine, never the less. At all times the talent of the individual should be encouraged. So, nice one, Joany, nice one, Val. Keep on doing it.

22 April 2005

Another day another dollar ... Ah, actually, no.

I can't help but wonder just how much the war cost. Two billion? Three billion? Ten billion? I wonder where you find that sort of information? But it would be good to have it just before an election. The Government spent XXXX on fighting a war, which the majority of the British people didn't want. And this mysterious figure alone could win the Bethnal Green & Bow seat for George Galloway.

It was quite comforting to read this week that George was held under siege and threatened while campaigning in my local neighbourhood. Of course, it isn't comforting to hear he was threatened by a gang of Asian men, who are accusing him of being a false prophet. No, the comforting factor was that 30 policemen went to George's rescue. I didn't know we had 30 policemen in Tower Hamlets.

I can tell you a little story about George. I have always been hesitant about telling it. But what the hell, here goes. Back in the late nineties, when Iraq was under sanctions, I quite happily donated a good few bob to George's relief campaign. I'm not sure how they got hold of me, how they found me, but they did.

One day I got a phone call asking if I would give a work of art to be auctioned and all the funds that were raised would go to a little girl named Mariam, who needed urgent medical treatment. I hastily made a drawing titled *Mariam* and stuck it in the post. I tried to

follow up and ask if they had received the drawing, but I never heard a word. Until they rang me asking if I would go to Iraq. I told them I couldn't. It was at this point that campaign workers started to bombard me and harass me, using all sorts of guilt tactics, saying that if I couldn't go, I should pay for someone else to go. In the end I was in tears and told them never to call me again. I wonder what happened to Mariam—and I wonder what happened to my drawing.

So, after last week's remarks about big and small dicks, sadly there was no queue of eligible men around the block. I had many remarks like "I never knew you were such a size queen," and "you're never going to get a boyfriend now." My friend Joe, who lives in my cottage, took great delight in handing me a copy of *QX International*. This, for those of you not in the know, is a gay contact mag of an extreme variety. (Readers of a sensitive disposition, look away now.)

Joe told me to check out "the vodka bottle, 20-stone, 23-inch arms, 56-inch chest, no-text-messaging bodybuilder." When I said "big" last week, I didn't mean that big. Some of the ads were really scary. For example: "Black, sleazy spit-roasting duo, 24 hours, all colours." I screamed at Joe, "What do they do, cook you?" As Joe explained the, erm, ins and outs of "spit-roasting," it was at this point I realised just how naive I am. After so many years of saying *Deliverance* was one of my favourite films, I've only just understood the line: "You wanna play piggy, boy?"

Oh, it's been a lonely week. Friday night in London, the fourth most exciting city in the world, and Me—voted the sixth most eligible woman in Britain by *Tatler*—and what am I doing? Sitting in bed eating a Marks & Spencer meal for one, while watching *Cosmetic Surgery Live*, that's what.

My ban on going out doesn't seem to be working. I've had two mind-blowing nights out in a row. I got in at 5 a.m. this morning and my brain is mashed to a pulp. But I did have lots of smart conversation. I had the great pleasure of giving the Waterstones literary fiction prize at the British Book Awards, hosted by Richard

and Judy. I'd been looking forward to it for ages and ages. The only problem was that I'd overdone it the night before.

Yesterday's hangover was like revenge from the deepest part of Hell. My skull wasn't fitting inside my face. And I was really sick—that kind of projectile vomit that gets stuck inside your windpipe and you know it could jump out at any moment. Normally I can deal with this situation, but not in front of 1,000 literary people at the Grosvenor House Hotel. Sweet, intelligent people, who usually stay home and read. This was their big night out, and there was no way I was going to be seen throwing up on daytime TV.

I'm living in a danger zone, but I think I just about got away with it. I'm going to have a quiet weekend finding out a bit more about "Passive Bondage Boy," "Hooded Horny Guy" and many more.

PS: Just for the record: don't take it personally, Mr. Angry Small Dick From Surrey.

13 May 2005

What's the difference between me and Sharon Stone? She's a mother and I'm not. She didn't actually give birth, but nevertheless she's a mother. This week saw her rushing off to the other side of the Atlantic to cradle her long-awaited baby. Every time I think of the story of Moses, how he was picked up as a little bundle from the bullrushes, I wish I could find a baby like that. The same goes for babies found in telephone boxes (not that I've used a telephone box since 1996. It's true, you forget how to use them). I know that if I ever found one I would never hand it back.

When I was young I always believed in some kind of reincarnation, that your soul was bound to the Earth with blood, and the easiest way to break the bond was never to have children. I still believe that to an extent. My problem is I'm quite happy bobbing along on the earth these days, and I'm sure my soul wouldn't mind hanging out a bit longer.

But at the grand old age of 42, I'm cutting it very fine on the baby front. When I say this to people, the argument is always, "Oh, come on Tracey—look at your peer group" (female British artists, that is). Hardly any of them have children. But there are two good reasons for that. A lot of them don't want children—and most of them are three or four years younger than me. They are in steady relationships and one day probably will.

For the last few years, I've been thinking about having IVF, but I would still need to count on sperm, I still need someone else's DNA.

I'm only just coming to terms with my own family—never mind someone else's.

Then I started thinking about having my eggs frozen, not that I would want to be one of those crazy Italians who give birth at 59, but at least it would give me more time to think about things.

But guess what? The whole procedure is really painful, and you have to have lots of drugs, and even then the eggs might die.

This is going to sound rich from someone who has had two abortions, but what if you never use the eggs, and they were just suspended in time in no-man's-land? No man being the point. The main problem with having a baby on my own is that after already not having sex for two years, I'm not sure if I could go another nine months without it. I think I'd find it very hard having sex with someone while carrying another man's baby.

Maybe adoption would be a good alternative. But any adoption agency that took one look at my CV would frogmarch me out of the door. Of course, there are people who think I don't deserve to be a mother. Especially the person who got me pregnant, who on finding out, patted me on the stomach and said, "We are going to kill you."

And then there are the others who think I'm just too wild, a bit too career-orientated or maybe that I just drink a bit too much to have a baby.

Seven or eight years ago, when I was madly in love, I'd wake up with a hangover and say, "Imagine if I had a baby, I'd have to ring up every bar, every pub, every club and say, 'erm ... it's Tracey Emin here, did I leave something in your club last night?'"

Did you know there was compulsory sterilisation in Sweden until 1974? If you didn't fit into society (i.e., had three hands, were genetically blind, were an alcoholic, your parents were alcoholics, you're a psychiatric case or your grandmother was a psychiatric case ...), wham! Out with those ovaries.

I found that especially shocking in 1996, when I spent six weeks in Sweden to do a project called *Exorcism of the Last Painting I Ever Made*. I wanted to get over some fears and anxieties. 1) I hated my

body. 2) I was afraid of the dark. 3) I could not paint since I had had an abortion. And 4) my grandmother had died and I wanted time to grieve for her.

So, in a nutshell, I was in Sweden, the temperature was -15, I was in a gallery, inside a box, with fisheye lenses watching me painting naked. I chose Sweden because I thought the Swedes would be cool about the naked flesh. Every day I would potter around my constructed studio, listening to really loud music, the Doors, the Clash. At no time did I know how many people could be spying on me through the lenses. I set myself a task: to paint my way through my own history of painting, Picasso, Munch, Egon Schiele, Gary Hume, Frida Kahlo, early Renaissance Dutch masters.

Everything was cool until the final week. I even felt happy naked. It was time for my swansong into the history of modern art. After weeks of hearing nothing behind the stud wall, and even with the Clash blaring "White Riot" at top volume, I could hear the shouts in among the stampede to look at me through the fish-eye lenses: "SHE IS DOING AN YVES KLEIN."

It's not all bad. At least I'll have stories to tell the kids one day.

20 May 2005

Just when I thought nothing was happening, and my life had reached an all-time social low ... Bam! An invite to Buckingham Palace arrives through the door. The private secretary to HRH The Duke of York has been commanded to invite Me, Ms **Tracey Emin**. And do you know what? I said yes. I have an insatiable interest to know what it's like in other people's houses.

Not just that, but I've been asked to speak on behalf of the NSPCC for its Full Stop campaign (full stop meaning no more cruelty to children). I've always made donations to the NSPCC, ever since I started earning money. When we were students, my friend Maria and I worked out that a monthly payment to save children's lives was no more than what we would spend on biscuits.

This is a really obvious thing, but I can't understand that anybody would be cruel to children. Mental abuse, physical abuse, sexual abuse. Babies with cigarette burns up their arms, Children sitting in their own excrement in dustbins for days—the list is endless.

But let's go back to Buckingham Palace. I was invited there once before, by the Queen's equerry. He'd been asked to look at the Queen's paintings and invited me along. But he'd only been in the job a few days, so I said to him, "You must be joking. Do you want to get the sack?" Now, looking back, maybe promotion would have been in order.

If you read my childhood CV, it goes something like: Sunday school (against my mum's wishes); gym club (which I was useless at); St John's youth club; Jesus Art Club (against my mum's wishes); and the Girl Guides, (against my mum's wishes). The Guides was a problem mainly because she had to buy a uniform—and the posh one that I wanted to go to was miles away from where I lived. But I was in my element sitting around campfires singing "Haila Shaila ging gang gooly gooly gooly watcha ging gang goo," which, to this day, I've never been able to work out. But I do say "watcha" all the time like some demented 11-year-old.

When I remember the Girl Guides, what really confuses me is that we had to swear allegiance to the Queen. Even at the age of 10, I felt there was something profoundly dodgy about this.

There was a time in my life when I thought the Royal Family should be given two options: to keep their possessions and lose their titles; or be shot. But now I've changed my mind. And no, not just because I've got an invitation to Buckingham Palace. The Royal Family is like a living soap opera—years ago I said, "They should pay more taxes, and spend more time doing *Hello* covers," and hey presto, they are.

I was so much against the class system in Britain because I believe so firmly in the meritocracy, the constant battle to distribute wealth more fairly. As they said in the TV series 'A Very British Coup,' it's not what you inherit, it's what you do with your inheritance. My grandma died when she was 94. I was in a state of complete bereavement and shock. People just didn't get it. For them it was obvious she was going to die because of her age.

We are conditioned to know our grandparents will probably die before us, but she was one of my best friends. As she got older and more frail, I would go to Margate to visit her. I would sit on her bed, holding her hand, listening to the radio. Sometimes we dozed off to sleep, and when we woke up we would tell each other our dreams.

Two years before my Nan died, she gave me a small armchair that had belonged to her mother. When she gave it to me she said, "There's a lot of money in chairs." By that, she meant people stuffed the upholstery with wads of cash. But I took it to be a legacy.

TRACEY EMIN

In 1994 I wrote a book called *Exploration of the Soul*. It was the story of my life from the moment of conception to me losing my virginity. Then I decorated my Nan's chair. With the book and the chair, my then boyfriend, the gallerist Carl Freedman, and I drove across America. Stopping off at museums and galleries, I would perform readings from the book, using the chair as my mini throne, my point of confidence, selling the book on the way.

I think my highlight was performing at the Majestic Theatre in Detroit. It was the last place Houdini performed, and it seated an audience of 1,000. I had a grand total of 50. You could hear a pin drop, and yet there are still art magazines that refer to my sellout US tour. But by selling copies of the book I did raise £6,000, which paid for our flights, our Cadillac, our hotels, shopping in New York, belly surfing in San Diego, bear watching in Big Sur, and four days of mental gambling in Las Vegas.

My grandma didn't say: "I am going to die soon. Here is some money. I want you and your boyfriend to have the holiday of a lifetime in America." She said: "There's a lot of money in chairs." And I listened to her. And if you don't believe me, pop down to Tate Britain, and see the chair for yourself. I think that's a very British coup.

27 May 2005

Every morning when I get up and go downstairs to make a cup of tea, I spend a few minutes looking out the landing window. And I count my roses. Beautiful, white, and enchanting, they look like something from a bygone age. Today I counted 45, and tomorrow there will probably be 48. Although it sounds childlike, the magic never ceases to amaze me. I've always believed that your garden is like a mirror to your soul, to your whole being.

When my boyfriend left me two and a half years ago, I allowed my garden to go to rack and ruin. The ivy was like something from a horror film; it made its way across the courtyard like some black monster from hell. The rose tree had so much black spot and green fly that it was hard to tell what it was. And to make matters worse, every cat in the whole of Spitalfields dumped their shit in my back yard. When I looked from the landing window it was as if I could see what was going on but was powerless to do anything about it.

But it's amazing what a bit of pruning, nurturing, loving, and hacking can do. I set to with clippers and shears like some crazed fascist gardener, until I had blisters on my hands. I really do believe that by cutting back, the roots grow stronger.

This has been a really mad week for me, and stressful too, because I've been installing my new show at White Cube. The only thing that keeps me human is the fact that I swim every day. I swim around

30 lengths very slowly. In my local pool the rule is to swim anticlockwise. But you always find some backstroking, splashing moron going the opposite way. Or all the gay dads with their kids who want to swim in a line. And do you know what I have to do? I have to go and tell the lifeguard. Yes, the pool police.

Once when I was in Amsterdam, staying at the Grand Canal Hotel, I caught a girl giving a guy a blowjob in the sauna. I closed the door and pretended nothing had happened and started to swim my 50 lengths. When the sauna door opened, this girl in leopard-print bikini bottoms, who looked like a cross between Kate Moss and Liz Hurley, jumped into the pool and douched herself. I went totally apeshit. As I screamed at her, Mr. Blowjob put his face around the door, and asked what the problem was. Putting hygiene aside, the problem was that I felt old and frumpy.

Last Friday I went to see *The Kumars at No. 42*. (It's not really a house, it's a TV studio.) Sanjeev is really bright and shagging his grandma, who isn't old at all.

No, seriously, I did get slightly confused. For all my wild behaviour, I am an extremely polite guest when visiting people's homes, and I get slightly shy. Which isn't so good if you're doing a TV interview.

It's quite weird being an artist and doing something like that. But what's even stranger is that somehow, being an artist, the world denies you the possibility of having a sense of humour. Anybody that knows me will know that I like to spend at least 80 per cent of my time laughing. And I like to be extremely puerile. For example, Joe, who lives in my cottage, will tell you that every time he comes into the house, he risks a near heart attack. I like to hide behind a door and jump out on him.

Anyway, back to really large penises. Even if he's got one, a man who doesn't make me laugh doesn't stand a chance. I recently had a penis encounter. As someone went to greet me, I felt a semi-erect penis bounce against my thigh. Though completely unintentional, it did put a smile on my face.

Being celibate for nearly two years does make you view the world in a very different way. This is why I called my exhibition *When I Think About Sex*. The full title of the show is *When I Think About Sex I Think About Men, Women, Dogs, Lions, Groups (And I Love You All)*.

This doesn't mean that I've slept with a lion, it just means I've thought about it. I don't even masturbate, I just have ideas. I like my mind to go off into the strangest of places, and that's what leads to my creativity.

I realised this week how passionate I am about what I do. Making art is not a job, it's a way of life, a way of being. I have sacrificed things in my life for my art. But this week sees me happy, happy, happy. Big, big show, big, big party, belly dancers, shisha pipes and tom-tom drums. All my family and friends, me prancing around in my white suit, the super bride married to her art, celebrating her silver jubilee, 25 years of expressing my creative self.

It's important for me that the world sees what I do. It's the way that I communicate. It's a reflection of my soul, the same as my garden. Lucky girl.

10 June 2005

Now this could be one of the most interesting weeks I have had for a long time. Monday night: dinner for the opening of the Frida Kahlo show at Tate Modern, surrounded by HSBC bankers and half the Mexican embassy, and I was having a great time. Tuesday: opening show for *The Postman Only Rings Twice*. Wednesday: I flew to Venice with Jo and Ronnie Wood.

At one time, all of this could have been agony for me. Why? Because I smoked. I chain-smoked. I smoked a cigarette every five minutes from around three in the afternoon until I went to sleep. I was followed around by the strangest cloud of smoke. I did stop in 1990, on April Fools' Day. I was pregnant and smoking made me feel sick. Even though I knew I was going to have an abortion, I couldn't bring myself to smoke.

I didn't smoke for two and a half years, mainly because I didn't have the money. But as my friend Gary Hume said, "My God, Trace. I've never seen someone go from no fags to 40 Marlboro a day." I could be at a really great party, having a really good time, but the moment the cigarettes ran out, I was out of there.

L.A. was just a total no-no—and New York would see me standing outside in Arctic conditions. That's how I nearly lost a finger. It was so cold that I started to neigh like a horse, and as I puffed my smoke into the New York skyline, neighing and cantering, cantering and neighing, I was flat on my face with my fourth finger snapped in half. But hell, that didn't stop me.

After clubbing and breakfasting, I packed my bags and headed to the airport. Those were the days when I would say, "Please God, please God, give me an upgrade." As I went to check in, I looked down at my finger, and saw that it had gone completely grey, my fingernail was black, and between my ring and my knuckle there appeared to be some weird ping-pong ball. I thought it could help, and waved it at the check-in lady. She immediately called security, who all got on their walkie-talkies, "Jus' come down to Virgin see this finger ..."

And then they called an ambulance. I felt like some mad extra out of *ER*. In fact, I felt embarrassed. The first thing they did in the hospital was try to remove my rings. One of them was my grandmother's eternity ring and another I had been trying to get off for 20 years. The swelling was too much, and the pain was excruciating. Oh yes, I started to sober up now. They wanted to give me a general anaesthetic, but needed to know my next of kin, because, wait for it, they might need to amputate my finger. It was at this point I started crying.

In the end, five people held me down and they gave me a local anaesthetic. They cut the rings off, put a splint on my hand, gave me enough Valium to last a lifetime and said, "The taxi driver will have your name on a card, do not stand close to the automatic doors, because you'll get mugged." After flying back premium economy, and having to keep my hand up in the air throughout the flight, the doctor at Guy's hospital said one of two things would have happened if I had got on the flight with those rings on: a) My finger would have exploded on the plane; b) If it hadn't it definitely would have had to be amputated. It all started with a cigarette.

I finally stopped smoking on Christmas Day 2003. I was going to spend Christmas alone, mainly because I dislike Christmas, but it's a good time to get my head sorted out. But my friends weren't having any of it. Vivienne (Westwood) and Andreas picked me up and took me to Joe (Vivienne's son) and Serena's.

I took a magnum of champagne and 60 cigarettes. The only

time I didn't smoke was when we were actually eating dinner. At one point, when I was a bit tipsy after we played charades, I was thinking: why is the window open? Like I was some demented dragon, a perpetual column of smoke billowed from my nostrils and lungs. I had smoked all 60 fags.

On the way back home, Vivienne and Andreas dropped in on a friend. In my drunken stupor I'd fallen asleep in the car. I woke up to find myself locked in, and as I banged on the window of the 1970 Mini and waved my arms around like a lunatic, Andreas spotted me and, in his mellow Austrian tones, said, "Oh dear, the poor darling. She must be desperate for a cigarette."

The next day when I woke up, I thought about what a sweet lovely time I had had, and how brilliant and funny her family are. And then the guilt hit me—there had been children there. I haven't smoked since. If I ever have any moments of doubt, I look in the mirror and smile like some smug git and say to myself, "I DON'T SMOKE."

17 June 2005

Mad brilliant week. Sometimes I have to pinch myself, like on the jet when I took a glimpse in the mirror to see my reflection with Ronnie and Jo Wood. The stewardess poked her head around the cabin door, with a quizzical look on her face as we all sat there quietly sipping our tea. The only bit of excitement was when Ronnie finished his crossword. Not really rock 'n' roll as we know it.

The 51st Venice Biennale, so much art, so many parties, and millions of people. I wanted there to be ground rules (even though most the time we were all at sea, hee hee hee). Everybody has got to go to bed early, because we have to get up early and look at some art—that is why we are here. I was lying by the pool when Lynn Barber told me off, in her often motherly style, "Tracey, you can't tell a Rolling Stone they can't party."

At the Venice Biennale there's a whole jargon to get to grips with. It goes something like this: "Have you done Luxembourg? I'll meet you at the Turkish. Don't forget to do Afghanistan on the way. The British Pavilion rocks and the Australians have got it just right. Never found the Kiki Smith, the Pipilloti Rist is fucking brilliant, which bag do you prefer? The Hussein Chalayan or the Gilbert and George? The Frieze party was fantastic—proud to be British. If you haven't seen *Caligula*, go back to Giardini—don't worry, I've got my own boat."

One of my highlights was trying to get Janet Street-Porter to miaow; she wasn't having any of it. In the end I was quite happy with

any animal noise, but she wasn't. She wouldn't even join in being a meerkat on the boat, and she was wearing a tiger-print top. Cub Granet, as we now like to call her. Ooh, she's scary. And do you know what she told me? That I shouldn't write this column anymore. (I suppose she's got a point.)

But let's get back to the art. The Venice Biennale is like the Art Olympics, countries from all over the world compete with their pavilions, showing the artists they feel best represent them at that point in history. We did brilliantly with Gilbert and George—their work was spot on. The ginkgo pictures, images of Gilbert and George and the hoodies, graffiti from the area where they live. And they'd thought about the pavilion so well. The work was powerful and sensitive at the same time. There was nothing gung-ho about it.

Another artist who represented their country well was Lida Abdul, from Afghanistan. She had shot a film in some weird Afghan landscape, where you see a woman whitewashing the wrecked stones of monuments long gone.

I love going to Venice, because it reaffirms my belief in art, and as an artist, I cannot tell you how important that is. My only big problem is, since I stepped back on dry land I haven't stopped rocking—and I don't mean partying, I mean literally rocking. But it turns out I'm not the only one. Which is quite comforting but extremely disturbing when we are all in the same room.

I've only ever had seasickness once before in my life. I was with my dad, sailing from Mersin in Turkey to Cyprus. It was 1984, and Dad wanted to show me the motherland. While he went to sort the cabins out, I went to the ship's bar and had a drink. Neat whisky as I remember. Some bloke next to me with an airplane collar kept on offering me a drink every 22 seconds and lighting my fags. God it was irritating, so much so that my dad, on arriving back at the bar, threatened to cut the guy's balls off and throw them into the sea if he so much even looked at me again.

My dad had done something really smart. He had got us a cabin in the centre of the boat. But still I thought we were going to die. We

were caught in the tail end of a hurricane, and as I sat in the cabin, my dad told me all these magical stories about my ancestors.

My great-great-great-grandfather was from the Sudan, a slave in the Ottoman Empire. As I listened I chain-smoked. Instead of my dad telling me off like he usually did, as an act of solidarity from the fear of the waves, he lit my cigarettes. And there on the box of matches were written the words in Turkish: "Meet me on the deck at one o'clock, when your father has gone to sleep." Boy did we laugh. I rocked for three days after that trip.

Today I am so tired, profoundly tired. I need to sleep for about a million years. But I am so excited, it is like the quote from Byron: "I am standing on the edge of precipice, and it is a wonderful view."

Tomorrow I go to Basel, on another friend's jet. I have to get up at the crack of dawn. Why am I going? To look at art. I once had an exhibition called *I Need Art Like I Need God*. Art has been my best friend, my spiritual guidance, and at the lowest times of my life it has swept me up and taken care of me.

Thank you art, I love you.

24 June 2005

Fuck me what, a week. I don't know where to start. But there were a hell of a lot of jets and planes for a start. I went to Switzerland twice in one week, for the Basel art fair. Millions of galleries all under one roof, it is the world trade fair for art, where you can buy anything from Francis Bacon to Joseph Beuys. It is where the big players steam in on their jets, spend millions, then fly out again.

I can't believe I have never been on a Lear jet in all my life, then I knock up three in one week. Similarly, I never go to Notting Hill Gate (in fact I hardly ever leave the East End). But this week I have been to west London three times, including the airport. You might think this is a mundane fact. But it is like for two years there being no men and then suddenly they are everywhere—in the bars, in the parks, in the Palace, "Christopher Robin went down on Alice."

Ooh, I forgot, I went to Buckingham Palace last night. I had a really great time. I was the key speaker, talking on behalf of the NSPCC, to promote the Full Stop campaign, which is a helpline for children or anyone suffering child abuse. Telephones are placed in schools all over Britain, but currently, out of every three calls, only two can be answered. I would hate to be the person who decides which calls should not be answered.

Anyway, back to the Palace. I kept saying to myself, "Please God let me stay sober," but luckily my friend's mum was there, Sally Wigram, and every time she saw my glass empty she subtly made sure it wasn't refilled. Smart woman.

I sometimes wonder if I would be any brainier if I did not drink. I know for a fact that I would not do so many stupid things, either stuff I regret or, sadly, stuff I don't regret but have no memory of. Like this weekend when I was in Basel. I woke up on Sunday morning to find out I had sung meow-meow karaoke to a very distinguished art audience, would you believe it, at a place called the Kat bar. Apparently, I was in my meow-cat element. That was a bit embarrassing.

But hell, I can live with it. Especially after thinking about that mad story of those three Norwegian guys, who had drinking competitions to see who could get the most out of their head. They punched themselves in the face to prove they could not feel anything, and self-mutilated to prove they had passed through the pain barrier.

One night, one of the guys picked up a chain saw and, to prove he had more balls than the others, swiping the saw through the air managed to hack his own head off. Could you imagine waking up to that? "Yah, Lars, it was a heavy evening last night."

Yep, got to stop drinking. Made a pact with my inner soul—if I pass my driving test, I will cut down by 300 per cent. I think drinking and driving is insane. My uncle Colin, whose birthday it would have been in a couple of weeks, was decapitated when a pissed-up lorry driver pushed his car under a bus at traffic lights in Chingford in 1982. Personally I would have said it was murder—the crime is in knowing that you are doing something wrong. Sometimes when I am drunk, I don't know what the hell I am doing, but I wouldn't get in a car and drive, that's for sure.

The Rhine all mine all mine. Back in Basel, I did this brilliant thing on Sunday. I swam down the Rhine. There is a really strong current, and it pulls you really fast. You can go for miles and miles, and when you try to swim against the current, you have a giggling fit because you just stay in the same spot, and that's if you're lucky. I had a beautiful day on Sunday. British Airways treated me like the Queen of Sheba, and I had lots of friends around me. Meow, I really was the cat that got the cream.

Oh, I saw Janet Street-Porter at Sam Taylor-Wood and Jay Jopling's party on Friday. She growled at me, which is a good start, I think. It was an excellent party. Me and my friend Eric fell over again, which meant I went to Switzerland with a bruised nose—very chic. These last few weeks have felt like one big party. I suppose it is that I am celebrating how brilliant life can be. The saddest thing about drinking is the loss of memory of beautiful things. Life is too short.

It is the last few days of my show at White Cube, and when it comes down the partying stops. And the work begins all over again. Oh shit, damn, it is my birthday next week, so maybe my workaholic tendencies will have to wait a little bit longer.

My theme for this year's party is LET THOSE CHARIOTS ROLL, and no, I don't think I am setting myself up, but I know it is going to be a big one. More cream, please. Me-bloody-ow.

1 July 2005

I was walking down the street today, and some complete stranger looked at me and said, "Old witch." I stood in my tracks and smiled, and she said it again: "Old witch." I laughed and thought, too damn right I am. In my forties, live alone with a cat, read palms and keys, have a séance at least once a week and I scare the life out of men. No doubt about it; 400 years ago, if I hadn't have been ducked, I would most definitely have been burnt. But hey-ho, that's the way we like it.

Ahhh, the power of the catnap, I just woke up. I fell asleep on my sofa at my studio. Exhaustion. This week I've done two jets, three palaces, two planes, one wedding, parties. And my name is Tracey—what are the odds of that? This is my favourite time of year; my heart beats faster and faster. As childish as it seems, it is because it is my birthday, it will soon be a new year for me. I never celebrate New Year's Eve—in fact, I hate it. I usually go to bed around nine o'clock, turn my phone off and try to miss the whole thing. But the eve of my birthday is different. I spend my time wishing and dreaming, trying to project a positive future: I will pass my driving test, I will have a map of Britain and I will have a dart and I will throw the dart at that map, and I will go wherever it takes me. The passion to be free and moving, but still feel safe.

The most wonderful thing that has happened to me recently is

finding a really good driver. And instead of getting more off my face, I seem to be holding it together and enjoying that responsibility. And everyone is saying how well I look because I am smiling. Last night I went to the Anselm Kiefer after-party, and I danced like a banshee possessed. Didn't fall over once—is this something I should be proud of? I saw Cub Granet (Janet Street-Porter), she actually picked up her paws and meowed at me—a giant leap for Cub Granet, and a small step for the animal kingdom.

So this weekend I have my party. The invitation reads like this: "What to do at 42: have a party to end all parties. So let your chariots roll, love Tracey." The small print says: "And remember, if you want to hang out with Charlie, don't come to my party." For those of you who don't know, that's cocaine, a class-fucking-A, fucking disgusting substance. I have seen it ruin so many of my friends. Last year I was on the TV programme *Room 101*, and cocaine was one of the things I had banished from the face of the Earth. Paul Merton made a strong point to the audience that I had never taken cocaine— it is not some born-again thing (like my anti-smoking). But it is obvious, being a full-on, self-confessed drinker, never the twain shall meet. I might feel shit and bad with my head down a toilet, but all the coke heads are still in there, and they all say the same thing: coke isn't addictive. I have never taken the stuff, but for years I walked around with rolled-up notes, had nosebleeds and talked incessantly about myself. Passive coke, man—it's bad.

My party this year is gonna be a killer, but my birthday is actually on Sunday. Every year I have a mad party. In the old days I used to book out the whole of the Walpole Bay Hotel in Cliftonville. The party used to last at least three or four days, in the end people were scared to come. My 40th was fantastic. I celebrated it with 150 friends at the home of my friend Hamish McAlpine, on the edge of a cliff, with marquee tent, champagne on tap, Morelli's ice-cream, millions of lobsters—amazing food all by Caprice. It was like a wedding. My single wedding. Some women are only the centre of attention once in their lives, but with me there are countless occasions.

I think that is why if I ever got married I would do it with just the person I love.

But witches don't get married. Back to Saturday night. I will be in my 10th element. I will no doubt get smashed out of my tiny brains, there will be break dancing competitions, and by six in the morning there will be dancing to the same record again and again and again: "My milkshake brings all the boys to the yard and their life is better than yours."

But when I think about what I really want to do on my birthday, I dream about lying in a field, surrounded by poppies, being made love to. But no, I know at twelve o'clock on Sunday afternoon, the 30 or so strong survivors (the all-night crowd that do it naturally) will be down at the Golden Heart. The jukebox will be turned up full blast, we will be dancing like lunatics, screaming "In the year 2525, when man was still alive," and Sandra, my favourite landlady in the whole world, will be saying "Er, Trace, you nurf look good." I will be flying on autopilot so fast my wings are on fire. Happy birthday, Tracey, see you down the pub.

TRACEY EMIN

8 July 2005

I didn't expect to be crying today. I didn't expect to be afraid. My London, my beautiful city, my home, has been filled with an evil fear. These atrocities are unforgivable, but that's all I'm going to say, the show must go on.

Old witch, shall we try Aldwych, like, do I know the way to Aldwych. Talk about paranoia. What was my head going through last week? The party to end all parties, 300 lunatics dancing like maniacs. There wasn't one person who left my place without bruised knees. Half of London looked like they'd gone to a giant gang-bang, but that's what happens when you dance on tables.

I went to bed at seven. My studio assistant, Trilby, she didn't actually go to bed at all. She left the studio with a glass of champagne and her dress ripped right up to her backside, pinned together with a bulldog clip, and with her breasts hanging out everywhere, proceeded to get into a taxi, may I add, not sober.

This is where the fun starts. She had no money, so she had to get the taxi to stop at a cash point. As she got out, she dropped the glass and it smashed. The taxi driver went ballistic and demanded she pay him £100 for the damage. Trilby, in her stupor, told him to bugger off, and, can I say, in a very posh tone, a touch of the 1930s debutante.

At which the taxi driver flagged down a police car. The policeman started having a go at Trilby and, quiet rightfully, she said, "Don't be a knobhead, it's only a glass." Whoops! The handcuffs were out,

and she was carted off to the cells for the night. They released her at 3 o'clock the next day, and on returning her possessions, handed her one bulldog clip.

My friend Harriet had her bag stolen last week, snatched from her, where were the police then? I had my windows shot at by an air rifle; the police haven't even bothered to come and look at the holes. They told us to photograph it and they'd add it to the file. They did turn up at my party, though. At which I said, "Who the fuck ordered me a strippergram?"

I did something exciting this week that I haven't done in a long time. I started boxing again. Left jab, left jab, right jab, left jab, right hook, left hook, left jab, right jab. My hands have been shaking for two days. It feels incredible, the adrenalin. My whole body feels alive. It's good, it's intelligent exercise, and the amount of concentration is phenomenal. Anyone who knows me very well, will tell you that I have this strong powerful streak in me. I think it's because I don't fuck enough, so the boxing comes as a great relief. Plus, a girl's got to be able to look after herself, because no one's going to do it for me.

Meercats. After princess Diana's funeral, the programme that followed was *Meercats United*. We'll probably see the meercats on our TVs this week. What's so wonderful about these little creatures is the fact that they have such an egalitarian society. They are true socialists. When they go out hunting and gathering, they don't take their babies with them, and two or three other meercats are delegated to look after them. The meercat crèche. And this is what's really clever: the mummy meercats don't look after their own babies, so if under attack there'll be no bias as to which baby they help. Really cool.

They also do this other really great thing. When threatened, say by a snake or a jackal, the meercats will climb up onto each other's shoulders and with their backs towards the sun, make one big weird shadow. Big motherfucker!

Next week I'm going to be sober for seven days. And on the Friday, I'm going to try and pass my driving test. I am so nervous of failing. Everyone else is so nervous about me passing.

Last time, before my driving test, I went to a hypnotist to try to sort out my left and right. When I'm under pressure, little things like that seem to go out the window. So she put me into a trance and she said, "Think of the letter L," and I imagined my L plates in my left hand and then it was, "throooooow them away." And then she said to me, "Imagine something in your right hand," so I imagined a pen that I was writing with (the hypnotist thought this was very clever).

Then she said make the action of writing. But of course, the action I made was of a hand job, and there it was, on my driving test, every time the examiner said left, it was left, and every time he said right, I had the image of a whacking great big dick in my hand. Lordy, lordy lord, I nearly killed two cyclists reversing round a corner. As my friend Mat Collishaw said, "cycle killer, *qu'est que c'est?*"

The other night, I went to see Jack Dee and his mates live at the Apollo. We laughed for four hours non-stop. We also got incredibly smashed. I met Quentin Wilson, and do you know what? He offered me driving lessons. Brave man! Dara O'Briain told this joke, "What do kualas do for a job?" And much to my embarrassment I heckled, "They're bears." He said, "We know they're bears Tracey, but what do they do for a job?" At which I shouted, "Cuddle." Pregnant paws!

15 July 2005

I am not actually psycho or a slut. In fact recently I've been doing everything possible not to give that impression. My big challenge for this week was to stay sober for seven days, and at the end of which pass my driving test. I've made it quite clear to everyone: "Don't phone me, don't call me, don't invite me, don't challenge me." I need to be calm. I need to be quiet. I need to be focused.

But there's always one who slips through the net. On Saturday morning I was sitting in bed reading a book. In fact I was reading Ian McEwan's *Enduring Love*, trying to brush up on my stalking techniques. (Anyone who's ever been to the cinema with me will know it only takes me two seconds to work out a plot; but the problem is that I kind of interact with the film. For example, in *The Usual Suspects* I stood up and shouted, while pointing at Kevin Spacey, "He's Keyser Söze!") These days finding out someone's address or phone number doesn't take more than two phone calls. God, life can be dull.

So I had just thrown the book across the room when I got a phone call. It was my little mate Pokey, the actor Russ Tovey to anyone else. "Wotcha Trace, what you up to this weekend?" I tell him I'm in bed reading, not seeing anyone, not drinking. And I'm going to Kent for a week to try and pass my driving test. And then he comes out with a killer line: "Trace, you're gonna miss my play."

Damn. Damn. Damn. Fuck. Shit. Not only am I turning into a thespian, there seems to be no way out of this. But *The Laramie Project*

is a really good play, I'm so pleased I saw it. Gay persecution with a twist in mid-America. And then of course it's me, Pokey, Joe at 1 a.m., downing vast amounts of sweet wine in J Sheekey's in the name of dessert. Alcoholic deception, a great start to my nonalcoholic week.

My name is Tracey. I am 42 and my hobbies include: reversing around corners; three-point turns; parallel parking; and hill starts. It's fantastic where I'm learning to drive, the coastal town of Herne Bay. The Emerald School of Driving. Herne Bay has a few distinguishing features—lots of pensioners in little motorised wheelchairs, and thousands upon thousands of learner drivers, there's a real spirit of camaraderie.

I really like my driving instructor, Chris. We had a bit of a rocky start on Monday morning. I opened the gate to see him smoking a cigarette and that was it—I was off on one. "Oh, you smoke. I can't be near smoke. Do you smoke in your car?" He just stood there and smiled. He'd seen it all before.

Of course he didn't smoke in his car. It was when I offered him a cup of tea and started mincing backwards, clinging on to bits of furniture like a limpet on a rock, the fear of failure written across my face, that we came to an agreement. I would help him to give up smoking, and he would help me to pass my test.

He is making everything very comfortable and simple for me. But my problem is nerves. Today I did my mock test. I ended up shaking, in tears. People have been saying to me: "Try and relax. Don't build it up to be such a big thing. Don't make it so important." But with top lip trembling, I say, "It's the most important thing in my life, the ability to take control and change my life. I'm tired of all the parties, the drunken repetition, the loss of memory. I want something new in my life."

The problem is that I concentrated so hard on my art, my work is a vocation, and everything else has been pushed out the way, but this time I want to do something for me. I have so much confidence in so many ways, but not this time. Because it matters to me, too much. I have never sat a test in my life (apart from the last driving test).

Throughout my life the only discipline that has been enforced is by me on myself. I didn't have to go to school, because I hated it. I ate what I wanted, drank what I wanted, smoked what I wanted, fucked who I wanted—and that was when I was a kid. And now there's something that I really want, and that is the ability to change my life. So many stupid people drive cars and have babies, and on the eve of my test there is a harsh realisation that I've left it too late. But tough shit, kitty—that's the way it goes.

I will be on *Top Gear*. I will drive with the Stig. I will take that roundabout slowly. I will indicate as I move on to the dual carriageway. Mirror, mirror, blindspot, signal. Minimum of 1.6 millimetres of tread on the tyres. Oh sorry, I thought you said turn right.

This time tomorrow I will know, and it sounds pathetic, but whatever, pass or fail, I will be in tears.

Some people learn to drive and they don't like driving. Me? I absolutely love it. The furthest I've ever driven was at Christmas, to Stonehenge. But remember: Stonehenge isn't just for Christmas—it's for life.

29 July 2005

I forgot to say last week—I did pass my driving test. Only joking. No, of course I didn't. Like they're going to let me on the road. But if I can't drive, I can drink. And have I drunk this week. It's the rosé, man. It's so moreish. The champagne at the polo match went down pretty well, too. Rock 'n' bloody roll. Oh, how the mighty fall, as Nietzsche said. But worse than drinking, I spent 36 hours in bed this weekend in some kind of strange coma.

Sleeping, dreaming, News 24, Egypt, Istanbul—I just couldn't get out of bed. Four pints of Robinson's barley water, Docket having to survive on Supersnacks. I'd like to blame it on Mick Jones and celebrating his 50th birthday, but I can't.

You see, I've been falling asleep all over London this week. First, it was the Rivington Bar & Grill, where I apparently miaowed a few times, and then passed out at the table, because they hadn't brought my fish fingers.

At the Berkeley Square Ball (where I was the only woman wearing trousers), a friend politely asked, "Tracey, do you mind if I smoke?" I spent the next half hour ranting and raving about the consequences of smoking—then bang! My head was on the table. And my swan song was to curl up, all cosy and comfy, without a care in the world, at the very sophisticated and stylish Sketch.

Galileo, I think I've got it. The reason I drink so much is because I get bored out of my tiny brain. I'm quite smart, but obviously no

academic. But I've set myself a regime—it's mental replacement programme.

Ideally, I would have liked to replace the drink with either sex or driving. But at the grand old age of 42, one thing I've learnt by failing my driving test is that just because I want something doesn't mean I can have it. Anyway, back to my mental replacement programme. I must: a) read one book a week; b) swim a minimum five times a week (if depressed, swim for extra half an hour); c) cycle at least 20 kilometres a week; d) go to cinema or theatre once a week; e) turn all my sexual energy into art.

Busy, busy, busy. Of course, I know I can do all of these with a drink in my hand or a drink in my body. But do you know what? If I'd passed my driving test, the first place I would have driven is Longleat.

Sometimes, in the morning, when I want to give myself a treat, Docket and I watch *Animal Park* in bed. This morning, there was this pack of wolves. Did you know that the only wolves to mate at any one time are the alpha wolves? This is so the whole pack protects the cubs, and what is so lovely is that the alpha wolves bond and stay together for the rest of their lives. This morning, there were three wolves pregnant. But let's forget that, the *Animal Park* people couldn't explain that either. I know just how that alpha wolf feels.

I have never, never, ever, ever known any man to be faithful to me. Have you ever found someone you love in bed with someone else? God it's a killer. What I did was sit by the side of the bed and tell them how weak they were, and chain-smoked their cigarettes, and left them in a puff of smoke.

Mind you, when I did leave the building, I had a nosebleed that was so bad strangers wanted to call an ambulance. Call it sad, but it's the truth. Oh, I wonder why that is. Maybe it's because I'm too busy to be fucked every day. Maybe it's because I spend months out of the country. Maybe I can't meet someone international enough. Or maybe I'm just shit in bed.

One of my favourite ex-boyfriends, who for the purposes of this story I will refer to as F, always clamed to be faithful to me. And F is pretty cool because he doesn't lie. He has spine-chilling integrity,

and that's why he's still one of my best friends.

Back in the good old days when we were a couple, he turned up at my flat around six o'clock, p.m. for the record, looking his normal self, apart from the fact that he had this whacking great big lovebite on his neck, and his ear looked like it had been bitten to pieces. I summoned all the gods, braced myself, and said really calmly, "Froggy, why have you got a lovebite on your neck?"

He went to the bathroom, looked in the mirror, put his hand on his neck and said, "Oh Jesus, it looks terrible. I didn't tell you, did I? I was walking down Wardour Street and I decided to take a shortcut to my brother's office, as I cut through the NCP car park, the barrier came down, scraped my ear and landed on my neck." At which point, I put my arms around him and said, "Aw, are you okay?"

Every time I tell this story, eyes roll, and F and I always have a really good laugh about it. But the joke's on me. I hate my monogamy as much as I hate my drinking. Some days, I wake up and I think I want to fuck the world. And I suppose, in my sweet way, I do.

5 August 2005

My studio assistant walked into my bedroom. I opened my eyes and said: "Fuck, what time is it?" It was 12:30. Laura started laughing. "You look so funny, lying in bed with your cycle crash helmet," she said. "Yeah, well I went to sleep wearing it," I replied. "There's worse things to wake up next to. I think it's pretty harmless."

Maybe I should explain myself a little after last week's column— I hope I didn't come across as too self-righteous. For example, I don't masturbate. But if I ate chocolate I definitely would. In fact no living thing would be safe with me around. I stupidly once ate a chocolate mousse on a BA flight to Berlin. My God, did those chambermaids in the Grand Hyatt have a lot of cleaning to do. It's like sex, it's like drinking, it's like anything. If I slept with all the people I liked I'd spend all my time in bed. That's why love's so important—I'd give everything up for love.

Last night, on my way to a lecture on lidos and open-air swimming pools, the cab driver said, "Don't I know you from somewhere?" In such situations I'm always tempted to say, in a very Ali G way, "Ya man—it's woman from TV." That's what the Bangladeshi boys say when they see me walking down the street. Back to Mr. Cab Driver ... at this point I told him he was going the wrong way. He said, "Right way, wrong way, I would go any way for you." I said: "No, you really are going the wrong way."

He shook his head, turned off the meter, and said, "This one's on me." We then played a game in which he had to guess what I did,

45

and I had to guess what he did before the Knowledge. My first guess—ex-footballer—was right. He then asked me out about 100 times. I was really laughing. I said to him, "Okay then, what happens on the date, when you pick me up? Where do I sit?" As we got to my destination he said he was very tempted to lock the doors and drive off with me. I just laughed and said, "And then what?"

Well, I've been cramming my brain with all sorts of stuff this week. I went to the cinema to see *The Festival*, with Eric and Joe. We loved it. We laughed. I've never seen a film with such bad sex in it. At one point you see a fully erect penis, but it's still bad sex.

And then the highlight of the week was me, and 10 of my friends, going to see *The Postman Always Rings Twice*. Again. Yes, it's hard work being my mate Val's No. 2 fan. But it was brilliant.

I'd never seen a play twice before. The play itself becomes an entity that has a natural evolution, and it was good as I now have a proper perspective on it—unlike the first time, when I was just so nervous. And it was great to sit in a theatre that was full.

I can't believe what actors have to do, especially on stage night after night. If I were an actor I would be flaking all over the place. I could never have the stamina.

It's funny how in life, whenever you're low or depressed, or you feel a bit hurt or bruised, you really do need to pick yourself up. It's the faith thing that's so important. I used to do this really bad thing; when something went wrong I would just start to add up every failure in my life, every hurt, every fear—and I would plummet. It would be like a long, downward spiral. Nowadays I put the brakes on, but it's a conscious thing, I have to work at it.

In 1997, I was in the French House, really, really drunk having a great time. One phone call later, I found out that my mum was in intensive care, on a life-support machine. I lay alone in her bedroom, surrounded by all her things, crying myself to sleep.

I had a dream that my mum was climbing up a mountain path, it was a Wile E. Coyote cartoon mountain. My mum was carrying me on her shoulders and she kept saying, "We are not there yet."

My mum survived, but now I can see the spiral in a positive way, it doesn't have to go down.

This week I took the girls from my studio out. Sometimes in this situation I feel like a bit of a mother hen. The next day I had to do hair, makeup, photo shoot, interview, while they were all vomiting. I must admit I did find it funny. You see, they're the ones who are usually looking after me.

Onwards and upwards with my mental replacement programme. Can't wait to get that book back in my hand. People are saying I look beautiful, but it's how I feel. And tonight it is Greek Tragedy with Vivienne Westwood. So many doors, so many surprises.

12 August 2005

Where's a tree surgeon when you need one? Yellow Pages—let your fingers do the walking. Sorry. We don't cut trees in August.

Remember a few months ago I said, "Your garden is the mirror to your life?" Well last week, just before I was about to go off on holiday, I looked out of the window to see a vision of pure insanity. My rose bush had gone ballistic. A matted web of thorns completely engulfed by a crazy, selfish, belligerent wisteria. The ivy—man, it was evil.

I hacked my way through it, engulfed by small spiders and dust. After two hours of fascist pruning and a look of total shock on Docket's face, as if to say, "Mummy's gone mental," I was left with a pile of branches and leaves a good five feet high—it's a jungle out there.

You see, it wouldn't have mattered if I hadn't been going away, but it's like the situation of being run over when you're wearing dirty underwear. The idea of the plane crashing and people saying, "The state of her garden!"

I was in the steam rooms with my friend the Viennese artist Elka Kyrustafek, or Krusty as I like to call her, and she said, "Tracey, how come you never have sex with people?" I said to her, "I do, sometimes. People just jump on me, but it is always when my pubic hair has got really long and way out of control." At that she looked down at the perfect, neat triangle and said, "Ah, so I see you leave nothing to chance."

Once, I didn't have sex for more than two years. When I finally did, I weighed myself the next day and, you know, I was four pounds lighter—there's got to be something in it. Where does cum come from? Do we go round storing it like small camels? Ah, the mysteries of life. Must lose some weight.

It was fantastic being on holiday. Sometimes I like to go on holiday on my own. I go to Northern Cyprus and stay in a really cheap little place that has a tiny kitchen. Every morning I make my breakfast and watch a very crackly BBC World. Sometimes I watch Turkish football, and the managers have fights on screen. I love it when that happens. I go to bed really early and I get up really late and guess what? I don't drink. My only major form of indulgence is the text messaging.

I hire a mountain bike and I cycle along the old Roman roads (they aren't actually Roman, but you know what I mean. They're old, right, but, when I think about it, not that straight, but then what is straight in Rome? I knew this girl who had a Roman boyfriend once who was as camp as nine pins. He did everything to persuade her he could be straight. He probably did it all for the benefit of his mum. Ah, the gay pollen of Rome!).

Back to Cyprus, and I'd cycle between 30 and 50 kilometres in a day, in temperatures of 45 degrees. In fact, that last trip to the turtle sanctuary nearly killed me. I've adopted three turtles so far, which might seem a little excessive and may prove to be my other addiction.

But this holiday was with the commune, man. I live alone, so it's an absolute pleasure at 8:30 in the morning to have breakfast with my friends and their children, three tiny toddlers all meowing and calling me "Meow meow." And in the evening getting really drunk, walking into a tree, wetting myself and having a giggling fit. All part of the group dynamic. But what's great when you go away together is that you see sides of people that often remain private. Like Kate Moss has a brilliant sense of humour, she is very gracious when it comes to helping out, and she's a fantastic mum—but I didn't like the book she was reading.

I loved it when we were in the little village talking to the major

after having our Benny Hill moment (which was me and Kate walking into town in very short shorts with letchy men in cars driving slowly behind us. I took great pleasure in taking out my teeth and smiling—that scared 'em). Anyway, Kate was bending over a wall looking at this amazing Renaissance landscape. We were discussing how much it looked like a Giorgione painting, while these two guys across the square were enjoying the amazing view of Kate's arse. When she turned around, their jaws dropped.

And so did ours, when they said, "Claudia Schiffer." So fucking funny ...

I spent the last two days at Ruth and Richard Rogers's house in Tuscany. I discussed Samuel Beckett with the Chief Whip, the Holocaust with Alan Yentob.

I had a guided tour and mini-lecture on fourteenth-century architecture by Lord Rogers of Riverside himself, discussed the pros and cons of the contemporary art market in connection with the rise and fall of the dollar with the gallerist Lorcan O'Neill; and group discussions varied from the doctrine of Opus Dei, to what's so interesting about *Heat* magazine and where does such a phenomenon come from within our culture of the twenty-first century, should there be more bridges built or should we try to get to Mars, and what are the odds at Ladbrokes that I don't become a Dame within the next three years?

2 September 2005

What's the mantra for today, Docket? Yes that's right, Mummy's fat, ugly, and lonely. It's Bank Holiday Monday. I'm lying on my roof, half-naked, watching the planes fly above me. Beautiful white lines carved into the rich sky blue.

I used to have a fantasy about an international man. I imagined we would meet in such weird locations, like the disabled toilets at Frankfurt airport. I used to believe I would feel a tremor when he flew above me. All his suits and shirts would be made in Hong Kong, and he would miss me and really love me.

There's no room for fantasy. I'm lying on the roof surrounded by the London holiday silence. I text. I call. But it's one of those days when not an entire soul I know lives on this earth. I actually feel like I could cry.

For a combination of different reasons, I've just had another holiday on my own, surrounded by friends who care and really adore me, to the point where I almost get away with murder. But I'm still somehow on my own, and that's because I know when I enter my house and close my door I will be alone.

A few weeks ago I passed through a town where a friend of mine lives. My friend is in her late seventies. I had some time to spare, so I called her. On the end of the phone, she sounded sad. I said: "What are you up to? I'm passing through—let's meet."

She had been sitting in Marks & Spencer's having a cup of tea

on her own. We arranged to meet at the harbour half an hour later. The town was full of life; there was some kind of crazy festival going on. I was with Eric (just for the record, Eric is black, tall, thin, and one of the best-dressed, most stylish men in Christendom. In fact, when I think about it, in the whole damn Alpha Quadrant), and every now and then, he'll say something like, "Hey sweets—what's candyfloss?"

As we strolled along to the harbour, we watched 1950s-looking men on the beach, diving from 50-foot diving boards into a tiny bucket of water. The crowds were ecstatic.

My friend was sitting on one of the stone benches. She looked tired, but very happy to see me. I went and brought her some jellied eels and myself some cockles. Even though he's from San Francisco, Eric seemed quite amazed by the jellied eels. I sang a few cockney numbers so he could get his bearings. "On Muvver Kelly's doorstep, blah blah blah."

Eric decided to taste the delights of fish and chips for the first time, so off he bravely trotted to Pete's fish and chip bar. Left alone with my friend, I could see the sadness in her eyes. I had to do everything I could to stop my voice from sounding too brittle and snappy, because I hated seeing her like this. Not because I'm powerless to help her, but because I had the ability to help her too much.

She said that when she was having a cup of tea in Marks & Spencer's, she had looked across to the door and could see couples older than her coming in holding hands, chatting, laughing. And as I looked at her, tears welled up in her eyes. Looking at me, she said, "Tray, what have I done so wrong? Why am I so alone?"

Yesterday, I was in St. Ives, filming my TV programme for Channel 4 on female artists. There's nothing like a Dame, like Dame Barbara Hepworth. Before visiting her house and her studio, I can quite honestly say I was wrong about her; but now I know the woman was a full-blown diva, partygoer, and workaholic. A mother of four, she was surrounded by a network of loyal friends, but was often left carrying the responsibility of the baby. Or should I say babies, as far

as her and Ben Nicholson's triplets were concerned.

She also changed the face of British art. She was a league ahead of her time. She spent the last 25 years of her life living alone, unattached, and she eventually died at 77, in bed, puffing on a cigarette.

Walking along the beach in St. Ives, apart from wondering whether I would ever become a Dame (hee hee hee), I kept thinking about whether I would spend the next 25 years alone. But for me, I wouldn't even have a child to hold my hand. These thoughts were exhausting me, because I knew that in a more confident mood I would remind myself that I have been privileged enough to choose my life.

I've had two abortions—both, strangely enough, with the same person. I might have had twins of 15 now, and another child of 14. But you see, I never would. I never wanted those children, and I never wanted those abortions, but I felt I had no choice. In those days I was not mentally strong enough to bring children up alone. And for me it would be extremely hard to have a baby with someone who didn't love me. Even if I die alone, holding my own hands, praying alone for some rotten salvation, I will always thank God that I never had those children.

This is for my friend: don't feel sad, you were brave to have your children alone, much braver than I could ever be, and the legacy that you give to the world is a wonderful independence. I love you, and that means you're never alone. And don't forget—you have a great sense of humour.

9 September 2005

I was on a train going to Glasgow last week. Oops. Did I say Glasgow? Actually, no, I wasn't. I was on a train going to St. Ives, but I do hate repetition of any kind. It is like when you have a song going around and around in your head. Let's take the Buzzcocks: "Ever fallen in love with someone, ever fallen in love, in love with someone, ever fallen in love, in love with someone you shouldn't fall in love with."

"Money can't buy you love." But it can buy you a first-class round-the-world air ticket at any given moment—or, as events have sadly shown in the last week, a one-way ticket out of New Orleans. Now I'm not going to bang on about this too much, because it is stating the obvious, but crimes against humanity are looking high on the agenda.

I had this boyfriend once who I had been with for years. When I finally found out that he was having a full-blown affair from a mutual friend, who sadly informed me that it was common knowledge, I can quite honestly say I wasn't in denial. I just couldn't understand how anyone would lie like that.

After texting him the word beginning with C and rhyming with "front" 220 times, I packed up all his clothes and belongings. I even washed and ironed his dirty clothes, and left them in the hall to be collected, between four and six on a Monday afternoon. I came home and cried. I didn't stop crying for days and days.

He wanted space. I went to Australia for two weeks. I stayed three months.

Out of sight, out of mind, you reckon—like you're going to stop that telepathic shit from happening.

It's like when you have a broken heart. I always think of it as a piece of paper. It can only be folded eight times. Each fold is like the heart closing in on itself—and one more fold after the eight and it will spring open. The thing is, you never know when the origami master will come along. Oh, you have to laugh. The pseudo-philosophy we give ourselves to try and stay sane.

Cheer up love, it might never happen. Tell me about it.

Mental blowout. Friday was a bit of a killer; I think I upset myself with my own column. But blimey, did I get a lot of invitations. My favourite text message was from my friend in Paris, Charles Henry, which read: "Tracey, you're not fat, you're not ugly—just lonely."

All the parties, all the glamour. Monte Carlo, Shirley Bassey, Donatella Versace, helicopters, swimming pools, Yves Saint Laurent, Valentino. Where's the invitation to snuggle up and watch TV? Maybe I threw it away a long time ago, without realising. Along with the picnic in the countryside, on the tartan blanket, or walking around the supermarket trying to work out what to have for that cosy dinner. Every morning, I look out for that invitation.

I'm at my studio. I'm half a bottle of rosé down. It's five o'clock. It's Friday afternoon and it's Crackerjack time. Fuck it, I make my own invitations. I phone J Sheekey and book a table for six for 10 p.m.

"Will we be arriving from the theatre, Miss Emin?"

"No, I'm working at my studio. I just want a late table."

My phone is ringing. It's Miranda, the mother of my goddaughter. I can hear her voice saying, "Tracey? Tracey? Where are you?" I open my eyes. I can see I am at a table with a group of people I don't know. It's a reflection in a mirror, and I am really confused.

"Where am I?" I gasp.

Eric has his arm around me. "It's okay, sweets. We're in the restaurant."

"Yeah, but which restaurant? Which city? Which country?"

"J Sheekey, sweets."

Then, slowly, everyone at the table is transformed from ghostly apparitions to really good, close friends.

At that, I demand to know where my food is, to find I have already eaten it, and have already paid the bill, and have knocked back half a bottle of dessert wine on top of the three bottles of rosé. Nice one Trace. Really cool. See how you've got a grip of things?

To all at J Sheekey:

I am so sorry for my stupid, drunken behaviour, and the fact that I passed out. This is no reflection upon your restaurant, as I love the food and the service. But it appears I love my drink a little too much. I apologise if I caused any stress or embarrassment to staff or any other diners. I promise it won't happen again.

Yours sincerely,
Tracey Emin

Back to the train. I was half-dozing, staring out of the window, trying to imagine what it would be like to live in the countryside. A sort of Heathcliff situation. Then I started to wonder if people really did shag sheep. I imagined myself in a small sheep outfit, roaming around the moors, a kind of woolly knickers ensemble and suddenly I screamed to my assistant, "FUCK! THE EGGS!"

Three hours earlier, I had done the sensible thing of putting on two eggs to hard-boil for my journey. Docket had had his tail attacked, and Laura, my studio assistant, had taken him to the vet's. On returning to the house, she found the whole place filled with smoke. The reason? Two dried-out, burnt, shrivelled-up eggs. That'll teach me to be sensible. Bring back the old crazy wild anorexic alcoholic. See if she'd burn the house down.

30 September 2005

When I was a student at Maidstone College of Art in the early eighties, a major part of our degree course was to write a thesis, not just in the final year, but every year. I swung it in the first year with creative writing, but I still had to have meetings every week with my creative studies tutor, Professor Noel Machin.

I used to love these meetings. We would spend 40 minutes analysing the last book I'd read. Noel's questioning and reasoning would always make me a little bit more intellectually ambitious. Not long after I left Maidstone, Noel died. I remember sitting in a pub reading the letter his wife had sent me, and crying and crying and crying. I had just come back from Turkey and was unaware that Noel had died.

A few weeks earlier, I had the most amazing dream. I was standing on the bank of a river, on fantastic vivid blades of green grass. To my left there was a very elegant suspension bridge, quite Brunel–like in appearance, except not made of iron, but of some amazing, lightweight, white organic kind of steel. And on the other side of the bridge, Noel was waving at me. Great big smile, his red beard and hair glowing in the light. It was only when I walked towards him that I realised the bridge was suspended over nothing, that below me was pure space.

As I got closer to Noel, he said, "You can't come any further. I have just come to tell you how wonderful it is here." And then he pointed to where he'd come from. "Look. Look," he said, and there was the

most beautiful crystal tower. I mean pure crystal, light reflecting from every angle. It was at least 300 feet high. I said, "Wow, this is the most beautiful thing I have ever seen." "Yes," he said, "I just wanted to show you. I made it. It's amazing here—you can make whatever you dream."

Then, last week, I dreamt of Noel again. We were in a glass room and he was handing over to me a huge roll of banknotes. I said, "I can't take this." He replied, "Everyone gets paid here. They get what they deserve—and you deserve this. It's your reward."

I have changed my life since passing my driving test, just like I said. Every time I've had a drink—with one exception: the birthday of Sandra ("Oh babe, its the bee's knees, no fleas on my gizmo") Esqualant, my mate and the best pub landlady in the world—I have stuck within the units. Galileo, the wonderful clear light of day. Apart from when I had a kidney infection in 1999, this is the longest I've had my act together on the drinking front. And it feels fantastic.

Back on the mental replacement programme, my highlight this week was going to see the Munch exhibition at the Royal Academy and then having a brilliant dinner at the Wolesley. I actually wrote my art thesis on Edvard Munch on a ferry travelling back from Amsterdam. It was Sunday night, and it had to be handed in on Monday morning. So I analysed four of his paintings using the Oxford English Dictionary. For the painting *Madonna*, I used the argument "mad and onerous." My conclusion being that you couldn't chop up Munch's paintings intellectually, morally or spiritually; they were about passion and emotion, and should be viewed as a whole. Plus, all the titles originally were in Norwegian, so it made no sense analysing them from the English dictionary, la-di-da-di-da. Professor Machin wasn't having any of it. He gave me a II ii, and said I would have got a First had I spent longer than two hours on it, pissed on a ferryboat.

What I find incredible about Edvard Munch is the way that he painted women. Women and girls, from the skinny pubescent to the voluptuous Madonna, with her full breast, curvy hips, thunder

thighs, and rounded stomach. For a man who supposedly had crap relationships, he really did understand the female anatomy.

I saw a shocking thing yesterday. My friend Sebastian Sharples, who I make all my films with, had put together a small documentary about me me me me me. It was made in the summer of 2003, and there on the screen appeared a brown stick insect with a walnut for a head. I was so thin it was scary, and all the girls in the studio squealed out loud.

If anyone had told me at the time that I was thin (as Mat Collishaw would say, I resembled a shrunken head, something an eighteenth-century pirate would tie to their belt), I would not have listened. God, let me be generous to myself. It's like the oxygen masks on planes—you sort yourself out first, and then assist others. I'm too generous to be thin.

I am working flat out for my show in New York, which is called I CAN FEEL YOUR SMILE. The title came from a text I sent a friend whose husband had recently died. It was somehow like the dead wanting us to be happy, as they are in their world.

I have decided to make a 12-foot tower from wood and neon, and I am going to call it "Crystal Tower." I have a photograph of myself when I was three, holding hands with my nan at Crystal Palace, south London. I always thought it was a magical place. Sometimes I miss my nan terribly. I once dreamt she was talking to me down a mobile phone, while floating around her bedroom, telling me never to have collagen (can I just add this was in 1995). Nice one, Plum.

So cheers, Professor Machin. Thanks for the idea. Thanks for the reward. And thanks for paying me. Love, Tracey

14 October 2005

I made a mistake in my column last week. You can either put it down to laziness, or maybe just a slip of the pen. As one of my mates said this week (and may I add, a good-looking heterosexual, male mate), "You, Trace? Desperate for a shag? Get real." I suppose he's right. You see, what I should have said was that I woke up and I was up for it, and then what I should have done was dance around the house and sing hallelujah. Sex drive is good. It's healthy.

It helps push the world round. It's strange when people pick up on it, like some mad sex magnet. Eric told me it would be like this. "Hey, sweets," he said. "You know, when you give up drinking, those boys are going to be all over you." Christ, I couldn't believe it, I should have taken out a cricket bat, something just to nudge them back, back. One whole week without one single alcoholic beverage. Not only has my brain been springing back into action, but every pheromone has spun out of control like some massive, giant web.

By the time I got home on Tuesday night I was thinking, what have I done? Behaved impeccably, had nice witty conversation, and didn't fall over once. Or maybe it's just because I was more engaging with people and the thing that was propping me up was my soul, not another drink.

This morning I woke up at 6.30 a.m. My bedroom was quite dark. I could hear the rain. Docket came in through the catflap, soaking wet. He miaowed a bit, he looked so cute and skinny. I went and got a towel and dried him. My bedroom was all warm and cosy.

As far as my I Ching is concerned, I'm supposed to sleep in a white room, with white sheets, white rugs, and blinds. My inner being is full of fire, so I'm supposed to calm it down. The last thing I'm supposed to have is red sheets, checked duvet, bloodred pillows, buckskin headboard, red Persian carpet, and tartan curtains. But that's the way I like it.

But I've done something really smart this week, to help with the cuddle factor. I brought this great big fur blanket. Not real fur, of course—the only real fur I have around me is Docket.

I once got asked to do an advertising campaign for the anti-fur movement. It went like this: "SOMETIMES I FANTASISE ABOUT BEING FUCKED BY A LION. KEEP IT REAL, BABY. KEEP IT LIVE." Er, I don't know why, but it never got used. I don't really want to sleep with animals. In fact I think it's wrong. Do they have a conscience?

The same goes for a lot of men. Take Docket, for example. Can you really imagine him saying, "Miaow, Mum. Sorry I threw up on your carpet and your mate trod in it." Do you really think he is sorry, or do you think he did it on purpose? He is a possessive little creature and is prone to fits of jealousy. In fact, on one occasion he threw up all over the house. I could just hear him going up and down the stairs going bleurgh, bleurgh, bleurgh. Mega embarrassing. As I say, "He's not usually like this." But then I don't usually entertain. You see, my very good-looking heterosexual male friend is right. I'm not desperate for a shag—never have been, never will be.

While interviewing me last week, a journalist said: "Now tell me about your celibacy." I felt like saying, "As long as you tell me how you fucked your wife last night." But I just answered honestly, "I am not celibate. If I decide to abstain physically it is simply because there isn't anyone I want to have sex with. But if I want to, I will." My thing is that I'm monogamous—and yeah, it's a big deal, it does my head in. It can be years before I'm free. Sometimes I just want to throw myself to the lions and see what happens. Room for one small cat.

But I secretly can't help but admire my friends who sleep around. I think, how the hell can they live like that? That straight-faced lie

was hardcore. I don't even like to masturbate because I see too many people's faces. Have you ever made love to someone and wished you were making love to someone else? Eyes closed, conjuring up a face of another. Cruel. Shame on such people who do that. I'm not talking about fucking, I'm talking about making love.

I respect those who live alone, far more than those who live a lie. But next week you can read all about my infidelities. I'm no bloody angel. I have done things that would make Machiavelli eat his heart out (if he'd had one). Yes, I'm an author. It's a big thing to write a book. People keep telling me it's good. I say it's not that good—it's taken me 25 years to write. What is incredible over 25 years is that however much we have the ability to change, the core, the essence stays the same. But everything can be moulded through emotion and experience. What I thought was right then, I no longer have to feel is right for now. We all have the ability to change our minds. Party party here I come.

21 October 2005

Winter is coming, porridge is back, cosy times will be had. Going to bed at eight o'clock in the evening. Flicking through the channels. Waking up at 2 a.m. feeling like I've had a whole night's sleep. I nestle down in the furry blanket, but it is impossible to go to sleep. Something is keeping me awake, as a ghost walks across the floor. I'm verging on the world of super-insomnia. It is my physical torment that is keeping me awake. As Nietzsche said, "All too human."

It's amazing what we can live without. I used to be able to go three or four days without food, no trouble, one or two nights without sleep, one or two years without sex. But as you get older it seems to become more difficult. To quote Nietzsche again, "Oh how the mighty fall." I always thought *The Will to Power* makes an amazing present for a newborn baby—just as it's having its head splashed, our ears are filled with the words "when the hammer strikes." (I can't remember if that is from *The Will to Power*, but it sounds good.)

In the film *It's Alive*, the baby comes screeching out of the vagina with a giant head and claws. It attacks the doctor and the midwife, leaving the mother dead and finally taking over the world. Another good reason for not having sex! Someone suggested today that I should get a vibrator—never used one, never had one. Someone did put one inside me once, but I laughed so much it shot across the room.

Back to scary babies. A few years ago I was invited to a neighbour's house for a Christmas party. It was an early party and the average age was around 60, but it was all really sweet and festive. And

everyone was being very kind, as my boyfriend had just left me. I hadn't told anybody, but it was common knowledge. The party host always carried out a Scandinavian ritual: a giant rice pudding would be cooked and in it placed a white almond. And the rule was that whoever got the white almond would be married within the year.

The host force-fed me rice pudding for 45 minutes—um, um, lovely, lovely. No one dared mention the break-up, for fear of me bursting into tears. People seemed genuinely pleased that I was eating. After my third plate, the host cried, "There it is! Tracey has it, Tracey has the white almond!" There was a small eruption of cheers—"Hoorah, Tracey has the almond. Good girl, congratulations, wonderful!" Then I had a tap on my shoulder, and a slightly angry, somewhat peeved middle-aged woman pointed dramatically to her plate with her spoon, saying, "It's me, it's me, I have the almond."

My host and everyone else surrounded me, pointing down to my plate and saying to the woman, "Don't be ridiculous, what's that?"

From where I was sitting I could only describe what I saw in front of me to be a raisin, but it was at that moment I realised I was starring in the reality remake of Roman Polanski's *Rosemary's Baby*. I removed the Tannis balm from around my neck and ran to the nearest phone box.

But seriously, there are people out there who would do anything for a break. They would sell their soul, they would sell their wife's and baby's souls. I am always swapping imaginary scenarios: a few months ago I was in Liverpool having lunch with a group of really good people—by that I mean that their souls were good—and as I got on to my second bottle of wine I decided to liven up the conversation. It went something like this: "Who would you have sex with at this table for £1 million?" No one actually spat their drink out, but a few Adam's apples moved.

Someone should have thrown the question back at me, but I forced out answers from people. Only one person didn't have to play, on the grounds that she actually had £1 million, in fact many millions, so she didn't need to sleep with anyone at the table.

Everyone looked pretty relieved with their answers: my mate Dean Sullivan just pointed, saying, "You, you, you, and you." Why he didn't choose the whole table, God only knows. The question was too easy. It should have been: how much would you sell your kidney for?

There is another game F taught me how to play, and it's really mean. In the raft game, three people are on a raft going down the rapids and you're one of them. The other two people are falling off, and you can only save one. Who do you save? It can be famous people or just close friends. When you get on to close friends things really heat up, and this game has to be played fast so you don't have time to think. It's how I worked out I had a crush on someone—I blushed every time I saved them.

But in life, there are people who never stop playing games. It's a way of retaining power, without feeling, without emotion. They want to win—always at the cost of dignity to others. We all know how easy it is to make someone cry, so why bother? So who would I save, a literary critic or his editor? You know what? I'd let them both drown. Don't forget, chaps, it's just a game.

28 October 2005

I can't write my column this week, so I have to write a letter. In my heart I'd like to make it a love letter. All my dreams, my emotions, aspirations and desires.

NY's a weird place. As a city it has the ability to push so many people to extremes. So much light and yet no light at all. The kind of place you have to be very careful about making decisions. It's why windows only open three inches. NY feels like an easy place to die. I was nearly killed yesterday in a taxi. I was in a deep sleep, the kind of sleep I dream about. Deep, deep, deep, almost comatose. Then lurch, thrust, screech—and I'm wide awake, like I can see for the first time.

I wish I wasn't so thick. Thick as in stupid. Sometimes I have the most amazing moments of clarity. Razor sharp, crystal clear. It's at these times I can see how fucking stupid I am. I have always thought and said, clarity = harmony. Sometimes I hate my loyalty. I hate the way it holds me hostage. My friend Vanessa once had a go at me for trying to be nice. She said to me in her fantastic Swedish Eurotrash accent, "Fuck man, just be a bitch."

And with all her Euro worldly wisdom, she's so right. It's like people who are unfaithful, it's so obvious that it's so much better to tell the truth. Why undercut someone else's development? Because we are afraid of the truth. It really hurts. I hate telling it, feeling it, being it.

At the moment I'm in my hotel. I've just been crying. It's too much of a long story to go into. Tonight I am to give a lecture at New York's

School of Visual Arts and my face has turned into crater mass for the first time in years, full-blown herpes. Nothing like an attack of scabs to kill your confidence. What am I supposed to say to a gang of art students young enough to be my children? One of my favourite pieces of advice given to young people was by the rap star Eminem. When asked his views on drugs he said in a very drawn-out Detroit way, "Hey kids, don't do drugs, just give them to me." There used to be this joke that went around playgrounds in Tottenham. If Tracey Emin married Slim Shady what would she be called? Em-em Em dan na da doon nan Em an em da na da doom. I thought it was funny and cool that the kids knew who I was.

People have children so their legacies can continue. It's cool being a recognised artist. You don't have the pressure to procreate. I have never had the breeder mentality, but sometimes I just want to make love. The idea that love can last forever. The most beautiful kiss in the world.

When I flew here on Tuesday I was afraid. I was very tired and exhausted. I went to sleep and I woke up to be told, "If you look to your left, we will be passing Edinburgh, and to your right Glasgow." I blew a kiss to Glasgow and I thought, "Oh my God, Hurricane bloody Wilma." I curled up in a small foetal position and tried to remember lovely things—being held, being loved, being wanted, not rejected. Rejection is, I think, one of the most terrible things in the world, when someone says I don't want you, I reject you. But even in death you can feel rejected. All my life I've felt left behind.

When I was young I used to have this amazing dream that I'd be standing by a cliff, looking out to sea. The sea had disappeared, leaving rocks covered in seagrass and weed. Rock pools and fish flapping. When I think, it was strangely biblical, and there, miles away, the white line of the horizon. And as I look, the line moves closer and closer with a sound so intense it is deafening, a giant wave. I turn towards the cliff, but it's futile, so I face back towards the wave. It hits me, and within seconds it recedes as fast as it has come, and I am left wet and standing.

As a child this repetitive dream would almost kill me with fear, and now I long for it to return. It is so obvious—sometimes the things

we are most afraid of cannot actually hurt. It's the sentimentality of holding on that hurts. When I'm miles away from home I sometimes have a clear view on things, and at the moment all I can quite honestly say is, "God, my life's a mess and there's some big housecleaning to be done."

Years ago, Sarah Lucas (the artist) said to me, "What you up to Trace?" I said, "I'm really busy throwing tons of stuff away." When she said, "What?" I said, "The 1980s."

Humour always overrides fear. Tonight I'm in one of the most exciting cities in the world. Alone. I'm going to curl up in bed and watch *The Evil Dead*. There is this terrible scene where a tree rapes a woman. First some ivy grabs her legs and then, well, you can guess! My point is that I will get over my fear of trees and one day I shall sit in a log cabin, in a forest, at night, surrounded by the bloody things. But I shall think of them as my friends. Majestic giants, but I'm not too sure if I'm ready to do that one alone.

4 November 2005

New York, New York. So good they named it twice. The city that never sleeps. The only thing that's not sleeping in this city is me. Jet-lag kitten or what? I can't believe it. I've been here for 10 days. I'm still waking up at 5 a.m. and wanting to curl up at 6 p.m. Why am I so sensitive?

It's physically and mentally painful. Sleep deprivation, an indescribable torture. I look tired and haggard and have great big black rings around my eyes. I've aged a good 10 or 15 years. I've fallen asleep in four or five taxis to wake up disorientated and confused, but not half as disorientated as most New York taxi drivers. Fuck, are they shit! They really, really, REALLY don't know where they're going. Makes our boys in black cabs look like superheroes. Last night, I ended up screaming at a driver, "You stupid bloody idiot. If you don't know the way say, 'I don't know,'—don't pretend you do!" That's a clear, basic philosophy for the whole of life. Had he read Plato's *Road to Larissa*? I don't think so.

I was on my way to the Elton John Aids Foundation charity gala in a cerise pink, heavily-boned, corseted Vivienne Westwood dress. I had to lie across the back seat in a weird angle, keeping my body as straight as possible to stop my tits from exploding out of the top.

I had prepared myself for half an hour of this ridiculous agony. (If only my dress had been an inch bigger.) The car was going round and round in circles. I could see the headlines: "Brit artist found dead in back of limo. Death by glamour."

The night ended in disaster, as once back in my hotel room I realised I had no one to help me take the damn dress off. After 25 minutes of twisting and contorting, I ripped it off. Three thousand pounds worth of my favourite dress torn off my own back with my own hands. What a waste. Some deranged, mad fantasy all gone so terribly wrong.

My hotel has a very nice pool. It's up on the 22nd floor. There are glass windows on three sides, and as you swim you are surrounded by the gothic, art deco, futuristic Manhattan skyline. The light is blinding. At 10 a.m., there's an aqua aerobics class. The pool suddenly becomes full of 45-going-on-85 uptown ladies, who, in their day, must have been the belles of the ball. Some of them have had a lot of face-work done. Scars concealed by the firm set of waves of hair. Contorted generations joined by the neck. Younger faces perched on older bodies bobbing beneath the water. Moving slowly in time to music more suited to the body-popping street kids: "YO Mammas got the rap!"

One lady is around 80. (I have to call them ladies because the word "woman" would seem so wholly impolite. So wrong. These women were born ladies. Even as little girls, they would have been ladies. Even as married women, they would still seem like Misses.) This one lady, she's wearing a white swimsuit, big dark glasses and a dash of red lipstick. She has a really good figure. The swimsuit is slightly see-through and you can see her breast. Her arms are up in the air and she's smiling. She's beautiful and this gives me faith.

A male friend of mine once said, "Tracey, you have a wonderful body for a woman of your age." I nearly punched him through the wall.

The age thing, man: it's weird. So many of us are so afraid of it and it's coming, and there is nothing we can do. Self-preservation is the only step. Look after what we have. Thy body is thy temple.

When I'm in a strange city, no one knows who I am. Like here, the art world and the fashion world may know my name, but no one knows who I am. I walk through the streets in total anonymity.

It's in these cities I always take advantage and go and visit some mystic or other—palms, tarot, or crystal balls. In Sydney a few years ago, I had my astrological chart done, plus my tarot cards read. They both said the same thing. That I was going to give birth on 17 July, 2005. The third week of October last year, I freaked out. I became a nervous wreck. My male heterosexual friends left the country. I was scared to go out the house for fear of conceiving.

A neon sign glowed outside a ramshackle house. The words said "psychic readings." I went up the stairs and rang the bell. The door was scruffy and white. It didn't match up to the neon sign and, as it swung open, an intolerable stench hit me.

A small woman, slightly hunched, with a face full of makeup, smiled—and with a voice that was a cross between Robert De Niro in *Taxi Driver* and Woody Allen, said, "You comin' to see me?" And as I walked in through the door and it closed behind me and the smell overwhelmed me, I wondered if I would ever be seen again.

11 November 2005

Interviewer: It was a cold and windy night ...
Emin: No it wasn't, it was a warm and balmy evening, with a gentle autumnal breeze. I was standing in the Hollywood Bowl—right up front, left of stage. The Stones gyrated only a few feet away. Ronnie played hard rock 'n' roll guitar as Mick blasted out the lyrics. Keith's jacket shone a million sequin stars. Charlie Watts's drum kit glided around like a Popemobile. Mini giants—gods of the twenty-first century—filling up the airways of the Los Angeles sky, and Cilla Black smiles and says, "Eh chuck—this is a night to remember!"
I: Are you referring to a dream?
E: No, it was real. I went to see the Stones play last night. But sometimes I have to pinch myself to check that my life is real.
I: You do seem to spend a lot of time living in a twilight zone. You speak of the dead, dreams, the paranormal, and other-worldly things, as though they are everyday occurrences.
E: For me, they are everyday.
I: Let's talk about your new show in New York. *I Can Feel Your Smile.* How did you arrive at that title?
E: A friend of mine—her husband had died. Of course, it was very sad. She was very sad. A few months ago we shared a small joke together. She texted me: "Tracey, you're so funny." And I texted her back the words: "I can feel your smile." You see, I could actually feel her smile through her message, and I wondered if the dead could

feel us, if they looked down and willed us to be happy, to be able to live without them.

I: That's beautiful. Your work in this show seems to be very different, more personal, as though deeply private. Is there a hidden code?

E: One of my favourite paintings is a Vermeer. I think it's called *The Love Letter*. There's a kitchen and in it stands a maid with her mistress. The letter is being passed between them. I have spent days, weeks, years, imagining what was written. Who is it from? Who is it to? It turns me on, the heightened romance.

I: So, you are saying there's a private code?

E: No, what I'm saying is that, at times, some things should be kept private, unspoken, to keep them special.

I: This is a big departure for you. Do you feel that, in the past, maybe you've given too much of yourself away?

E: YES. And now I want some back.

I: Don't you think it's too late? Pandora's box is well and truly open.

E: I've always thought Pandora was a beautiful name, but I guess it's a bit loaded—and you'd end up being called Pan. Names are funny things. I was going to be called Pebble, and my twin brother Django, after Django Reinhardt. I wonder how our lives would have panned out [pun].

I: Can we go back to the show? You made some quite ambitious sculptures. These also seemed to be a big departure. Pure abstraction.

E: There's nothing abstract about them. In fact, they're quite literal.

I: Maybe this goes back to your secret code.

E: There's nothing secret. I told you, just private. I have nothing to hide. What you see is what you get.

I: Yes, and what I see is abstraction.

E: Up until the age of 11, my two favourite hobbies were lying on the floor in a small ball, bum in air, head on palms, dreaming of crystal formations. And, when I wasn't doing that, I spent a lot of time scouring the line of the horizon, waiting for tidal waves. Neither of these things are abstract, but as a drawing or a sculpture

that's how they may appear. They are lodged deep in the recesses of my mind. I am pulling them to the foreground. It's in this way I want to change my life.

I: And you feel you can change your life through your art?

E: Yes—by making art that gives me more answers. It's my journey.

I: What's your favourite work in the show?

E: *Sleeping with You*. One of the wood and neon sculptures. When I first moved into my house a few years ago, I tried to make a sculpture for my cat, Docket. Little spiral steps so that he could look out of the window. I called them cat spirals. In fact they're helixes. A magic spiral that resembles DNA that often shows up in sci-fi townscapes. It is a shape from my childhood. Of course, if I could ever get one to stand I would win the Nobel prize for engineering!

The spirals are placed in a group on the floor, in the corner. And above them a wild line of neon, like a rip of pure energy. All my life I've been afraid of the dark. I have to sleep with the light on. I have nightmares that take place in the room where I am sleeping.

Sometimes I'm so afraid, I can't sleep. I wake up and Docket is jumping around, going crazy. It's then I definitely know there is something in the room. What I just experienced was not a dream. A friend told me I must sleep on my right side. Keep my heart high. For years, in fact all my life, I've slept in a small foetal position, curled up tight on my left. My heart and liver squashed, shadowed by darkness, literal and emotional. And now, I am tired of the insomnia, the sleep deprivation, the nightmares, and the fear.

And through my work I have found a way to fight back. I LOVE SLEEPING WITH YOU BECAUSE NOW THERE IS LIGHT.

I: Tracey Emin, thank you very much.

18 November 2005

I woke up to a strange thudding sound. I looked at the clock: 4:25 a.m. I liked this room, number 1022. Everything was white, everything light, like a little apartment. L-shaped with a small kitchen area. Pale green wooden table and chairs. Two white sofas. TV. Dressing room. Bathroom. And windows from floor to ceiling, with an amazing view going east along Sunset Boulevard.

I pulled back the curtains to take a view. A Prussian blue sky with a million little lights below. I kept staring and then I saw it. At first it didn't make sense, the sky seemed to be divided, something black, and below a trillion sparks seemed to fly. It was moving really fast. Then I realised.

Fuck. A tornado. I grabbed my phone, pillows, bed covers, and towels. I don't know how I kept my head together. I closed the dressing room and bathroom doors, jumped into the bath, putting the towels, bed linen and pillows on top. And I began to pray. I thought about my Nan in 1907 when Halley's Comet appeared. How she and her family had hid in the cupboard under the stairs holding hands and praying, believing it was the end of the world. And now I was here alone. I tried to think of everyone I had ever loved. I was crying. I began to tremble. I heard an unbelievable sound, like a million souls being whipped into hell. I don't remember screaming but I remember thinking no one could hear me. And then it was over. A deathly silence. I clambered out of the bath.

I don't know how long I had been in there. It could have been

minutes. It could have been days. I made my way forward and pushed the dressing room door. Sunrise hit me—a searing, blinding light. Then the realisation: the windows had gone, the furniture had gone, the ceiling was away and the sky was coming through. My hotel had disappeared. Only my corner remained. I was suspended on the 10th floor. Concrete and plaster started to crumble. There was no way down.

I picked up the receiver and dialled room service. "Yes, Miss Emin. What can we do for you today?"

"I'd like scrambled eggs, a side order of bacon, grapefruit segments, and English breakfast tea."

"Will that be all, Miss Emin?"

"No. I'd like to make something very clear. Now, I don't want to sound mean, but can you make the scrambled eggs with only two eggs. I repeat: two eggs. Not 12, but two. Also, please can the toast be toasted, preferably hot, the bacon crispy, and the tea with cold milk. Repeat: cold milk, not hot."

"Is that all, Miss Emin?"

"No. I would like the grapefruit segments away from the egg. In fact, God help us all if anything appears anywhere near that egg!"

"So, Miss Emin, let me get this right. You don't want your eggs served with potatoes and mushrooms, but you are happy to go with our fruit-of- the-season, pineapple."

In a really curt, crisp, fascist tone I say, "For the last time, let me make this very clear. If there is one tiny scrap of pineapple lurking or touching anywhere near that egg I will puff and huff!"

Oh God, these Americans and food. They just don't get it! From the crappiest diners to the best restaurants, they still serve portions fit for baby elephants. There's no room on the plate to move the food around. Now, I simply ask for two plates—one of them empty.

Years ago I went to Santa Cruz with F and his friend, Adam. We had a fantastic day, watching sea lions barking and surfing in and out on the waves. Their shiny black coats, hard to distinguish from their surfing human counterparts. It was so mesmerising to watch these majestic animals roll in the waves. A couple of years before, Santa Cruz had been hit really hard by an earthquake. Masses of

empty plots of land, vacant, where buildings once stood. There was something ghostly and serene about this place. Benches lined the clifftops, engraved with the names of the dead. "In loving memory of ..." We went along the pier and ordered fish and chips. OH CRIKEY! I was given a fried fish, not exaggerating, at least two foot long, and a bucket of fat full of chips. I pushed it away in disgust. The waitress asked, "Do you want it to go?" I said, "Yeah, just get it away from me." Ten minutes later I was given a beautiful box, tied up with string, and inside was the dirty great, big, greasy fish. I nearly had a seizure.

I was going to say: It gets right under my skin, I just can't get no satisfaction, but I try ... Being a rock chick (mouse), it's hard going hanging out with the Rolling Stones. I'm not impressed by much, like I could never be a groupie and would never admit to being a fan. I'm just too cool (just a normal mouse). But it was a total WOW! Have you ever been on stage at the same time as the Rolling Stones? Well, I have. Petco Stadium, San Diego, 2005, the Bigger Bang tour.

Mind-blowing to see what they see, from where they see it. Thousands upon thousands of people. The excitement. The adrenalin. The performance. These 60-year-old men. So super-fit. Not an ounce of fat between them. Sinew. Pure muscle. Focused minds. Super gladiators of our time.

For me, something fantastic not to feel afraid of the crowd, to share their enjoyment, to be part of it. Something for the rest of my life that I shall never forget. But for now, I would like to just go home, cook chicken soup, and be happy. L.A. can be a very humbling place.

2 December 2005

I've never done this before, but I am so stressed out and wound up that I thought I'd like to share it with you. A Day in the Life of Tracey Emin.

Before I do that, I'd like to write something about my Australian friend, Shane. He died on 7 July this year, after months and months of pain. A row of tumours ran along his spine. He was young and very handsome and extremely funny. The last time I saw him we were in the Golden Heart.

Ironically, I had a very bad pain in my shoulder, and Shane was attempting (very well, might I add) to ease the gremlin out, whilst Sandra merrily topped up our glasses. We were all laughing because, as Shane rubbed my back, my giant, humongous breast seemed to catapult across the bar. I have a lovely photo of Shane. His partner, Troy, sent it to me. It hangs in my studio next to a beady-eyed 3-D photo of the Pope. I use the photo of Shane as inspiration, for good karma and light.

Last summer I sat at a table sipping rosé, laughing and mucking around. I was being really silly, and puerile as hell. I had a white paper napkin. I was pretending to be a magician. I wrapped the napkin around my face, first one side, then the other, to show that nothing could be concealed. On the third go I stuck my tongue through the centre, its sharp little end ripping through the tissue. Something rude but not totally disgusting. My mates rolled around. They were falling off their chairs. And as I giggled and stared

around the table I realised that four of these six people, four of my friends, were HIV positive. But it's good to know. Knowing equals responsibility. Which means they can monitor the virus, take combination drugs, and live to be as old as the next person.

I have an HIV test every time I embark on a new physical relationship. I take the test because I feel it's the correct thing to do, and I am someone who has had very, very few sexual partners in the last 20 years. And I have never taken drugs intravenously, which actually puts me in a very low-risk category. But then, 20-odd years ago, I did have a boyfriend who slept with a German prostitute and happily landed me with gonorrhoea.

Me. Miss Goody Two Shoes, going down the clap clinic. Being asked when was the last time I had sex. Me saying, "Last night." The Irish nurse saying, "Did you know the person?" Worse than the gut-wrenching humiliation was the unbearable pain, like I had a burning-hot iron in my womb.

Just because I'm honest and I'm clear, just because I'm monogamous, doesn't mean the rest of my world is going to be. That's why I have an HIV test. And no, I'm not wasting NHS money. I pay for it out of my own pocket. It costs a few quid, gives me peace of mind, and I take responsibility.

In 2004 there were 4,287 people were diagnosed HIV positive in Britain, the majority being heterosexual. But also, there were 19,700 people undiagnosed.

There are 18 hospitals across the UK that have anonymous screening programmes. From this, they have a fair idea of what is happening. The statistic is horrifying. It's like a timebomb waiting to go off. Yesterday was International Aids Day, so forgive me if you think I'm ramming this down your throat, or preaching to the converted, but have you ever heard of the expression "measure twice, cut once"? So I just want you to be double double aware.

It's so strange how people can fight over the dead. A man can leave nothing, but there are those who will still scrap over a few pieces of cloth. Pulling and tugging to the complete destruction of any pure or sweet memory. Standing around at funerals, listening to the

possessive tongues—the last things he or she ever said ... the final words ... the last wish ... how they wanted to be cremated ... and how the unknown relations insist on burial. Making decisions for the dead.

I can hear people now saying, "NO. It's what she would have wanted." I think I might do one of those video wills and screen it at a really big fuck-off cinema. I am going to have my funeral at my friend Hamish McAlpine's house. It stands on an amazing cliff, looking out to sea. My body will be wrapped in some kind of shroud. I will be placed at the bottom of the cliff, body resting on a funeral pyre. Trusted friends will line the cliff's edge with bows and lighted arrows. On the count of 10, the arrows will be released to the sound of popping champagne corks.

Everyone will be cheering, wishing me well on my journey. As the fire burns, the tide will turn and my ashes drift out to sea. No one is crying. It's the red-hot ticket of the twenty-first century.

At the moment I'm on a train, travelling from Liverpool to Manchester for my book signings. Last night at I went to bed 4 a.m., happily drunk out of my tiny skull. Up sharp at 7 a.m. and on my way. I am so lucky to have focus. So lucky to have a direction. And so lucky to love life—and, of course, with my best friends. Those being my everyday thoughts that I can share with you.

I DREAM ON.

9 December 2005

A couple of years ago I had a date. Not so much of a date, more of a special meeting, with a special friend. There was definitely some romance flying around, but it was all uncertain, and terrifying ...

He is a brilliant snowboarder, and spent most of his spare time in the winter hanging out in the Alps. So that's where we decided to meet. Switzerland.

This was a big deal for me, as I hadn't been back since I ripped my cruciate ligament snowboarding in Saas-Fee. And now I'd been working flat-out. Nonstop. I was at exhaustion point. In fact, I had totally burnt myself out, and so much needed this weekend.

I flew into Geneva. I know Geneva well. I had spent the summer of '93 there with Sarah Lucas. We had six mad weeks doing a crazy project called *From Army to Armani*. I had read a Gorilla Girls poster, which questioned what constituted being a successful artist—being male, wearing Armani suits and smoking big, fat cigars.

Our idea was to go to Geneva wearing second-hand army gear, like true mercenaries, by train and boat, smoking duty-frees. And fly back, business class, in fuck-off Armani suits, smoking big, fat cigars. A simple route to success.

Geneva looked beautiful with its crisp layer of snow, bright blue skies, and surrounding mountains. I hadn't exactly kept my rendezvous a secret. There was nothing that clandestine, but I was afraid of being hurt. So to be on the safe side, I had lunch with Barbara and Luigi Pollard of Analix gallery, followed by a meeting

with Paulo Colombo, the then director of the Museum of Contemporary Art.

I felt by having these meetings, by doing my work, I could justify being there. But as we pored over yearly planners, exhibition dates, film, neon, and installation, I found myself staring out of the window. My eyes resting on individual drops of snow. An overwhelming feeling of butterflies would engulf me. I had thought of nothing but a kiss, for weeks. A kiss. Just a kiss.

The hotel was his suggestion. I arrived late. It was dark and the driveway was lit. The fir trees looked so pretty with their lacy layer of snow. My heart was beating. The hotel lobby was very snug. A log fire burned, surrounded by great big leather comfy chairs. Tasteful, interesting art hung on the walls. Small oil paintings of famous boys and men who had climbed the Matterhorn. A collection of very old Swiss Army knives. A display cabinet full of antique pickaxes, ropes and climbing gear. Maps and photos of early cable cars. I loved cable cars—so sexy. Once I took a little holiday on my own to Barcelona and spent the whole day going up and down across the city in a cable car.

I was taken to the chalet. A holly and mistletoe wreath hung on the door. Inside—pure luxury. Bed big enough for a giant, draped in a canopy of rich green velvet. A sauna and a hot tub by a burning fire, and brandy snaps on the side.

I sent him a text: "The hotel is really lovely." I waited. No reply. Then I called. It went straight to answerphone. I called again. In fact, I hadn't heard from him for a few days. I started to worry. The next morning I rang reception. No messages. I lay in bed till 2 p.m. In the bathroom I found some cotton wool buds. They were tied together in a bundle, with a ribbon covered in tiny edelweiss. I put them in an envelope with a note and made my way to the ski lodge where I knew he often stayed. I rang the Swiss cowbells that were hanging outside. No answer. I was actually worried. I dropped the note through the door. It said: "I hope you're OK. I'm here. I'm waiting." I waited, and waited, confused. I lay in the giant bed, curled up like some small baby seal cub, like I had just been clubbed half to death. And I had been left breathing. All I could

hear was the intake of my own breath. I heard nothing. The next day I flew home.

It's amazing how life can change. This week I celebrated my anniversary. Yes, I've been single for three years. Apparently, according to the media, no longer a spinster. And you know how I celebrated it? I jumped in my car—the mouse rocket—a Mini Cooper, just like everybody else's, except with blacked-out windows, leather sports seats, rubber rugs, bigger wheels, and green "P" plates stamped all over it. I bombed down the motorway—my first trip on the M2—an inaugural journey to do some radical nest-building. A celebration of the Power of One. Perched on a cliff with a beautiful view across the sea. The classy, contemporary, minimal, Italian furniture is on its way! I'm making something new. For me.

Even at our saddest times—moments of anger—we mustn't judge. We must always have the ability to see past the obvious. Maybe not question others, but look at ourselves. It's not all bad being a spinster. Today I eased my TomTom satnav console into its cradle. Now I'm back on the road.

"Never mind, love. He had big ears anyway."

23 December 2005

What is it that makes me so sad about Christmas? And why do I hate it so much? One simple answer: it's a true affliction upon my soul. It actually hurts me.

Last week my mum said to me, "Tray, it's strange the way you dislike Christmas as much as me. I often wonder if it's hereditary." I looked at her in a kind of shock. "Mum, for fuck's sake, my first memory of Christmas is from when I was about three. You sat by the tree alone, tears ran down your face, and with every sound, with each twig, your heart missed a beat and you wiped the tears away from your eyes. But he never showed up, and in the end you sat Paul and I on your knee and sang, 'Daddy doesn't love us anymore.'"

Throughout our childhood my mum worked almost every Christmas. In fact she worked all year round, to give us what we needed. But most Christmas Days we were left sitting there watching TV while she worked her guts out waitressing from 6 a.m. till night. Christmas did come eventually. But always four or five days out, like we were living in some strange time warp. We rarely had Christmas decorations. My mum believed them to be a waste of time and money.

When I was around nine, I cut a flat tree out of green wrapping paper and pinned it to my bedroom wall, next to my poster of Marc Bolan, and wet-bed chart. I covered all three in glitter.

I always plan to spend Christmas alone. Then friends will always

come and kidnap me. You see, I give all year round. I resent being pushed and pulled into some insane, resented act of generosity. And I don't need to be rolled around every office party under the sun. I want to curl up and be quiet. I want to contemplate. I want my brains fucked out. Ooh! Oh! Oh! NO! No! No! No! I didn't even think that!

Christmas is for Jesus. And yeah, I have thought about making love with Jesus—we all have. Jesus, Mary Magdalene, driving through the desert on their way to some great oasis, drinking cans of Stella, Mary casually tossing the cans out the windows. (Their minions collecting their debris on the way.) The man had an army. Shall we celebrate this? No seriously, my two favourite Jesus stories, the first one going back to my mum.

When she was little, her mum made her go to Sunday school. It was during the Blitz. After a terrible raid, my mum and her little chums were told not to worry, because Jesus was everywhere. My mum said, "I don't want some strange man following me!" and on arriving home checked that he wasn't in the teapot. She has been agnostic ever since.

Of course, at the age of nine I had to rebel. Much to my mum's dismay, I loved Sunday school. Anything from "Kumbaya, My Lord" to "He's Got the Whole World in His Hands."

After every session (can I just say the Sunday school was next to the library, and I'd hang out there too) we would be asked to give a donation. And of course, every kid had their Sunday school money. But as I kept the whole big deal a secret, it was sherbet dabs, flying saucers, hundreds and thousands, or a donation to Jesus. I would just sit there and keep my head down as low as possible. And then came the story of a lifetime.

The Sunday school teacher stood there. An amazing smile crossed her face. She said:

"I'm going to tell you a story about a little boy. He used to come to Sunday school every week. And every week after scripture, and after prayers, and after songs, a collection plate would be taken round. Anything could be donated: tuppence, a shilling, a penny, thruppence. But this little boy just put his head down. He never had

any money to give. One week when the collection plate came near to him, he held his head up and asked, 'Can you lower the plate a little bit please? A little lower. A little lower. A little lower.' The curate then got on his hands and knees and put the plate on the floor. The boy stood on the plate and said, 'I give myself to Jesus.'"

I believe that is one of the most beautiful stories I have ever heard in the whole of my life. And I'm not religious. But I really care about things. This time of year, I care about my friends who may be alone. I care about my friends who are grieving.

But what I really want to do is care about myself. Forgive me if I have said this before. That thing on aeroplanes—when the oxygen mask drops down—we're told to look after ourselves first, then others who are less able. Christmas is a very difficult time to do this. I rarely ever have sex anymore. I believe in making love. When it's really good and I am somehow taken outside of myself, I feel like I am being crucified. And then I remember, I come back, knowing that I am the cross.

If you want to give anybody anything this Christmas, anything, I think forgiving and understanding would be a really good start.

27 January 2006

But weary fa'the laithrondoup
And may it ne'er be thriven!
It's no the length that makes meloup,
But it's the double drivin.
Come nidge me, Tam, come nidge me, Tam,
Come nidge me o'er the nyvel!
Come lowse and lugy our battering ram,
And thrash him at mygyvel.

That's what I've been doing the last couple of days. In bed with Robbie Burns. Mind-blowingly sexy! I put it down to the rhythm myself. The closest I got to any of that was wearing tartan pyjamas. But it does conjure up amazing images, like the Scott's Porridge Oats man walking across the Highlands, when his kilt blows up and he says. "Mornin' ladies!"

The advert always makes me smile. I only worked it out the other day, though. Morning glory! Hee hee hee. The idea of lifting a man's kilt up is a real turn-on. (Why is wearing no underpants called "going commando"? You'd think those commandos would need some protection, with all those barbed wire fences they have to jump over.)

Back to Robbie Burns, it's amazing how sex can raise itself from the grave and take a grip. And as for Burns Night, a room full of men wearing skirts and reading poetry to each other—just too much for my little mind to contemplate.

I eventually let go of Robbie and forced myself out of bed. It's terrible having flu. I can't think. I can't breathe. My nose is bright red. And I'm in the process of moving studios. Still. I thought it was 10 years of shit, but it turns out to be more like 25, or maybe 35. Who's counting the odd decade when it comes to piles and piles and piles of stuff! I've found everything, from handmade miniature trolls' clothes to diamond jewellery. I got rid of at least 70 dustbin bags. Every piece of paper had to be shredded, every piece of fabric cut up, every object broken. And we did have a whole section of boxes for charity. Then everything has to put into a landfill. That's the price of being eBay-able.

My doorbell hasn't been working for a few weeks. I've tried to get it fixed, but it's more complicated than one might think. Every day I write a note that says: "Doorbell not working. Please knock loudly." And every day the note goes missing. It's like my "missing cat" posters. They ended up on eBay for 500 quid.

The moving thing is insane. A fire did seem an attractive alternative. We're always hearing about artists' studios that go up in flames, their life's work destroyed. But no artist would do it. No real artist anyway. We're too sensitive. Too strategic. Most studio fires start with the combustion of turpentine-soaked rags in dustbin bags. But that's not how my work was destroyed in the Momart fire. That was arson. And you know, no one's actually said sorry.

My life has a level of complication which is very unattractive. But in some respects I feel very lucky. For 10 years I lived in a very tiny co-op flat, and I was an active member on the committee. It was always my job to decorate the communal Christmas tree. Sweep up the leaves in autumn. And deliver the pensioners' Christmas presents.

On my landing lived a guy who was a bit of a loner. One day I noticed his door open. It stayed open for three days and three nights. On the fourth day, I and other committee members ventured into the flat. God, it was like a disaster scene! Beer cans, takeaway food weeks old, washing up that was ancient, clothes thrown everywhere. And on his bed, porno mags strewn open, photographs of a very beautiful girl, and love letters. It was really sad.

We put a temporary lock on the door, and the flat stayed this way for six months. The guy was registered missing. He had no next of kin. It was the co-op's job to clear his flat out. And it was my job to put aside everything which had his name on. One of these things was a box with a rabbit's paw in it. The box was inscribed to him with the words: "the luckiest man in the world."

It was then I decided that this could never, ever happen to me.

My beach hut is a long story. I cried and cried when I heard it had been burnt. It held lots of memories. I bought it with the sale of a Henry Moore print. It cost me £250 in 1992. It was a dream fulfilled, to have a tiny wooden house by the sea. But by 1999 it was falling to pieces, and rather than keep patching it up, the sensible thing was to build a new one.

Rather than just knock it down, we took it apart piece by piece and numbered them, then had it fumigated and shipped to America. It took two months to arrive and then had to go through quarantine. It then lay on the gallery floor in pieces until we put it back together again. Proud little hut! It sold for £75,000. Not bad for my first property deal!

But the moral of this story isn't about money. It's about understanding what we have and what we don't have. And I am so lucky to lie in bed with Robbie Burns, even if he has been dead for over 200 years.

Extract from "Nine Inch Will Please a Lady" by Robert Burns.

3 February 2006

Thank God it's the Year of the Dog! Woof woof! Aawwh. Aaaowh. Grrrr. Woof! This week I've been going crazy. Up the wall is an understatement.

Last week, I spent a week in bed. I got up twice. On the Wednesday night, I went to my studio and worked until two o'clock in the morning. The next day I was told by Joe that when he tried to open the front door, when he came home late on Wednesday night, it was stuck. He managed to push it open a couple of inches, but there was something in the way. Could it be the corner of the doormat curled over? No. It was me. Apparently I had made myself a nice little nest, and on Joe's attempt to try and get me to go to bed, I just raised my head, hiccuped, and said: "Mice."

My next venture into the world last week was Friday. The auspicious occasion—the South Bank Show Awards. I went to bed on Thursday night saying, "Please God, make me better by tomorrow. Make me better by tomorrow." On Friday, at midday, I strutted into the Savoy Hotel, my body awash with Lemsip.

And as I breezed past my first tray of champagne, the words "I'm just so happy to be here. I don't need to drink alcohol" had no relevance in the situation whatsoever. I love the South Bank Show Awards. There is more testosterone per square foot than anywhere else in the world. Men, men, men! Single. Gay. Married. Lovely, intellectual men! It's not exactly a hunting ground— more of a stampede.

Melvyn's telling me how much he liked last week's column. Alan Rickman tells me how much he's enjoyed my book. Discussed the merits of Andy Warhol with Peter Blake. Jarvis Cocker and I give each other a knowing nod—of "we survived the 1990s." It's all so wonderful. Until two days later, when I get a phone call from a friend saying, "I thought I'd let you get over it." "What?" I say.

"Friday. The South Bank Awards." "Yeah," I say, "I was a little bit drunk." "What!" yells my friend down the phone, "Trace, you threw up in the American Bar!" Mmmm. Throwing up in public—that's a bad one. Trace's big chance to pull. Here, let me throw up in your drink for you! And on top of it I ate the fucking lunch! Any chance of the vomit just being pure alcohol would be too much to wish for. But at least a room full of dignitaries came to my rescue, apparently.

Then I walk into my studio to hear my assistant on the phone to a journalist. She puts her hand over the receiver and says, "Trace. They want to know if there's any truth in the story that you ..." "Yes, yes, its true! I threw up in the American Bar! I threw up in the American Bar." "No," she says, "that you had an altercation with an opera director called David McVicar. Apparently you upset him so much he stormed out of the room in tears!" "No," I say in a really sing-songy voice.

"No," says my assistant, "you didn't?" "No," I say. "No memory whatsoever! All I remember is saying to a taxi driver, 'Please hurry up! I think I'm going to wet myself!'" Another press statement wings its way!

Yes, probably, it's true. It's all true. And yes, also probably true that I threw up in the American Bar. Also probably true that I should have never gone out on that day. And if so, never alone. And I'm so ashamed I'm leaving the country!

It's a tricky life getting the balance right. I'm not a big drinker, I just can't take my drink. I have the constitution of a mouse. Hic. But one thing is, I have a phenomenal constitution for emotion. I think that's why I'm so often in psychic pain. I've never run away from anything—except having an opinion on opera!

C'est la vie. Tracey Emin will be away for the next six weeks.

10 February 2006

When he first met her he didn't like her much at all. In fact he didn't really want her anywhere near him, and made it quite clear that he found her mentality and attitude bordering on the insane. For her, it all felt very different. She regarded him as someone special, someone who carried light and aura.

A year later, they met up again. But this time it was different. He was chilled out on one of his mum's morphine tabs. She had begun to relax and feel more confident. They walked across Waterloo Bridge and, rather than travel 10 miles across London, he decided to stay at her house. They held hands and she said, "I feel like I've known you all my life. I don't want anything from you, I'm just so happy we're friends."

He spent the night, and in the morning they had breakfast. It was April Fools' Day. They sat on the balcony of her small flat cracking jokes and giggling. Before he left, she asked if he knew a good dentist. He and his friends had spent the last year referring to her as "Jaws," on account of the vast amount of metal in her mouth. He wrote down an address and a phone number. He kissed her goodbye. She waved, yelling, "If the dentist takes my mouth on, I'll give you a pound for every tooth he removes!" A week later, two teeth gone, she wrapped up two pound coins in cardboard and popped them in the post.

The next day he appeared at the door with half a bottle of brandy. The day after that, in the early evening, when he was going

to leave, she didn't want him to. But he insisted that he had to go. He'd come the 10 miles across town on his bike. Before closing the door he made it quite clear to her: "I like you. But I can't be with you. I don't want to make a commitment. And I do not want to have a girlfriend. And I'm leaving now." As she watched him walk away, she thought, "Sod that! No one spends two days fucking me and walks away so easily."

She ran out of the flat, down the stairs, unlocked her bike and started to ride after him. It was a good five minutes before he realised, and by this time they were cycling along the river. It was an amazing spring evening. The sky was Prussian blue, striped with amazing lines of purple. He was really fit, and he kept shouting at her, "Go away and leave me alone! Stop following me! I told you— I don't want a girlfriend!"

By the time they had reached Greenwich, she was breathless and sweating. At one point she almost lost sight of him as he disappeared into an industrial estate.

And there, a row of gas-workers' cottages, surrounded by nothing but wasteland. He stood outside one of the houses, and as she cycled up with a smile on her face, he said, "You're not coming in. I didn't ask you to follow me." She looked down sadly and replied, "So I'm supposed to cycle all the way back then?" "OK," he said, but with absolutely no humour, "you can stay the night. But whatever happens, you are not going to be my girlfriend." As she closed the door behind her, she smiled, and said, "Sure. But I bet you anything, before the night is out, you will say I'm your girlfriend."

She walked around the house. There was a feeling of desolation. No furniture, just one futon, brown rice, and water. This person lived like a monk. After having sex they fell asleep, to be woken by an almighty smash. He jumped up out of bed, naked like some deranged caveman. And picking up a baseball bat, he ran downstairs, shouting with such incredible force, "Get out of my house!"

His shout lingered in the air, and when the ringing sound disappeared, she nervously called out, "What is it? Is everything OK?" He told her to stay where she was and not to move. He called the police. It appeared that someone had thrown a milk bottle

through the window. This was a house in the middle of nowhere, on a street which led to nowhere but the river Thames. This was a place where there were no passers-by. It was three o'clock in the morning.

The police did a routine check of the house. They asked him various questions. She listened at the top of the stairs. She could hear him say, "No. I don't know why anyone would throw a milk bottle through the window. No, I don't have any enemies."

Before the police left, they asked whether he lived in the house alone. "Yes," he said. "Well, who's that upstairs?" "Oh," he said, "It's just my girlfriend ..." He came back upstairs. She was lying on the bed, thrusting her pelvis forward, and slamming her fists up into the air, going: "Yes! Yes! YES!"

Tracey Emin is on an aeroplane somewhere in the world at the moment, remembering some of her favourite moments of her life.

10 March 2006

This time I got it right. I got off the phone, jumped in the car, and told the driver to take me to the whole food store. Here I was, fresh from Sydney, 8 a.m. in L.A., rolling peaches in my hands and squeezing avocados. I had already called ahead to the hotel to ask that everything be removed from the mini-bar. Being a Fruitarian is not that difficult, you just have to think ahead.

The hotel is very white—sort of minimal in a 1990s/1950s kind of way. The clientele are a cross between "Yeah, I have a script to read," Puerto Rican rock chicks, and roadies from Motörhead. And on the entire twelfth floor, the King of Bling—great big guy and his whole entourage take up the whole lift.

As I checked in, they said, "Well, Miss Emin, you have come well prepared." I've checked into hotels with my dad before—hotels where you have a suite of rooms including a kitchen. And I swear my dad will have a whole bloody suitcase full of food—tons of vegetables, spices, cooking knives, lemons. He'll go shopping in the markets and return with mountains of melons and vine tomatoes. Then he'll just have the stuff perched round his room, loosely displayed. I always thought this bordered on the insane. But now I see exactly where he was coming from. Keeping a routine, staying in control.

So here I am in Room 1122. Every morning chopping up fruit salad, and with each little chop, running a mantra of: "I can eat what I like!" And while my fruit salad ferments, I take to the streets. I go

for an early morning walk. Right out of the hotel, down Fountain to Santa Monica, up La Cienega and along Sunset, passing Book Soup.

My friend Daisy Bates told me my book was in Book Soup. So yesterday when I jogged past I thought it would be nice if I signed a few copies, as I like Book Soup. I stood at the counter all sweaty, in my giant purple sunglasses and said, "Hi, have you got a book called *Strangeland* by Tracey Emin?" (J.R. Hartley's *Fly Fishing* flashed across my mind.) I backtracked and said, "No. I'm Tracey Emin. I wrote the book." I was blushing. I then had to explain I didn't want a copy anyway, and she told me there was no record of such a book. She called over all the other staff to ask if they'd heard of the book. They all shook their heads and said, "No." Then the guy said, "'Strange thing,' you say, by Tracey who?" I then heard myself saying, "Tracey Emin. Tracey Emin. It's my book—I wrote it!" The girl looked down and said, "It's OK. We believe you."

Nobody walks in L.A., apart from the prostitutes, the poor, the criminal, and the insane. I think that's part of the reason why people are afraid to walk here. But then of course if you do walk, why shouldn't you be as scary as anyone else? So I walk for a good hour. Get really sweaty. That's another thing you never do in L.A.— sweat. I'm sure people don't even sweat when they fuck here. I then hit the pool and swim for 45 minutes.

Sometimes I get my little routine wrong, which Zadie Smith, the novelist, bore witness to. I forgot to say, it's been Oscar week. The place has been full of this person, that person, that party, those cocktails. The atmosphere round the pool is pretty intense. People are laid-back and dudeish, but still all posing. Apart from the beautiful Zadie, who sits totally upright, with a large yellow flower in her hair, tapping away on her laptop.

We haven't seen each other for years. It's a very nice thing about L.A.—it's incredibly easy to bump into people, make new friends or rekindle. Anyway Zadie and I rekindled. I told her I was just waiting to sign the papers for a hire-car. Then I was going to go for a swim. Zadie laughed, like I was cracking a really funny joke. The hotel pool is very small—say 12 by 7 metres, very warm, shallow, resembling a cruise pool. Something you would get on a ship.

Around it are low sunloungers. On the sunloungers lie the "cool." They drink bourbon on the rocks, speak very loudly, smoke, posturing with their cigarettes, blowing smoke in tight streams into the blue sky. (The ones who smoke are hardcore—it's like jacking up in public.) All the waitresses are very skinny, wearing sarongs, showing off their midriffs. The roadies are on our left in the shade. The hip-hop crew, with the woman with the amazing S-shaped figure and giant Afro, are down the end—half shade, half sun. And the tits-and-tans Mza M Vzoe crew are all blanched out to the right in the sun.

The temperature is about 75 degrees and the pool is empty. It has not been touched by human flesh all day. And it's crying out from its shallow, turquoise depths: "Christen me! Christen me! Make me ripple! Make me feel like a real pool!"

I pull my tracksuit bottoms off and Zadie says, "You're not really going in there?" As she looks down at her screen, SPLASH, like a true Selkie, I launch myself across the surface of the water, creating an almighty mini tidal wave. A scream as a pink Chanel handbag gets drenched. The hip-hop gang stare briefly in disbelief, and the fully clothed Miami Vice squad pipe up, "Jeez man! What is this crazy lady doing! Why can't people just chill? Like she's swimming—my script is soaked!"

I say I'm sorry and curb my breaststroke. The guy puts his hand in the water and says, "Yeah. I guess it's a pool."

Last night, due to bad timing on my part, I ended up at the Chateaux Marmont (a place to be seen) having dinner alone. Something I would never do in London. But I sat there all cosy in the garden, eavesdropping on two men's conversations about their wives, with my one glass of champagne, carving into my steak, wishing I'd had spinach instead of fries. I raised my glass and took a sip, and thought, "It's a damn sight better than room service and the Murder Channel."

Today I fly to New York and on Saturday my gallery will throw a party for me. Then it's home. I'm not homesick, I'm not travel sick, but I'll be happy to be back. And the one big thing that I have learnt from this trip, this piece of distance, is as long as I can make the choice, I can be very happy on my own.

i7 March 2006

First of all, I apologise. There's a very good chance this column isn't
going to be very good. In fact, there's a great possibility it's going
to be a load of spindly crap. Just call me Jet-Lag Kitten. I got up
about half an hour ago and contemplated how wonderful my life is,
until I realised it wasn't Wednesday and I had given myself 15
minutes to write this column.

But what was I doing for two hours this morning? Fading in and
out of sleep while watching George Best's memorial service. My mate
James Nesbitt was holding forth in the pulpit. Things got really
complicated when I found myself arm-wrestling with him, but of
course it was just a dream. I mentioned jet lag before, but it's
really tough.

I did have a really brilliant weekend in New York. New York, New
York—it's a good thing they named it twice. (Unlike Baden-Baden—
that's so bad they had to name it twice. In 1997, I was so drunk there
I wasn't allowed into a nightclub with my fellow Brits. I ended up
at a strip club, where Mat Collishaw said that I showed the strippers
how to dance. Which I have no memory of.)

Why are some of the best times so forgotten? Because I was
drunk out of my skull. Unlike New York last weekend, where I was
100 per cent *compos mentis*. On Friday, I had a brilliant meeting
with the Museum of Modern Art. Then I met my international
laughing friend, Amanda Love, for lunch. I'm not going to tell you
what we had to eat because that really would be stretching this

column out. And lunch was followed by a fantastic shopping spree.

Then to Gregory Crewdson's cocktail party in Times Square. And people were really happy to see me. When I walked into the room, it was like I had walked out of a grave. In fact, even when I checked into my hotel, they were happy to see me. Saturday morning I got up really early, and had a fantastic breakfast. That's the thing about the Peninsula Hotel—the sheets are really, really soft, the service is amazing, there's a brilliant art deco swimming pool on the roof, and you can have breakfast à la carte. For me, being a newly-fledged fruitarian meant fruit, fruit, and more fruit—and having a fantastic dialogue with the chef about how to boil an egg. It was a group effort, mixed with a wry sense of humour. By the Monday morning when I left, it was almost perfection.

On Saturday, I went for a mega walk around Central Park. It was so beautiful—68 degrees. It makes you realise how important just being close to a tree is. Before, when I stayed in New York, it was always in SoHo. It seemed more funky. But now I love it uptown. In the afternoon, Jay Jopling and I did the Chelsea galleries together, realizing that after all these years of knowing each other it's the first time we'd looked at art together. And it was good, we had very similar taste. We both wanted to buy the Basquiat, a snip at a mere $2.5 million. Jay looked at me quite seriously and said, "You know Min, you could if you really wanted to."

On Saturday night, my New York gallery, Lehmann Maupin, held a dinner for me. I sat next to two of my favourite men—Hamish McAlpine and Julian Schnabel. It was a really cool dinner and I stayed sober. Well, sober enough to go to Phil Collins's party. (That's Phil Collins the artist, not Phil Collins the musician.) Mad nutty party in a suite in the Chelsea Hotel. Dancing until 4:30 a.m. The grand finale, finding ourselves lost in the basement of the hotel. It was really scary. Like a scene out of *Most Haunted*. But I managed to stay calm and serene among the pipes and the ghosts—that's because I was reasonably sober. Any other time, I think I would have wet myself. That's what people do when they are really afraid. They wet themselves.

Sunday—fantastic brunch at the Peninsula with Amanda Love and Willy LeMarque. Willy was knocking back Bloody Marys. I sat there high up on my righteous seat. I then went to the roof, swam for an hour followed by a steam, and then a brisk half-hour walk to the Armory Art Fair to meet Hamish and Carol. And do you know what? I saw lots of art I liked.

It was really nice bumping into people I hadn't seen for a long time. That's because I didn't have a hangover. People were saying, "Tracey, you look so well. Your skin is glowing. Your eyes are so bright. You seem so happy."

On Sunday night, I had dinner at one of my favourite restaurants, Wallsé, which is Viennese and has Julian Schnabel paintings on the wall. And my favourite thing to eat is the goulash and the beetroot salad. This food is so not American and it makes me feel cosy and safe. The last time I was in New York, I fell asleep on John Waters's lap in this restaurant. Luckily it was John—people being totally aware of his sexual orientation. Otherwise, I am sure from the outside a blowjob would have seemed like a reasonable assumption. John and I always refer back to this occasion as our "blowjob days."

Monday morning, got up at seven, packed, went for a swim, had a fantastic breakfast (this is my new thing—I'm not allowed to have room service, otherwise I end up being too cocooned). Then met Amanda at the Met Museum where we were given an exclusive viewing of the Rauschenberg exhibition. No queues, no people, just art. A quick wobbly spin around the Guggenheim to view the David Smith and an amazing lunch at the Neue Galerie Museum. The restaurant's really interesting—lots of little old ladies wearing hats. The museum's fantastic—Egon Schiele, Gustav Klimt, and everything beautifully displayed.

I was really chuffed to find out I had an image in an Egon Schiele book. Then we had a lovely walk through the park back to the hotel, collected my bags. Amanda and I were treated like royalty at JFK. Slept most of the flight. Arrived home and went on a 12-hour drinking bender. What is it about alcohol and English soil? Please could someone tell me?

31 March 2006

16:24. Spread-eagled and my eyes feel like they've been burnt out of their sockets. My body contorts as though it's been dragged through some medieval torture. When I woke up this morning, I could feel a draught. I kept trying to pull the covers over me. My hand kept scraping something bristly. Just as I was about to investigate further, there was a loud, thunderous noise and a pile of letters fell on top of me.

I would love to have a film of myself from the last drink onwards, getting home, opening the front door, and collapsing. It's quite frightening. I honestly can't be responsible for my actions, because I'm completely unaware of them.

I had to send a text message to my studio saying: "Today's not happening." The message came back: "What's not happening?" I have to explain the whole of today—the morning, the afternoon, the evening, the whole of today—it's not happening. I just can't believe it—how I can make myself comfortable on a floorboard.

In the old days, when I was with Mat, he would throw me over his shoulder and give me a fireman's lift up the stairs. Oh happy days!

I've had quite an extraordinary week, one way or another. I appear to have become a lunchurian. Yes, I've had lunch with five different men, with various occupations—international insurance bankers, newspaper editors, and the highlight was a bishop. Lunch with the Bishop of Liverpool at the House of Lords. It's a pretty amazing place.

The stained glass, the carpentry, the corridors, the overwhelming smell of school dinners. I think the bishop, the Canon Precentor, and I were the youngest people in the building. It's great to have an intense conversation with brainy theologians. It's well beyond the political and digs deep into the belly of the beast, dealing with the emotional and the spiritual. We talked about what's inherently good in the soul—the fact that if you don't question or judge yourself then you have no chance of truly knowing yourself.

I've been very unhappy recently. And the unhappiness has manifested itself in anger. So I am constantly questioning why, and I will not accept the surface of the situation. I'm unhappy with the boundaries and the lack of space that I have created for myself. It's somehow spun out of my control. The only place where I seem to find happiness is when I'm asleep. And the first moment when I wake up and just for a second I forget who I am. Or in this morning's case, not knowing where I am. Just existing, being, without the weight of the Self. It probably has something to do with being an artist. Everything I am is inside of me. And there's lots of it. Far too much of it. And sometimes I feel like I'm going to explode. That's why it's good for me to have stimulating conversation. Particularly with heterosexual men.

One of my very close friends had a theory that I spent far too much time with homosexual men. (He's gay himself.) The theory being that when I'm in the company of heterosexual men, I send out the wrong signals. I'm not a great one for dating, but this lunch thing is working really well. I love to be stimulated intellectually. I love the company of good men. I think that's one of the reasons why I don't sleep with people. As I only get off on the idea of sleeping with someone who's more intelligent than myself.

I can hear you all say, "That shouldn't be too difficult." Well get this: they've got to be really sexy and telepathic. And have a profound understanding of the core essence of creativity. That means they've got to fuck properly—intellectually as well as emotionally.

I have a desperate desire at the moment to be closer to nature. I feel there's something lacking in my life. If I can't be touching another human, I'd like to be touching the sun. Or smelling the grass after the rain. Or the arid smell of pine needles from the trees. Or the feeling of density from the salt in the sea. Cold sand between my toes. I'm longing for passion and romance. I want to be picked up and swept away. Carried far, far away from myself. A chance to see the world through someone else's eyes. The idea of being kissed by someone who really loves you, who wants you, desires you, when you walk past them they breathe you in. That's what I want.

Sometimes I really hate being me. But the cliché is all too true: that you can't love others if you don't love yourself. And today at 17:11, the woman who is myself I sadly, but truly, despise. Some people say I'm too hard on myself, but I think most people let themselves off far too lightly. The bad news is I have to get up and live in the world. The good news is things can only get better. PMT—way to go! I'm just too old to have periods. Full stop.

7 April 2006

I just spent the last few days in Liverpool. How I get to Liverpool is to catch the train from Euston. And at 7:30 a.m. on Monday morning, as I raised my head from the Circle Line, like a tiny mole squinting in daylight for the first time, I put on my big purple sunglasses. A wave of depression flooded over me.

It always happens to me at Euston, especially in the spring, when the blossom's budding, the skies are blue, white puffy clouds and April showers. The mixture of spring and the fumes of Euston Road, and the great shadow of the abortion clinic cast down on me. I can always hear myself saying, "Oh, yeah, Euston. That's where I had my abortions."

But the clinic isn't there anymore. It sort of miraculously disappeared a few years ago. A whole hospital just gone, disappeared. Those pro-lifers sure do have some power behind them! No, seriously, they do! They really frighten people—frighten people over something which should be discussed and understood.

I will never go to Euston without a sense of sadness, or a thought for what I did. And that's because I now have a lifetime to think about it. And I think about it without regret, but it still makes me melancholy. This is a hard thing to rationalise, and I think the feeling is different for every woman.

After my first abortion, my guilt was so horrendous that I wanted to die. I had a lot of difficulty coming to terms with what I'd done. This was partly to do with the fact that I was made to feel extremely

I felt, even at the time, with all my mixed-up emotions and an infuriating degree of naivety, that it was wrong of him to force his beliefs on me when I was having to make one of the most serious decisions of my life. I've said this many times: no woman wants to have an abortion. But if she comes to that decision, it is because there is an overriding reason why she cannot have a baby.

Going back to the pro-lifers, I agree. The creation of life is a wonderful thing. And for me, with my beliefs, that means right from the moment of conception. It's a miracle. But not everyone is put on this earth to procreate.

In my case I was in no fit state to have a child of my own. And while I was pregnant I was plagued with horrendous visions of myself throwing a baby out of a window, and me jumping after the baby. I just wasn't strong enough. I truly felt bad and very guilty for sleeping with someone who didn't love me enough. God, I was stupid.

On top of all of that, I have a fundamental belief in the soul, so I was really fucked up. What was most important was that it was my decision.

So that's why I always feel slightly depressed when I'm at Euston!

I've been in Liverpool judging the John Moores painting competition. My fellow judges were (and will be again) Sir Peter Blake, or the great Papa Smurf of Pop Art, as we like to call him, Andrea Rose from the British Council, and the painter Jason Brookes. We spent three days, from early morning to late evening, in a dark room, looking at more than 3,000 slides. This column is very difficult for me to write at the moment as I keep finding myself nodding and saying, "Yes. No. Yes—yes—no." And last night in Liverpool, in a Chinese restaurant, I realised that myself and my fellow judges were transfixed by a glass door with fish on it. And after a short pause, in complete unison, we all nodded and said, "Yes."

It's amazingly hard being a judge, but it can also be great fun. Sharing the balance of responsibility makes it a lot easier. We were

all in perfect agreement not to argue with each other. This was an unspoken rule. Instead we used our energies to argue in defence of the paintings we wanted to stand by. And this is why I've just had a really amazing few days in Liverpool—because I had utmost respect for the others' opinions.

Nevertheless, I did manage to give everyone a lecture on being a judge.

While we were having lunch yesterday, there was a flipchart and I couldn't resist coming over all schoolmarm in the old Liverpudlian courthouse. I really wanted to make a drawing, but came over shy in front of Peter. I tapped my Magic Marker and we all made up a rule. Some of them were very funny, and some of them deadly serious, but I can't say what they were because I'm under an embargo. Can you believe someone has asked me to keep a secret for two months!

My favourite moment of the whole adventure was getting a taxi back to the hotel with the others. Peter had the front seat and the taxi driver said, in a very strong Scouse accent, "So, you must be special, like? That you get the front seat and the others all squeeze in the back?" Peter said quite blandly, "No, I'm not special, I'm just older and fatter than the others." I jumped in and said to the taxi driver, "Do you realise, this is Sir Peter Blake?" The driver seemed quite amused and said, "So, why's this then? What have you done to go round calling yourself 'Sir?'"

We cracked up laughing, and as we pulled over to the kerb, Peter opened the door, and explained to the driver, "It's rock and roll."

Life can be so funny. We laughed all the way home on the train from Lime Street to London. I nearly said Euston, but who wants to go there?

(Tracey Emin would like to say that she has nothing against Euston, or the people of Euston, and that maybe a really good, long snog on Platform 2 would make a hell of a difference.)

14 April 2006

A few weeks ago, I did something very sensible. I had my drains capped. My house is very old and the main sewage pipe that links up with the drain in the street is a dinosaur. And there's a good possibility that, if there had been more than about 10 inches of rainfall, my kitchen would have been a foot deep in shit.

For me, what should have been a simple job turned out to be a nightmare. On the first drain investigation, to the workmen's horror, they found 6ft of solid shit! Via text message from Australia I inquired: "Is it all mine?" Once they had pumped all the shit out (which, just for the record, wasn't all mine), the drain collapsed in on itself.

Most people don't have their drains capped, or they just never get round to doing it. It's one of those things that's done after the event. Like going to the dentist. Doesn't seem so difficult to make that appointment when you have a mouth full of pain. Anybody who knows me well, or knows the inside of my mouth intimately, will know that I've had more than my fair share of dental pain.

As a child, I remember banging my head against the wall. Screaming and crying. A searing mass of nerve endings taking up the whole space of my head. Every trip to the dentist was torture. It was never just a check-up. I remember the injections, the needle crammed into my gums, up past my nose, feeling as though it was touching the corner of my eye. I won't bore you with all the graphic details, but there isn't one tooth in my head that doesn't have a

filling. And when I was 13, I had my front teeth smashed out. The dentist tried to give me crowns, but they would never stay in. For months, I walked around with two screws coming down from my gums. I always kept my hand over my mouth. Finally I accepted I had to have dentures.

In the Seventies, this had a massive stigma: "Urggh, she's got false teeth!" But I didn't just have false teeth, I was flat-chested and wore national health glasses. The boys used to call me Chip because they'd seen more fat on a chip. That was their logic, not mine.

Every Christmas at school, we used to watch a film, usually *Kes*. And we'd all sit there with bated breath, waiting for the bit when he climbs over the shower wall, and you see every bit of his genitalia— cock, balls, the whole lot!

That was always our cue to pass the sweets around. I remember taking my teeth out of my head and saying to Maria: "Pass them on." Me and Maria, Nicky and Jeanette, we killed ourselves laughing and nearly got thrown out.

"You girls in the front row! What's so funny?"

"Nothing, Sir." All four of us were united in my secret.

Secrets can be terrible things. They can destroy people. The art of blackmail. Having one over on someone. Always keeping them on eggshells. I have kept secrets for years.

Yesterday, I went to the dentist. I was in quite a frivolous, carefree mood. I was having a tooth re-crowned. Over the years, my gum had receded slightly, and there was a small black line between my gum and my tooth. I thought it looked dirty. I sat in the chair and was made to wear a large pair of orange sunglasses, because the enamel was going to fly all over the place. I expected a level of discomfort, but what I didn't expect was that I would have a complete bloody breakdown on the chair.

As the drill screeched, I started to hyperventilate, tears were rolling down my face, and the dentist had to stop. I kept being apologetic. I couldn't explain to him what I was going through: the most horrendous, sexual, grotesque, flashbacks. In between the orange light, fractals of myself as a child, with a penis being thrust

into my mouth, my eyes watering from the fear. Not fear once, but again, and again, and again. The drilling and the crowning took about an hour. I kept trying to rationalise the situation, but I couldn't. I felt like a First World War soldier with shellshock.

Then I had to sit in the waiting room for 40 minutes, without my teeth in, while the cast was being made. I did think about going to see my friend Jonnie, who lives up the road, but I was too apprehensive about being spotted with my teeth missing. (Those paps sure love Harley Street!) I just sat there thinking about my life, knowing that having false teeth was the least of my problems. But when you're 12, and you're already being picked on, in a most obscene, cruel way, and then on top of that, to be constantly in and out of the dentist's chair, suffering extraordinary pain, it's very easy to get these things confused. But what happened yesterday is still shocking me.

After the dentist, I went to Westwood's for a dress fitting. I'm treating myself to a beautiful ball gown. Soft, black taffeta, plunging neckline, copious amounts of skirt. I stood in front of the mirror unable to recognise the woman in front of me. I just had terrible visions of this pretty little girl smashing her head against a wall. Yesterday did get a bit better.

21 April 2006

Life can be fun, all-night drinking binge, playing air guitar like radical mice, dancing when the sun pops up. Running around Spitalfields going mad—culminating in me and my new best friend carrying out a 9 a.m. survey outside my house with a found clipboard.

Q: Would you love this woman?

The first victim was apparently Polish, I say apparently because I have no memory of this amusing event whatsoever. Anyway, he got scared and said, "No polease, I in hurry. No understand poleeese."

But the traffic warden (who looked like the funky member of the *Art* cast) was a different story, he ticked all the right boxes.

The thing is, would I love this woman? Would I love me? Today the answer is yes, definitely. I'm standing in front of the mirror, naked, middle-aged, long brown hair with streaks of grey, dark brown eyes, wrinkly forehead. Thoughtful looking in a simian kind of way. Full lips and a crooked smile, bony elbows, long arms, Egyptian tummy, full thighs. What I like about this mirror image is not me but what else reflects back at me—an amazing strip of pure Mediterranean blue.

I'm in Cyprus, home of my father, land of my ancestors, the place where Pontius Pilate died alone and Cleopatra took a bath.

God, I feel beautiful here. Even with my skin infection on the side of my face and my third-degree burns, I feel good. It's true, beauty does come from within, and without going into too much detail, I have let a hell of a lot out recently. I spend most of my time fighting to do the right thing, I don't just automatically do it. I think, and

then I act upon my decisions—but not when I'm really, really drunk.

Well, maybe doing the right thing isn't right for me. Maybe I spent the last 25 years lying, just in denial, in denial of my dark side.

I spat at someone the other week. I didn't just transgress the rules of the club I was in at the time, but the rules of humanity. And I'm sorry for that, but I still have a lot of shock left in me. I will not be boxed in by anything or by anyone, least of all my own mind or my own success. The girl in me will still come out fighting.

When I was six and we lived in our hotel, the Hotel International, the place was so big. So many rooms. So many corridors, I could go missing for hours, I used to enjoy spying on people in their rooms.

A six-year-old girl looking through your keyhole, a cross between *The Shining* and *Alice in Wonderland*, a whole new postmodern Lewis Carroll adventure.

Part of that adventure was a man luring me up to the top landing, into his room. One day, I'd had enough, so, sworn to secrecy, my only option was to bite the entire skin off his elbow. Dirty old git. He deserved it. And I felt triumphant every time I saw his weeping wound.

The only problem was sometime later, when I was at school, and was made to read out loud, and I couldn't. I didn't understand the words and everyone was laughing at me, I tried to run out of the classroom and the teacher (would you believe this name), Mrs. Man, blocked the door. So what did I do? Sank my razor-sharp gnashers straight into her elbow.

I remember dangling on as she tried to shake me off. That's no apology, just pure explanation.

In 1996 I came to Cyprus to see my dad. We had a really brilliant time. Every day, I would go swimming and every night he would cook for me. My dad's an excellent cook. He's also teetotal, has been since my twin and I were born. But he still professes to be an alcoholic and says a spoonful of sherry truffle would send him over the edge.

Anyway, every night we would eat, I'd get really drunk and talk, and my dad would listen. One day I told him about lots of things that happened to me when I was little. He just sat there and wept, tears rolling down his face. I cried and said, "Daddy why weren't you

there? Why didn't you protect me?" He said he was so sorry and that now he would always be there for me.

But now I'm in Cyprus, I'm here for him. He's 85 and getting slower (even though he did keep us dancing till 1 a.m. last night). I wish he wasn't 85. I wish he was younger. The same goes for my mum. I'm just starting to know who I am and they're slipping away. But saying that—who knows when it's time to go?

Minor disaster. Me and my friend Tigs did this amazing hike across volcanic rock. We set out from the hotel around 3:30 p.m. to avoid the scorpions. We decided to climb along the water's edge. It was really windy. The waves were splashing up and the rocks were getting bigger and bigger. Two hours later, with torn heads and ripped-up fingernails, we were only two-thirds of the way down and had a minor disaster when my Gucci sunglasses dropped down a 10-foot ravine, and there was no way up and no way down. I said to Tigs, "It'll be getting dark soon."

We both imagined the headlines: "British Women in their 40s Found Dead on Rocks," alongside questions asking why they were so inappropriately dressed.

I'm telling you, these rocks were fucking sharp. Tigs had a vague moment of trying to be sensible and said, "Let's go back. At least we know which way we've climbed."

"Tigs," I said, in a grand philosophical moment, "every rock will be completely different on the way back."

Last Word: every time I come to Northern Cyprus, I adopt a turtle. My dad said to me, "Are you going to see if any of your babies have come back?" Turtles always return to give birth in the place they were born. I've seen them hatch out. So sweet, tiny little things scraping through the sand trying to get to the first wave. All the odds are against them.

My friend has just had a baby, so I wanted to adopt a turtle in the baby's name. But guess what? The turtle research centre that once stood in the middle of nowhere is now boarded up, surrounded by breezeblock culture.

It's not so easy for turtles to move on. I wanted to cry.

5 May 2006

Prosecco, prosecco, prosecco. Out in the garden. Should be writing the column. Extra dry. No, seriously, sometimes I can be a bit reckless and leave my column to the last moment. Sometimes it goes in my favour and makes it slightly more spunky, and other times it's just completely flat!

Last week must have been just flat, flat, flat. But it was entitled to be. Firstly, I was really stressed out because I was doing all the promotion for my DVD, *Top Spot*, released by Tartan, signing today at the Tate Modern between 7 p.m. and 8 p.m. Secondly because I was off to Belfast.

Yes, yes, as my friend Stephen Webster said on the plane, "Just for the crack of it!" The crack of it was helping James Nesbitt and others raise £280,000 for Wave Trauma, a charity set up to help children and young people affected by the troubles in Northern Ireland. Where's the charity to help us with our hangovers? A 48-hour drinking marathon! If there's one thing I can say about Belfast: it's very cold outside, it's very hot inside. Air-conditioning seems to be a nonexistent word. Everyone decided that my sleeping on the bathroom floor was a cool stroke of genius as I had sadly bottled out after only 12 hours of drinking.

It's fantastic being an artist. Being able to create something, which is so desirable that it can help others. Almost everything I do now has a certain palatability. For some kinds of work there are waiting lists all around the world and I'm banging my head against

the wall, saying, "If I make another blanket I will go absolutely insane!" I want to protect and love all the blankets I've ever made. When I make work I want to be able to see the work in my mind. And as corny as this sounds, I can't live with myself if I see only £s and $s. Pound and dollar signs with a big Bugs Bunny would actually make a good blanket—but that's not what the collectors are waiting for.

Next week I'm going to the Baltic, not the Baltic seas, the Baltic Centre for Contemporary Art in Gateshead. But I do often think about the Bering Sea. Sometimes I have nightmares about it. I did this morning. It's a very calm sea and ships will suddenly disappear because of 100-foot waves that appear from nowhere, like giant tongues taking the ships out of the sea. Sorry, I just went off on a bit of a tangent there. Back to the art gallery.

Apparently it's a very large space. Some artists don't bother to go and view spaces they are going to be exhibited in. They send their assistants and they have small maquettes, and often this does the job very well, as, being international, it is extremely difficult to visit every site. In 1996, a year before I had my show at the South London Gallery, David Thorpe, the then director, very proudly handed over a miniature South London Gallery. Two months before my show, on a final studio visit, he looked quite alarmed to see the contents of the miniature gallery filled with a ball of orange wool, a crochet hook, and a packet of Marlboro Lights. (But it was my local gallery at the time.)

Back to this large Baltic space. I think maybe I should do something completely different. Maybe even an idea that I had for a show in 1997 with the German curator Stephan Schmidt-Wulffen at the Hamburg Kunstverein. I would live and work in the giant empty gallery space for six weeks, and every day I would have a budget to make one piece of work. And every day I would have to present my ideas to the gallery director to see if they were agreeable. My first idea was to light a fire in the centre of the gallery, which apparently would have blown my budget for the complete duration of the project. My next idea was to mirror an entire wall—the wall being something like 100 feet by 20 feet—then I would fly a friend's band over and dance in front of the mirror. Again I had blown the

budget. These ideas went on, and on, but eventually it would have made an incredible show. The performance of making art seems a great idea for the Baltic.

But this is an idea I had 10 years ago. Am I hankering after something that has already gone? Am I a little bit too old to be dancing alone in front of a giant mirror? Or maybe it's just a crap idea and I'm just being sentimental for the youth and audacity of young art.

I want to be courageous in what I do and, as corny as it sounds, I never want to rest on my laurels. At the moment I feel like I want to smash everything up and tear everything down. I want to turn myself inside out. I want to enjoy my moment of confusion, but at the same time, not feel that I am standing on the border of the reckless and insane. I want to be free. When I was at the Royal College, in the courtyard, I smashed all my work up (just for the record, they were painted on wood) with a sledgehammer. I was screaming at my paintings calling them every name under the sun. Like Lady Macbeth, my hands were covered in blood, blisters were bursting one by one. It is soul destroying to create something which cannot be loved. I learnt my lesson. Now back to the prosecco. Extra dry.

12 May 2006

I have had the most amazing, extraordinary week of good luck. I've lost my phone twice—both times I've had it returned to me. You see, there are honest people out there in the world. My mates were going to try to put it into a charity auction to see how much I'd pay for it. I've had a mobile phone for 10 years now, and, as sad as it sounds, I honestly couldn't live without it.

Last year, for a fleeting moment, when I thought about ending it all, my first line of action was to throw my phone in the river. Just as I was about to do it, it rang and brought me to my senses. Whoah, whoah! Hold the horses! This is supposed to be a good luck story!

Last Friday I got a parking ticket. (This was after ranting on to my friends that when you get a parking ticket it's your own fault and you just have to pay it.) After my first parking ticket experience I wasn't so happy, but my friends were delighted.

All the parking bays had been suspended because a film crew was using them. With a big smile on my face, I walked up to the fixer and handed over my parking ticket. I said, "I think this is yours." He humbly said, "Sorry about that, Tracey." And gave me £60—£10 more than the amount payable on the ticket.

On Sunday night, I presented a Bafta award to Jamie Oliver. It was great—I really had my act together. But somehow it took me an hour and a half to get back to my table. On plonking myself in my chair in a drunken swoop, I turned to my neighbour and said,

"God, this is a big restaurant! Where are we?" It was at this point I realised I had to leave, which was smart thinking. Shame I missed the step when I came out of the loo, ending up on my hands and knees, and smashing my front teeth out on the doorframe. Apparently, I looked quite elegant, in a classic hatha yoga position. But I was in a slight state of shock. The Grosvenor House Hotel, with a thousand celebrities inside and just as many paparazzi outside. And there I was with no teeth. But we left via the kitchen.

And what was so lucky about breaking my front teeth was the fact that they were false in the first place. An amazing feeling of liberation came over me. I realised that, with all my openness, I'm still terribly shy about people seeing me without my teeth. (Apart from Halloween, when children do trick or treat—I like to put Docket under my arm, take out my teeth and hold a candle in my hand and make all the little trick-or-treat kids scream.) It's because of the stigma involved. And it doesn't look very nice. But I found myself completely drunk, in the arms of a wonderful man, laughing, saying, "I'm free! I'm free!"

And now for more of the good luck bit: I have a fantastic dentist! I made my way down Harley Street in disguise, wearing a leopard-print YSL scarf and a long red mac—very Arab Chic. By three o'clock in the afternoon, I had really beautiful new teeth and they're so much better than the ones I had before. I just kept looking in the mirror and smiling and saying, "I'm so lucky. I'm so lucky." We then went to see my friend Stephen Webster, the jeweller, to have my fingers measured for a ring. A beautiful, old gold, blue crystal ring. I decided to treat myself because I'm so happy.

At the same time, I tried on two beautiful gold rings, one in rose gold and one in yellow gold, which lock together in perfect harmony. They slid on my wedding finger like they had always been there. I immediately wanted to buy them, but Stephen insisted on giving them to me. Why? Because I'm the luckiest girl in the world, of course! My friend Trilby was quite apprehensive about this as it's meant to be bad luck to wear rings on your wedding finger. I disagreed and said it simply meant I was spoken for.

After years of being in the wilderness, I feel whole again. I've spent

the last week crying with laughter, being surrounded by wonderful friends. The sun's shining and the world is my oyster. I've always maintained that energy leads to energy. A chain of good things has been following me. I feel that I'm allowed to enjoy my life and celebrate my successes. It's a really wonderful feeling.

Today I went for a walk. I went to Spitalfields City Farm. I can't believe I've never been there before—a five-minute walk from my house—right in the heart of the East End. Hundreds of really cute little animals: goats, mice, ducks, a really big, fat, black pig and really, really cute long-eared rabbits, beautiful little gardens, vegetable patches, and a magic garden where I made a wish. I wished that life could always be like this.

19 May 2006

I dreamt I was in a strange casino with lots of friends and Chinese people on stage. We had taken a weird journey across lots of bridges. There I was holding the mic with Neil Tennant, singing "West End Girls" really badly. But instead of singing "West End Girls," I hollered out, "East End Girls! Meow! Meow! Meow!" Another one of those amazing/horrendous Kafka moments. But it wasn't a dream. It was true.

I spent the last couple of days in Newcastle, drinking mainly, and attending my friend Sam Taylor-Wood's private view. It's rare these days that the art world comes together and supports a friend. And that's what made this trip so special. The anecdotal highlights are as good as any from the last 10 years.

Most of us were staying in the Malmaison hotel. I've got to be honest, I don't remember getting back to the hotel at all. And I always know when someone's helped me to bed because I wake up half-dressed, with two sets of keys. When I went down to breakfast, everyone was talking about the fire alarm that had gone off at 5 a.m., so loud that you could hear it from miles away. Everybody was standing on the street half-dressed, including Norman Rosenthal, director of the Royal Academy, pyjama-clad with no slippers; half the sexy girls who work at White Cube, in various states of undress; three fire engines; various international collectors and the hotel staff. Me? I slept right through it.

We discussed this over breakfast, and I tried to get some attention

from the waitress, to be told it was 10:20 a.m. and I'd missed breakfast by 20 minutes. I did my John McEnroe impersonation: "YOU CANNOT BE SERIOUS!"

There was public outrage, and I must admit I did go into a small rant of, "Do you know who I used to be? Just two eggs—boiled for five minutes," only to be told the kitchen was definitely closed. There were more screams of objection, especially from the writer Harland Miller. He pointed out that we'd all been woken up at 5 a.m. by a false fire alarm and kept on the streets for half an hour. Cries of "Hear! Hear!"—a mass movement of breakfast solidarity!

Just when I was about to say, "I might write about this in my column," an apology was sent from the kitchen. I tucked into two perfectly boiled eggs and was told that breakfast would be on the house. I apologised sincerely to the waitress, saying I was totally aware that it wasn't her decision, but sometimes rules have to be broken. But I did have one clear complaint about the hotel: that fire alarm just wasn't loud enough!

It's really brilliant going to other parts of the UK. Last weekend I was down in Broadstairs. I don't mean I was "down"; in fact I was very happy. I've been happy for ages now. Usually it makes me scared, as I'm waiting for the bad to come in. Maybe it's the fear which is bad in itself, and being happy is cool. Mind you, it's really bad for your work. Trilby says it's just a new challenge, which is a really good, positive way of looking at things.

Last weekend I did something fantastic. I organised a surprise birthday party for Mum. I was apprehensive because I never know how she's going to react. My mum generally enjoys her own solitude. And, unlike her daughter, she likes to be in control. Champagne and cream tea at the Walpole Bay Hotel went down a treat. My uncle Colin, who died in 1982, had two children. A half sister and brother, they met for the first time. I kind of felt like a cross between Oprah and *Families Reunited*. It was very difficult not to cry.

There were about 25 of us. I really wanted my dad to come, but I thought it might wind Mum up. The climax was calling Dad and asking him to propose to her on the phone. I'd already got Mum agree, if he asked. She was running round the hotel trying to get

my phone off me. At the point when I was about to ring Vivienne Westwood to get the dress sorted—"Think, Mum, a stiff taffeta, a cross between Boudicca and Princess Diana ..."—Mum's eyes lit up. She said, "You'd like it, wouldn't you?"

I put my head down and thought. It's romantic and naive but, yes, I would like it if Mum and Dad got married. I said to her, "Well, what's the problem? Don't you like the idea of Dad's shoes under your table?" I haven't seen Mum laugh so much for ages! But then we were all laughing. All very happy. And somehow all together. It's amazing to come from such a dysfunctional family—how we all have something wonderful in common, an undeniable sense of humour. Halfway through tea I gave a speech and my brother Paul told a joke. There's three balloons. Mummy balloon, daddy balloon, and baby balloon. Baby balloon is now six, and Daddy balloon has decided it's time baby balloon slept on his own, so baby balloon is tucked up in his own bed. In the night, baby balloon gets up and tries to get into bed with mummy and daddy balloon. First he tries mummy balloon, but there's no room, so he just lets out a little bit of her air. There's still no room, so he goes round to daddy balloon's side and lets out a bit of his air. Baby balloon then tries to wriggle in between them. But there's still no room, so he lets out all his own air. SSSWOOOOOOSH!

In the morning, daddy balloon is really angry and he takes baby balloon aside. He says, "Do you realise what you've done? Not only have you let me down, and your mother down, but most of all, you've let yourself down!"

2 June 2006

The last days of May. My favourite, most sensual, romantic time of year.

The last of the blossom has fallen. The summer sun has arrived. It appears and reappears behind the beautiful puffed-up cumulonimbus clouds. This year it's been a bit too chilly to really let myself go in the memory stakes. But May is my favourite month. It's like the beginning of something exciting—the possibility of heat with copious quantities of fresh air.

When I was little, I used to walk to school. Staring up into the air, I would call it the "Mediterranean sky," a turquoise infusion between the yellow and the blue. And then there was the maypole. It comes to me like some strange Victorian memory. Singing rhymes with coloured ribbons, skipping round and round in circles until the pole was covered in a labyrinth of criss-crossed colour. But as hard as I try to remember, I still can't work out what happened when we reached the bottom. I guess we just turned and skipped back the way we came.

1968. Everything was so incredibly different then. I was five and reasonably innocent. But the thing I remember most is that colours were so different. I'd like to try and explain this but I think it would become too boring! Plus I've waxed lyrical enough to land myself firmly in Pseuds Corner. But sometimes you just have to.

Often life can appear very beautiful, draped in a veil of poetic mystery. The problem with most of life today is that there isn't

enough poetry. Or nature. Or genuine aesthetic beauty. Most things are tarnished and contaminated. I find it very difficult to read these days. My brain is bombarded by so much crap. Going into WH Smith is like being an extra in the opening scene of *Apocalypse Now*. I find myself browsing and looking at stuff that totally coincides with the death of my brain. I try to justify it by saying things like, "This is popular culture. This is what the majority is looking at. It's good to be in tune with the psyche of the nation."

A friend watched half an episode of *Big Brother* and said it was so indicative of Western decadence that it made them want to go and join al-Qa'ida immediately.

I'm not censored in this column, but after more than a year of writing it, I have an understanding of what the boundaries are. It's no good me writing "F- F- F- C-, you F-ing C" when I know full well it's unacceptable for most readers. I'm also aware that I have to be careful about the image I choose. A large erect penis isn't what everyone wants to see at the breakfast table. (Of course, I'm not speaking about myself here!) But as the writer of this column I have to take some responsibility.

And I'm supposed to be a wild child, a maverick, an enfant terrible, a strong, opinionated woman, immune from judgement! Well, I do care. Because if everything I wrote was totally offensive, no one would read it! That's why, within four minutes of tuning into *Big Brother* one night, I turned my TV off and thought, "What is this fucking world coming to?"

Now, this is all going to sound pretty rich coming from me. But there were two people obviously drunk and incoherent, and another three in bed together. The next few minutes consisted entirely of fumbling and banter. And I'm making it sound better than it was. There are no beautiful sets, no profound moments—it's just the most demeaning level of human behaviour and everybody's watching, waiting for something to go terribly wrong. First TV suicide. Sex on screen leading to pregnancy. Our first live abortion, the bookies taking bets on whether she'll go through with it.

We might think the Romans were bad—"Throw that Christian to the lions!" Visions of Spartacus being split in half down a giant

slide, or men being crucified. But the Romans did give us central heating, sanitation and roads. The same audience that egged those gladiators on is alive and thriving in Grand Britannia today.

I go out a lot. In fact, I go out drinking a lot. But after a few weeks on that roll, I have this irresistible urge to stay home and be comforted. To feel cosy and safe. To go to bed early. And watch TV. I can't believe so much money is invested in the same kind of stuff. It's a reflection of our society.

Would it be wonderful if children were in playgrounds discussing clouds and the stars that they had seen the night before, and distinguishing the sounds of different birds? But sadly, I don't think it's like that. I'm an adult and I worry about the contamination of my own soul. I wish we had more of a choice. I'm not moralising—I'm just scared.

When I grew up, there wasn't one book in the house. The first time I read a book from cover to cover, I was 17. But at 14, my favourite TV programme was *The Prisoner*. And that's why I'm scared, because they don't make them like that anymore. "I'm not a number—I'm a free man!"

9 June 2006

It's Tuesday. Usually I would be writing this column on Thursday. But I've got to write it today because I'm going to Liverpool tomorrow, to do the last three remaining judging days of the John Moore's 24-painting competition. It's slightly frustrating, because for the last few weeks I've had a creative block. And this week I really feel like painting. And I don't feel like writing. And the irony is that I'm writing this column now and it's going to be really difficult.

To cap it all, it's a really, really, beautiful sunny day! If I had my way I would be lying on my roof sunbathing, with a bottle of prosecco close by. I came to the conclusion this week that even though I'm not lazy, I do the smallest amount that I can possibly get away with. This makes the lives of everyone around me extremely difficult, because I'll squirm and wriggle to get myself out of almost anything involving work, or dates, or deadlines. I think it might have something to do with the Cypriot in me. The Tree of Idleness and all that.

I've actually sat under the same tree that Lawrence Durrell wrote about, and the problem is that even though I've moved, the tree seems to be following me.

Hmm, what do you do about self-inflicted, "It's all right, I'll do it tomorrow-ness, just let me daydream about this for a little bit longer please?"

On the other hand, I spent the last six months fighting in my head for a title for my L.A. show. Then last week, on Tuesday, when I knew

I should have been working, when I knew I had a backlog of things with screaming deadlines, and I knew that on Wednesday morning the phone would be jumping off the hook and my office would get a real earful, what did I do? I managed to have three very serious meetings. The first one (about having this column published as a book) went without a hitch. The next, with my banker, which included lunch at the bank, ended with me leaving at 4 p.m., throwing pennies into the indoor decorative fishpond, surrounded by vast acres of marble, with an atrium the size of Mount Sufi, pissed out of my head and happily making wishes all over the place. I'd just spent the last few hours working out my will. God, it's a laugh!

As I hobbled up the Charing Cross Road to my next meeting, my assistant did attempt to straighten me out and go through what we were going to talk about with my accountant. I stroppily said, "Can't we do it at the Groucho Club?" After having a bottle of wine at my accountant's (and I must say it was a good, serious meeting) I attempted to keep the minutes and took loads of nutty, illegible notes.

Then all of us took off to the Groucho, including the accountant. I just remember standing there at the bar saying, "My God, it's so light! My God, it's so light!" I thought we were going through some early summer reverse eclipse. I kept looking at my watch, thinking it was 12 midnight, when actually it was 6 p.m.

I don't remember getting home. I don't remember how I got to bed. All I know is that I woke up very early with the title of my show beside my bed. Somehow in the middle of the night, of which I have no memory, I managed to write the words, as though my hand were guided by a poltergeist: "With you I want to live."

These words made me so happy. They had been tucked away deep down inside my psyche and I had to delve down deep into oblivion to bring them into this world. The words made me happy, not just because they are life affirming and positive, but because they open up a true dialogue with my work, with myself.

I'm not looking for a revelation, but what I truly need is something that I don't know about in myself. It's very difficult to make work when I'm happy. But as I get older I realise this is something I have to try to understand and not fight against. I'd

much rather be happy and concentrate on that, and look after it a little bit. Anybody who knows me very well will tell you that I won't allow myself to be happy. I will do everything I'm capable of to destroy that happiness. I'm often laughing and smiling, but caught in the throes of the moment. Before, if someone had asked me, "Tracey, are you happy?" the answer would have been: "Out of 10, four." Today if you'd asked me, the answer would be seven, and I can see a nine just round the corner.

Maybe I should be lighter on myself. I don't have to prove anything. What I do have to do is take pleasure from my life, enjoy my creativity, not treat it like a burden.

So as I sit in the shadow of the Tree of Idleness I shall cherish the moment, and take delight in the fact that even though shadows are dark, some of them can be really very friendly.

So, column done two days early—I'm off to my roof! Make hay while the sun shines.

16 June 2006

What a week. I've suffered the worst case of domestic psychic attack ever known to man, woman or mouse. It's like someone's put a hex on me. I'm just going to write a simple list of the trail of disaster.

Docket (my cat) went missing for four days. He returned via the upstairs catflap, limping, with a bloody mouth. To cut a long story short, after two-and-a-half grand's worth of pet bills, going up and down the M1 to the special cat-and-dog hospital, he has a smashed Achilles heel—which means he has a pin through his leg, a cast on it, an Elizabethan collar so he doesn't chew it off, and he has to be kept in a cage for five weeks with a litter tray—and it's been really hot. And I can't take it, his little miaows.

He looks so sad. I really hate leaving him. I asked the vet if he may resent me for keeping him contained, but it's the total opposite—it's a case of Stockholm syndrome, when hostages fall in love with their captors: Docket/Patty Hearst, Patty Hearst/Docket.

Last week, I lost my telephone in Liverpool. I lost it between the lift door and my hotel room, a distance of no more than five yards, but across which I had to be supported by my fellow John Moores judge, the One and Only, "he's a fucking legend—it's Rock 'n' Roll" Papa Smurf of the Pop Art world, SIR Peter Blake, who can also boast of being a hardcore Luddite. He'll never go down in history as Techno Pete.

Anyway, Peter found my key card, got me into my room, poured

me some water and made sure I was in the recovery position. The next day, no phone. I was walking around Liverpool offering a reward, which started at £20 and, by 6 p.m., had gone up to £100. And then I began to suffer phone withdrawal to the point that another fellow judge had to lend me her phone just so I could text message (I send 1,000 texts a month and I'm not exaggerating). I love writing, I can't stop myself.

Anyway, to cut a short story long, guess where my phone was? Peter had it in his bloody pocket the whole time. (But I still haven't found my coat. It's a tea-coloured Connolly driving mac.)

Friday, I was at my friends' place, celebrating their 10-year anniversary, and I walked into a wall and cut my head open. Then there was the gas leak in my studio. And the whole kitchen had to be ripped out. Tons and tons of other things, some I can't write about because they'll seem too trivial.

But the worst thing: I'd just sat down in the bath with a pot of tea and a book (Jack Black's *You Can't Win*. Written in 1926. Brilliant, brilliant autobiography. The life of an outlaw. So vernacular you can actually hear his voice), and lots of bubbles, when the doorbell rang. Now, my doorbell never rings, mainly because it's disconnected. Weird. So I got out of the bath and stuck my head out of the window, true East End style. My neighbour was standing there. A lump of glass, 4 feet by 3 feet, had fallen out of my baby studio roof and landed in her garden—on to the deckchair where her daughter always sunbathes.

Thank God for the storm and the floods. Thank God it wasn't sunny. It turns out that so many sheets of glass are loose that the whole roof has got to be done. All I keep saying to myself, "God, I'm lucky." Whoever has thrown this hex at me, I want them to know I've taken it, I've eaten it, and now it's right where it belongs: down the toilet, flushed out to sea, making its way right back to you.

It's strange, the things in life that are lost and found. My friend Sandra, landlady of the Golden Heart and commentator extraordinaire (her quote of the week while watching the Poland vs. Germany match was, "Babe, it's not about football, it's about the Pope"), lost her dog last week. Her dog is called Molly, she is a black

terrier, is very sweet and friendly and looks not dissimilar to Sandra. I don't like to see my friends cry, so please, whoever has Molly, please give her back.

One of my favourite stories of all time is about Hoger Nasradin, who lost his donkey. He searched high and low. In the fields, the valleys, the mountain trails. But the donkey was nowhere to be found. Finally, he stood in the village square and cried out to the crowds on market day, "I, Hoger Nasradin, have lost my donkey. If it shall be found, there will be a great reward."

A man made his way through the crowd with Hoger Nasradin's donkey in tow. When he asked, "What shall be my reward?" Hoger Nasradin raised his arms up in the air and said, "Why, my donkey, of course!"

Last word. My highlight of the week was watching Mikhail Gorbachev dance with Salman Rushdie to the Black Eyed Peas. And I've just heard that my coat has been found and is in the post.

Life is wonderful.

23 June 2006

You know, some things really annoy me. Like the fact that it's taken Sky three months to come round and get my picture sorted out. The other night I had to sit in the pub, drinking a cup of tea (because I didn't want alcohol) watching England versus Sweden— God, what a game. That really annoyed me. My hatred for Sweden is so intense that I nearly cried when they got that second goal.

It's strange how you can have animosity against a country just because your ex slept with some old, blonde, Swedish, airhead slapper.

The other thing that annoyed me about that game was that every time I saw David Beckham's pretty blue boots, I had to ask the question: why hadn't he and his good wife acknowledged or thanked me for donating a piece of my art to their charity auction for Unicef—a neon which sold for £28,000?

Another thing that really annoys me is that there's a Japanese restaurant in central London that I will refer to as Nob heads. The restaurant is divided in two: the bar downstairs, the restaurant upstairs. The first time I went there it was pretty amazing—a celebration for Patrick Cox, the shoe designer. Such a glamorous night, the food and atmosphere impeccable. The other week, a group of my friends were eating there. When I turned up, the girls on the front desk wouldn't let me go upstairs. They made me sit in the hallway. Why? Every other bugger was let in. True, I was wearing trainers. But may I say, I looked a damn sight less trashy than

most of the short-skirted, high-heeled women prancing past.

Yep, tacky restaurants and people with no style. That really, really annoys me. People who are impolite annoy me. It's true: manners are free—they cost nobody anything.

Anyway, back to The Sky Man Cometh. Have you tried to get Sky on the phone? It's pretty insane. The longest wait so far has been 45 minutes with millions of "press this, press that" options. Finally, an appointment is made, they fiddle around and change the box, but it's still not working.

Then yesterday, I had a knock on the door. I was in a deep sleep having a nightmare that Docket had jumped out of a weird hotel window. I had run out on to a fire escape, only to realise that I was at least 200 feet up in the air—Docket with his Elizabethan collar and leg in green plaster cast, star-shaped, flying through the air. Once I had reached the bottom of the fire escape, with my friend Maria (I call her Moomin), who I've known since I was four, I became aware that I was in Bosnia, walking through a Cold War housing estate, and I knew there were snipers everywhere. Great Alsatian dogs, snipers with Kalashnikov rifles. But I just knew I had to get Docket back. That's when I heard the knock at the door.

I jumped out of bed. Crikey, it's the Sky man—must answer the door. I ran down the stairs, putting on a pair of shorts and a top on the way. I opened the door. Two young men stood there—may I say, quite handsome young men. Handsome young Polish men. "We come Sky," one said.

"Great," I said. "Can I see your ID?"

"We have no ID," one said. "We have appointment."

I sort of half let them in, then said, "No. No, I can't. There's two of you and you have no ID." They shrugged and said, "Well you make appointment. We no come in if you no like us." My neighbour was outside his house, so I said, "You be my witness—I'm letting in these two nice men from Sky, but they have no ID."

I then closed the door and walked up the five flights of stairs with the two men following me. There, in the centre of my bedroom, stood a large cage (where Docket has to be kept overnight due to his leg injury), my bed all ruffled up and the curtains drawn. Both men said

in unison: "What is wrong?"

I then looked at Docket and said, "He's broken his leg."

"No," said the Poles. "What is wrong with picture?"

The TV is now fucking perfect. God, did those guys look scared.

But you do hear about it. My ex used to sell shammy leathers. The older lady in the negligee, dying for it. I have a well-known friend who would shag anyone who knocked at her door—gasman, FedEx man, handyman—and she got away with it, because no one would believe them. It was such a cliché. It showed amazing confidence and initiative on her part. Good going for the older single woman.

This week, I don't really know where this column's going. In fact, to be honest, it's a stream of consciousness, full of distraction. Yep, as I write this, my mind is on something else. And right now I'm going off to do it.

PS: Great news. Molly was returned to the Golden Heart, via Battersea Dogs' Home. Thank you to whoever handed her back.

TRACEY EMIN

30 June 2006

The bells, the bells, the bells. The drums, the drums, the drums. The bells, the drums. The drums, the bells. The drums, the drums, the drums. The bells, the drums. The bells. OK, I know where the bells are coming from. I know I have a hangover from complete hell on this godforsaken Sunday morning. Our almighty maker has decreed that I suffer the noise of ringing bells. I live opposite a Grade-I listed church, in my Grade-II listed house, which unfortunately, according to English Heritage, is not allowed to have double glazing. I did say to the reverend, "You might know when it's St. Swithin's day, for example, but I don't. Maybe you should give us some prior warning when there's going to be a massive bell-ringing session?" A few days later, a letter came through my door.

"Dear Parish neighbour, we at Christ Church Spitalfields are very proud to announce that we are a main contender for the Guinness Book of Records' bell-ringing record. At present the record stands at 48 hours, and we do hope that we will have your consideration and understanding, that not all our bell-ringers are professional, and at certain times during the attempt to break the record, amateur bell-ringers may be required to take over."
I had to laugh.

But you see, I love my local church. It is a truly beautiful building designed by Hawksmoor. A church for the poor, just outside the city

walls. It's been here a lot longer than I have, so even when I have a chronic hangover, I more than tolerate the bells. I appreciate them for their beauty. (That's an absolute lie.) The fact is, it's part of the territory. Huguenot Street. Huguenot Church. Huguenot bells. What doesn't make sense are the vast number of drummers, girls in bikinis, palm trees, tons of sand, and really, really loud fucking drums! On a Sunday morning, around the corner from where I live!

Do you know what? It starts at 10 in the morning and goes on until 11 at night. Oh, I forgot to say what it is exactly. It's a beach in the East End, in a car park! I'm not being a spoilsport, but would you like it at the end of your street? Four thousand drunk people, on a Sunday, pissing all over the place, leaving rubbish everywhere. Surely the right place for a beach is by the river, or by the sea? Tower Hamlets council is so dodgy. They didn't even consult the residents. I'm going to get a really big drum and go down to the council offices. I'll bang it really hard, nonstop, and see how they like it.

Sleep is really important. It's time when our whole bodies and our minds regenerate. At the moment I'm desperate for a nap. I've really been overdoing it and it makes me very snappy. Yesterday I shouted at a cement mixer. When I was three, my mum and my nan took my twin brother and I to Watford market, and somehow my brother got lost. I suppose he was only lost for a few minutes, but when you're a child, time seems to relate far more in cat years than in human years. To me, the few minutes seemed like hours. I can still remember my mum running around, hysterically screaming at men in hard hats to turn their cement mixer off. She was convinced that he was in there. It was probably the worst thing she could imagine at that time. It's incredible how in times of fear we throw ourselves into more fear. What frightens me most in life, if I'm honest, is abandonment. There's a good reason for this. It's because I was left when I was little.

My dad's been writing a book. He's 85 now and he's got to page 270, all written in longhand, a strange mixture of little letters and capitals, broken English and a wild use of phonetic spelling. He's told me that as he's been writing, it's made him sad looking back on his life. He said he feels guilty, knowing that the women in his

life, and his children, must have suffered. I believe that it's really good he's working all this stuff out. Better late than never, Daddy.

My mum left me as well. She hasn't quite got round to putting pen to paper, but I bet it's going to be a cracker, too! The last manuscript she wrote was when she was 30. The one and only copy she had, she left on the Northern Line. And my dad's last great foray at being a literary genius was executed at May Day Hospital, in 1963, while he was recovering from severe alcoholism. It's amazing what's hereditary!

1963, oh what a year! Kennedy was shot and I was born! In fact it's my birthday next week. Monday 3 July. I share it with many greats: Julie Burchill, Franz Kafka, Ken Russell, to name just a few. This year, being 43, I thought I should calm down on the party scene. Grow up a little bit. And I pleaded with all my friends not to give me any presents. I really don't need anything. It's a great way to feel on my last week of being 42. On Sunday night I'll go to bed excited, just looking forward to another year.

St. Swithin's day if thou dost rain For forty days it will remain St. Swithin's day if thou be fair For forty days, beach revellers, Beware.

7 July 2006

God, I'm tired. I've been tired for over a week now. And being 43 hasn't made it any easier. Do you know what? I'm going to be completely honest about this, being 43 has made me a little depressed. It seems so much older than 42!

My gallerist, Jay Jopling, has a little girl who said something incredibly profound once. It was on her fourth birthday. She was looking a bit thoughtful and Jay said to her, "Angelica, how is it to be four?" She looked up at him and said, sadly, "Daddy, I can still feel the three."

Oh, how I can relate to that! I can feel the 42, the 41, the 26, the 29, the 18, the seven. I can feel the whole damn lot of it, 43 years and nine months since my conception—the whole damn lot of it! Crushing down on me like a ton of bricks from God knows where. And you know what? I'm seven years off 50! That's quite shocking timewise, because it was seven years ago that I was nominated for the Turner Prize. A wink of the eye, and seven years gone. And I spent the last week prancing around like some demented seven-year-old.

Christ, am I spoilt. Not really spoilt, but I do sulk when I don't get my own way. I never realised before how badly I handle myself in group situations. Fantastic if I'm the leader, but a nightmare when I feel I'm not in control.

I went to Russia for the weekend. I was really, really excited about it. *To Russia with Love* and all that stuff. St. Petersburg, the Venice of the north, the Hermitage, the bauble-bauble churches, bucket-

loads of caviar and pole dancing. But the strange thing was, the moment that the plane landed, I came over all nauseous, tired and dysfunctional.

In St. Petersburg at this time of year it doesn't really get dark. As the sun sets, the sun rises. It's quite beautiful, but it made me feel extremely strange. Somehow it seemed to make the group that I was with (who are, for the record, really brilliant people) deliriously happy.

I really hated the hotel we were staying in. But, on the other hand, I really hated being out in the streets. I just felt moody, and intolerably uncomfortable, even when I was having a good time. Part of me just wouldn't let go. I have the same feeling when I go to north London! It's nothing specific, just knowing that you're standing on the wrong part of the hemisphere. My highlight in Russia was playing "dirty, filthy." Sitting on the grand terrace on a main shopping street, watching millions of strangely dressed people. (Strangely dressed in an interesting way—a blend of 1982, Alexis Carrington, *Working Girls* and Bon Jovi.) The game started off quite innocently, looking at how people were dressed, and my friend made a comment: "I thought there would be hundreds and hundreds of thousands of beautiful women in Russia." I pointed out to him that they'd all left. And it was at this point that we started to look for anybody with style who we found reasonably attractive.

After 10 minutes we'd reached base level—one of us had to point at someone in the crowd and comment at how we thought they would be in bed. Hamish McAlpine got lucky with a gaggle of Japanese girls. Yes, that was my highlight. No, seriously, my friend Stephen Webster had a fantastic party. We went on a few drunken, deranged boat trips. I just remember everyone saying, "St Petersburg's so beautiful!" And me replying, "Have you never been to Venice?" I just couldn't let go.

And the almighty climax was coming home with some Russian bug—and I'm not talking about the 1960s KGB version. I'm talking about the most excruciating 24-hour stomach cramps. I'm not going to go into the bodily functions. Let's just say, on Monday 3 July I woke up not very happy on my birthday. I was in so much pain, and

so miserable, that I thought I was going to have to cancel my party. Let's bring on the seven-year-old spoilt brat! I was screaming, crying, stamping my feet, hating Russia more than Sweden—and you know Finland joins them together.

Just for the record, a couple of weeks ago, when I said I hated Sweden, it was a joke. I do actually have a number of Swedish friends. True, they don't actually live in Sweden. And it is also true that the Swedish government carried out compulsory sterilisation until 1974. It is also true that Sweden allied itself with the Nazis during the Second World War. And it's also true that my ex slept with a Swedish slapper airhead. And they serve wine in really tiny glasses! And if you want to buy a crate, you have to queue up and get a ticket with a number on, then you have to go to a little counter with your ticket and say why you want the alcohol. Not my kind of place.

Back to what I was saying. What was I saying? Oh yeah, I know, Russia. On Friday a law was decreed, suddenly, overnight, and all our alcohol was confiscated from our minibars. And by Saturday all the wine in St. Petersburg had run dry. Something to do with the labelling—all the wines in the southern states of Russia had to be re-labelled. AAARGGGH!

So on my birthday I was vomiting and shitting and crying, and wondering whether I should cancel my party. Then I had a moment of genius. I realised that if you're going to get married and you're stood up at the altar, you don't cancel the wedding. The wedding continues, but maybe without the bride. And on this happy thought, the pain started to push away. There's an old Turkish expression: "When you love a rose, you learn to love the thorns." Tracey's dead. Long live Tracey!

14 July 2006

A strange thing happened to me the other day—I completely lost my temper. I'd been out to a reclaimed woodyard in Barking. The woodyard was in a spectacular industrial estate, the kind of place that doesn't seem to exist in London anymore. Lonely Victorian warehouses dotted across the landscape. Canals interweaving and interlocking. Everything tainted with an industrial beauty. It made me want to get my sketchbook out. My sketchbook from 20 years ago. The sketchbook of the student who would draw a 30-second thumbnail sketch from the train window, seven stations every morning, from Strood to Maidstone. A Kentish path winding along the river Medway.

The woodyard was stacked with thousands and millions of planks. Eighteenth-century floorboards, American dance-hall floors, the galleys of ships and walk-the-plank decking. Beautiful, complicated parquet, giant wooden girders salvaged from piers blasted away by hurricanes. A goldmine, an Aladdin's cave, and every piece of wood steeped in somebody else's past, and now some of this wood would hurl itself into my future. It's very simple: I use wood to make sculptures. Towers, stairs, spirals, roller coasters, helter-skelters. But the wood has to be good.

It began to pour with rain. I drove back to the studio in a very good mood. I even managed to park the car myself. Declan and Trilby, who accompanied me to the woodyard, wanted to have a cigarette. So we stood out in the street, under some scaffolding, to shelter from

the rain as they puffed away. I understand for smokers how nice it is to smoke in the rain. That cold, shivery feeling, and the smoke kind of sticks to you like a solid film. You feel like you're an extra in some 1960s kitchen-sink film. Actually, now I come to say it, it sounds really vile!

I rang my studio door. I always ring my own doorbell, as I'm really lazy at getting my keys out of my bag. It also allows people to know that I'm on my way in. But on this occasion, as the rain poured down and I rang and rang, there seemed to be nobody there. But they were there—as I opened my studio door, two of my employees, in my studio yard, standing under my portico, standing on my decking, smoking their dirty, disgusting, filthy cigarettes.

It went something like this: "What the hell do you think you're doing? How dare you smoke outside the studio, in my space! How fucking dare you! And don't throw the book at me for speaking to you like this—you can have smelly clothes, you can have smelly hair, you can have lung cancer, emphysema, bronchitis. You can deny your children 20 years of your life but don't give it to me! I'm the one that smoked 40 a day and I'm the one who had to use every ounce of will power to give up! It's just one rule! Please don't smoke in the studio!"

My heart was beating and I was shaking. I felt like an ogre, a tyrant, but on the other hand I knew that I was absolutely right—just maybe the way I handled it wasn't so good.

Later on that night in bed, I realised that everybody who works for me smokes. I was trying to work out what would happen if I caught someone smoking in the studio again. Would I have to give them a written warning?

Then it occurred to me, the people who work for me are really good—I would have to end up firing them all and then where would that leave me? I started to laugh as I had a strong image of all my employees blowing smoke in my face and me not being able to do a damn thing about it. It's amazing in life what our tolerance levels are. I can be incredibly tolerant about the strangest, most outrageous things and other things just push me to the edge. I am looking forward to a blanket no-smoking policy all over Britain, apart from

the hardcore, lose your tongue and your voice-box smoking joints.

So, back to the woodyard. I'm going to make five really beautiful towers. In my mind, they kind of represent a family. I'm also going to make some really lovely individual plinths. Each plinth will go with its own individual sculpture. A papier-mâché bird, a group of porcelain phalluses, two tiny seals surrounded by cement and broken glass. I'm looking forward to making my giant expressionist paintings of the female nude. I'm looking forward to my show in Rome, my show in L.A., the publication of my paperback, my 400-page coffee-table book and my monograph by Tate Publishing. I'm looking forward to my trip to Hawaii, watching the giant surf, singing the theme tune to *Hawaii Five-0*—da na na na, da na na na naaa. I'm looking forward to my annual trip to Australia where I get super fit, healthy and clean. You know what—I'm very busy. I have a wonderful life mapped ahead of me. So wonderful, it would be foolish of me to pay attention to the wrong things—the small and unimportant, the unnecessary shit that's thrown around in life. So, thank you everyone! Thank you all my friends who love me and adore me, thank you for making sure I'm OK. I'm 100 per cent couldn't be better!

21 July 2006

I'd like to start this column off by saying, "Guess where I am?" But I'm not sure if I should, in case it sounds a bit puerile. Then again, it's fun to be a little on the childish side. So, guess where I am? Yes. Folkestone. I've just hijacked the office at the Metropole Gallery. That's the wonderful thing about being a celebrated artist in the British Isles. Whenever they're needed, office facilities just throw themselves at you!

I'm here on a recce to mark out potential sites for a public sculpture. So far, I've set my heart on a rusty old bridge that cuts the harbour in two. Little boats lay dotted around in the sand. And, incredible though it is, the bridge has a visitation of the Orient Express every Thursday afternoon. Today was my lucky day, and later on I'm going to hang out in a cave. A nineteenth-century grotto folly. I could create the whole of Mother Shipton's world.

Mother Shipton was born over 500 years ago. Some said she was a witch, some said she was a prophet. She was born in a cave by the river Nidd. The illegitimate child of a servant girl. At the moment of her birth, it was reported that there was a giant crack of thunder and the smell of sulphur filled the air. The child of the devil had been born ... If you visit the cave of Mother Shipton, you will be blessed with child. Stalagmites hang side by side with baby boots.

Could I re-create this moment for my public sculpture? Maybe some postmodern, hardcore, seventies feminist-type thing. A performance? Me on my back in a cave. Assistants dressed up as

TRACEY EMIN

druids. A small fire burns in the corner. A cauldron bubbles away. And I writhe around the floor naked as the druid assistants splash pig's blood over me, and I scream: "I AM NOT THE DEVIL'S MISTRESS!"

Last time I was in Folkestone was in 1978, under very different circumstances. I was 14. It was night. And a friend who was considerably older than me, but nevertheless a very bad influence, had persuaded me to take a taxi from Margate to try to meet up with a group of Margate boys who were hanging out at some new disco in Folkestone.

She persuaded me to get in the taxi and go on the 30-mile journey knowing full well that neither of us had any money. I remember sitting in the back of the car and the further we went, the more I started to panic. I'm not going to lie about this, but I am going to lie about her name. Let's just say her name was Jean. Jean who should have known better.

The taxi driver kept asking, "You girls do know where you're going?" Jean was black, very attractive with massive lips and a super-giant Afro. She would often have three boyfriends going at the same time. She and her friend would go to restaurants and arrive at separate times. They would both order from the menu separately and after eating, one would slip out the back door and the other would deny all knowledge of knowing the other person. Constant scam, after scam, after scam. Shoplifting was about as far as it went with me. But Jean was in a different league of dishonesty.

As we drove in the darkness she kept saying to me, through gritted teeth, "When the car stops, we run!" I was wearing really tight drainpipe jeans. (Looking back, maybe they didn't look so pleasant on a certain part of my anatomy—really tight!) Also, an extremely high pair of open-heel, open-toe, silver stilettos.

Jean said to the taxi driver, "Just pull over here."

"Here" was a dark cul-de-sac with an alley, and I realised that Jean had probably done this many times to taxi drivers. As the car came to a halt, I said to Jean, "No—I'm not doing it!" And as she went to jump out the car, I saw she had a knife in her hand.

My heart pounded, as I had a strong, clear vision of Jean slashing

the taxi driver's throat. I held her arm and froze as she struggled with me. The taxi driver had twigged by now. The fare was £6. I had started to cry and was trying to give the taxi driver my address. It was at this point that Jean did a really weird thing. She handed over her watch. The taxi driver said we were lucky that he wasn't going to go to the police. Jean and I made our way to the nightclub. Winter. No coat on. Open-toed shoes. Jean was shouting at me, saying everything was all my fault. We found the boys. I just remember being curled up on an armchair in some sleazy flat while everyone was doing drugs. I could hear Jean in the room next door having her brains shagged out. I remember thinking: "What a price to pay."

It makes me wonder if some people are born bad. Or whether through circumstances they just become something terrible. I have never intentionally tried to hurt someone, or carried out some premeditated act. I did used to daydream about putting a lighted newspaper through some girl's letterbox when my boyfriend of the time was having an affair. So glad I didn't! But I do have a wonderful imagination. Sometimes we have to conjure up revenge as a matter of survival. Just for release of the mind.

When I was 14 at school, my favourite subject was drama. "Ooohh," I hear you say, "surprise, surprise!" Julie Milton, Cindy McIntyre, Maria Tantony, Nicky Calvert, Jeanette Pyle and me. Our drama classes consisted of me doing the whole of Harold Pinter's *Request Stop* alone, acting out every character, all of us shouting, "Look ayonder! It's the Eddison lighthouse!"—whatever that was supposed to mean, every Monty Python sketch in the book: "Beans shopping? Na, been shopping." "I'm a lumberjack and I'm OK!" Culminating in the great ode to *Macbeth*: "Thunder, lightning, wind and rain! When shall we three meet again? When the hurly-burly's done. When the war is lost and won." Ah such innocence! And now for that cave ...

28 July 2006

Interviewer: So how long have you known Tracey?
Docket: Mum! I call her Mum.

I look at Docket, he stares at me with his big round eyes, opens his mouth for a very large cat yawn, and I realise there is not an ounce of cynicism there. From now on I have to refer to her as Mum.

I: OK, but she's not your real mum!
D: (*voice deep and surly*) Then who is?
I: Your cat mum—the cat who gave birth to you.
D: As kittens, we know that our lives will change. For me, one day I was living in a small council house down Vallance Road, Bethnal Green. The next, I was in a giant warehouse studio, a pair of brown hands pulling me out of the cat basket, brown eyes squinting at me, and a mouth with smelly breath screeching, "Docket! Docket! Small enough to fit in my pocket!" That's the first time I met my mum.
I: Were you afraid?
D: Dad always said I suffered from Citizen Kane complex.
I: Your dad!
D: Yes, Mat, my dad. He's the one who came and got me from Vallance Road. Chose me.

Docket lowers his head, and licks a paw.

D: I don't speak to my dad. Every time he comes to the house and tries to say hello, I make a point of hiding behind the curtain. When he left us I was much younger and it really did my head in. It was Christmas, I was halfway up the tree, showing off, doing my Gremlins thing, and the next I knew, Daddy had walked out and Mummy was in tears singing, "Daddy doesn't love us anymore."

I: Must have been a difficult time. But now, now do you think he loves you?

D: Yes. I still don't talk to him, but have a really cool stepbrother and he is wicked on the skateboard.

I: You're quite a family cat when it comes to humans, but how do you feel about other cats, especially the ones who live in your neighbourhood?

Docket looks up. A bland expression covers his furry little face as if to say "CATS? What are cats?" I realise at this point, Docket is either in some great denial or maybe just a little bit affected.

D: It's not the cats that are the problem, it's the dogs. There's George the Great Dane. The girls next door have two Scotties, Daisy and Poppy. All these dogs give me a hard time. No way can I go through their gardens. Got stuck once—Poppy and Daisy kept me under siege all night till Mum received a phone call to come and rescue me. But worse is next door. Paul Shearer's black wolfhound made my life hell. And they have a black cat. Longhaired thing called Special Diet. Actually its real name is Sooty, but it has a thing on its collar saying Special Diet. No wonder it's a bit plump! And it gave me hell. No, things have changed since I first lived there.

I: People refer to this part of Spitalfields as PPC. How do you feel about that?

D: Ermmm, I've heard the term Posh Pets Corner, but my mate Fleabite, there was nothing posh about him. He deserved to live here. You know those stories where cats walk for hundreds of miles. Well, he was one of them. He deserved his place.

I: So Docket, do you believe in the meritocracy?

D: Yes, yes I do.

I: So how do you feel about the mice that have always lived in the area?

Suddenly there's a noise. A man comes down the stairs to the kitchen. Docket looks up. The man—charismatic, freshly tanned—makes his way across the kitchen floor, bends down towards Docket and with both hands grabs hold of him by the jowls and says: "Who's Mummy's little cowboy?" I look on in amazement at this time-honoured male bonding ritual, wondering whether to be enchanted or embarrassed. By the look of Docket he shares the same sentiment!

D: That's my uncle Joe, who lives in the cottage. Sometimes it's really bad. There's him and Mum. Mum comes home first, and I can hear her singing, really badly out of tune, in this strange melancholic way: "Docket, Docket. Mummy loves yoooou." So high pitched. I can be in a deep sleep, then the almighty squeeze—10 minutes later, Uncle Joe, same story different words: "Dock, Dock, Dock, Dock, where is he, you furry little thing!" I try to hide, but it's no good. Another almighty squeeze! I used to think, if just only one of them could get a boyfriend.
I: How do you feel about being brought out by your gay uncle?
D: Cool. Remember I was brought up in Vallance Road. Being gay doesn't mean you're not tough. And my mum's a gay icon.
I: How do you feel about your mother's success?
D: To me she's not **Tracey Emin**, she's just my mum, who takes care of me. More than anything I wish she would take care of herself.
I: How do you mean?
D: I wish she didn't drink so much. Sometimes I feel like one of those mountain rescue dogs when I find her asleep at the bottom of the stairs. It's then that I wish I wasn't a cat, that I wish I was human, that I wish I could carry her—make her safe.

Docket looks down, curls himself into a ball. And as he drifts off into cat dreams, I think to myself—if only he knew.

4 August 2006

It was great to be able to go swimming at the end of my road, but as I waded my way through the shallow pool, the water only coming up to my waist, turquoise with a strange consistency of Slush Puppy, I decided to try my luck in the big pool.

I climbed up eight or nine tiled steps, through an archway leading into a tunnel, past lots of filthy loos—stinking, covered in shit, like some crazy, dirty protest. Then through another tiled tunnel, down some more steps and straight into the water—still Mediterranean, but a darker blue. It was odd, there was no edge to the pool. The water went wall to wall.

Then I realised that the actual edge of the pool was a good 5 feet below me. The pool room appeared to be flooded. A few lifeguards stood around a lilo discussing the matter. I joined in the conversation and they called over the manager. I asked him why the room had flooded. He explained, "It's very simple. The lever gauge has slipped, and the pressure is keeping it down. Now if you were to write about this in your *Independent* column, maybe the council would get it fixed ..."

I sat bolt upright in bed. MY COLUMN! MY COLUMN! I've got to write my column! I looked out of the window, across to the Golden Horn bridge. A thousand million boats—ships, ferries, coasters and cruisers—made their way up and down the Bosporus, Istanbul, where Europe meets Asia. The old and the new, the West and the East, symbiotically, happily chugging along side by side.

I say happily because on the surface that's how it appears. A fantastic combination of a circular contemporary society—joining hands with the Islamic world.

The first time I came to Istanbul I was maybe a year, or a year and a half old. My dad used to drive us here in no more than five days—sleeping in lay-bys, frying eggs on a small Calor gas stove. We had a gold Ford Zodiac. My mum and dad hung hooks from the roll bar at the back, and from the hooks hung me and my twin brother in our bouncy chairs. My dad says the drivers in the cars behind couldn't believe their eyes—two giggly, chubby, bouncy babies and a row of international nodding dogs. That would have been the early sixties. We came back and forth to Turkey quite a few times.

Even though I was very young, crossing the Bulgarian border remains a memory fixed firmly in my mind. Darkness, fields, checkpoints, searches, floodlights illuminating figures. I guess people must have been trying to cross the border all the time.

It was one hell of a drive. Once we stopped in Yugoslavia for a rest. No more than an hour. And as we all slept in the car, everything that could be removed, was removed: the luggage, the roof rack, the bumpers, even the bloody wheels. Highwaymen of the ethnic Gypsy kind.

Six months later, we had all our clothes returned, everything dyed, with crazy embroidery. All my dad's suit fabrics chopped up to make tiny clothes. Everything inside the suitcases totally reinvented. I often wonder what happened to the thieves when they were caught.

One big moment in Istanbul was when I went missing in Topkapi—the former Ottoman palace, home of the Sultans and their Harems, now a museum of all the amazing trinkets from the Ottoman Empire's plundering conquests, my favourite being John the Baptist's hand. What genius thought of hacking off the hand that touched Jesus?

Anyway, I was three and I had been missing for a good 10 minutes. My mum and dad apparently had started to panic, when suddenly they heard the sound of a torrent of bells, alarms ringing every which way. My mum and dad ran into the Sultan's great room to see me

surrounded by guards pointing guns and me happily seated in the Sultan's throne.

Even though it's a cute story, it wasn't the only time I had a gun aimed at me as a child. Once we were in a kebab restaurant somewhere in south London. I was about seven. The whole window was shot out, we were dragged through the kitchen to the fire exit and bundled into a car. I still have no idea why. I've asked on several occasions, but every family member seems to draw a blank. It's strange, as a child, what you can remember and what you don't remember. Sometimes I'm sure memories are fired into our minds by suggestion—photos, anecdotes, conversation.

And then there are the things that happen in life, that you know about, that you can feel but you just can't touch—like a ghost slipping through the palm of your hand.

At the moment, I'm sitting on a sun bed, maybe 8 feet away from the Bosporus. I'm sitting in Europe and Asia is just across the water. I can see a steady stream of traffic heading across the Golden Horn bridge. A really massive cargo boat is going by, its foghorn blasting to warn smaller craft. A giant wave moves in its wake. Little tugboats jostle around in the surf.

Later in the afternoon I will visit Topkapi, not just to stare in wonderment at John the Baptist's hand, but to thank God that I'm lucky enough to go back to a place where I'm happy enough to conjure up the childhood of my past.

YEP! I'm on holiday in Istanbul.

20 October 2006

I'm back. I'm back. I'm on the right track. People have been saying: "Hey Trace, what have you been doing the last couple of months while you haven't been writing your column?" Like as if I don't have anything else to do. But to be really honest I haven't done that much. Well not as much as I usually do. It's as though I've gone down a couple of gears. Slower, slower, slow. Mentally as well as physically.

The one thing I have managed to do exceptionally well is put on a ton of weight—10 whole, fat kilos. At first it was OK because it seemed to be all in the bust—and then suddenly one day none of my clothes fitted me. From a size 10 to a size 14 is a pretty big leap when you only wear designer labels. I never used to understand it when women would say they couldn't go somewhere because they had nothing to wear. But it's not about the wearing, it's about the feeling.

I'm going to admit something now and be really honest. The only times in my life where I haven't looked in the mirror and loathed myself are the times when I have been dangerously thin. The less there is of me, the more I like of me. Now, the reason why that's an admission is because I'm quite brainy and not that unhinged. I'd like to sound all psychologically cleaned up but I can't, because part of me still hangs on to the anorexic teenager. But anyway, that's not my problem at the moment.

My problem is that it's half past three in the afternoon and I'm lying in bed with what I can only describe as a mild case of bubonic

plague. I'm surrounded by Lemsip, Beechams Powders, cough medicine and Panadol. And I smell. That horrible, weasely, cold smell. Damp. Normally this wouldn't be such a big deal. I'd just potter around and get over it. But today I have to thrust myself up and force myself to be a media person. Another book signing—my fifth this month.

This time it's for my paperback, *Strangeland*. At the moment, lying here, I am trying to conserve all my energy, as tonight I may have to meet and greet hundreds of people. And all of these people will tell me their names. At the same time as I will be smiling and shaking their hands, part of me will feel afraid, because I just never know who is actually standing in front of me.

But what is considerably worse at a book signing is when there is nobody standing in front of you. The other week I was sitting in Borders on Charing Cross Road surrounded by mountains of my book. My giant tome-like book. I was quite pleased at the end when the security guard came and bought one. I had been sitting there for a good hour saying: "Hello. I'm **Tracey Emin**, the Alan Partridge of the art world." It really is quite humiliating, even for someone like me who is never at a loss for something to say and quite splendid in times of adversity. It's so embarrassing when no one turns up. You have to go all existential on yourself. And sometimes they make an announcement in the shop and that means that people will come and stare at you. Oh God, I'm dreading tonight! This is not me moaning and whining. This is me trying to express how it is to muster up the energy to go out, to put a face on what I do. It's as though I become public property.

And now my brain has come to a complete grinding halt. I can't think, I can't write. It's because, mentally, I just don't feel sharp. I'm out of practice of being on the ball. I've got to get my head back in that gym. I've got to pull myself through that water. Relinquish that mental stodge. Release the silt that clogs up my veins. I have sworn to God that from tomorrow I will be totally focused.

Oh, I forgot to say—I do have some big news. If you haven't already heard, I'm going to be representing Great Britain in the 2007 Venice Biennale. And for anyone who doesn't know what this means

exactly, I will explain simply: it's the World Cup of art. And I am your British team! With this appointment comes a great deal of honour, but also a vast amount of responsibility. Only three women in the 100-year history of the Biennale have represented Britain. It's a fucking big deal! In Venice there is a garden and in the garden there are all the different countries' pavilions. It's sort of nationalism in a really sweet way.

For example, the Japanese Pavilion looks really Japanese. The Australian Pavilion is a cross between something beachy and a mini Sydney Opera House. The British Pavilion is somewhat colonial. As you walk up the steps, words and phrases like Britannia, God Save the Queen, Queen Mary, King George, double-decker buses, red postbox—all things British fly around your head like a giant Union Jack blowing in the wind. Which is really cool for someone like me who is half-Turkish. I am the epitome of what it is to be British now. Everything is all in place. I'm not afraid, I'm just really excited. The big thing now is to be focused and make the work. And that's the biggest challenge of all. It's great to be back!

27 October 2006

Today I am in a phenomenally bad mood. I have spent most of last week in bed with a very vile case of the flu. I have spent hours and hours in my bedroom staring around the room, attempting to see things I have never seen before, in between sweating, shivering, heating and overheating followed by manic rasping for fresh air. I lunged myself out of bed towards the window, pulled back the curtains and opened it as wide as possible. The most amazing, autumnal, crystal-blue light of day fills my field of vision. I focus on the eclectic East End rooftops with their personalised chimneys and simple but yet somehow exotic tile work. I looked down at my garden—everything is still green and vastly overgrown. In between the ivy something rustles and Docket's little face appears. My eyes follow him as he climbs up the steps of the cottage roof, tilters on the decking and after three little movements, leaps up onto a neighbour's rooftop garden—a good three feet away. He then goes out of sight for a few moments and reappears, graceful in terms of human, but extremely jittery for the cat world, as he ambles dangerously along the skinny rooftop parapets. No matter how nervous he looks, I can still see he enjoys his freedom and his independence. He's only had this strange cat-like apprehension since smashing up his little Achilles' heel in the summer. It's as though every little step he takes is made with the most massive amount of caution. I wonder whether this is a good thing or a bad thing for a cat. I can relate to it—it's like every time I turn the ignition for my

car and boldly, yet timidly, drive out into the streets of London, my heart pounding trying to enjoy my journey, but also in fear of every moment of it. There is danger in being over-safe and over-cautious, like the person who drives far too slow on the motorway, or the person who will never try anything new on the menu. Oh, the fear of exploring.

I have been watching a lot of daytime TV. Such great classics as *Under the Hammer*, *Treasure in the Attic*, *Move to the Country*, *To Buy or Not to Buy*. They must definitely have a hardcore cult following— or were they intended for the lame and addicted? It's horrible being ill. Especially as this time last week I was swearing I was going to change my whole life, give myself 100 per cent more direction and focus. I did my book signing—there was a good hundred people there. I dragged myself out of bed and somehow patted myself all together, knowing that any time I could completely collapse. I signed all the books stoically. The moment I finished, I rose from the table and projectile vomited all the way down the marble stairs. It was like a vomit Niagara Falls in Waterstone's Piccadilly. I was truly the professional about it. It's weird, there is one thing I have never done and would never do—that is to cry wolf when being ill. I really, really want to go out tonight—I want to go to the launch of the Audi. I want to go to the opening of the new Café at the National Gallery. I want to see the new exhibition at White Cube. But I am not drinking, and I feel really unwell. And I want to get better really soon. One good thing about being ill is you have time to read. I have had a bit of a Janet Street-Porter fest. I decided to Google her—it's extremely entertaining. Christ, that woman's got some gumption. And now I am reading her latest book, *Fall Out*. It's brilliant—in between coughing up balls of green phlegm, bucket loads of snot and eyes that have the consistency of sandpaper—it's fantastic to read something that makes you laugh out loud, if only for its pure, unshakeable irreverence. Lucky that I know Janet is really cute and sweet, otherwise I would be really scared of her. I wonder if there has ever been a Janet Street-Porter doll? It would be brilliant—you could have different glasses, different colour hair, spangly outfits, little walking boots. You

could have Janet the newspaper editor, TV executive, Jungle Janet—someone's got to do it.

It's brilliant when you're not well—what you think about, having time on your hands. The worst thing about lying in bed for days, especially my bed, is it's really uncomfortable. Recently I have been having to go to the chiropractor because I dislodged one of my lower vertebras, or something like that, I don't want to get all technical. What it's actually meant is the last few months, I have been in quite a lot of pain and my hip joint kept setting. And I was having to go up and down the stairs one leg at a time. Have you ever been to a chiropractor? The only way I can describe the treatment is that I feel like a crab who has its whole shell splattered. And after the initial pain, a new shell grows, and it's immediate relief. And I don't mean that in any hippie, guru-type-of-shit way. I was telling my chiropractor the other week how amazing it was, the fact that I even dreamt better after the treatments. And we talked about how dreams were connected to the nervous system and the whole of life's energy flow. And I said, while we're talking about dreaming and sleep, my mattress is really uncomfortable. It's knackered and it's really had it. Can you suggest something that would be good for my back? He then told me about the Tempur mattress that was designed by NASA that fits and fulfils every one of your contours as if you were floating on space. He then said, what's really great about this company is they will usually give you a six-month trial on any mattress. I chuckled to myself as I walked out the door. I thought, God my chiropractor's a professional—who'd give me a trial on any mattress? But then again, I too am a professional. You know, maybe I will go out tonight.

3 November 2006

More sickness. More daytime television. I know I shouldn't do it to myself. I should be reading. But every single piece of print I pick up seems to literally be shrinking in front of my eyes. I had an eye operation in 2000. Unfortunately it was in France. Not speaking a word of French, the person translating for me told the eye surgeon I was 26 instead of 36. So they overcompensated on my long vision. But I'm not moody about it.

Before, the only advantage of being completely myopic was the fact that I could read an A–Z at night, in the dark, in the back of a taxi, two inches away from my nose. I was like a bat at night-time. Sonar senses. Nothing too close for me to read. The eye operation is laser surgery—and, can I also say, extremely painful. It only takes half an hour. Little kids were having it done before me. They skipped into the surgery and they skipped out of the surgery.

Me? I was a quivering wreck. Your head is bolted into a manacle and a round instrument is placed on your eye, stretching and bulging it as much as possible. Then the top layer of the eyeball is shaved off and left flapping like a little door. Then the laser goes in and does its work. The weirdest thing is that you can see everything as it's happening. Like red lightning bolts firing into the core of your brain. And there's the smell of burning. It's a wholly weird sensation. Ten painful seconds and the gift of sight.

I had both my eyes done at the same time, which, looking back on it, was either incredibly brave or incredibly stupid. But luckily

for me the eye surgeon was one of the best in the world. The next 24 hours were spent at the Majestic Hotel in Cannes. I was heavily sedated, with sunglasses on, in a room of complete darkness. The next morning, when I woke up, I went to the bathroom, removed the glasses and looked in the mirror. It was the first time I had ever seen myself with flaws, features, eyelashes, freckles, and most surprising, really soft brown, downy skin. I'd felt softness but had never actually seen it.

The eye surgeon told me that it might take three or four months before I would be able to read properly, as it would be very difficult for my brain to be able to judge the distance of the words. And it's true. Even now I hold the book far too close to my face and everything's a blur. And that's what makes me lazy and watch too much TV.

So I'm lying in bed with this stupid, shitty flu thing. I've done *Flog It* and *Treasure in the Attic* with some little old lady who just got rid of everything that meant anything to her. For those of you who don't know, *Treasure in the Attic* is a programme where people come round and find things of value that you didn't know you had. (A Burmese hand-carved eighteenth-century table, a whole Clarice Cliff coffee set previously owned by Barbara Hepworth.) And they do you the favour of selling them for you in the auction house or the boot fair, so you'll have enough money for one year's membership at the golf club.

Luckily for me it's half-term, and as I flick through the channels Docket and I jump with excitement as *Animal Rescue* appears on screen. I remember watching it once when the bottle-fed kitten died. A little black thing with floppy hair. I know that children have to learn about life and death, and having pets is a good way of learning. But I felt the kitten thing was unnecessary—almost gratuitous. But today's problem is six snakes that have been left to their own devices in a council flat for weeks. It didn't explain what the snakes had been eating, but I can only presume mice or rats.

One of these snakes was an 18-foot boa constrictor, and two of the others had jaw bites as strong as a crocodile. Enough to take off your hand. I was asking myself what sicko would just leave six

snakes to fend for themselves. Then it occurred to me that they are really irresponsible people, probably running away from a trail of debts. Then I had a clear vision of the bailiffs banging on the door. And just before they break the door down, one of the bailiffs says to his colleague, "Shhh. I heard something. There's someone in there." As he gets down on his knees and prises open the letterbox to take a look through—SNAP! Python snake head straight from the letterbox—left eye and nose missing from bailiff.

I suppose it was kind of a vengeful daydream. I mean, it could have been a postman, gasman, but I chose the bailiffs because they are such gits. Maybe that's a generalisation, but if you've ever had the bailiffs knocking on your door like I did once or twice, it's so frightening. The threats, the abuse, the language, and the piece of paper coming underneath the door saying: "We know you're in there."

You know you daren't open the door and try and discuss the matter because these people have the mentality of animals, like latter-day pirates roaming around with their swag bags. Last time they came to see me it was concerning the good, old-fashioned Community Charge. Which, just for the record, I had paid up in full and was actually in credit. But no they wouldn't have any of it—all they wanted was my stuff or the money. I was shaking and crying by the time they left.

My reaction to this whole event was to go off and make a film where I actually kick my own door in and scare myself to death. I suppose I can consider myself lucky.

10 November 2006

I don't actually like this time of year very much. Even if the skies are blue I find it harder and harder to crawl out of bed. Hibernation is the only true answer. This isn't a new thing. It's been like this since I was a child. It's the time of year when I feel that I have nothing to look forward to. It's the time of year when the old people and the weak decide to give up, rather than face another winter.

The only thing I look forward to in the November/December months is the ritual of pomegranate eating. I have been doing it since I was a little girl. At the age of 10 I would rush home from school, fly through the front door, and run upstairs to the kitchen. (I know it was odd to have a kitchen upstairs, but next to the bathroom was the only place we had running water. From the age of seven to the age of 13 my mum, myself and my brother, and various strangers who would come and go, squatted in the smallest cottage in Trinity Square, Margate.)

I would take a knife and two bowls, lay them out on a tray nicely and place a pomegranate into one of the bowls. I would then take the tray downstairs and sit cross-legged on the sofa, a pillow on my lap, with the tray on top. In a trance-like state I sliced the pomegranate in half and for the next hour no one would be able to communicate with me. I would slowly pick every single pomegranate seed, meticulously and carefully, removing every ounce of pith so that each seed would shine and sparkle like a little jewel. One bowl left with pith and skin, the other bowl like a tiny jewelled

mountain. I would not let myself eat one single seed until the cleaning of the pomegranate was complete. But before one taste I would raise the bowl to the light and always be amazed to watch it shine through each seed, like looking at a three-dimensional kaleidoscope.

My other winter highlight was to chase the school bus down the hill. I would leave home just at the moment when I knew that if I got my timing slightly wrong I would be in trouble again. Breathless and panting, I'd race against the number 50 bus, along the alley, past the police station, down Fort Hill past the haunted hotels to arrive at the harbour just in time. My heart pounding, cheeks red and flushed. I was excited—I had a crush on a boy.

Sometimes I would sit next to him upstairs and we would chat about music. He was a few years older than me, but seemed somehow much older. He was from Northern Ireland. When I was 13 he moved back to Belfast and for a long time we wrote to each other. It was amazing. I had first-hand information of what it was like to live in a place under military siege. I remember how shocked I was when I first read that you were searched going into shops and frisked from head to foot when entering discos. He would often describe shootings, bombs, and the day-to-day fear.

I really missed him when he left school. It was like someone who took me very seriously wasn't around anymore. I think this may have contributed to part of my boredom at school, or with school, just getting there. Along with the 10 No. 6. For anyone who is too young, that's 10 tiny, cheap cigarettes, almost designed for the tiny hands of schoolchildren. Christ, I can't believe it! You could go into any sweetshop, pick up a bag full of sherbet dabs, two bags of Wotsits and 10 No. 6, please.

I'd get to school late every morning. They used to shout at me, "Emin, you're late!" One morning I'd just had enough and I said, "No Sir, you're lucky." With that, Mr. Tuppen marched me off to his office. When I say marched, I really mean marched—military style. This man was still there for land and honour, fighting for his country. To all intents and purposes it could have been 1942: "Corporal Emin! Will you stand to attention!" I would cock my

head to one side and say, "My name's not Emin, Sir." Mr Tuppen would say: "If it's not Emin, then what is it?"

"Miss, Sir. Miss Tracey Emin. I have to call you Sir, Sir, if you-know-what-I-mean, Sir."

"No," said Mr. Tuppen, "I do not know what you mean."

"Sorry, Sir, but you-know-what-I-mean, Sir."

"Emin, will you stop saying 'know what I mean?'"

What I didn't know at this time was the reason why I had been summoned to Mr. Tuppen's office was because my purse had been handed in. He held out my red, shiny purse and said, "Is this yours, Emin?"

"No, Sir, it's my mum's, Sir."

He unzipped the purse. Inside was my bus pass with a photo, numerous stickers of David Bowie, kittens, and other cute animals. Plus numerous photobooth photos of me and Maria. And there, smack bang in the middle of the purse, two unsmoked No. 6 and one half dog-end. I was in big trouble—not just for having a verbal tic. I managed to get a message to my friend Susan. She lived quite close by and went home for lunch. I said, "You got to call my mum. She's at work. Tell her when the school calls, she's got a red purse covered in David Bowie stickers and she smokes No. 6." It worked like a treat. You should have seen the look on Mr. Tuppen's face.

God knows where all that just came from! I was supposed to be writing about running. Loneliest long-distance runner, if you know what I mean? Yes, Emin, we do know what you mean!

17 November 2006

Today I hate my life. I have spent the last week or so totally immersed and dragged down by my past. The "past" being around 5,000 photographs strewn across my painting room floor on a large plastic sheet. Piles and piles of snapshots, Polaroids, negatives, photobooth photos—all displaying various tones of sepia and ageing. A good 43 years' worth of moments of my life caught on camera. But not just my life—friends, acquaintances, and a whole section called "The Miscellaneous Unknowns."

I'm trying to compartmentalise my life, with sections such as: "Denmark Art Trip 1995"; "Being Happy in Toronto 1997"; and "Wild Time in New York 1998" next to a giant section of "Me and Carl in Greece 1994/1995/1996."

In between these memories there are whole sections of my life that just don't seem to appear. The times in my life when there wasn't a camera around—mainly when I was a little girl. We just didn't have the money for a camera and film I suppose. And when I think about it, that's why it's so important to have that annual school photograph taken. My favourite school photo ever was a group shot of the girls' football team. We were 10. Our strip was red and white. I was the goalkeeper and sported a number 11.

We had the most brilliant teacher. His name was Mr. Folkard. And to prove how much respect we had for him, purely on the basis that he totally revolutionised our education, no one, not once, ever referred to him as Mr. Fuckard. Apart from one girl whose name I

can't remember who affectionately wrote a story about him and accidentally spelt his name incorrectly all the way through. At which Mr. Folkard had the great pleasure in reading out the story to us, whilst coughing every time at the appropriate spelling mistake. A 40-strong class of 10-year-olds on their knees giggling, wheezing with laughter.

Our classroom was a Portakabin on the school field. It used to be called a "mobile." When someone was late it was always a dramatic scene as they would have to run across the school playground, and you could feel their state of panic as they bolted up the Portakabin stairs. I have a clear vivid memory of Maria being late and Mr. Folkard shouting, "Maria Tantony! If you are late one more time I'm going to pick you up, hang you on that coat peg, rip off your arm, and beat you with the soggy end!" Not a dry eye in the house.

Mr. Folkard did many brilliant things. God knows what inspired him, but one day he decided we should all go on a ski trip to Austria. Twenty grubby little kids from Margate going off-piste in the Tyrol. What was so genius about this whole thing was that for two months before we went, every Wednesday evening, we did ski exercises, followed by a German lesson. Ein, zwei, drei, vier, funf, sechs, sieben, acht, neun, zehn, elf, zwolf, etc, etc ... Guten morgen, or guten abend mein freund *Independent* reader. I don't need to impress you anymore, but I remember every bloody word he taught us. And to cap it all I have a certificate somewhere, with my name on, to say I am qualified to ski on any slope in Austria.

The only sad thing about the whole trip was that I wet the bed. And because I was sharing a room with four other girls, I was really scared they would find out. So I took the sheet off the bed in the middle of the night and hid it in a chest of drawers. Every morning I would make sure I was the last person to leave the room, which would give me enough time to tear off part of the sheet and stuff it in my anorak. On my way trundling up the slope I would stop and pretend to do up my shoelaces, and like a badger, within two seconds I had buried the sheet in the snow.

It's amazing what we remember when we look at a photo. One minute the joy and laughter, the next the sadness and depression

of a 10-year-old girl. I even have a section of photographs called "Dead People." I'm convinced that some of the memories we hold from childhood only exist because of the photo we have. True memory and inflicted memory—or, not to be so harsh—provoked or procured memory, are very different things.

I remember a tutor at the Royal College of Art, Keith Critchlow, who funnily enough, was one of the founder members of Forgotten Knowledge. (For those of you out there who don't know what that is: it's a group of people who are interested in the things that we used to know that we don't know anymore, in terms of our collective knowledge. For example, how far away mountains are, the shape of the Milky Way—just general things that we ought to know, such as sacred geometry and a natural awareness of space.) Anyway, I remember he said to me: "Tracey, if you can't draw it, take a photograph." A piece of advice I really listened to because the photographic evidence of my life really did start in 1989.

And now it's in my studio. Scattered across the floor and it's making me feel really sick. Full-up and nauseous. Because somehow it all seems too much and in another way I think: is this all there is? It's a general feeling of dissatisfaction and loss with myself. Maybe it's because they are all images. When I miss someone, it's not their face I want to see, it's their breath I want to feel and their voice I want to hear. All the photos in the world cannot make up for that. I miss you, past—come back!

24 November 2006

Right at this very moment I should be at the Serpentine Gallery listening to Damien Hirst giving a talk on his Murderme collection of art. I really wanted to go because I wanted to hear what he had to say. Why does he collect art? What is it that makes him think that something is good? Is it because he loves art so much that he has the desire to collect it?

Now I really love art, but I've never had the desire to collect it. I have too much and too many ideas floating around in my head, often quite scrambled and muddled, fighting for space to get out. I also have the responsibility of my art, the history of art, the meaning of art—all of it whirling around in my head. When I say the history of art, I don't mean that I'm responsible for it, but I must take the responsibility to know about it. I carry around lots of artists' work: Picasso, Rubens, Klee, Miró, Mondrian, Nauman, Freud, and Beuys. Millions and millions of artists. Their ideas, their images, their theories. I could never actually carry around the real stuff and take care of it.

Anyway, that's why I would have liked to go to the Serpentine tonight. But I'm not going anywhere. I have cancelled everything. I hate it when I feel emotionally crushed. It usually coincides with me being physically smashed. Smashed as in being bruised and battered after some God-almighty psychic attack. I feel a bit like Frankie Howerd in *Up Pompeii*, when he shouted, "Infamy, infamy, they've all got it infamy!" I've seen Frankie Howerd live (obviously

not recently). I've also seen Norman Wisdom, Danny La Rue, and countless other jesters of notoriety. Where? In Margate of course. That's why they called it "The Last Resort."

Imagine waking up one day, looking in the mirror, and saying, "I'm going to be a comedian. I'm going to make people laugh. My whole career, my whole being, my persona is based on how funny I am." What makes someone decide that they are funny? Damien Hirst is very funny. That's another reason why it would have been good to go to the Serpentine tonight. People don't expect artists to be funny. They think we're all white on white—uber-Kant, with 02 paintbrushes stuck up our bums. But you'll find most successful artists have a wicked sense of humour. I have heard that even Lucian Freud, who has the appearance of a ghostly apparition, is extremely funny. In fact I *know* he's very funny.

I was round at the house of a journalist friend of mine the other day, sitting on the loo staring at her objets d'art. My eyes focused on a small etching of mine—a bird in a nest with her baby chicks. And next to it, framed, was a letter. The handwriting resembled that of a psychotic eight-year-old child. I started to read with much interest: "Dear Mrs. Barber, your letter to me is based on the assumption that there exists some reason or need for you to interview or write about me. I do, as you rightly suppose, occasionally eat something and (as a result) go to the dentist but that is some way from agreeing to be shat on by a stranger. Sincerely, Lucian Freud."

And yes, I pissed myself laughing! So funny, so funny. Suddenly the whole of Lucian Freud's work fell into place. And so did the career of Lynn Barber. I asked her over our roast duck Sunday dinner (as she puffed away on another cigarette) why such a letter should ever be sent. She blew her smoke into the air and said, "You know. I harangued him."

Harangued him? Turns out she virtually stalked him! The more Lynn described her desperation to interview him, the greater and funnier the letter became. But it would have been such a fantastic interview.

I'm starting to feel a bit better now, maybe because I've been laughing. I really want to cry. I feel that my mind is full of poison,

tears, silt of the soul. The best way to cry is to giggle. I know I have gone on about this before, I'm not plagiarising myself, but often we can have repeated emotions and this one I'm experiencing at the moment I really hate.

I fell off my bike on Saturday night. I was cycling down Brick Lane at about 2 a.m. Have you ever been down Brick Lane at 2 a.m. on a Saturday night? *Night of the Living Dead*, or what? Zombies everywhere, waving their arms around with cans of Red Stripe, singing, "Maga-loof-loof-loof do-do-do-do-do-do-do..."

I didn't actually fall, but an elastic bungee thing jumped out of my basket, got caught up in my spokes and my bike came to an amazing grinding halt. I fell off sideways and smashed my hip. I then had to carry my bike a good half mile, surrounded by arm-waving zombies. If anyone looked at me, I just shouted at them, "Be careful! Get out my way. Be careful!" Like I was nestling on the brink of insanity. And then, on finally opening my front door, I collapsed on my knees and projectile vomited all the way across the floorboards. I think it's what we call purging the soul. And that's why I'm not going to the Serpentine tonight.

8 December 2006

Do you know, last week, (in a very Michael Caine kind of way), my column took me 35 minutes? I had some very, very nice kind words and compliments but, in general, most people found it very sad. Well I find World Aids Day very sad. I would have felt that my column was wholly inappropriate if I had been laughing all over the place like a hyena. Also, last Friday I had a strange, sad, beautiful day at my friend's funeral.

It's not always easy to write something every week. This week I wanted to write about the Turner Prize. And today (well, since last night actually), I have vented my spleen so much that I hardly have any breath left, let alone anything to say! And do you know what winds me up so much? I still care. I'm practically a veteran and I still care about the politics of the Turner Prize. I'm not naive. I'm not resentful. I'm not envious. Not jealous. But somehow the whole thing still manages to wind me up.

I have a small Rebecca Warren sculpture. It's of a pair of woman's legs and half bent-over torso, knickers at half-mast around the knees, and a small dog jumps up towards the crotch. This small sculpture is made out of porcelain. It stands about a foot high on a Victorian jardinière. It's positioned underneath a very delicate Gary Hume painting of dandelions, 1993, and an extremely delicate etching by Michael Landy of some forlorn, forgotten weeds and their roots. All three of these works, in my home, appear graceful and understated. It's only with a second glance, and a moment's

concentration, that we realise that they are exponents of such a great "wow!" generation of British artists. (Rather than them be called the YBAs, I would now like them to be known as the WBAs!)

I nearly went along to the Tate gallery, but the Turner Prize party was standing only and, feeling like a little old lady, I didn't want to stand around for two hours. So I rushed home from my studio at 7:30 p.m., threw on Channel 4 News in high definition from a Sky HD satellite box on a Sony Bravia HD TV! I sat there with bated breath looking at Rebecca's little sculpture, which now seemed to take up, mentally, the whole entire room. As the last few draws of the news floated by and the ads came on, I thought, Christ, it was seven years ago that I was nominated! I remember I was beside myself with anticipation. Couldn't sleep, couldn't eat. I was so excited by the possibility of winning.

Many artists who are nominated state, claim, state and claim again that they don't care if they win or not. I have to seriously question why they take part in the first place, unless they are truly cynical and couldn't give a toss. Or maybe just so uber-cool that it really doesn't matter to them, that they are above such trivialities. Then why accept the nomination? The Turner Prize was truly coveted. It meant something. It was an accolade. A stepping-stone of achievement. You had to have actually *achieved* something or have made a difference to have been nominated. Whether the public were aware of this or not.

And the most wonderful thing about the Turner Prize was that the public became aware. An open debate, a discussion occurred about contemporary art in a land which was philistine. The Turner Prize had the ability to focus on artists who were truly ground-breaking in their field. The Turner Prize had the ability to pick up on a seminal moment within art history. I actually dressed up. I wore an amazing Westwood dress. I remember going to the Tate gallery in the car with Mat (corr) Collishaw and my mum and dad. And can I just say, it was really strange going out for the night with my mum and dad. They were all done up and really, really proud. It seemed like everything that had appeared to have gone so wrong with me, now had the possibility of going so right—the public recognition of

being an over-achiever. As we veered along the Embankment, my mum asked me if I was OK. My dad said: "Are you nervous Tray?" I said, "Yes, I am. I'm nervous for you. Now, I categorically know for a fact that I am not going to win. In fact I know that I haven't won. When the winner is announced I don't want you to get upset or appear upset, I just want you to clap and celebrate the winner. Now promise me you will do that?"

Channel 4 had asked if they could keep the camera on me as the announcement was made. I didn't think it was a very good idea. When the winner was announced I looked at my mum and dad. I could see my mum's lip quiver. My dad took one quick glance at me. They both smiled and started to clap exactly as I had asked them to, but, fuck, I'm telling you, the disappointment on their faces was really not worth it.

I went through hell with the Turner Prize. I was slagged off non-stop in the papers, not just the tabloids but the broadsheets, for months. I was regularly doorstepped and so was my boyfriend and I was referred to as an embarrassment to British art by the then minister of culture. (That really put a nail in the coffin.) My work was vandalised twice—three times including the fact that the Tate removed six of my films without my permission. The whole thing about the Turner Prize—it can be a pretty nasty experience.

On a cynical note, your prices will double within a year, and for most artists who are nominated, they will receive some overnight kudos if they didn't have any before. For me, the best thing about the Turner Prize was my party. There has never been a Turner Prize party quite like it and there probably never will be again. OK, quite a statement, but sadly the Turner Prize doesn't do what it used to do anymore.

PS: At the time I was nominated for the Turner Prize, I suggested to the Tate that all the nominees, past and present, could be given a free Tate membership for life. They informed me, "No, we can't possibly do that. There are far too many nominees." Nice one!

22 December 2006

Have you seen the BBC hippos? Every time I watch them—their little feet; the baby one that joins in at the end—I'm lulled into a whole sense of enchantment. It's probably one of my favourite, most comforting things of the year. And what's strange is when I mention it to other people, their faces light up with glee. It's nice to know that I'm not the only one out there that still cherishes the old-fashioned sense of security.

The thing that scares me most at the moment is time. The way it just seems to flash by. It's a cliché, but as we get older it does seem to move faster. Time that is. I seem to move slower. I'm not as agile as I used to be. I can't bend and put myself into many awkward shapes without looking extremely uncomfortable.

I can't believe a year has gone by since Elton and David's wedding, which was one of my high highlights of last year. And then there was the weeks de-toxing in Australia. And I'm talking hardcore! No wheat, no gluten, no sugar, no fat. And, of course, no alcohol. I actually carried on not drinking for five weeks. Until I crash-landed into London like a giant flamingo speeding down the runway of Heathrow, gullet wide open ...

People tell me my column is really boring when I just go on about drink all the time. Obviously, alcohol doesn't affect them as much as it does me. So I won't write about drinking! I'll just miss that one out and carry on with the highs and the lows.

Having my brains shagged out by a guy who dresses like a

173

Womble was definitely high on my list! Along with having the most amazing time in Istanbul. Sometimes I just forget how Mediterranean I am. People often ask me which half of me is Turkish? I say, "The bottom of course!"

I'm quite scared to talk about it, due to my creative block— VENICE MENICE! Yes, yes, yes, definitely a massive highlight of the year! Undoubtedly the best phone call I've ever had. Especially as I really thought the phone call was to tell me that I wasn't going to represent Britain. I spent most of my life understanding disappointment; having to deal with it and at times even fight it off, like some vile enemy that really wants to kick me when I least need it.

The news about Venice was, as the expression goes, the icing on the cake. It's weird how there are so many sayings about cake. All three of them: icing on the cake; let them eat cake; you can't have your cake and eat it; no good crying about spilt cake.

Oh, I'm really happy today! Maybe it's because I'm just worth so much more money than the editor of this newspaper! Check out lot 33. Oh, and I keep telling the editor to mention this, along with the drawing class, I'm sure there will be a drawing thrown in. (Depending upon the diligence and tenacity of the student!)

Let's go back to the highs and lows. Bringing out three books and one DVD. My paperback; my giant, fuck-off 400-page coffee-table book published by Rizzoli; a monograph by Neal Brown published by Tate; and a DVD of *Top Spot* distributed by Tartan Video. All of this sounds very good and very commendable and should really come into the highs, but I'm telling you book signings, any signings, really come into my lows, especially as I projectile vomited all the way down the stairs at my last signing at Waterstone's in Piccadilly. A nice couple were pointing at me saying, "Look, there's Tracey Emin." The next thing I had two security guards escorting me into the gents. That moment really knocked me for six and took me weeks to get over.

This year has just been full of so much pressure. When I was little I would suffer the most terrible migraine headaches. At the beginning I used to bang my head against a wall and as I got older

I understood what to do. Just be very quiet in a dark room with either a very hot or a very cold towel behind my neck and bend my head back as far as I could. But sometimes the only thing that would relieve the pressure and the pain was some incensed, bilious attack, where vomit would fly out of me like a scene from *The Exorcist*. I was told that these fits or attacks were probably due to my teeth—the pressure going up into my brain. But I don't think it was that—I think it was purely pressure, like in the bookshop. That day I actually needed to be somewhere else. And I probably needed to be someone else. It's very difficult to go out in the world when you're not happy with yourself. It makes you feel like you're a liar.

This last year, no matter how good, I have felt somehow very clumsy. I have been stumbling and falling—literally and metaphorically—and I really don't want next year to be like that! I'm going to change things. This week I changed my phone number after 10 years. It made me feel quite sad. Bye, bye little numbers. And no matter how much I loved you, there's plenty more where you came from!

Anyway, this column is all over the place and that's because I've been partying too much, and that's because it's Christmas! So, for fear of not wanting to sound too humbug to everyone who enjoys reading my column, and even to those that don't, Happy, Happy 2007! The numbers are a lot, lot better than last year.

5 January 2007

Thank God it's 2007. Last year was so roly-poly. Strangely, being cradled in the 00s the 2 didn't seem sharp at all, and the 6 was totally bottom heavy. Everything in 2006 seemed to be about waiting for it to happen, whatever the "it" was. It was like, "We'll just sit here in 2006 until 2007 comes along," as though 2007 was the real year. We have the 007 factor, the $2 + 7 = 9$ thing, and best of all the 2 and the 7 look like they're really good friends and could not care less to have a couple of zeros trying to keep them apart. Plus, the 2's just happy to be there instead of the more glamorous (in the numeric world) 3. Yes, I feel it in my bones: 2007 is going to be a dynamic year!

I usually spend New Year's Eve at home in bed, Docket all curled up next to me, at the stroke of 12, my hands tightly pressed against my eyes. But this year was slightly different.

I was on a dhow floating around the Indian Ocean. Not the entire Indian Ocean, but sailing round and round in circles. I remember at one point, as great fireworks lit up the African sky, saying to Michael Clark (the dancer), "God this is weird." Then it was as if our boat and the sea were being picked up in the palm of a giant hand, and the moon became an eye staring down at us. And a big, booming voice said, "This is really beautiful." And then I started to cry; apparently I couldn't believe how beautiful the Indian Ocean was. I wanted to get closer and closer to it.

Then, Michael wasn't on the boat anymore. I was with Roberta

Hanley, the film producer. She was sitting on the end of the dhow, gold dress, head up, some black hair trailing in the wind like some Egyptian cat-like sphinx. "Roberta!" I called out, "where are we?" She pointed across the water to a giant sandstone, Gothic-looking castle. "There," she said, "the house is there."

I woke up in the morning to the distant sound of bagpipes somehow combined with the chants of the Masai: drums, horns, a phenomenal amount of noise coming from the beach—or maybe just my head; a clatter of weird shapes and memories from the night before. Oh No! Waves of embarrassment came flooding over me, literally, as I still felt like I was in the boat. The bed felt like it was at sea. Then I squirmed as I remembered being chuffed at winning the dancing competition, which meant I obviously danced too much. Yes there is such a thing! (Why be remembered, when you could just have a nice time?) And then speaking fluent cat with the Masai.

Kenya is a strange place. You don't stop dreaming. This morning I dreamt again that I had a baby. I had gone out to buy it some clothes. I passed a strange haberdashery shop. Outside there were hundreds of boxes full of amazing ribbons and braids, fantastic brightly coloured balls of silk and wool. Inside the shop I found a really beautiful cardigan, hand-crocheted in the softest wool I had ever felt. Interwoven between the wool was gold snake-like thread. I put the cardigan on; it was a deep chocolate, eggplant-brown colour. The gold and the brown totally made me alive. I said to the black, blind, albino drummer (who actually in real life was the one who said I won the dancing competition), "Yes, I'll take it." Then he said, "What about your baby. Your baby needs clothes." Looking in the mirror and safely engulfed in the cosy softness of the wool I replied, "I will take it, but do you have it in a size very, very small?"

On New Year's Day three of us with our 2007 hangovers took a slow stroll across the dunes. Hundreds of people lined the water's edge, dressed up in finery: handmade floral dresses, tiny children in matching outfits, all brightly coloured and in high contrast to the whiteness of the sand.

I was feeling quite happy apart from my hangover and dodgy tummy. I had survived New Year's Eve without too many major fuck-

ups. We walked up the point. The sun was starting to set and the air became cooler. Dave and Roberta wanted to swim. A small sand island hung out a couple of hundred metres from the shore. It was nothing to swim. In fact, we joked about our laziness, until we got halfway across, the tide began to pull and, well, we had to put some effort in.

Flocks of birds landed and took off from the island. We did a full recce of our newfound land. The sun had just about set when we decided to swim back, but now the 200 metres appeared to be more like 400 and as we attempted to swim, it was like we were going nowhere. There was nowhere shallow, everywhere was deep. Then Dave, who is by no means a small bloke, said in his upstate New York drawl, "You know guys, I'm not that much of a good swimmer." Roberta decided, no matter what, the three of us should attempt to swim back across together. It was like being in water with an undercurrent rapid—a fast channel straight out to the vastness of the Indian Ocean. I could not believe we had been so stupid. I could see the headlines: "Three bodies swept up in Indian Ocean. The two women were known to be competent swimmers." Just as the reality and danger of the situation hit home, a boat came along and rescued us. And then when we were back on shore, the little sand island, as it slowly disappeared, still did not look that far away.

It's odd the dreams here are so vivid and so perfectly clear. It's because of the purity of the nature, so beautiful and so dangerous. I was right in my heightened, drunken new-year state to fall madly in love with the Indian Ocean, because everything that we love has the intensity to destroy us.

12 January 2007

I should be home by now, in my new studio—all five-and-a-half thousand square feet of it—working away like a Martian, having my head in full gear for Venice. But no! I'm still here, taking massive two-hour walks along the sand dunes and hanging out in funny little stationery shops buying faded old notepads.

Quite a few people have said to me (in received English), "Tracey, you must find it *awfully* inspiring here." And then they bombard me with a million thousand trillion questions about art. I raise my eyebrows and say, "Sorry but can we talk about the stock exchange or something?" You see, I'm on holiday. I'm not looking for inspiration. I wish for the complete opposite; for my work I become inspired by my own train of thought. To be able to think freshly and clearly, to be able to open up and expand, I need to get rid of loads of the old shit that's silting up my brainwaves, my sense of vision and my imagination. It's like emptying out my message box.

On a subconscious level, something big must be happening. I'm not sure if it's the malaria tablets, or Africa, but I am having the most amazing, vivid, incredible dreams. And the strangest thing is they are so rational, as if each one contains a message.

The other morning I heard knocking on the door. Then I heard a girl saying, "Please, please help me. I need food for my baby." My host let her in. Then the sound of mayhem—it was a gang of women looting the place. There was nowhere for me to hide. My room has no furniture. It's very minimal: huge bed made of concrete,

high, high ceiling with the ebony beams painted with thin, black African stripes and a mosquito net that hangs from floor to ceiling. I cowered in the corner, clumsily trying to take off my gold chains and Nubian earrings, with the hope of hiding them. The door burst open. Four women, Indian looking, dressed in bright colours, stood there, one with a baby in her arms, another with a handmade pistol. They took off my gold and shoved me to the floor. I watched my chains disappear as they joined the rest of the swag. My grandma's wedding ring (my daughter's ring); the Turkish chains my brother had given me for being nominated for the Turner Prize; my handmade Nubian earrings I had bought myself as a present after my South London gallery show; my rose gold and old gold snake rings that Stephen gave me; my tiny antique chain from Eric, with my tiny gold key from New York and, finally, my fucking Swatch watch. All gone into a giant bag of swag.

I looked at the woman with the baby and I said to her, "Why are you doing this?" She said, "I need food for my baby." "Yeah," I screamed, "but why are you stealing from other women? Women should help each other, not steal from each other!" To my amazement she agreed and gave me all my stuff back.

There I was, standing on the helm of an old pirate ship. I was with Sting and Trudie Styler. All their family were there, seated on brightly coloured silk cushions. As the ship gently drifted toward the mangroves, a wind started up. There was an order to set sail. To our astonishment, as the sail unfurled, a gust of wind caught it and a giant rip appeared. The sail was going crazy as the crew tried to hold it down. The sail was really old, white, made up of hundreds of different patches, all hand-sewn. Sting looked at me and said, "Tracey, you want it sent directly to your studio?"

Then, me and my mum were on a boat. It was a bit like a scene from *Death in Venice*, but of course it was in Kenya. We stood in the boat upright. We were carrying a black canvas hold-all. We placed the hold-all into another bag. It was a very sad dream, just the last bit. It was connected but yet detached. I felt the obvious: that I should somehow put something to rest, to forgive.

My main problem here is that I have felt very, very old. Older than

I have ever felt before. There are lots of young people here. They are very nice but they play music very loud—hard-core drum-and-bass. I ask them to turn it down. They apologise and smile at me respectfully because they see me as being so much older. Then there are the good-looking young beach boys: "Madam, you need a massage?" Shirley bloody Valentine—they wouldn't ask if I was 18!

Then I went to see a healer. A lovely little lady—aged 75 with the agility of a 15-year-old. She was great. She showed me how to do the lion's roar to release anger, hip swinging and eye rolling. All the moves made me feel 100 per cent better. She said I needed it as arthritis was setting in and I had to watch out for the vast amount of excess body weight that was coming as I headed towards my menopause.

I don't want to be 20 or 25 years younger; I just wish I were 6 or 7 years younger. I have reached that age where I have crept over to the other side. Goals and achievements are no longer ahead, they are parallel. Everything I do, I do for me. There is a certain level of selfishness, which at the end of the day feels unsatisfying.

Yesterday I spent a good two hours sitting on the beach watching the ghost crabs perform, almost invisible against the sand. Hundreds of them scamper this way and that, sometimes being blown around in the wind. Their funny little claws digging away at the sand and then dumping it a few inches away. Their crazy little manic movements made me laugh. As I sat there thinking, and wishing I had a camera to film them, the tide suddenly washed over my feet. It rolled back, and all the crabs were gone. Then I realised that these tiny holes were the only things stopping the crabs from being washed away forever. It's time I stopped procrastinating and got back to work.

19 January 2007

It's 7:30 in the morning. A strange hazy mist lifts itself up from the sea. As we sweep down low over these mangrove swamps, our wings and nose tip slightly upward, just enough to lift us over the sand dunes. Then, a straight low run, maybe no higher than 15 feet, all the way along the shoreline. Miles and miles of nothing but sand. Hundreds of baboons scamper madly, arms and little legs going all over the place, fiercely funning up the dunes to escape the noise of the plane. Hippos cower under the water. Herds of buffalo charge away. The zebra just coolly stand still and look up. The baby elephant run after their mums to hide under them.

We are flying with a Kenyan cowboy. He gives me the thumbs-up for spotting the elephants. We turn back doing a sharp 360-degree turn to get another look. Five or six elephants, ears outstretched— this is not a Safari park, or a game reserve, this is just Kenya.

Our plane twists and turns, sweeping up the skies. Roads leading to nowhere open through a haze. Small settlements dot their way across the landscape. Children wave from a school, which seems 1,000 miles from anywhere. And a sea eagle soars above us as we come in to land.

My mind is full of a million different greens—from a translucent yellowish hue to a pungent, blackish, British racing green. We take a ride through the mangrove swamps, our little boat, its engine gurgling away, grinding into the black, salty waters that hide a myriad of creatures. The further we go, the denser it gets. The

mangroves lift out of the blackness; branches and roots twisted and knotted, hundreds of years old. We turn the engine off. We listen to a mad, clacking, snapping sound: giant freshwater crabs swing across the branches. Small sea monkeys appear, their little eyes dance around in the dark.

I look over the side of the boat. The water is a blackened mirror, and no light from the sun comes through. I become slightly afraid. I feel like an extra from *Apocalypse Now*. I look at my watch, and say, "It's time to go."

Our boat returns to the light and we head right around the island—toward the openness of the Indian Ocean. As the channel opens out, different shades of sea appear—from an effervescent green, fizzy and white, to an opaque navy blue—a jigsaw of different ocean layers. We drop anchor and walk across the dunes. The white seahorses of the Indian Ocean roll across our feet. I am in love with nature. Shells the colour of jewels line the shore; shells that I have never seen before. I pick them up and hold them to the light—a mini, rose, glass window, happily balanced between finger and thumb. I place it back in the sea. Our footprints light up the shore. I half expect to see the Statue of Liberty poking her head out of the sand.

Something heavily prehistoric, untouched by man—the equatorial sun, so hot and hazy, so low, burning through our clothes to our skin. We stand on the edge of a dune—a foot away from the water's edge—and so close, dive into a bottomless sea. Currents flow hot and cold, and as we climb the steep climb out, the sand moves like an avalanche beneath our feet.

God, Kenya is such a beautiful place I don't want to leave. But I did leave. We left our hotel in the centre of Nairobi, happy, staring out the windows, looking up at the vultures as they escorted us down the Mombasa road. Giant wing-spanned creatures that should have given us a clue. They all say Nairobi is a dangerous place.

We read the billboard posters and stared at the casual workers as they lined the roads. And, sadly, said farewell. Until we were pulled over by the police. They were wearing uniforms with guns. They seemed very angry and agitated. They interrogated the driver for

a short while and insisted that he open the boot. Our luggage was checked over. It was all clear and we were told to move on. We moved two feet and a hand came crashing down on our bonnet. The policeman insisted that we open our window.

The Womble was told to explain why he hadn't got a seat belt on. It's quite simple, we stop, we undo the seat belt, we start up again, we put the seat belt back on. But waving the gun in our face, they weren't having any of that. They insisted on a fine of 300 Kenyan shillings. (Which to me and you is about 25 quid.) The Womble waved a £5 note. They said it wasn't enough. We said we had no other money. It was at that point that they started to get quite aggressive. Luckily I had 50 euros. The self-made *bureau de change* policeman (who incidentally had no ID, nor did any of his chums) seemed quite happy with his booty.

We carried on towards the airport. I was shaking. I had heard about the hijackings, but never thought in a million years that it would come from a policeman. My lip was quivering and I felt so sad for the majority of the people of Kenya, whose sole existence relies upon tourism in one form or another.

When I confirmed my flight with British Airways, they didn't tell me the flight had been cancelled. I don't want to sound like a prima donna and go into all the ins and outs of it, but I have been travelling all night, that's including going back to Nairobi airport twice (with the fear of God in me), I no longer resemble an enlightened person who's had new experiences in a three-week holiday. I look like a small potato that's been kicked around a bit. And the reason why I had to finish my holiday—because today I am being filmed as a guest on the *Terry Wogan: Now and Then* show. I am brain dead and I feel like shit. All I can say to British Airways is that I am a very loyal customer. Your cabin crews are fantastic. In terms of my compensation for the rest of that fiasco that was flying with you: possibly a chartered jet to every point of destination that I go to, and maybe the naming of the new Terminal 5 could possibly be the Tracey Emin Terminal, and if not, I would be happy with TKE5. Sad to come down with such a bump.

2 February 2007

I don't want to write my column today. There are some days when I find it quite difficult, like when I have to write it at an airport or in Istanbul when I really want to go to the Topkapi Museum. On days like that it feels like I'm trying to get my homework in. Not that I ever really knew what that felt like. I always did most of my homework at school. It seemed too much, eating on my lap and writing on my lap.

All those magical A-level students happily dosed up on their Pro-Plus, with their miniature libraries by their side, and the family library in the drawing room. That's how I imagined it would be. I never did any A-levels, or O-levels, or level anything for that matter. I did 5 CSEs—which stands for Certificate of Secondary Education. Which means I went to secondary school and had a second-rate education.

But it's not exactly fair to say that about my school. You see, my school looked nice. It was built in 1940. One level—a giant, sprawling bungalow—with two magical quadrangles in the middle, divided by the assembly hall. Two tortoises lived in the quadrangles. We'd see them occasionally rummaging between the long grasses and the palms. One with the word "Ethel," the other with the word "Bert," on their backs. Yes, my school was called King Ethelbert's.

A fatefully cruel thing happened one day. Personally, I blame it on punk rock and anarchy. We were all called to the assembly hall. We were informed by the headmaster that Ethel had come to a

violent, tragic death. His secretary had witnessed Ethel flying through the air, resembling a Frisbee, until she bounced underneath Mr Tuppens's car. These tortoises were as old as the school—and do you know what? Some people actually sniggered and laughed. It's events like that that make you realise what kind of educational establishment you're in. But perhaps even in the highest echelons of education these cruel events of life happen.

My school had an amazing running track; an old haunted cricket pavilion where everyone had sex; the most fantastic allotments; a really good archaeology class run by an old hippie and a very good sports department. My thing was cross-country. It was brilliant. I didn't have to run fast, but just keep to the same pace, no matter what the terrain, which meant cabbage fields with mud up to your thighs, old Roman roads, and my favourite: the beach. I remember all my skin tingling and being bright red. And then I'd sprint the last 500 metres. Sometimes, halfway through, we would stop for a fag. We could run at such a steady pace, that occasionally it would give us time to pop round to our friend Susan's house.

It was strange, school. It was somewhere I never, ever really took seriously. Not until 1989 when I had to sign on at Elephant & Castle after receiving an MA in Painting at the Royal College of Art. When I had to fill the forms in I didn't bother putting down the CSEs. I just put down my First Class Honours degree and my MA in Fine Art.

The next day I was called up and told that I had to go and work in a baker's shop. I explained to them in the employment centre that I was actually over-qualified. "I've got an MA, I'm not going to work in a baker's. I'd actually be taking someone else's job."

They said I wasn't over-qualified because I didn't have any O-levels or A-levels. I said to them, "The whole thing is a bit embarrassing. Just because I haven't put them down on the form doesn't mean I haven't got them."

They said, "How many have you got then?" I took the pen and my form and filled in 11 O-levels and 9 A-levels. They looked at me in astonishment. "9 A-levels?" they said. "What grades did you get?" "Oh, not very high. Mainly Cs and Bs. Three As."

"And what subjects did you take? Can you write down the grades?" English Literature, B. "And English language?" they asked. "NO, I didn't get English language, because I can't spell." Art, A, Art History, B, Drama, A, Modern Philosophy, A, Zoology, C, Anthropology, C. As I started to hesitate they said, "Maths?" And I replied, "Er, no, funnily enough, not maths." Meteorological Studies, B, Alchemy, C. They just sat there shaking their heads. "Wow," said the guy in the velvet jacket. "Would you like a sweet?" Oh, how the tables had turned now!

I was never offered another job. And even when I did my job restart programme they treated me with kid gloves. All I had to do was prove that I could put together a CV and I was let off scot-free.

Even though there was a level of dishonesty here, it's pretty obvious that I didn't know what you were supposed to have, and what you were not supposed to have, in terms of education. But I knew what I really did have. And the whole time I was on the dole I never once wasted a moment. And it's really paid off.

People are often happy to believe the most incredible things.

Yes, thinking about taking up Swahili next week...

9 February 2007

This week my brain has been stormed with one image of a thin girl after another. On the TV, on the news, on the radio, in magazines, in the newspapers. Slinky hips running down the catwalk. Jeremy Paxman umming and aaahing. Size zero this, size zero that, which is a British size 4. I'm presently a British size 12. A 14 if you include the bosom acreage. Well, I tell you, this skinny model thing sent me straight down to the gym to get a personal trainer.

I've had personal trainers before. One of them actually made me cry. So this time I was very clear with what results I wanted. After filling in the forms, I said to Phil, my new personal trainer, "Four years ago I weighed seven stone. I now weigh 10 stone."

He looked at me, scrunched up his face, and said, "You want to be seven stone again?"

"No," I said, "I want to be happy."

I'm carrying around the equivalent of a bag of cement in fat. To put on three stone in four years would mean that in eight years' time, or (let's get really scary) in 12 years time, I would have to be lifted out of my house by a crane. And in between the folds of my flesh, they'd find my cat Docket, who had apparently been missing since 2010. There would be big newspaper stories: "Cat survives in folds of flesh for nine years—living off sweat."

Phil asked if I had tried yoga. "Yoga?" I said, "I fucking hate it." It was like someone asking me if I thought Pol Pot was a nice man. He said there are lots of different kinds of yoga.

"Yeah," I said, "I've tried it and I don't like it. If you think there is any satisfaction in having someone fart in your face, being surrounded by loads of middle-aged, dumpy mothers who constantly congratulate themselves on their core stability and actually haven't done anything in their lives apart from having a few children and getting high off their sun salutations. And then saying stuff to me like, 'What's wonderful about yoga is that it's a great leveller. It's for everybody—the novice, the beginner, the hardcore Buddhist monk. You just go into the class and take it at your own flow.' What it actually means is you are in a room full of show-offs and you are made to feel like a physical retard. And one time I ever triumphed I was accused of being double-jointed. No, Phil, yoga is not for me."

It's weird about body weight—carrying it around. It actually feels like carrying a dead body. People have to understand that some are born to feel thin and others are born to be chubby and cuddly. When it comes to sex, I find very skinny people very unsexy. Getting into bed with a bag of bones is not my idea of a turn-on—eyes popping, teeth jutting, like a demented skull resting on the shoulders of a corpse. But anyone who has ever been very, very thin will tell you how good it feels. You don't sleep, you don't eat, you just float. If I didn't have a mirror and I lived on a desert island, I would still feel unhappy with excess body fat, because it makes me feel like a slug. A depressed, moody, emotional slug.

Phil said to me, "Where do you think the excess weight has come from?"

"My age," I said, "I think it's a hormone thing."

One minute you look in the mirror and you're a girl. A few years later you've shrunk, you have rolls of fat, and the posture of a grandma, and I reckon it's because I've missed out the middleman—the middleman being motherhood and giving birth. It's like missing out on being a teenager. One minute I was innocently playing netball and my periods had just started, the next I was having my brains shagged out in the back of a red van outside Hades nightclub. Girl to woman in no time at all. And now mentally I feel like I'm thinking as if I'm 20 years older than I am.

Lots of my closest female friends are around the 60 mark. They

are the women who I feel most at ease with. I like their worldly, take-it-or-leave-it attitude. And they are not petty about anything. It's a shame the majority of women, in these times that we live in, consider self-improvement to be in the way they look. Whereas before, when the babies had flown the nest, a lot of women would have gone and done that flower arranging course they always dreamt of, or finally had the courage to enroll in that yoga class, or maybe taken up a degree. The pressure on how women look is phenomenal and has got completely out of control. It's incredibly sad and it has very little to do with internal self-preservation.

I swear to God, I can lose 1,000 calories just by thinking really hard, by stretching my mind and expanding. But even me, with my slightly higher than average IQ (based purely on my ability to think laterally), still, with all my mental agility, I find it almost impossible to look in the mirror and see what is actually there. And that has nothing to do with media bombardment.

It has more to do with me wanting to have more control. Going to the gym, making an appointment, having a routine, is the start of all that. I want to grow old and agile. Slugs don't grow old, they have salt thrown over them.

It's a very complex issue.

16 February 2007

The Gilbert & George show at Tate Modern is mind-blowingly fantastic. It's so brilliant to see the progression of 40 years work. And it was great to see Gilbert and George surrounded by their legions. I think that they should be made "Sirs." Sir Gilbert & Sir George. It would be brilliant, because you know that the Queen would get them muddled up. You can imagine one of her aides subtly whispering into her ear, "Ma'am. George is the taller. Gilbert is the shorter."

This week I've been showered with accolades. It's been a week of extremely strange, wonderful letters. One letter I received was from the University of Kent, inviting me to accept an honorary PhD, to be made a Doctor of Letters this summer. I was really chuffed and quite taken aback. I kept having to explain to people, "But you're not a real doctor. People don't actually call you a doctor." The other week I was on a plane where they actually asked, "Is there a doctor on board?" And then quickly followed with the words, "Medical doctor." I said to my friend, "Lucky they got that in quick. Before you know it, you would half the plane debating the Descartian theory, determinism, and the finer points between Hegel and Kant." Dr. Emin.

A few years ago, I was made an Honorary Fellow by Kent Institute of Art and Design. My gown and puffy beefeater hat were designed by Zandra Rhodes. And they actually really suit me. And I've been a guest speaker at the Oxford Union. I said to the Union President,

about half an hour before the talk, "Is there somewhere where I can change into my gown?" At which he just presumed it would be Westwood.

But as I strutted down the stairs in my cowboy boots, and my puffy beefeater hat, and my royal-looking satin silks, he asked me, "Where the hell did you get that from?" I replied, "What? Do you think I've nicked it?" And I remember, when I walked into the grand hall, I'd never heard so many wolf whistles.

But it is odd; if you have a slightly "chavvy" twang, let's just say you're a little bit rough round the edges, and you have a good education, let's say you got into a good university, people somehow think that your dad must have sold a few pairs of tights under the table or pulled a few strings to get you in there. It's not like that with other dialects or accents, say Northern or Scottish; you're either cultured, or you have to work really hard to get a place. I don't know, maybe that's just how it was 20 years ago. Hopefully it's all changed now.

I like being a doctor of letters. I think it suits me. And people who know me really well know that I like sending all manner of missives and notes through the post. I like it in an old-fashioned kind of way. It's how I imagine myself being when I'm really old. That's if I'm old and happy, sitting cosy by a fire with Docket, who's just broken the Guinness Book of Records again for being the oldest cat on the planet. Happily sitting there, writing letters and sending them out into the ether.

I have received some cracking letters this week. One from Africa—an ex-mercenary putting me straight. It's a fascinating letter that describes the whole history of mercenaries. It was a very thoughtful, sophisticated letter—something which would be quite hard to achieve in conversation. That's what is so amazing about letters, there's timelessness about them, where the thoughts hang in space and then you have time to deal with those thoughts. Especially in terms of an argument which, for the record, I am absolutely useless at. I have no chance of ever winning an argument. I am too emotional and react very immaturely to certain situations.

For example, I could be arguing about the Suez Canal crisis in

1956 knowing that I am 100 per cent right, and I find myself in a heated moment saying, "And you turned up late at the restaurant last week!" My friend Sacky, who has got an IQ of 175 (not that it should matter, but she is pretty sharp), says, "Quite often Tracey is 100 per cent right but her delivery is 100 per cent wrong."

Back to the letters. I had a lovely one from the NSPCC who want to induct me into the third NSPCC Hall of Fame for the support I have given them over the last few years. I became all teary when I read the letter. When you speak out on behalf of people or children who don't have a voice, that's the reward in doing it. Hoping that you are making a difference somewhere. But to be honoured for doing it is really lovely.

Even Docket received a letter today. It was sent to 'Docket Emin, c/o White Cube,' with a giant, great big pack of fishy organic cat food. (Burgess "Supa Cat with Ocean fish—extra tasty for adult cats.") Docket still hasn't recovered from not appearing in the Whiskas calendar. We almost had to invent a new month. Anyway, what I liked was that the letter was really cute and it put a smile on my face…

…But not half as big a smile as the letter I received last Friday. "May I offer my sincere apologies that you did not receive my letter of 28th November 2006. I have the greatest pleasure in inviting you, on behalf of the Council and the Senate of the College, to accept an Honorary Doctorate of the Royal College of Art…" YES! Double whammy! Dr. Dr. Emin. X X X

2 March 2007

This column comes to you live and direct from the beanbag. I will describe to you what the beanbag is. It's a giant, kidney bean-shaped, kidney bean-coloured, beanbag. And yeah, that just goes to show I can use the word "bean" more than 10 times in one paragraph if I want to. Anyway, I'm in my studio and I am lying on a giant beanbag. It's 4:30 in the afternoon and I spent most of today in a very, very, deep sleep. I can hear my assistant in the distance apologising to someone on the phone about the fact I'm so terribly busy. The back of my neck feels slightly sweaty. And I realise I could do with a couple of hours more sleep.

I didn't go to bed late last night. In fact this week I have been going to bed early. On Monday night I actually went to bed at 8 p.m. My assistant comes into my drawing room (that's the room in my studio where I make my drawings). I stretch out as far as I can on the beanbag and say to her, "Guess who I feel like today?" With a smile she gently humours me and says, "Who?" "Docket," I reply. "I really, really, really feel like Docket."

She then tells me that a rather serious, eminent art critic is downstairs waiting to interview me, that I have missed my appointment at the gym with the personal trainer, and that I have my column to write. I start saying things like, "But it's different. I'm profoundly tired. The tiredness is coming from a different place. It's a deep inner core of tiredness, as though I have been jettisoned on to the wrong hemisphere. A true moment of spring has arrived and

I feel as if I'm living in the twilight zone." "Trace," she says, "he's downstairs, waiting. Wash your face and get on with it."

It's strange being interviewed. Especially by someone intelligent who you know could probably turn you into mincemeat. And especially when you have only been awake for no more than five minutes. As I sit there, visions of Adam Ant fly into my eyes and the words "stand and deliver." I'm staring out into the furthest corner of the room, my eyes completely glazed and every muscle in my face so relaxed that my mouth doesn't actually function properly as I open it to say, "Ah, yes, the other self. The puppet persona and the private persona. I've never really been into Jungian psychoanalysis that much—found it a bit on the sentimental side—but it is weird when you have a dream, and in the dream you have a conversation with another, and as the other person speaks you see the room from their perspective. We are the centres of our universe, the universe which we witness and which we create. Yes, I suppose that's what my work is about."

I realise that I'm really, really tired. I've already told him that I've just been asleep. I feel that I've given the wrong impression. One of those superwomen who catnaps—powernaps. I explain to him that I'm really tired because I've been cracking the code. In fact I've spent weeks trying to do it. It's always like this before I make the body of work for a show. I can't justify just making art. There has to be a personal endeavour, a journey—I have to go somewhere I haven't been before. And the older I get, the more difficult that becomes.

The other night I had a really small, good dream. I dreamt that I was getting a sack of sand out of a boot of a car. The sand was so heavy I could hardly drag it along the road. But I was stranded in the middle of nowhere. I have never been to Afghanistan, but it looked like somewhere similar. Rocky terrain, desert, plateaus with roads carved through them. To my amazement a double-decker bus came along. The doors opened and the bus driver asked me where I wanted to go. On the front of the bus it said "ROME." I said to the bus driver, "The bus says it's going to Rome." "No," he said, "where would you like to go?" I smiled and said, "London." It was

an old Routemaster bus. He then changed the destination at the front and said, "London it is, then."

I like this dream a lot. It was a dream with a very simple message, which is obvious—if you say where you want to go; there is a much greater chance of you getting there. And incidentally, the sandbag was because of a tidal wave. Always good to be prepared! And now, back to cracking the code. In the last couple of weeks I have finally done it. I've created a new language for myself and it's very exciting. After weeks of worry and sleepless nights, the fear of failure and anxiety, and the worry of what other people will think, it now doesn't matter. It's just me and it. And that it, I have invented and I have created and I'm the one locked in passionate discussion. Just like my dreams I can enjoy wrestling with my conscious as much as my subconscious. All on board—watch out for the tidal wave!

30 March 2007

Ra, Ra-Ra, a Ra, Ra, RA! What does it mean to be a Royal Academician? Ra, Ra-Ra, ra, RA, RA, RA! I've been singing this little song all morning. I just read in the paper that it means I can enter up to six works in the Summer Exhibition. I bet it means a lot more than that. I'm quite excited to find out exactly what it means. I've been to a few events at the Royal Academy—dinners, drinks, soirées—and on a few occasions I have gone on my own and always ended up having very, very interesting conversations, my favourite being when two women had a bet that I wasn't me. The conversation went something like this: "Hello. Hope you don't mind us asking, but my friend here is convinced that you are you, and I'm convinced that you are not." At which point I said, "If I'm not me, who are you supposed to be talking to?"

Anyway, I'm sure that was a one-off blip. I'm sure what we are all going to be talking about is: Did Turner really tie himself to a mast? Did Ruskin really destroy Turner's entire porno collection? Would Jasper Johns have made such different work if his name had been John Jasper? Was Jackson Pollock financially supported by the CIA as well as the Mafia? Was his alcoholism a plea for help, and his death actually suicide? Had Egon Schiele not died of influenza when he was 28, could he have possibly have lived to, say, the grand old age of 90 and spent his last 20 years hanging out in New York with the likes of Donald Judd and Carl André? Could they have possibly influenced him? Could we now be thinking of "Egon

197

Schiele—the hardcore minimalist?" Are Andy Warhol's portraits of the 1980s German industrialists a complete sell-out, or a fantastic monument to twentieth-century industrialism? Should we isolate Matisse's work from politics? Would that be possible if he were working now? (Ooooh, oooh, oooh, let's all hang out in the south of France with the Vichy party. I don't care that there's a raging war going on and millions of people are being killed. Let's just carry on painting pretty pictures. Oooh – we – oooh – oooh oooh... I just found myself going into song again.) Did Picasso sell his really bad paintings to the Nazis and keep his best ones thrown in the corner of his studio next to the rubbish, or was it the other way round?

Oh, yes, I can see already the Ra-Ra club is going to be a lot of fun. I think on my first visit I will take a couple of pom-poms and make a grand entrance while doing a little dance. And if I can lose a little bit of weight I'll wear some kind of performing bear outfit. No, I know, it really is a big honour. I haven't had to grow a beard or anything!

It's quite strange recently. I have been landed a rather lot of honours and accolades. I'm not going to list them all, but believe me there are a lot, and of course, some I've had to reluctantly refuse. I did say to my good friend Mr. Rudi Fuchs, (eminent art historian, former director of the Stedelijk Museum for 30 years, and world authority on Rembrandt), "Why do you think I keep being given things all at once?" He looked thoughtful and discerning and after a few seconds said in his soft, professor-like Dutch accent, "Ah, it's obvious. You are going to die."

And then we talked about the seriousness of it—of course not the seriousness of death, but understanding the line of establishment. Does it come with age, experience, or pure staying power? Every 20 or 30 years, is there a big turnaround? We can see the 70-year-old hippies on their Zimmer frames mulling their way through San Francisco. The 55-year-old punks sightseeing down the Kings Road, with their whole families in tow. Mummy punk, baby punk, daddy punk, granddaddy punk. Sweet. And the grand finale: the 60-year-old Hell's Angel bank manager riding his Harley Davidson through the New Forest on a Sunday afternoon.

It's good that I have been made a Royal Academician. It's good for the other Royal Academicians. It doesn't mean that I have become more conformist; it means that the Royal Academy has become more open, which is healthy and brilliant. Sometimes I have to remind myself how void and totally empty my life would be without art. I take art for granted so often and I shouldn't and I mustn't. It's something that should be fought for because so often, even in our society, art is so easily dismissed. Something, a presence, which has graced this earth, in terms of man's consciousness, for thousands and thousands of years is still disregarded and put down at the bottom of the list of what we need to survive.

So, chipmunks, talking about survival, I will have to take a few weeks off from my column. The day job calls, the art beckons. Venice looms! So after Easter I will be taking a few weeks off from the column and I will catch up with you when I am in Venice installing my work, on the way to representing Britain in the 52nd Biennale.

Tracey Emin RA, Ra-Ra, ta-ra-Ra-RA!

TRACEY EMIN

8 June 2007

This column was supposed to say two sentences.

SORRY EVERYBODY, CANT DO MY COLUMN—IN VENICE.
LOVE TRACEY.

It's funny how I said that was two sentences when actually it's only one. But "love Tracey" seems to be the sentence that's been bouncing around my ears the last couple of days.

I cannot really explain to anybody (well, I can actually, because sometimes I am incredibly articulate) but, not to sound too crass or corny, I feel that I am on the journey of my lifetime. And this Venice thing is a giant, massive full stop. I'm at a place in my life where I seem to be looking back and looking forward with total clarity.

This morning, I was very sad for a number of different reasons. But I was also slightly angry because it's absolutely pouring down with rain. Venice is extremely difficult to get around when it's glorious sunshine. The rain makes everything more or less impossible, and I hate feeling cold and shuddery.

I spent my whole morning doing interviews and press calls and photo shoots. Talking to collectors and curators. At 12 noon, I had my official photo call on the British Pavilion steps. I actually expected to be doing it with the other British artists—the Welsh, Scottish, and Irish. But it wasn't. It was just me. Countless

photographers and camera crews stood in front of me. The rain was pouring down and the steps of the pavilion were very muddy. The photographers coaxed me out of the portico and, as I minced down the steps in my white-linen trousers, I shouted out to them all, "What? You think I'm scared of getting wet?" And then, as the cameras flashed, to my absolute amazement, everybody in the top end of the Giardini started to clap! I punched my fist in the air and said, "Yes!"

And now I have just come back from an amazing lunch for a mere 100 people at Harry's Dolci, hosted by the Gagosian Gallery in my honour. The rain poured down outside, but it was brilliant. As I sat, I couldn't help but feel really chuffed that I was in a room with all four galleries that represent me, and many friends from far-flung corners of the globe. I actually felt quite happy and I thought, it doesn't matter about the rain. Tonight, when I go to sleep, I will close my eyes and conjure up the image of a little old lady of around 80 or 85, slightly wizened, yet energetic, walking through the Giardini, up the steps of the pavilion, and smiling to herself as she says to the young people around her, "When I showed here in 2007..."

Really sorry, I have to go. No time to finish this column. I have to cut my own ribbon!

15 June 2007

Today I am angry. My whole house is shaking, my brain is shaking, my soul is being turned inside out. Not just because of what's going on in my own mind, but because of the nonstop drilling that's going on outside my house. When you live inside an antique you understand it is very fragile, but unfortunately the authorities don't.

But today's drills and shaking are a good thing. We're finally having our Victorian sewage pipes changed. Our whole area will jump and rejoice, as we no longer have to tolerate the insufferable Dickensian stench, which so often pollutes the homes in the streets where we live.

It's strange when you vent your spleen. It's so difficult to direct it at the right person. Every time my period is due... I'm sorry, I forgot. I'm not allowed to write about that sort of thing! (Because half of the people in the world don't have a menstrual cycle and may be offended!) In fact I am now going to "open brackets": mild anger is not a bad thing. We should all scream a bit more, box a bit more. The world has just become a bit too polite for its own good. Even recently, at my local swimming pool (I say local, but it's really an exclusive club in the middle of the city, or it was until Virgin Active took it over), some interior designer must have had a runner's job on changing rooms and has decided not only to paint part of the fire escape orange as you go into the basement, but also decided to tackily cover a giant glass window with some

horrible frosted logo, completely obscuring the giant massive Howard Hodgkin wave mosaic.

I went in there yesterday with all guns blazing. After having to jump over the orange and not touch it due to the most negative feng shui attack I have ever had in my life, I realised that they had completely obliterated the view of a priceless Howard Hodgkin RA. I said to them why didn't they just hack it off the wall (it's a good 30 metres long and 20 metres high) and sell it to someone in Saudi Arabia for three million quid. It's not about the money; it's about the quality of life. Stockbrokers, city people, artists. We swim every day in that pool and that wave looks down on us. We take it for granted that subconsciously it is always there. It's the image which shadows the release of our energy, and it is incredibly beautiful. This wave is not like Muzak, it's intentional and incredibly beautiful and should be given a lot more respect.

Last week in Venice, when I met Tessa Jowell on the steps of the British Pavilion, she was extremely complimentary and very supportive towards my work, which quite took me aback. I had intentionally tried to avoid her so as not to have some international political incident but on meeting her it gave me an opportunity to ask her why this government is not supportive towards the visual arts. In a very Michael Caine kind of way, "not many people know this," if the visual arts in Britain were not so privately funded and sponsored, they would never get off the ground.

And can I just add here that most of my budget for Venice was spent on renovating the Pavilion, that was not just for myself but for the future. I paid for the production of all my work and for one day in Venice it rained but for every other day the sun shone. I just had the trip of a lifetime. I don't think anything will ever live up to it. So now I am going to give you my favourite moments of Venice:

* Norman Cook saying we have got to take the decks downstairs, for fear that the sixteenth-century palazzo ceiling was going to collapse.

* Jerry Hall saying to me in her Texas drawl, "Tracey, I don't think I can dance with a mouse." And me replying, "Jerry, it's not a

mouse, it's a puppet!"

* Lynn Barber in her lime-green kaftan, saying, "Are these anybody's glasses?" and then dancing like a muppet with the largest pair of black sunglasses on I have ever seen.

* James Nesbitt, completely naked, standing with one hand on his hip, shouting to Janet Street-Porter, "Take your clothes off and jump in." And she did, along with many other people.

* Marco the boatman saying I had the loveliest family in the world and that he would take us around Venice anytime.

* Standing on my friend's boat, or should I say giant yacht, with a very attractive gondolier guy serenading me from the shore, and being spotted by Dave Bennett.

* Having a fantastic, laid-back party on the Missoni yacht.

* Being given amazing lunches in top restaurants and somehow being able to wangle a 24-hour bar in Venice. Basically being spoilt rotten by all my galleries.

* Seeing the biggest smile I have ever seen on Jay Jopling's face. (When I am around.)

In total, seven days of absolute, 100 per cent, full-on life. But for me, my highlight, which I will never ever forget one second of, was standing on those steps of the British Pavilion and getting a standing ovation. I really, really, really was awarded the Golden Mouse. This column may be a bit chip-choppy, but I am back kitty-cats and here is the lion's roar.

22 June 2007

I just spent the last half hour trundling round Spitalfields antique market looking for a tiara. And no, it's not because I want to lord it around like some princess, it's because the charity season has begun. It comes in like some almighty wave, taking over people's lives to varying degrees. Shrieks of "I can't possibly be seen wearing the same dress again!" The whole thing is pretty mental in a way. I'm making it a policy, for as long as possible, to always wear the same dress to every large charity ball I go to.

This week, it's been the NSPCC. Tonight it's the Terrence Higgins Trust. And next week it's the Elton John Aids Foundation— hence the hunt for the second-hand tiara. All this stuff takes quite a lot of energy. And what always surprises me, even if it's a bit naive of me, is that it's always the same people using up the energy to make things happen.

This week I was interviewed by *Newsnight* in connection with the Sotheby's auction for the NSPCC, to which I have donated a piece of work. I couldn't believe it as I sat there with the camera on me—the stream of ill-advised, contentious questions that were being thrown at me by the interviewer. They jumped up and down from patronising to sarcastic. In the end I had to say to him, "I don't know what the hell your agenda is, or what angle you're working at, but this is mine!" And with that I exploded at him for a good five minutes on why cruelty to children was absolutely so wrong. And then, after the interview, I said loudly, "Where the hell did they dig

that twat up from? At least we're lucky he's not the editor." This man incensed me, with his pettiness, and his lack of understanding of why we were there. It's incredible how some people just can't see a big picture. They live through life wearing myopic blinkers, never expanding or accepting the fact that as human beings, we have the ability to change many things. I really do honestly believe that we have a duty to take care of those who are weaker than ourselves. It's the essence of humanity. It's that which makes us human and not animals.

I've had a very strange week, running around breathless—tired and overemotional. Every thing feels as though it's in a heightened state. The hot clamminess of the clouded skies. Perspiration running down my neck on the Central Line. All my thoughts cluttered and mashed up. I feel like I'm desperately waiting for a cooler time. I'm still coming down from Venice. And believe me—it is a comedown.

At this point I could lay into all the critics who gave me really stinking reviews, but I'm not going to. I just think it's such a shame they missed the trip. They weren't on my boat. And they never will be. Being an artist is an extremely personal, intimate pursuit. It never ends. Only when you close your eyes and die. And then we don't know.

It's odd, every time I do a big show I am always waiting for the big slag-off. But this time I wasn't—mainly because I'm totally in love with my pavilion in Venice. I think it's elegant, classic, and timeless. In Venice, people give pavilions a two-minute time-slot. Most artists go for the "wow power" factor. I decided to have a very nice show. A show that takes more than five minutes to go round. Something which is intimate, emotional, but has the appearance of being light. I wanted Venice to be a platform for me. Something which I could lean on and work from. And I have achieved that. So stick that up your pipe and smoke it—get over it, will you! And now, on a bigger note, who will buy my wonderful blanket? (Last sentence better sung.)

Please can we make this Reuters news: "*Star Trek Voyager* goes under hammer for Elton John Aids Foundation."

Who says staying up all night with insomnia is a waste of time—

scribbling down the profound prose of Captain Jean-Luc Picard? I'm not so keen on the first *Star Trek*, because somehow it gets all mixed up with some childhood melancholia, but I really do love *Star Trek: Next Generation* and *Star Trek: Voyager*.

The episodes always unwind like some fantastic futuristic fable. Good does not always prevail and occasionally we are left in the balance having to make our own decisions. *Star Trek* is a world where love exists but no sex. The closest was in *Voyager*, when Captain Janeway and Chakotay became marooned on a planet that was the ideal of paradise. He wore lumberjack shirts and made a log cabin, and she became the Martha Stewart of the twenty-fifth century. But the moral at the end of that story was that paradise isn't all it's cracked up to be. It's like being really happy is a strange place too.

But to hell with all of that: who says being a Trekkie is an indulgent pursuit? It's a fantastic feeling to be an artist, and know that it gives you the ability to be able to help and change part of the world.

29 June 2007

I have just come out with my most profound sentence for the week. And that sentence was: "Actually, there is no tomorrow." My office stood still and everyone looked at me. After a few seconds' thought, they nodded sternly. "She's right," they said, "there is no tomorrow."

The next question was: "Is there a next week?" Then it was my turn to go quiet for a few seconds and project my mind through time. Monday's gone. Tuesday's gone. Most of Wednesday. Thursday is column day. "No," I shook my head. "No, I'm afraid next week has gone too." Dates, places, times, other people's instructions. I have to wake up very early in the morning and spend at least two hours unscrambling my compass for the day. Sometimes I don't know if I'm half-empty, half-full, coming or going—I hate clichés like that! It's really sad when you realise that the elements of life's surprises are fast being taken away.

It's like the idea of wanting to be taken. But at the same time, having the fear of losing control. It's like making insane, unapologetic love and then complaining about having to make the bed again. We all think we know what we want, but actually what would be really beautiful is not to actually know what we want, and then one day wake up to find we have it. (Oooh, I can feel Pseuds Corner coming on again!)

Last night I went to a new private members' club that's opened round the corner. I dramatically fell asleep. People who know me admire me for my easy-going catnapping. But there's another

school of thought that says if you want to do that kind of thing—get a room! My reply to those people is, "Don't be so crass!"

Rudi Fuchs, the eminent art historian, said that when analysing the work *My Bed* (1998), what really annoyed him about people's comments is that it's obvious—you don't do it in bed, you do it on the floor. If that's her bed, imagine what her floor is like!

Maybe that's what the problem is these days. We don't have time to imagine. Imagination seems to be something just for the old and the very, very young. Or maybe with the old it's a system of remembering, of the could-have-beens, should-have-beens, and the might-have-beens. And with the young it's obvious, whether it be living as an Aztec king in a pyramid to wanting to wear a pink dress on your wedding day. Or at least it was when I was a child.

But as a teenager I stopped daydreaming and threw myself into a harsh system of reality, which had a lot to do with survival. I was 16 and homeless, living in a guesthouse in Margate, in one room with a shared bathroom that I actually didn't even want to piss in, let alone bathe in. The bath was enamel but the enamel had disappeared after years and years of miscellaneous bodies trying to get themselves clean. My room was really tiny, about 7 feet by 10 feet. It contained a single bed, a wardrobe, a dressing table, and a sink. And all my worldly possessions, which by that time was a small collection. My most important things were my bowl and my electric kettle and a two-bar electric fire. Every morning I would boil the kettle and have a stand-up wash in the bowl. Even though I never had clean clothes, and hadn't even heard of deodorant by that time, keeping my body clean—from my feet to my brow—was so important. It gave me some kind of dignity, unlike the Pot Noodles and Kentucky Fried Chicken that became my regular diet. I somehow vaguely remember being given food vouchers, but it is all quite a blur. One of my big memories was meeting my mum at Victoria train station. She was really upset and distressed to see me so forlorn and hungry. We both sat there, neither of us with a penny to our names. She had a gold necklace on that my grandma had given her. She gave it to me and within 10 minutes I came back with £25. She took £10 and gave me £15. I just remember watching

her disappear through the crowds in Victoria and me shouting, "I love you Mum."

I don't know why I'm thinking of these things today. Maybe it's because my life has changed so radically and amazingly. Even though I know that the clock can't be turned back (and this is cliché column after all), isn't it good how life can change? And I have education to thank for that. So tomorrow is my big day, when I receive my first honorary PhD. And it will be very special as I am receiving it from my old school—the Royal College of Art. I keep saying to people, "Does this really make me a doctor?" Please can I just repeat the doctor on the airplane syndrome again? So... "Is there a doctor on board?" says the captain. "Me, Me! Me, Me!" I squeak!

So tonight I get all glammed up and head off to Windsor to the Elton John Aids Foundation White Tie and Tiara Ball. I'm really excited because my blanket, *Star Trek Voyager*, will be auctioned. In fact, I'm actually nervous. I've never donated such a large work before but the atmosphere is going to be electric. And I'm going to be there to gee it on! I just hope with all the excitement I manage to get up early—in time to receive my honorary PhD! Is there a doctor in the house? Too bloody right there is!

6 July 2007

Tracey bombasey, stick a lacy fi facey, fi facey bombasey, that's how
you spell Tracey. Chair bombair, stick a lair fi fair, fi fair bombair,
that's how you spell chair. Table bombable, stick a label fi fable, fi
fable bombable, that's how you spell table. Bed bombed, stick a lead
fi fed, fi fed bombed, that's how you spell bed. I can do it with any
word. Some are more complicated than others, depending on how
many syllables they have. For example, computer bombuter, stick
a luter fi futer, fi futer bombuter, that's how you spell computer.
Doesn't matter what word it is, you can ask me in 10 years' time and
I will still come up with the same nutty little rhyme.

Occasionally in life I come across other people that can do it. In
unison our voices will chime with exactly the same words. It's
almost a creepy little thing. Something I picked up in the playground,
while playing cat's cradle or running underneath the skipping rope.
In my mind, I remember all the other children playing the same
word game. But maybe they didn't. Maybe that's just my wishful
memory. Maybe it's what I used to repeat to myself at night, like a
mantra, when I was afraid. A scared little girl curled up, laying awake
listening to the windows rattle and the sound of footsteps coming
up the stairs.

I wet the bed almost every night I can remember. I started when
I was around eight and went on until I was around 11. In the end I
was taken to the doctor and after much medical inspection, he
determined there was nothing wrong with me and that it was

psychological. Instead of finding out what was psychologically wrong with me, I was given the glorious wet-bed chart.

I think I may have already written about this at some point but it's such a strange, weird thing, I don't think there's any harm in me writing about it again. The wet-bed consisted of a weekly calendar. Monday night, Tuesday night, Wednesday night etc.... and it was pinned up by my bed. If I didn't wet the bed I got a blue star. And if I didn't wet the bed for a week I got a silver star. And if I didn't wet the bed for a month I got a gold star. When I got a gold star I got a tube of Smarties from the doctor. I dislike chocolate immensely. Not the taste of it so much, but somehow mentally how I relate to it—a reward for having to keep my mouth shut. As a child I was so sexually aware and as a teenager I was positively rampant. I confused sex with emotion because as a child I found it hard to differentiate. What the hell were doctors thinking in the seventies?

I've been thinking about these things this week because I have been trying to understand guilt, where it comes from, and why it exists. Partly this is due to the fact that I turned 44, and on Monday night, the eve of my birthday, I was catapulted into a deep melancholic state. I actually felt quite alone and this in turn made me think about when I was small. It's amazing how much we shut out with the fake idea of protecting ourselves. Some days I get really aggressive and I lash out at the world, but really I should lash out directly at the people who mistreated me as a child. But last time I heard, they were in prison. We spend a lot of our lives, as it says in the great book, forgiving those who trespass against us. Carrying around guilt and fear is a massive burden and extremely unhealthy. I'm at a halfway stage in my life and I really would like to clear the decks, but even for someone like me who is incredibly open, with a very loud voice, I find it extremely hard to holler the right words.

Where shall I go from here? I'm always making decisions. Organising the event. But now, at the grand old age of 44, I want to be taken. I want to be lifted out of my shell to bask in a pool of light. I find as I am getting older I am becoming more and more romantic, passionate. I want to ride high on the wave of insanity where everything feels unbearably real. Tingly, spangly, hot, and

exotic. I want to touch and be touched and I don't want to feel afraid. I'd like to sit in the dark at night and be able to count the stars, to celebrate their light and not be afraid of the night. I'd like to be able to go to bed with the lights turned off, stretched out, not curled up in some small crab-like ball. I want to feel like me, all of me, and I don't want no part to be locked away.

There are some men who make better boys and there are some boys who grow into very good men. I would like to become and grow into a very good woman. I'm glad the girl in me has gone. When I think about her honestly, I didn't like her very much, and she didn't like herself. Now I've got the rest of my life ahead. I'm happy to use the past as a barometer, a measuring tool, but that's it.

13 July 2007

This week I am writing my column on Wednesday. It's Wednesday 11 July. The eleventh of July is a date that somehow should mean something to me. It's caught in the recesses of my memory demanding some kind of importance. Maybe it's my dead uncle's birthday, or maybe the last day of college, or the day that I received my degree results. Then again maybe it's just the 7/11 thing—you think something's important because it sounds like you should remember it. It's strange how our memories fade in and out and deliver to us sometimes what is the least important or the least expected. A razor-sharp vision of myopia.

My first memory is of sitting on the floor and drinking tea from a milky-brown bottle. The reason why I can remember it so clearly is the teat of my bottle was blue, when it should have been pink. My twin brother was drinking from my bottle and I was drinking from his. Quite often our flash memories are produced by a photograph—either the photo triggers something, or we think we remember something because of the photograph. But the bottle incident is really quite unimportant, and that's how I know that it's true.

I can suffer the most terrible blackouts, where it's almost impossible for me to remember anything. On the other hand, I can remember meeting someone clearly for two minutes, 12 years ago. Where it was, what we said. The same as someone can say, "What were you doing 10 years ago on 18 November?" And after a short while I can generally work it out. It's like a mental tracking system.

At the moment I'm trying to remember emotions. Mainly love. I'm trying to remember what it feels like when you first fall deeply in love. I'm trying to work out if it's something you have control over or not. Or whether it's all-consuming, like a giant thunderball of fire, a meteor of rock and molten ash collecting and destroying everything in its path.

A project I have always wanted to do, a sort of Arts Council–funded project, is that when I'm an old lady, maybe around 80, I visit every volcano possible around the world. And there, closest to the point of its internal eruption, I think about all the people I have ever loved. And for each volcano I recite a love poem. I have visions of me dangling from a helicopter, covered in metal armour plating, as little volcanic rocks jump out at me.

There was that amazing French couple who spent their whole life investigating volcanos. There's this brilliant clip of Super 8 film of their honeymoon night—dancing on the inside of the lip of a volcano, the molten lava only a few feet away. They are wearing the inspirational armour-plated metal suits. They hop around in love, resembling Bill and Ben. They spent years together taking risks and sharing their love of volcanos. They finally disappeared in an almighty dust cloud. They just vanished.

I can't imagine them living in some apartment in Paris, or her doing the daily shopping, or him loading up the car. Or him, maybe, down the local GiGi bar with some friends, having a few drinks. Impossible! I can only imagine this extraordinary couple on the edge of mountains. In strange Nissen huts, small bivouacs, tiny log cabins, frying eggs on a Calor gas stove, surrounded by maps and graphs, stacks of technical equipment, compasses, and a shortwave radio. Maybe a small washing line strung between two twigs with two pairs of very stiff socks hanging out to dry. None of these images exist in my memory. They are conjured up from the semi-quasi Mills & Boon romantic intensity. I can imagine them being chased by the cloud, a giant black smouldering monster. And he's screaming, "Allez, vite! Fuyez! Fuyez! Fuyez!" Both of them knowing no matter how far they run, or how fast they run, they would be engulfed and consumed. For two seconds, just before the cloud

hits them, they lie on the ground, holding each other in their arms, and they say for one last time, "I love you, I love you."

Today, on Wednesday 11 July, as I lie in bed at ten to one in the afternoon, feeling slightly depressed and morose for no apparent reason, I would so much rather think about this beautiful French couple—the volcano hunters—than to possibly dare go anywhere near my own life. Today I wish I could run a million miles away from myself. I wish I didn't have a body and I wish I didn't have a mind. I wish I could just be a happy-go-lucky amoeba floating in life's giant ocean, not having to make decisions, not being confused, and devoid of all emotion. Today I wish I were just the part of me that was the very, very beginning.

Wonderful things have happened to me, whether it be the Venice Biennale, Paul McCartney singing happy birthday to me, being made à Royal Academician, getting my honorary PhD from the Royal College of Art, selling my blanket for £800,000 for the Elton John Aids Foundation. It really has been a fantastic month and tomorrow I am being given another honorary doctorate—this time a Doctor of Letters, which I was awarded partly on the basis of this column. So thank you, little column. As the giant ball of black-grey dust comes to engulf us... I love you.

20 July 2007

Weather-wise, it was probably one of the loveliest days of the summer so far. I saw it briefly, this week, glimpsed through the crack in my curtains. It was a day when I could hardly move. It happens to me on a monthly basis. My body turns into a weighted mass of tiredness and lethargy. Now I don't fight it, I just go with it. I just lie in bed and went into a deep, deep sleep. So deep that I don't even remember my dreams.

I woke up sometime late in the afternoon, slightly sweaty, the back of my neck damp. Docket was stretched out beside me with his little paws gently resting on my hand. It occurred to me to question how much Docket was aware that he was more or less holding my hand. How far does a cat's level of consciousness actually go?

When he was a kitten I made him watch *Stuart Little* with me, hoping it might give him some kind of clue of where he really came from. Imagine if one gave birth to a cat, or should I say kitten; it would be really strange and most definitely Egyptian. When I was younger, I had a very sadistic boyfriend who took great pleasure and delight in showing me a dead kitten. He opened up the palm of his hand and said, "I've got something to show you." And there it was, this stiff, petrified, furry little thing, with its paws raised up and a look of complete terror frozen on its face.

I remember screaming and going into some kind of convulsions over it. It had some kind of primal relevance to me. An act of cruelty is far worse when the perpetrator has calculated the effect.

217

And this was one of those occasions.

This week, I wanted to write about the effect of giving birth to something that is dead. But for some reason I am actually afraid to write about it. It's somewhere my consciousness really doesn't want to go. This week, I wanted to write about life and generosity and spontaneity and all the wonderful things life has to offer. For some reason I keep seeing that dead kitten. The image is trapped in my central eye and I'm desperate to replace it with something positive. I guess this is part of the monthly lethargy; the brain slowing down to a mild point of depression, and there's only one thing that can probably sort it out—an intense burst of energy. As soon as I have finished writing this column, I'm going to march myself up the road and swim for a good 40 minutes. I think it's what they used to call shaking off the cobwebs. I'm like a fly trapped in some giant web waiting to be eaten by some giant spider.

Ahhh... two hours later, that's better! I have just had the most incredible swim. The water in the pool was the perfect temperature. And when the lifeguard turned his back, I dived in and did one length underwater. It felt like I was being baptised. My muscles sprang into action and said, "Thank you, God."

And it was brilliant—I tried out my new flippers. I did 15 lengths backstroke, three lengths using both my arms in a butterfly action on my back, 12 lengths just using my legs—really fast, really splashing—and 10 of breaststroke. It was cool, I beat my own personal world record. Which in actual fact is quite slow. It took 25 minutes.

Can I just add here (in case there is some debate over this time) that I was using flippers, which is sort of cheating. In fact, everything I have just written about swimming is cheating as I actually haven't been anywhere!

Anyway, I'm still lying in bed, desperately trying hard to use mind over matter. Oh to be a whirling dervish and to be able to levitate a mere four feet off the ground. I saw the whirling dervishes in Istanbul. They were doing the April ceremony. It was so sweet it made me cry. I often cry at things that make me really happy. I embarrassingly cried on national television because I was so

overwhelmed with the ceremony in Canterbury Cathedral where I received my honorary doctorate last week. I wasn't alone in the crying stakes, Michael Gambon shed a few tears when he received his, too.

Ah good, the kitten is going now. I'm in Canterbury Cathedral. My mum and dad are looking at me as I lead the procession. It's all regalia, pomp, and ceremony. Trumpets and bugles are playing. It really is a grand occasion and I keep seeing myself from outside of myself, looking down. Part of my soul is levitating above me—the part which is happy and light and free.

When you have perspective on yourself, when you're outside of yourself, it means you are in a good place. It's like understanding how a dream works. It's very comforting. I should know—trust me, I'm a doctor. So I just spent the last hour or so making myself feel better, enjoying some of my small achievement, congratulating myself. Thinking how pleased I was to get my mum and dad in the same room, even it was a giant cathedral. At one point my dad tried to flirt and kiss my mum on the cheek. She screamed and ran away. My dad is 86. My mum is 79.

Yes, I'm feeling much better now. I think I'll get up.

27 July 2007

I spend all night awake. Not exactly insomnia, more like an anxious mind. I hate myself when I do things wrong. My brain climbs on to a treadmill and repeats and repeats and repeats itself—as if repetition of the mistake had any chance of making things better. But of course, after a night of lying in bed watching back-to-back episodes of *CSI: Criminal Minds*, and any *Top Gear* I could lay my hands on, I feel absolutely exhausted. My mind is all over the place, from vengeful mechanics to human hunting and the new Aston Martin.

It's 4 a.m. and I'm finding it very hard to get a grip on things, and I'm not writing any of this, I'm just thinking about it. The dawn light is starting to appear. For some insane reason, I have decided to check and delete all the emails and messages on my BlackBerry—including the ones that I've written.

An hour later, it's 5 a.m. and the sun has started to do something quite beautiful. My bedroom has both north- and south-facing windows. There's a slight crack in the curtain in front of me. An amazing jet of eastern light has shot through the room, marking out a very beautiful, strange grid. The reason why it's so unusual is because it can only happen for so many minutes early in the morning, before the sun moves over the roof.

But this envelope of beauty and my poetic notions towards it are not going to help with the deletion of all the insane messages and emails I send all over the world. Some I don't even remember writing. It's as though Beelzebub has taken my hand and

unconsciously I have been drawn into strange secret language codes that only exist for the extremely drunk, the sleepwalking, and the conscious dead. The weird thing is, on one level I really hate myself for it, and on another level I'm well impressed that I can do anything when I'm so out of it.

The BBC World Service is full of news today. The last king of Afghanistan was buried this week. A slow, strange, mournful procession, world dignitaries making their way through the mud-sodden streets, a curfew in place to keep every sniper away, a really peculiar brass band that reminded me of something from a performance of Otto Mühl, the music that the band made, haunting and melodic as though from a distant century. It's still only 6 a.m. and my brain has got nowhere to go. It's the time of day really when I like to have sex—as the sun is rising, as the day begins. I wonder if we like to have sex the same as we were conceived, or the time when we were born. I was born at 6:50 a.m., but I have no actual idea of what time I was conceived. It's amazing some people know exactly the moment when their child was conceived. My mum and dad actually aren't even sure where. One of them says Southend, the other says southern Ireland. Poetically speaking, for a woman like me, there isn't that much in it. One thing I know definitely: after my mum came out of hospital she was looked after by a friend in Southend and the first place my twin brother slept was in a chest of drawers. It's one of those strange things. I almost have a memory of it, just because mentally the vision is something so incredibly sweet and cute. These two tiny little brown babies with dark hair and blue eyes (so strange the idea of blue eyes when my eyes are now so brown), all snugged up in their little drawer.

The last images of the kind disappear and I turn the TV off. I wake up after one of those really insane, mad, naked dreams that's too complicated to piece together. Unfortunately it isn't hours later, it's 6:50 a.m. and I've had a mere half-hour's sleep. And now just lying in bed I start to have a panic attack. I've got about a million appointments and I'm worried that I'm going to be too tired, or at best irritable, or do my usual trick of falling asleep round at someone's house, or in someone's office, or someone's car. I wish for

24 hours a day and then when I get them I can't use them. I wish we could have credit hours. So that would mean sleeping nearly all winter, like some small hibernating vole, and by doing so it would allow me to stay awake all summer.

On the roof of my house there is a nest with really beautiful little birds. They chirp and sing from early morning until when I get up. Not just bird noises, but real singing, like old-fashioned birdsong, like something from a music box. It would be so wonderful if we could understand what they sing, this happy early-bird family tucked up safely on my roof.

This morning I really wished I could be them. Then again, this morning I wished for so many impossible things. But maybe to be a bird was the simplest of all.

3 August 2007

I'm lying by the pool and I am sun-drenched. This overwhelming sense of relaxation has come as a complete surprise! I surprise myself! I said, "Tracey, you deserve a break. I'm going to take you somewhere nice." And now I'm in a Roman province, in the shadow of an old monastery, surrounded by the most beautiful trees and eyeing up the deep royal blue of the water from the pool. I even have a book in my hand. I suppose this is what you call a holiday. I have been sulking and whining and stamping my feet for the last few weeks, because I felt exhausted and my brain wouldn't work. But now lying here, alone in this quiet, idyllic setting, all I can think about is my show in Los Angeles.

I'm filled with some ferocious excitement. I have a brilliant title: *You Left Me Breathing*. I like it because it has lots of different connotations. Of course, the obvious is half-dead, but also, when someone leaves you standing—crying—as you sob and inhale the air you realise how important breath is. The same as when making love with uncontrollable passion, when there are no thoughts but just breath and the sound of a beating heart. Yes, I'm very happy with this title. And that's the starting point with all shows. Targets are for shooting at. Once you know where you are going you can work towards it. I want to make a series of crazy sex paintings—half Tony Hancock and *The Rebel*, a quarter Tracey Emin and a good 25 per cent alcohol-induced. I want to push myself to the limit. I want to get to that point where I'm afraid to go to the studio the next day

for fear of what I may have done. I want to scare and excite myself all at the same time. I want to fall off the trapeze wire, but bounce back higher from the safety net.

I had a dream the other night that I was on the highest building in the world and it was made of very small red London brick. Almost like a square castle piece from a game of chess. I was with lots of people that I knew and we were on the roof of the turret. We were perhaps 1,000 feet high. There was no doorway, no stairs, and no lift. We were just stuck there, suspended for eternity until we died.

People that I loved and cared about took it in turns to jump. When it was my turn, I looked down between the turret walls and was hit with an incredible attack of vertigo. I folded my arms across my chest and rocked backwards and forwards, eventually finding my way back into the centre of the turret. I said to my best friend, Maria, who I have known since I was four, "I can't do it. I can't jump." At that point she jumped, followed by my mum.

The strange thing was, they looked supremely happy and at peace with their decision, whereas I just kept thinking I don't want to die. And this was that point when dreams go very strange. An inner voice said, "How do you know you are going to die? You don't even know what is at the bottom. You are even too afraid to look." And then I jumped.

And I hit the bottom and I died. And then I had the same old usual floaty out-of-body experience, followed by an incredibly sexually explicit dream—which I think was so obviously my reward!

I've made some very strange little sculptures. They are nearly all of animals, apart from one, which is a pineapple. They rest on mini-plinths made in a really brilliant L.A., beach, California, fifties surfer kind of style. Different woods put together in cute pattern formations. In some places the wood is eighteenth-century floorboards, some bits of cabin from tall ships or things which could have been found on the seashore—driftwood. There's millions of drawings, some new, some really old—a crazy wall scattered with tiny gems. Giant white wooden sculptures, caribou wigwams

presenting only their skeletal form, with neon threaded through. The deer, the stag, the neon, the nature, the love, the passion, the soul, the constant passive energy, which shall prevail! Oh yes, I'm really enjoying creating my show for L.A.!

But I suppose I'd better go back to the provinces of Rome to lie out by the pool and be cuddled by the sun. Away from the maddening mice and only my solitude for company. It is so wonderful to have time and space to think—to remove all the distracting silt that doesn't just clog up our thoughts, but our hearts and souls as well.

The most important thing about being an artist is to have the space to walk around inside our selves. It's not about what is made, what is external, but about the true essence of how it arrives and where it came from. And today I am very happy. I have shifted my mind all the way to L.A. and my future, and back. And I have been nowhere further than a sun lounger! Now I might just take a dip. Swim a few thousand miles to heaven and back. The sky is blue, the sea is blue and I can swim, float, and fly. Today is not a day for fear; today is a day when all things are possible. Yes! I'm going on holiday tomorrow! Now I'm leaving my office—hope you enjoy this column!

10 August 2007

I'm lying in bed and it's very early in the morning. Tired but not tired, sleepy but not sleepy. I try to read a bit more of my book but somehow get stuck on the minor facts and figures, important points and historic dates of the whole, entire African continent.

It's not what I want to be reading now. I fancy some kind of passionate poetry; something that makes me put my head back in the pillow and scream with a kind of "Ahhhhhhh!" kind of sound... I think of myself as some kind of Victorian virgin, maybe 19 or 20 years old with a high-necked lace collar and shell cameo brooch sitting by a gas lamp with the fire burning, turning the poetic pages as if they were pornography; my heart leaping in bounds, imagining a future that has no shape or form, just a sensual entity, heaving and breathing its way towards me, pinning me down and engulfing me.

As I read, my chest, thumb, and finger feverishly hold the corner of the page and as I turn, my breath, so deep, the pearl buttons ping off my blouse... Oh those lucky, dirty Victorians!

I put my book down and try to think of what to do next. It's 6:30 a.m.; I am really, really hot. I get up and turn the duvet over and rearrange the pillows. Docket appears to have eaten too many biscuits and has thrown up on the Persian rug. I have a choice: I can either clean it up NOW or I can wait for it to dry, when it will be a lot easier.

Once I had a man stay at my house who I can quite honestly say

Docket did not like. In the morning, this man said to me, "I think your cat has shit on the floor," as some gooey stuff appeared between his toes. I smiled and said, "Don't worry. That's not shit—it's vomit." And as I made my way down the five flights of stairs to the kitchen I gleefully noticed that Docket had performed his own little dirty protest by throwing up on every landing. I could just imagine him running up and down the stairs, frantically retching, with the words: "Eurgh Mummy—NO!" That's my Docket.

I get back into bed and watch the sun coming through again. I can hear a helicopter outside. I close my eyes and start to think of the three astronauts in *Capricorn One*. Imagine: one minute you think you're going to Mars, the next you're in an aircraft hangar somewhere on the edge of the desert and being chased by helicopters. I remember being at the cinema, climbing out of my seat, shouting, "Run run, climb, run, climb!" I really felt for those astronauts.

But it was so clever how one of them gave the clue to his wife. From the fake capsule, he gives one of his final messages before their moment of supposed disintegration. He says, "I keep thinking of you and the kids and the wonderful holidays we used to have in Florida," or something to that effect. They had never been to Florida, and it's from this little clue that she works out that he is not on Mars. But that scene with the helicopters—it filled me with fear and excitement.

I suppose it's because I get sexually aroused by helicopters. I know it sounds strange, but I am just being honest. I do. Any excuse to get on one and I'm there. Mat Collishaw and I did one ride, which was the highs and lows of New York. It was in the days when the World Trade Center was still there. The helicopter would go really high around the towers and then go really low, really quickly, almost so you could see what people were wearing on the street. Poor Mat. He drew blood from a Japanese girl's thigh, as the look of fear engulfed his whole body. Meanwhile, I more or less wet myself. And I'm telling you, it wasn't through fear!

I have even got a photo by some really well-known war photographer. It's a picture of American soldiers in Vietnam. They

are in the foreground running away from a helicopter that's exploding. As the black smoke and fumes fill the air, other helicopters circle above as though doing a dance of death.

I lie in bed for another 40 minutes, reliving every other helicopter flight I have ever had. Not sure where the sexual thing came from. It's not as simple as the whirring of the blades. It could be something to do with sea rescue, the coast guards, a childhood memory of heroes, men risking life and limb to pluck someone from the sea. The waves crashing and pounding...

A small vessel sails from the North Sea down through the English Channel, barely missing the Goodwin Sands. She had heard rumours that men had played cricket on such sands, out in the middle of the Channel, when tides were exceptionally low. She wondered what sort of gentlemen would take on such a bizarre task: guardsmen, naval officers, men of the cloth. "Ah," she thought, "men, men, men." And now, as her cabin rocked from side to side and the small gas lamp shone brightly, she loosened her cameo brooch from her neck and, taking a deep sigh as she turned the next page, she released the top pearl button from her blouse...

17 August 2007

I'm sitting on a hill, or should I say more of a hillock? To my left there is a cavernous gorge and it sort of peters out to my right. Directly in front of me is a huge hump of a hill, almost pyramid shaped. Apart from the grass verge of my hill that I'm sitting on, everything as far as the eye can see is covered in a thousand million trees—a green density that if you focus on and stay totally still, the greenness will sway and play tricks with your eyes.

A greyer sky hangs above. Tiny clusters of cumulus float by, resembling ancient smoke signals. Above the noise of the crickets and the odd hum of a bee as it darts from one wildflower to the next, there is absolute silence. The kind of silence you can hear. A ringing of atmosphere. A breeze ruffles through the long blades of grass, almost like a whisper: "I love you. I love you."

Voices from the long-lost dead, spirits shifting to another world. It is so silent, I can hear my heart beat. I lie on the grass and look up into the sky. I stretch out star-shaped. Small, warm raindrops splash onto the lids of my eyes. I feel like I am spinning, joined by two invisible lines connected to my core. Like a natural tug of war, I am being pulled up into the sky to join the higher blue, and down into the centre of the world, deep into the belly where the lava burns. Where I am right now, I don't mind which way I go. It's exciting. My brain is alive and the reality of literally going anywhere, let alone heaven or hell, is not going to happen because here and now is very beautiful.

Life did not look or feel like this this morning. Yesterday I went
to bed at about 7:30 p.m., for a catnap before dinner. I woke up at
7 a.m. this morning. People tried to wake me, but I was dead to the
world. I got up feeling like I had been asleep for maybe only half an
hour, with a slight confusion about the time factor—was it evening
or morning? Then I remembered the hot air balloons.

The day before, everyone had to draw lots, as 11 people wanted
to go and there was only room for eight. Our hosts made us take a
cigarette from a packet. On the cigarette was written the words
"You're in" or "You're not in." I refused to have anything to do with
the cigarette, but it was OK because I was the only person who 100
per cent did not want to go up in a balloon. There are many ways
to die, and the idea of being with seven hungover people in a small
basket, crashing somewhere in Spain, may not be the worst, but it's
still not my choice. I went up in a hot air balloon a few years ago.
I curled up on the basket floor and screamed so much that we had
to come down. It's not the heights thing, but the flame aspect, the
burning inferno, the Hades in the sky.

As a child, my grandma saw an airship go down. When I was a
child, it was one of her favourite stories to recount; the blue and red
of the flames against the black of the sky, the billowing clouds of
smoke and the burning bodies as they fell. These memories of my
Gran seem all the more vivid because of the TV images of September
11, people hurling themselves from the Twin Towers. There are many
terrible ways to die, but fire, for me, in terms of pushing my
imagination, is one of the worst.

Drowning, on the other hand, seems almost soothing, comforting.
I fell off a boat once in Turkey at night. I was very drunk. All I can
remember was being under the water thinking, "Mmm, this is
nice, this is cosy." I felt as though I was in a big bed, in a lovely duvet
with really, really soft pillows. And the further I went down the more
cosy and comfy I felt. I woke up on the beach with someone slapping
my face and pumping water out of my chest.

My great-grandfather (funnily enough, my grandmother's father)
was burnt alive as he fell asleep by the fire. Some coal fell out and
by the time he woke up his clothes were ablaze. He ran out

screaming. A neighbour threw a rug over him and rolled him to the ground, but it was too late. I once saw a car explode with two people in it. I don't know what happened to them. I was on a bus and it just kept moving.

It's amazing in life, these things that we see, that we witness, the visions that shape our fear. Fire and water—as much as we need them, we really don't need too much of them. I would take on the giant tidal wave any day compared to the inferno.

Oh, I forgot to say what happened this morning. After I waved everybody bon voyage, I suddenly came over so hot I thought I was going to spontaneously combust. My heart was pounding. I couldn't see properly. Purple rings floated before my eyes. I staggered to the bathroom and violently threw up. Acid balls of foam made their way up through my windpipe. I started to suffocate. My body started to convulse. I fell to the floor and white fizz poured out my open mouth. My body jerked so violently that I wet myself. My eyes rolled back and I thought I was going to die.

24 August 2007

There is total silence. The ground is slightly muddy. The grass is wet from summer dew. Small spirals of mist rise up from the trees. Like the early smoke of a forest fire. The mist elongates, from the spiral into a straight line, rising homeward to join a family of clouds. Everything feels so saturated, so dense, wet, almost subterranean.

In front of me is a perfect blue square, not totally square, but far more square than rectangle. It is a very neat, minimal pool. That gently dips off into infinity. The infinity being a steep gorge that acts like a dry moat between myself and the mountainous green of the fir tree-filled hill. The small mists are quickly dying off as they fast become vaporised in the rays of the early morning sun.

Then suddenly from nowhere a swallow on the wing sweeps at a sharp 30-degree angle on to the surface of the blue, barely touching the water. I follow it with my eyes as it glides up and makes a dramatic sharp return. This time, it is followed by four or five little friends, all in formation like a fighter-jet squadron showing off at an air display. One by one, they sharply descend into the pool, each one skimming or slightly diving as they hit the water. Now, from almost nowhere, a giant circle of tiny birds rotates like an amazing aerial ballet. More and more of the swallows join in. Twenty, 30, 40, maybe 100, maybe 200 of the little things cascade into a well-rehearsed magical descent, barely missing each other with each turn of the wing.

I am witnessing something extremely beautiful, something magical, something so uncommon for my eyes to see.

Now it's two days later. I am in a helicopter. The blades are turning, and we are flying high above the Côte d'Azur. I have the pleasure of sitting next to Mat Collishaw, who has strapped his arms into his seat belt to stop himself from grabbing the pilot's controls and plummeting us to the centre of the earth. Mat really, genuinely, has the worst case of vertigo I have ever known. I try to pacify him by pointing here and there and saying, "Let's count all the yachts." At that, he knits his brow and lowers his head like a condemned man about to be read the last rites. "OK," I say quickly, "let's do swimming pools, let's count swimming pools"—and then I tell him the story of the flight of the swallows.

Suddenly it's 1997, I'm lying in bed at Cooper Close, in my tiny little flat. It's 5 a.m. and I'm listening to the birds. There is a tree outside my window. In the tree, every spring, early summer, three or four nests would appear. First, there would be the noise of the toing and froing of the nest-making, followed by the chirping and cheeping of the chicks.

Mat and I never went to bed before four or five in the morning, and always wildly out of our heads. Giggling, laughing, fighting, fucking, always intense, always too much, then silence. We would lie there and listen to the birds, and I would say to Mat, "What do you think they are saying?" Stoned and laconic, he'd reply, "Trace, they're saying, 'Listen to them two in there, what do you think they're saying?'" And so it went on. Mat and the birds, me and Mat. Mat even said I should make a small film of the birds flying to and fro, with my own subtitles to the chirpy soundtrack.

When I was alone, the sound of the birds would always echo the way that I felt. Like the Persian thirteenth-century poetry known as "voices of the birds."

And now I'm sitting in the bath, waist high in lukewarm water. My knees are brought up high to my chest, and my hands are clasped in front of me. I am surrounded by beautiful Islamic tiles. Natural forms and shapes repeating and unrepeating. The last shaft of evening light shoots across the floor and, in the darkness,

233

I am left thinking and rethinking about love—new love, old love, strange love, unconditional love. I think about when Mat left me. How I thought I was going to die, and how I nearly did. How I cried from Sydney to Singapore. How I had no hatred, no malice. Just nowhere for my love to go. Nowhere but the future. I had no idea then that the future could be such a wonderful place, full of surprises.

There are a million thousand barriers in this life that are set up for us to break through. I love the way life moves on. No going backwards, only forwards. And, six years on, I am in a helicopter with one of my best friends in the whole world and we are laughing as I have just spotted, to my twelve o'clock, my 10th round swimming pool.

Today I feel extremely lucky.

14 September 2007

HOW AM I GOING TO DO THE COLUMN? Yes, perfect, a really big gap at the top. You know when you really love something, or someone? And it's time to leave? And you don't want to? And the only reason why you don't want to is because, most of the time, everything is quite good? I feel like this about my column. I never ever, ever want to hate, or not want to write, my column.

I need space. This morning when I woke up and I left my house, my head was held high into the sky and I just kept saying to myself, "I can't believe how beautiful today is." But what I should have been saying is, "Today is really beautiful." It's a small measure, but in some strange way, it decides how I stand.

In the old days when you looked up to the sky, at least one of your feet would be in dog shit. I have someone very close to me in my life from when I was young who made a bet. He bet that he would just walk through dog shit. His new little loafer trailed through the abundance of shit, but I didn't care.

He's my brother. And he is always faster than me. Always doing more things than me. Somehow I'm always sat there in the background, watching. But this time I cannot believe what he is going to do! He is going to walk through the biggest turd in the whole kingdom. At the end of it he just scrapes his wide-foot loafer, smiles to his surrounding audience, and I scream. (Actually I didn't scream. As an adult, when I think about it, in my head I did.)

We walked up the road and I said, "Why did you do it? Why did

you walk through the dog shit?" He put his hand in his pocket, stopped, opened his palm, and said, "Look, sis. Look at this."

I spent all day thinking and working about money. (For all you scrabbling enthusiasts and grammar kittens out there, you understand exactly what I'm trying to say, so don't get so pendantic! Miaow!) Miaow.

This morning when I woke up, that was the first word I heard. Miaow. Docket has been a bit, shall I say, AWOL recently. I sang "Cupboard Love" to Docket yesterday. It goes something like this: "You know your favourite cupboard—but Mummy loves you, you, you." Nothing made me more happy than when he responded with a giant, "Miaow!"

I'm very happy today. I'm happy because I have a better understanding of love and a slightly better understanding of myself. This morning I had to wake up early to do an interview about Louise Bourgeois's upcoming show. I say "about" rather than "with," because she's 97 and lives in New York. I was doing the interview with Alan Yentob. I teased him constantly about his noddy-dog situation.

But going back to Louise Bourgeois—what an amazing artist! This morning was so fantastic for me. Thanks to the BBC I gave myself a good couple of hours enjoying the work of Louise Bourgeois. It almost felt like an indulgence. My last Louise Bourgeois experience, apart from every day having her images of virile, sexy cats in my house (two etchings of turned-on cats facing each other), was being thrown out of a Louise Bourgeois art-establishment dinner. Louise wasn't actually there. The mistake I made was that I was exceptionally drunk and I miaowed very loudly through all the gallery speeches. But I must say the gallery certainly had my best interests at heart and organised a car to take me directly home.

Meanwhile, that night, when I woke up in bed, there was a tiny little old lady sitting there with a crochet hook. Docket was totally freaked out by the giant ball of cotton. As I tried to go to sleep, she kept mumbling the words of Simone Veil. The next minute I was parachuting over France. I was looking down. I couldn't believe how fast the air had gone. I felt like my lungs were going to explode.

I closed my eyes and tried to think for two seconds, and pulled the cord. My heart seemed to jump into my mouth and I started to vomit. And I was shitting myself but I had landed. I got my parachute and pulled it all in with my hands but my legs didn't seem to work very well. In fact nothing worked very well. I pulled up my kit. It was intact. My compass said "East/West" and I thought, "What the fuck does that mean?"

This week a very strange thing happened to me. I saw a film made by Julian Schnabel, *The Diving Bell and the Butterfly*. Julian asked me what I thought about the film afterwards. I secretly think that Julian thinks I'm a tough thing and that I deal with things how they should be dealt with in my own way. But I was embarrassed because I was crying. Once I'd wiped the tears away, I said to him, "I'LL TELL YOU HOW I FELT. I FELT LAZY."

21 September 2007

Last night I couldn't sleep properly. I went to bed quite early, exhausted. I spent most of the night tossing, turning and sweating. The back of my neck was boiling hot and my hair was wet, saturated in sweat. The pillow and everything I lay in resembled the Turin shroud. I had one nightmare after another, after another, after another.

In the end I couldn't stand it anymore so I got up, put some clothes on, let myself out of my house, and, with slipper-clad feet, made my way to the studio. I let myself in and went upstairs to the office, and for some mad reason I didn't turn any of the lights on. I suppose I didn't because outside the sky was a light Prussian blue, filled with the first rays of dawn.

Going up the stairs and walking into the office, the room was in complete darkness because the blinds were down. For some strange, inexplicable reason, instead of sitting on one of the really comfy Vitra chairs, I sat up on the desktop, with my legs crossed and the back of my head leaning against the window. The room was really dark. Then from downstairs I heard a noise.

My studio is a very modern-looking, contemporary building, but in reality it's about 100 years old. It definitely isn't the kind of place where you would be afraid. It's too clinical, too clean, too minimal. There's no room for ghosts to hang out here. But as I sat on the desktop, I could hear someone coming up the stairs, and not only could I hear their footsteps, but I could hear them weeping and

crying. The office door opened, and for a second there was a flash of light in the darkness. I could see it was a young woman.

She sat down on the chair next to me, sobbing, and sobbing, and sobbing. She lay her head on my lap and put her arms around me. She was wearing a very soft black leather jacket. As I let my fear of the situation go, I put my arms on her back and tried to comfort her. The leather was so soft—it was kid. My lap was starting to get wet from all her tears. As I persuaded her to tilt her face up, I recognised her. I'm not going to say who she is, but she was crying and crying because her mother had just died.

While she was trying to explain to me, I glanced up at the office door, and for just a brief second I saw a black umbrella hanging upside down. No one would hang an umbrella upside down in the studio. Her arms became tighter and tighter around me and I felt like I had to prise them off. She stood up and tried to kiss me. I pushed her away gently, and as I tried to be comforting and kind, her face turned and changed and she became evil. Not that she became evil but that she was evil—evil personified. What was once a girl crying in front of me, heartbroken, now took on the image of a man that I'd never seen before. I'd been tricked.

I hate these trick dreams. They remind me of my gullibility and my inner sense of knowing that it's good to understand fear—or at least to be able to feel it.

When I was a child, I was plagued by nightmares and dreams. I would refer to them as "the black mass." As an eight-year-old, I would lie in bed and watch the black mass as it entered the room—a giant ball of ions all fighting and competing to take more energy, especially mine. I'd have to will it to go away. If I became afraid and could not confront it, I knew in my heart that I possibly wouldn't wake up again. These dreams carried on until I was in my mid-twenties. My friend Maria, whom I have known since I was four, would say that sometimes, when she watched me asleep, my face would shake and contort uncontrollably as though I was possessed. These possessed moments would always coincide with the black mass.

As I got older, I became more afraid of these happenings and decided to seek professional advice about it. I talked to mediums,

spiritual gurus, the Church. Finally, I took advice from a very good Dutch friend of mine, who told me, "Next time it happens, you ask it to show itself. Don't be afraid because it won't. You are right: it is pure energy, and no doubt extremely malevolent. It wants something from you. So you ask it what it wants. And you make it quite clear that it can't get anything. And it will go away. And it will get tired, because it's picking up on your fear and that's where it takes your energy."

And it worked. The happenings stopped. The black mass ceased to appear. It went in on itself. And then the dream started. The black mass disguised itself, from a sexy skinhead who made love to me and then stabbed me in the stomach in my own bed, to sitting next to one of my best friends in a cinema when a noose drops down and I am about to be hung. There's even a nightclub that it entices me to go to, which of course is a cave, so I always think that it's silly and corny until the apparitions appear and the trick begins. But as I have explained, the most frightening ones are the ones that take place in real time and real space. I can't help but think that there must be a real element to this. I can touch, I can feel and smell what's going on. It's as though when I'm asleep part of me exists in a parallel world.

The balance of fear can be an exciting place. I'm so tired. I really want to go to sleep but I'm too afraid to.

28 September 2007

I've been going through a strange time lately. Inexplicable moments of purgatory: up and down, high and low. I think it's shown itself through my column. In fact, it has shown itself so much that I now have to thank everyone who sent me letters in the last few weeks wishing me to get well etc.... Even my stalker gave me a stern ticking off. They said that if I didn't get out of this depression they would start reading someone else's column. So I am now going to write a really depressing column!

I've had a kidney infection for over a week now. Can't drink, can't think, have a terrible headache in my left eye, and I feel like I have been violently kicked in the ribs. It has a really adverse side effect: I can't stand being touched. But I don't understand when you walk into a room of three or four hundred people that everybody wants to kiss you. I don't mean just kiss me; they all want to kiss each other. When you think about it rationally, it's really strange. You kiss people that you really love. You hold people that you have a deep, fond affection for. And in the big room, when you hug and hold and kiss, it means that you have a deep, fond, public affection for them. I find this really difficult with hundreds and hundreds of people. But then I find love very difficult. There are all different kinds of love. I'm a master of the unrequited. I make a very good, passionate runner, always puffing and panting my way to love, heart pounding. I would like to say now, "out of my tiny chest, like some small wounded bird," but it's not true. I have a very big, full, bouncy,

blossomy, heart-shaped breast that should be big enough to take all matters of the heart.

So let's go back to this really depressing migraine headache. I had to go back to bed at 2 o'clock in the afternoon. I had just watched Gordon Brown's party political speech and was mentally pondering the pros and cons. (And for all the fans of *Private Eye*'s Pseuds Corner, there are many other ways to ponder in bed!) When I realized it really wasn't helping the headache, I took two more paracetamol, drank another 25 gallons of water, and after holding the bridge of my nose as hard as I possibly could with my forefinger and thumb, pressing my brain as far up as I could underneath my eyebrows, my head sunk into the pillow, and I slowly drifted off to sleep—to be sharply woken, of course, by the strange, incongruous tiny feet of Docket. He somehow had pulled himself through the window backwards and was jumping around at the bottom of the bed in a sort of satanic warlord dance, and next to him was a chirping, screaming beautiful grey and green majestic-looking fledgling.

With my left eye screwed up like a corkscrew, naked and sweating like the speed of light, I hurled myself out of the bed to the other side of the room. The baby bird scampered underneath a wicker chair. Docket ran round in frenzied, crazy circles, swiping his paw underneath. He forced his head underneath the chair, his whole body becoming flat like a furry carpet and like some exotic, upside-down limbo dancer he wiggled his way underneath, forcing the bird to shoot out through the other side. The bird began to flap and panic as Docket started to pat it. Not killing it, not trying to kill it, just patting it, playing with it, trying to tease it. I grabbed Docket underneath his stomach. Shoving him underneath my arm I ran downstairs and locked him in my dressing room. Upstairs in my bedroom the bird lay under the chair totally motionless like it was dead. I thought it was dead at first. As I passed my hand underneath the wicker and gently rested it on the bird's wing. I could feel its little heart beating. Birds will play dead—it's safer. The cat doesn't want to eat the bird. Doesn't want to kill the bird. It wants to play with it. And if the bird's no fun, the cat will get bored, slightly distracted, giving the bird a chance to fly away.

In life we are sometimes asked questions that we really can't answer. It's a waiting game, knowing that time sorts stuff out. But sometimes there is a breathless moment where you feel if you don't act, if you don't make a decision, everything will be too late. It's one of those "now, now, now" things. Personally I should take note from my little friend the bird. I don't have to run around like a lunatic, complicating my life, feeling confused and indecisive. Maybe if I just rest back and close my eyes someone will come along, pick me up gently, and chuck me out the window! But it's cool when one is confused. Life is not all straight. We never know what's coming to get us. As Lord Byron said: "I'm standing on the edge of a precipice and it's the most wonderful view."

5 October 2007

I've felt so much happier the last few days. My mood has lifted enormously, simply because of some late-night Saturday artistic recreation. Last week I was really struggling with my painting. I was struggling so badly that I actually hated myself. I sat in my studio feeling really morose and every brushmark felt like another tick to failure. And every ounce of residue of self-loathing and fear that I have ever experienced constantly rose and bubbled to the surface.

I was listening to David Bowie's "Ziggy Stardust" and the lyrics— "Five years, that's all we've got ... five years, my brain hurts a lot..."—felt as though they were smashing through my head with the power of some almighty jackhammer.

This is why I hate painting so much. I tried to get a grip on the reality of the situation.

I looked in the mirror and said to myself, "This is just completely spoilt behaviour. Monks are being shot in Burma. Women and children are being raped in Darfur. The list is bloody endless and I'm throwing a fit about the fact that I've just ruined three paintings." It was like that when I was a student. I used to bang my head against my studio wall, literally, in my absolute frustration of not being able to control and manipulate the paint how I wanted to.

The worst thing is the fear. Seriously, how can someone be afraid of a paintbrush and some paint? But I am. I sit there for hours just staring at it, trying to pluck up the courage and telling myself just to go for it, do it, come on. Sometimes I cling on to part of the canvas

that I feel is OK, not brilliant, just OK. OK, when everything else on the canvas is shit. And then, like Saturday and Sunday, at two in the morning, when I have been drinking and I'm painting with the arms of a poltergeist, something magic happens. It happens because I push myself to an outside area where everything is just a little bit more dangerous. It's like jumping out of an airplane not knowing if your parachute is going to open. Really, in that situation, it's best to treat the fall like a trip of a lifetime.

That's what happened to me this weekend with my painting. Instead of everything being the spluttered mess of carnage, everything came together. I surprised myself and that is what art is about, or part of it. After you have been doing something for 20 years, you know what you are doing. You can close your eyes and do it and that can be soul destroying. To muster the strength to redefine your own parameters, even in a small way, is very difficult. The mood swings, the highs and the lows of it, are quite painful, and most of the time it feels safer to be hanging out on the other side of feelings.

Faced with the daily prospects of failure and self-loathing, a numb chrysalis starts to develop around you, and if you are not careful you wake up one morning to find yourself not awake, but in a semi-comatose state, baked into a hardened shell, breathless and mind-numbing. You have to poke your finger through the hardened crispy shell, and after you've pushed it through you have to wiggle it about until eventually the hole is big enough to smash a whole fist through. That's what it feels like when I'm alone in my studio trying to paint.

But today everything feels different. Today my studio is calling me. The paintings are all really happy and the paint wants to be used. It's all spangly and exciting. There's almost nothing that I hate, or nothing that depresses me. This is a state of mind that is created by what I make, not the other way around. To know that I will be spending the rest of my life being controlled by my own creative output is exhausting. It's not a job, and if it were a job I would just do it, I would just get up and do it.

I'm not moaning. I'm trying to explain how it is. And there is a

lot of pressure involved. Every exhibition, every show, builds up into some almighty crescendo, almost as if your brain is going to explode. It's not just the pressure of the deadline, but the battle to re-create and justify the things that you make. The world is full of so much stuff. Every second, every moment, things are rolling off a production line; our minds, our space, continually being contaminated with more and more things. That's why the justification is difficult.

What makes art more worthy, or what makes art, art? I would like boldly to say that it's the decision of the artist. That's true at the beginning, but of course that truth becomes mutated by the views of others. It's like the work of art has been ripped away from the artist and sails through the ether like a giant boomerang until it eventually returns home to the artist. I really feel like this about *My Bed*. The art goes out into the world and becomes so attacked that you feel that you have to defend it and protect it, as though it's almost human. But the strange thing is, a seminal work of art is actually much bigger and much stronger than the artist who made it. The idea will the eclipse the artist in their lifetime. So it's actually the art that protects the artist.

That's the way that I feel today. I feel that my art is looking after me, keeping me buoyant and well and truly alive.

12 October 2007

Art, art, art everywhere. I'm OD-ing fast and my brain is turning into a really mushy, syrupy thing. One image after another flying through my mental sphere and hanging on to the end of my retina. Dots are beginning to float on a permanent basis two or three inches from my eyes. My kidneys are screaming, "No more white wine, no more champagne!" And my stomach is rejecting any canapé that comes near me. It's a well-known trick for columnists to write lists to get their word count in. And I never normally write a column that says just "this week I have done this," but I'm just going to now run through the last week with you.

THURSDAY 4 OCTOBER
I wrote my column. I then went to the Royal Academy for the launch of my little mouse car, the Fiat 500. I posed for photographers as the car gleamed and smiled with its scratchy Emin drawing on its side. I then went to Gary Hume's show at White Cube, which was amazing, really sexy. There's something about Gary's paintings that makes me melt and I had the whole place to myself to look at them.

I then went back to the Royal Academy, where I was guest of honour at a fundraiser. I had to host a table of 10 friends and then give a dinner question-and-answer speech, in front of about 300 people, with the curator David Thorp. I got home about 2 a.m.

FRIDAY 5 OCTOBER

Got up at 6:30 a.m. and met my friend the art advisor Amanda Love at Gatwick. We flew to Venice, where I visited the Biennale, first of all stopping off at the British Pavilion to see my own work. There have been between 1,000 and 2,000 people visiting a day. Yes, A DAY. I was instantly recognised and gently mobbed wherever I went. In the French Pavilion, I would give Sophie Calle the prize for the most professional hang, and then I would give Isa Genzken in the German Pavilion a prize for the most nutty installation. I'd give the Americans a prize for the cool generosity of Felix Gonzalez-Torres. I could go into great detail explaining everything I looked at, what I thought, how I was feeling, but within five hours I probably saw over 2,000 works. I ended up with a crushing migraine.

SATURDAY 6 OCTOBER

Feeling atrocious—the migraine completely debilitated the sight in my left eye. Like the walking wounded I took on eight more pavilions outside the Giardini. I then took on the blockbuster shows. When I say "take on" I mean intellectually take on the exhibition like it's a challenge. Like you're trying to work out the physical and mental space of the juxtaposition of the works. So, for example, at the Palazzo Grassi, which is exhibiting François Pinault's collection, there were works I didn't like, but I loved the way they bounced off other works. You saw the corner of a Franz West sculpture alongside an Urs Fischer or the glaring gaudiness of Laura Owens. By the time I got to the top floor I was almost feverish with excitement. The art was having an effect. My headache was lifting and a sense of euphoria was sweeping over me. I loved the show. Visually, what once I would have thought I didn't like had proved me wrong.

Then I visited art heaven—the Musei Civici at the Palazzo Fortuny. The show begins with an El Anatsui giant woven curtain, which reminded me of skin. Then I went inside and saw the Francis Bacon, and I immediately got a sense of the whole show. It was going to be about flesh—the decaying, the rotting, the live, the visceral, and sexual. This show is so exquisite that by the time I got to the

top I was almost at the point of orgasm. At the same time my headache had come back. I had had a complete mental overload. I was visually saturated.

SUNDAY 7 OCTOBER

Did the Arsenale—another 500 works.

MONDAY 8 OCTOBER

Doris Salcedo and Louise Bourgeois at Tate. I did make the joke about who has the biggest crack at Tate Modern, but apparently lots of people had already said that. Louise Bourgeois's show is so elegant. For someone who you feel is an extreme space filler, the show came across as being refined, with air and grace, and some of the works scared me. Then dinner. Then art party.

TUESDAY 9 OCTOBER

I visited a photography show, followed by Louise Bourgeois prints at Marlborough Fine Art, then on to her show at Hauser & Wirth, where there were some big vaginal things that were frightening but amazing—not bad for a woman of 95. I then saw another show of extremely ambitious drawings by a young man. I was confused as to how he'd made them, but not as confused as everyone is about how Doris Salcedo made her crack. Then to White Cube to see the Chuck Close. Dinner. Then White Cube party at the Ritz. Then the Gagosian party at Nobu. Then my brain blew a gasket.

YESTERDAY

I spent all day at Frieze Art Fair. I cannot begin to describe... millions of galleries, millions of people, millions of collectors, tons of art... but I got through it. Well enough to have a fantastic dinner hosted by Dylan Jones at Annabel's and then a wild, fantastic party at Sketch where I danced with Tony Shaffffrazzzzi and had wonderful conversation with David LaChapelle. And now, I'm off to five different shows and the Zoo Art Fair, and then I'm going to have dinner at Shoreditch House as a guest of the Cartier Foundation. I'm exhausted.

26 October 2007

Firestorm. It's 4:30 a.m. I'm lying in my bed in room 242, flicking through all the channels, keeping up to date with the fires as they march their way through Southern California. I can't sleep. It's not jet lag. I just have far too much on my mind. As night becomes day, my mind becomes just a little bit more frazzled. It feels as though I have no peace. All of me has been shaken violently without my knowing, and inside I'm left with an unexplained, giant, peptic fizz, forcing its way up through my body and busting out of my left eye. I spent the weekend in New York, but the Saturday I missed completely. I lay in bed in a darkened room feeling slightly lost and frightened. I'd spent most of the day again vomiting violently. My last offerings were a strange kind of jelly with a red, furry fibre that lay in the bowl of the sink. I cannot believe that the body is capable of making such ugly, beautiful things.

Apart from the Saturday, my weekend was quite hectic and mad. On the Friday, as I came in from the airport, giant sheets of grey rain thundered down, giving me a feeling of deep depression. I checked into my hotel then wrapped up, in a sense of confusion, and trundled through the rain to visit the artist Louise Bourgeois.

Her house looked somehow dark and ominous. I stood on the steps and looked up at the windows. They looked dark, very grey, and slightly dusty. I rang the doorbell. Jerry, her assistant, opened the door. On his face he carried a big wide smile. We passed comments on my journey and the rain. As I walked through the hallway of the

house, everything seemed to become greyer. Not darker, just grey, almost as though the colour had begun to disappear.

He took me through to the back parlour room. The first thing I saw, on the floor, were bright shocking cerise watercolours—about 10 of them. Organic joined figures jumping wildly from their paper, from their bright pinkness into the surrounding grey, into the ever-growing greyness.

Then Jerry introduced me to Louise. She sat at a plain wooden table, which, even though it was wood, also seemed grey. She was dressed in a very thick ribbed jumper (grey). Her face looked exactly how I thought it would look. I froze for a second—I suppose a second of shyness, as I realised I had never met such a distinguished female artist before. Also, I had never met anyone that had reached the age of 96.

The first thing she asked was whether this was my first time in New York. I said no, I had been many times. She sort of shook her head, and then spent the rest of the conversation speaking to me in French. I can't speak French, so Jerry had to translate. She was a little bit gruff with me. I showed her pictures of Docket; she thought he looked nice, but she really wasn't that interested. She was much more interested in the text of my catalogue. She wanted to know about Rudi Fuchs, and did I know Nick Serota?

There was a brief discussion about male curators, and then the conversation drifted off into quietness and silence. With a lot of force she asked, "Stuart Morgan. You know my friend Stuart Morgan?" I was drinking a glass of wine at the time and the bottle had been retrieved from the corner of the room, and the strange thing was, I felt the wine was special. Then when Louise asked me about Stuart Morgan, I said, "Yes, I know him. He's my friend. He's dead." All along during this conversation, Louise's friend and documentary maker had been filming us. Louise asked, "How do you know Stuart?" I told her that he was one of the first people to write about me seriously. He was also the first person to put Louise Bourgeois's work into a contemporary setting at the Tate. She smiled and said, "Would you like to see Stuart?"

I went off into a slight daze and remembered the last time I saw

him. We had gone to the Ruskin School of Art, where Stuart taught, and I was given a lecture for a day. Stuart by this time was virtually blind, but it was a big secret—he thought he might not be allowed to teach anymore. We joked and mucked around as I made Stuart take photos of me so that I could show my mum that I had been to Oxford. Of course, the joke was that with Stuart's eyesight I probably wouldn't even appear in the photos. I loved Stuart. He was so funny but so fucking serious when it came to art.

Brigitte, the filmmaker, said, "We have a film of Stuart from when he came here to visit Louise. Would you like to see it?" Stuart's face then appeared in the room, filling up the entire TV screen. His eyes were very wide and just staring, his face almost blank and expressionless. Subtitles appeared on the bottom of the screen: Louise speaking in French, telling Stuart to smile. She gets quite aggressive, telling him again and again. After a few moments Stuart cracks and starts to laugh. I started to laugh as well. Then I realised that the camera was on me and I realised that I was sitting in the chair that Stuart would have been sitting in. I had gone to visit and pay homage to a woman of 96, but there we both were, enjoying and remembering the wonderful laughter of our friend. As I left Louise's I wondered if one day someone would visit her and they would see a film of me, laughing.

2 November 2007

My show's nearly hung and it's mind-blowingly spectacular. I'm squeaking with excitement and happiness. Eek! Eek! All my friends are jetting in and there's not much for me to do now apart for concentrate on the party side. God, L.A. is weird! It's a strange city, that more than any other place in the world relies upon who you know, and not what you know. Now I know millions of people, and even more millions of people know me. But the art world is sadly the poorest cousin in a city like Los Angeles. I'm torn between relying on some semblance of humility—or conjuring up the Eminator.

The Eminator is a mean machine. She stamps her feet, looks slightly sulky, has vast amounts of superlatives tripping off her lips, and is accused of having "attitude"! For example, she might say something to the effect of, "Don't you know who I used to be?" So my ego is really bruised. I have to keep fighting my little corner.

I'm staying in a really fantastic hotel. Out of 10, I'd give it a nine. The pool is absolutely phenomenal—old style, graceful, 18 metres long, surrounded by green-and-white-striped sunbeds and cute little cabanas. So as I rested and looked at the effervescent turquoise blue in the 80-degree heat, I racked my brains, thinking, what can I do for all my friends? The ones who hadn't even thought twice about travelling halfway across the world to see my art? Apart from dinner, and the usual stuff, what can I give them that epitomises the Los Angeles scene? And as I stared across at Matt Damon and

his entourage enjoying the use of a cabana, I had an Archimedes moment. I'll book three or four cabanas, and for a few hours on Saturday afternoon, we will all hang out by the poolside. I made a mental note to book them.

The next morning I leaned out of my four-poster bed and dialled the pool manager. And in my most polite, yet confident manner, I said, "Hey, you motherfucker arsehole! Give me four cabanas for Saturday or I'll burn your house down!" NO I didn't... but I may as well have. What I really said was, "Hello, this is Ms. Emin from 242. I wonder if it's possible for me to book three or four cabanas on Saturday afternoon? You see, I have a number of special people coming to Los Angeles and I would like to be able to give them a treat."

"No, that won't be possible ma'am. You can only book a cabana if you are a guest in the hotel."

"But I am a guest. I've just told you I'm a guest."

"Well I'm afraid that you can only book one cabana."

"And why is that?" I asked him.

"Because you only have one room, ma'am."

"Yes but I'd like to book four cabanas in the names of four other people who have rooms here at the hotel."

"You can't do that."

Just to make this column a little bit more interesting, I am not going to repeat the infuriating, inane, boring conversation I had with this person! But the grand finale was him telling me that "rules were rules." And it didn't matter what I said, I could only have one cabana.

It's just occurred to me: people might not know what a cabana is. It's like a little tent house. Extremely Tracey, and very cute, but basically it's a tool to mark out territory. "OK," I said to him, "I'll take just the one cabana!"

He then said, "Each cabana can only take six people. That's five more and you." (This is a city where you get fined $300 for walking across the road without a green man.)

"OK," I said, "I'm quite happy with that, thank you very much." I was desperate to put the phone down when I heard the words, "And

Ms. Emin, no pets."

"I don't have a pet here. I'm a guest in the hotel."

"Yeah, well, I'm just telling you the rules."

And then my voice started to change. "Rules?" I said. "OK then, let's talk about rules. How come I saw a small dog wearing a coat by the pool only yesterday? You seem to have a different set of rules depending on who you're talking to and who you're dealing with."

"Well ma'am, that must have been a special friend dog." And I'm thinking, what the fuck is a "special friend" dog?

"Oh," I said, "do you mean a blind dog?"

"I don't like that term."

"OK, a dog to help people with disabilities. Either way, the only disability this woman had was walking in her Manolo Blahniks and slightly overheating in her tight towelling pink tracksuit."

"We don't differentiate between people's disabilities here. Just because we can't see the disability doesn't mean the person doesn't have one."

"What? Like your major disability in not having a sense of humour? Or do you mean if you've just come out of AA you can carry a dog anywhere in this town?"

Two days later I have booked my four cabanas for this Saturday. Very pleased with this, I'm sitting by the pool, entertaining, waxing lyrical, behaving like the Queen of Sheba, when my friend Orlando Bloom turns up with his very lovely, beautiful... dog. Yes, dog. Orlando sits down on the sunbed next to me. The pool attendant approaches us, saying, "I'm sorry, sir, no dogs allowed."

Orlando smiles and says, "This is my special dog friend."

His dog then jumps up onto the sunbed next to him and Orlando proceeds to cover him up with a nice comfy white towel. As I left to go back to the gallery, I looked at the pool attendant, I winked and said, "Sorry about that."

Yes, this town is getting better.

9 November 2007

I remember when I was a student at Maidstone College of Art. It was a Monday afternoon, 4 p.m., and the lecture theatre was full. Today's art history lecture was going to be different. We all sat on the edge of our seats as we waited for the Kent Miners' Trade Union spokesman to take the stage.

He stood there, slightly majestic, a cross between a magical folk hero and a priest about to give the sermon of his life. He shook his fist in the air, and told us, "This is what we have in common. You students and us miners. This is what we have. We have to fight. We have to defend what we believe in, because what we believe in is what we are. I am a miner. My father, my grandfather, and my great-grandfather—it runs in our blood. It is not just the mines that they are threatening to close down; it's the closure of men. Some of you are going to go out in the world and you will have to fight. Fight for what you do. As an artist you will have to battle just to exist, to be accepted. Your artworks will be under intellectual attack. They will try to strip you of everything you believe in, that you built for yourself. They will try to destroy your inner self, the thing that gives you the strength to carry on, to stay who you are."

He had a good way about him. We all put lots of money in his bucket as it went up and down the auditorium. But the trouble was, as an art student, in 1984, you'd have to be mentally insane to ever step one foot into any Kent mining village. No travellers welcome. Hardcore was an understatement. But saying that, given

the choice of the mining village in the early 1980s or one more day in L.A., there's no competition. Never had a Kent miner's words rung so true.

Usually when I go to L.A., I feel beautiful. I don't look it, but I somehow feel it because of the general distortion of what the idea of beautiful is there. I enjoy my crooked smile, mad teeth, fast humour, and unconventional ways.

But this time when I was there giving that town probably so far (in my opinion) the best show of my life, everything was a battle, battle of rules. I could not conform. I could not get it right. By the end of my stay, I had full-blown Tourette's, a subconscious way of dealing with my frustration. It was a strange feeling to feel so awkward and at the same time make such a perfect show. My work just sank into the space, like it had grown there, like a beautiful weed, naturally balanced between hostile man and an urban landscape.

At the opening I felt strange. So many people and my work disappeared under the stampede and I felt it was getting lost. Lost in the ether of Los Angeles. Los Angeles has a great fakeness about it—this is what it sells, this is how it survives. It is Hollywood where the dream is made. I met some lovely people there, warm, real, and genuine but on the whole, the place is wrapped up in an ethos of total fakeness.

My work is really real and this is why it looks so good in L.A. I found myself getting really wound up. I wanted my art back. I wanted to be in my studio struggling with it two months ago, three months ago. I wanted the show just for me. But it was too late. And the paradox is, the more people that see my art, the more my art becomes mine. I wondered how different it would have been if I had done the show in London. I became confused, knowing that I had specifically made the show for L.A. The truth is, I wanted to take all my work home with me, hide it in a mental cupboard, and have it all for myself. This year, I have pushed myself to an extreme. I'm now in Sydney. I've crossed another dateline and it's 5 a.m. I feel overweight, covered in spots, and I have a migraine coming on. Over the next months I am looking forward to finding some space, but

sadly my favourite space, the one I keep going back to, is my beautiful show I left behind in L.A.

PS: One of the last things that was said to me as I left Los Angeles—as I went through passport control, the immigration officer pointed at me and said in a very stern way, "Ma'am, I advise you to button up your shirt, NOW." I looked down at my pink shirt with my cleavage tumbling out. I quietly nodded my head and buttoned myself up to the neck so I looked like a complete wally. But inside I was screaming. I was but one second away from ripping all my clothes off and running around the airport naked. I think I got out just in time.

16 November 2007

Today I feel absolutely wonderful, in fact I feel the best I have felt in a long, long time. I would almost go as far as to say today I like myself, in fact, I love myself. What a difference a week makes, from feeling absolutely wretched, tired, and exhausted and physically and emotionally redundant in every aspect. I now seem to have bounced back beyond my own belief. There are still parts of me that I don't like very much, souring moments of regret that, no matter how hard you try, rear their ugly heads into the centre of your mind.

Just the other day I was happily cycling around Centennial Park, rejoicing in the wonders of the Pacific spring. The weather is truly amazing. Imagine the hottest, most beautiful, fresh spring day, imagine the light shining through the leaves, jumping off the rich, evergreen blades of grass. Imagine the heat of the sun making the sweat run gently down your back, and a fresh air breeze, lightly rushing past your face. This is the mood I was in as I cycled through Centennial Park.

Then suddenly from nowhere the vision of myself as a 14-year-old girl appeared right before my eyes, sat on my bedroom floor, listening to David Bowie's "Rock 'n' Roll Suicide" as I took my last swig from a cheap bottle of sherry. I remember lying on the bed with the room swimming around. I had only ever been drunk a couple of times before, once when I was 12, and I let a complete stranger go down on me, and another time when I ended up having sex down an alley with a friend's boyfriend. I held myself up from the

bed, tried to run to the bathroom, but I projectile vomited all over the landing and all the way down the top flight of stairs. The next morning when I woke up (yes, I was in the house on my own) I decided to clean the mess up. So I proceeded to get the Hoover and suck up all the offending evidence of my drunken teenage angst. Fuck, fuck, fuck. Couldn't that have been a lesson to me. Even at the age of 14, even though I hadn't actually managed to electrocute myself, wasn't it quite clear, wasn't there enough evidence that maybe drink wasn't for me.

Get those thoughts out of my head, get those thoughts out of my head. Think clean. Think new beginning. I am so pleased with myself. I have not had a drink since L.A., since I hit someone with my handbag, and gave my friend who, for the record, is three times bigger than I am, a right-hander. Here in Sydney all I have concentrated on is trying to get better. I have gone to bed early every night, and got up early every morning. I bought myself a bike, not only am I cycling all over Sydney, but every morning I do three laps of the park. That is a good 15 kilometres. I rush back to the house, leap into the pool and swim for a good 45 minutes. I then jump onto my faithful steed, and cycle to Mister Foo's record shop, where I treat to myself to a CD that I've never heard before. I have had four lots of really knockout super powerful acupuncture. The first time I fell into a deep sleep and as I drifted off with about 50 needles in me, the acupuncturist said, "When I return and take the needles out, you will be 10 years younger." As I drifted off into my deep sleep, resembling a small porcupine, I dreamed of a constant stream of men coming to my bedside saying very nice things. The last man to enter my dream was quite plump and had a cheeky smile on his face. He was very handsome, he opened the door and in his hand he held a platter of bacon rolls. They were piled up high and smelled delicious. As he offered me one, he smiled, and I managed to resist. I have had three facials, I went to the doctors about my migraines, I have changed my diet, and I have even been to the optician to get some reading glasses, and I have bought a pile of new books to read. I am watching a DVD a night.

Every line of pain has fallen off my face and for the first time in ages, I'm excited and I'm looking forward to the future. I go to bed at night thinking about my five-year plan. I realise the last year or so I have been in a very traumatic place. Trapped inside my own head, desperately fighting to get out. I hate feeling constricted and my thinking time to be taken away, I hate my mind to be crushed and squashed into other peoples' patterns and configurations, and as conceited as this may sound, I think I hate it a bit more than other people do and I think possibly this is why I drink. After only 10 days of being sober, I feel like I am truly born again.

I so desperately want to feel beautiful again and it has got to be from the inside out. Here, without the pressure, without the stress, with the beautiful sunshine and the giant surf, and the freedom to just be me, the desire to be me is so much easier. The reflection I feel is of someone sweet and caring whose edge is to challenge themselves, not to challenge the world. Here there is only one battle, and that is to make myself better. Tomorrow I go to a hardcore detox camp. I have done it before, and being a complete fascist/masochist, I enjoy every single moment of it, but this time it's different, I've been practising, so let the battle commence.

7 December 2007

I'm lying on my back. It's four o'clock in the morning and I'm listening to the sound of tropical rain pounding on the corrugated-iron roof. I'm trying to be calm as all around there is forked lightning. Giant, massive clouts of thunder crack like the sound of hell opening up. If I was outside, I'd be really afraid.

I feel like a cat that should be under the bed, not on top of it, and then I feel like a fool who is afraid of nature. Like a child who can't trust in a situation. But then, when I think about it, nature is the one thing that we must be afraid of and the only thing we can trust about it is its total uncertainty.

It's the big and small thing. Compared with nature, we are tiny unless we want to feel that we are completely part of it, and an amoeba clipped on to the sail of a ship as it travels across the oceans. I'm full of it tonight. The big romantic journey. My life unfolding, not knowing where I'm going to end up. Knowing that I have the capability to turn up at the airport next week and not get on my flight home, I could just as well throw a metaphysical dart through the air and, depending upon where it landed, fly anywhere that it takes me.

I've always wanted to do a big art project. It would consist of me literally throwing a dart at a world map, and going to that place. For the sake of argument, let's say Iceland. Once in Iceland, a few geezers send a few postcards, and off I go to the airport and I take the first flight I see. It's Tokyo. And by the way, I forgot to say, I would

only take one small bag with me that fits over my shoulder. I would never carry more than washing stuff, notebook, reading book, first-aid kit, and a change of underwear.

Every destination I arrived at, I would buy an outfit appropriate to the climate, and as soon as I arrived in the new place (e.g. from Tokyo to Hawaii) I would immediately FedEx my Japanese schoolgirl outfit back to London and acquire a *Baywatch* swimsuit, Hawaiian shirt, and surfing shorts from the tourist shop at the airport. I would just carry on this insane journey, writing postcards, making notes, and sending parcels from wherever I happened to be, and one year later, my whole show would consist purely of that. Simple evidence of the journey I had taken.

In philosophy, I love Plato's *Road to Larissa*, his argument that we do not know the way to anywhere unless we have actually been on the journey. We can be given advice, guided, even told exactly how it feels, but in essence, we never truly know anything, unless we've experienced it ourselves. Yeah, I bet some 1970s conceptualist did my journey a long time ago, but what about my volcano trips when I'm an old lady? Sure, I've already written about my volcano trips, but they invoke passion and love and excitement. I imagine myself as an 80-year-old lady, standing on the rim of molten lava and exploding rocks, looking down into the belly of the centre of the earth, and screaming the names of long-lost lovers, proclaiming, "I could have really loved you."

Where do all the souls go? They can't just all float around in the ether. Where does lost love go? Maybe that is why clouds are formed. All the tears are collected, and the anger becomes thunder. And the lightning is the electricity that reminds us that we're still alive. I'm sure there are those on this planet who are living without souls. Their hearts have become so crushed that they are the living dead, who feel nothing. Not out of choice, but simply because there is nothing, They have become nothing. Broken hearts don't happen twice.

It's very sticky and humid. But I'm not sticky and humid, just the air outside of me. It is so dense it feels like an ocean. The humidity hangs solid and coats itself around me like a sticky web, but inside the web I feel cold and anxious. Afraid. I want to go to sleep, but I

can't. Even with the sound of the rain pelting down I can hear the brave sounds of screeching insanity. The manic dawn chorus of the highly strung lorikeets. From my bed it sounds as though 15 women are being strangled in the tree to the left of me. Kookaburras laugh like some evil, demented gargoyles perched on my windowsill. Magpies swoop in a frenzied gang, trying to steal the last pieces of silver.

My journey now is homeward bound. I'm mentally packing. Packing my last month's experiences into a big mental trunk. I'm wondering how much I should really be taking with me, but everything seems frightening at the moment. All things alien and raw. People keep telling me how well I look. Most people would look well if they were sleeping at least 12 hours a day, detoxing, not drinking, having vast amounts of acupuncture, and doing at least three hours' exercise a day. I want it to carry on. I don't want it to be my holiday. I want it to be my life. I want to feel clean and free. I don't want to frighten my friends anymore. I want to be honest.

I'm pissed off with this veneer that I have to have placed around me. It's fine when it's there to protect, but not when it starts to attack, because at that point, it's not on my side. I'm tired of being out of control. It's boring, which means I'm boring. Which means I'm bored with myself, and when that happens, it's either time to change, or stop living.

My senses are heightened to a level that I forgot was even possible. I realise listening to the storm, I'm not suffering fear but excitement to the realisation of the pure, beautiful sounds of nature. Clarity.

14 December 2007

I'm all hot and flustered. Tomorrow is my last day here. When I say "here," I mean Sydney. By the time you read this, I'll be strutting my stuff at the Barbican, receiving my third honorary PhD this year. This time it's from the London Metropolitan University and, charmingly enough, it's for philosophy. Yes, Tracey Emin, Doctor of Philosophy has a nice ring about it, and what is nice and cosy is the university is five minutes away from where I live.

It's horrible when it's time to leave. You start thinking about all the things you haven't done. I didn't hire a seaplane and fly around the harbour, I didn't take a helicopter trip up into the Blue Mountains. I didn't visit any ancient Aboriginal sites, but I'm sure I walked across quite a few in my everyday journeys. I didn't swim at Boy Charlton, and I still didn't make it across the coastline to that graveyard. I didn't hire a water taxi to Manly beach to watch the giant, giant surf. I didn't even take a picnic to Nelson Bay. All I've done is try to make myself feel better. I've had to buy another case just to get all my vitamin pills in, along with facial creams, Chinese herbal medicines, self-help books, and how-to-relax CDs.

One of the most interesting treatments I've had here is hypnotherapy, and no, you don't sit there while someone dangles a watch in front of you from side to side, saying, "You feel sleepy, look into my eyes." It's much more. In fact it's quite scary. I have a very good imagination, so I'm susceptible, and also take any opportunity to be able to relax my mind, and to be able to disappear into the

recesses of the subconscious. I'm totally up for it.

You lie there on a couch. Not the Sigmund Freud type of couch, but like a doctor's bed (maybe I should get one!), and on closing your eyes, the hypnotherapist obviously tells you to relax, tells you to unwind, and to try to think about how your body feels, and then relate to him which part of your body is feeling most prominent. With me it was always my stomach. He'd ask me to describe how I felt, or how I visualised my stomach. I saw myself like some wild banshee with an axe, hacking through my flesh. Slicing through sheets of fat. He'd then ask me why I was doing this to myself. I hear myself saying, "Because I hate my stomach, I wish it wasn't there, I hate it!" He tells me to relax and breathe deeply, and to thank my stomach. I tell him, "I can't, I hate it." He then asked me what was the next thing I'm thinking or I'm feeling, and from nowhere, an Indonesian puppet warlord comes towards me out of the darkness. It's razor sharp and flat, and its arms and legs are dancing sharply with zig-zaggy movements that resemble the blades of a knife. Its face is very ugly, and with an expression of pure hate. Its mouth open, its teeth showing, which are razor sharp.

Everything about this manic puppet is insanity, and then I realise that it's me. It's trying to edge its way into my body, sideways, its arms and legs moving in crazy, jerking actions, as if being pulled by strings. I tell the hypnotherapist what I can see. He then tells me not to be afraid, and to thank the puppet warlord, but I can't. I want this thing as far away from me as possible, and I try to banish it back into the darkness. My body goes into a strange spasm. There are goose-pimples all over me, as though the room has become ice.

The hypnotherapist, at this point, tells me to surround my body with light. Now usually this works. I can imagine, and summon up, all kinds of light patterns. And some of them just appear on their own. Fantastic cascading spirals that dance around my body, tiny electric sparks, resembling supernatural stars, but this time there is just a strange, orangey, limp fire. I tell the hypnotherapist I hate that puppet. "Why?" he asks. I screech out, "Because it was me! It was me when I was 19. When I was so stupid." I hate myself for such stupidity. It is when everything started to go very, very wrong.

There was still a chance then, and I let it all get fucked up, I let it all get ruined. I had horrible visions of myself, skinny with black wiry hair. Drinking pints of snakebite with Pernod.

The hypnotist then tells me to imagine myself standing in a place where there is light, and from nowhere, a vision of myself as a 12-year-old girl, standing in my old school field appears. I'm wearing a green-and-white striped school uniform summer dress. What is strange about this is that I never had one but I always wanted one. At the time I associated these dresses with the good girls. He tells me to imagine light coming from my hands, and the base of my spine, and the soles of my feet, and projecting it into the ground that I stand on. I have this clear image of myself as a 12-year-old, feeling warm. Bathed in an astral plane of light.

The hypnotherapist then tells me to walk towards the girl, who is myself, and it's at this point that I have an out-of-body experience, and I feel myself floating across the field towards the girl. The hypnotherapist tells me to stretch my arms out towards her. He asks me, "What is she trying to say to you?" "Nothing," I tell him. "She can't speak. She looks sad." He tells me to go further and further towards her, and then I'm there with her. I put my arms around her, her head rests on my breast, and I can feel her tears. I hold her very tightly, and she wraps her arms around me. The hypnotist tells me to ask her if she believes in angels. With all my heart and soul, I hear myself screaming, "Of course she doesn't!"

28 December 2007

I'm just not drinking today because I am unhappy and I'm tired. It's a week away from New Year. I am writing this column now so that I'm not all stressed out, running around looking for a fax machine. My column always has to be typed up by my assistant, or anyone close to hand who can type, and then emailed off. Sometimes when I am abroad I get caught out really badly and have to read it down the phone. Occasionally I have to fax my editor at *The Independent* directly and he has to decipher my crazed italic scrawl. The whole thing is really, really stressful.

Today I feel really stressed out for the first time in ages. I feel a burden. Not my own, but all the external stuff coming in. And I still feel phenomenally tired. I suppose I am tired from this last year. It's been really insane. To start off with the accolades: being made a Royal Academician; receiving three honorary doctorates (Royal College of Art, Doctor of Painting; University of Kent, Doctor of Letters; Metropolitan University, Doctor of Philosophy); being honoured in the House of Commons for the work I have done for the NSPCC; and of course, the big one, representing Britain in the 52nd Venice Biennale, which frankly took my breath away, left me gasping like a small goldfish tossed out of its pond.

I'm lucky I didn't spontaneously combust by the time I got to L.A. Two massive shows this year, neither of them in Britain. It takes a hell of a lot of organising. The logistics create an extra seven-hour day on top of the 12 already needed. But the irony is that I spent a

lot of this year asleep. And when I have been awake, at times it's felt like my emotions have catapulted out of control. This year I could be put into the category of a high achiever, but only on paper. In terms of my heart and soul, I feel there is so far to go. Today, spiritually, I feel like all of me is crying, bruised, slightly abandoned.

Rationally I am OK, if anything I look a bit feisty, but inside it's not like that at all. I bet this week there are so many people out there who feel so alone. I think this week is a killer for a lot of people. Even for the people who are surrounded by loved ones and Christmas and festivities, I bet even some of those people are crying inside. This is such an obvious thing, but I feel that Christmas is really out of control and I really think it should be stopped, or at least slowed down. Bring back the real intentions of love and sharing with thought and simplicity. If I could have received anything this Christmas I would have liked to receive a love letter. Passionate words that would melt my heart and make me feel complete again.

You touch me

And I'm not alone

I can feel your breath

Your heart moves slowly

It surrounds me

You devour me

I'm consumed within your soul

The touch of you

Makes me feel

Wouldn't that be nice to receive on a piece of paper? I imagine myself being woken up with a nice pot of tea and there, on the corner of the tray, an envelope. Light coming in through the window and I start to image spring; the crocuses pushing their way up through the grass, the smell of hyacinths on the windowsill sweetness and new life everywhere. I so much want a fresh beginning. This year I haven't made resolutions. I have made rules:

Stay sober.

Read more.

Turn fat into muscle.

Listen more.

Learn a new skill.

Try to avoid bad situations, or at least not make them worse.

Work harder.

Get closer to the meaningful.

Love more and feel happier in myself.

Let things go.

I so much want a new future, but today everything seems so deep and so dark. Today I could really do with a drink. Today I really feel alone. But 2008 is a fat, round jolly year and it will roll by. I just hope that I'm sitting on top of it; the last way I'd want to go is by being squashed by an eight. I just had a complete vision of myself small and flat with two rotundels rolling across my back. I can't tell whether it's semi-erotic or an extreme case of flagellence. But either way the image has disclosed something about my inner nature that I was previously oblivious to.

I obviously have some sick desire to be flattened. Must get that thought out of my head now. Yes, my eyes have just brightened, just had a big smile across my face. Me? Flattened? Never. I'm going to puff myself up, maybe even go for a swim right now, maybe even have a steam empty out all those Christmas pores get that blood circulating. And with each stroke I will think about my future. I know it's going to be a very wet, exciting place. Happy New Year.
Love, Tracey x

4 January 2008

This is a new angle on things. I am now at the local hotel on Lamu. In fact it's the only hotel, the Peponi, and the manager is kindly typing up this column for me. It is my first column of 2008 and it comes direct from Kenya where, at the moment, things politically are a little bit sticky. Maybe that's an understatement, but to be honest, I'm not sure what's true and what isn't.

People here are glued to BBC World and Sky for the latest updates of riot news. There's been an election here, and for a relatively new democratic country, things aren't really going that democratically. It's all down to some bad tribal relations. I can't profess to understand it, but I know that, at the moment, there are deaths, riots, looting, the burning of buildings, car tyres, and a general whirl of mayhem and fear. It's happening in big-city slums and areas of poverty, where most riots take place all over the world.

Where I am is relatively safe, in fact, it's very safe. It's a bit like being aboard the *Titanic* and commenting on how good the band sounds. There's something very British and a general level of fearlessness. In our house, we have run out of teabags. The tea discussion can take up as much time as the conversation on the civil war, but people do seem to be stocking up. Because we are in East Africa, south of the equator, the rules are different here. When an election has been fixed, there isn't a recount there's murder. This would never happen in the Al Gore / Bush situation. This is my New Year. My head filled with things that I don't really understand

much about. But events that could have big effects on me in the next few days.

I imagine myself packing furiously, throwing everything into one bag, shoving my passport in my pocket, grappling around for bundles of cash and anything that is barterable. Remembering that all electronic equipment is going to be useless and thanking God that I bought those really giant gold earrings that make my ears look really small. I think the secret when evacuating is only to take what you can literally run with.

I almost bought an amazing Louise Bourgeois sculpture once. It was £70,000 and so much money for me at the time. It was my deposit for a house but it was an incredible sculpture, like a fucked-up foetal figure, a semi-deformed human, about 2 feet high. I always thought to myself that if I was ever on the run, I could carry this small thing with me, wrapped up in a little swaddling cloth, like a baby, close to my heart. It was an odd sculpture, it almost had the air of the last thing in the toy box, the thing that had been so damaged but mended and patched a thousand times. I think this is why I related to it. I wish I had it now. I doubt here in Kenya it would have any barter power, but then again, there's the French guy with a small biplane who might be happy to swap.

As I sit here, dictating my column, the phone in the hotel office (which also acts as the local travel agent) has not stopped ringing. It's six in the evening, all the tourists should be hanging out on their verandas, raising their glasses while the sun goes down, but instead there is a mild state of panic as now they desperately try to change their flights to go home early. Many people are also cancelling their flights into the country. This is really bad for Kenya, which relies on green beans, coffee beans, and tourism for its whole economy.

I wanted to write about the beautiful things that I have seen, my sober New Year's Eve and my lovely New Year's Day, when I watched the local dhow race. Beautiful wooden boats with ancient sails skimming through the water, twisting and turning as though they were leaves in the stream, speedy, strong and elegant, a flotilla of objets d'art motorboats dance around the dhows. Music blares out,

boom chooca boom, everybody on the shore screaming, egging the winner home. The dhows, just a few seconds between them, gracefully collide into the shore. The teams screaming and wailing at the top of their voices as they backflip and dive into the Indian Ocean.

Maybe 150 boats surround this water carnival, another boat arrives with more music and even bigger speakers, everybody dancing and singing, and 2008, on its first day, from where I am standing looks like a truly happy scene.

This is the world where I am standing, this is the view that I am seeing, but I know that a few hundred miles away, the scene is death and destruction. And I realise that the happiness that I am watching is an act of defiance. There are people in Kenya who are not fighting, who are not tearing away at the soul of the economy but so desperately desire to live in a democracy and a forward-thinking country.

I'm standing by those people. I'm not getting on the first flight out of here. I'm eating the local fish, swimming in the Indian Ocean, looking up at the African sky, counting the African stars, smiling at the upside-down moon, and praying to God that stability can return to this country.

I I January 2008

Life is so strange. I've spent the last week deeply concerned about my social skills, about the fact that at times I have felt totally inept, almost shy. But the truth is that I actually don't have anything to say, or, to be even more truthful, I have nothing to say to the person to the left of me, or the person to the right of me. It's a combination of being alcohol-free and the notion that romance is dead.

The white wall is no longer blinding as the lunchtime sun dapples its light in rays of splendour. The stars are no longer a million, million miles away twinkling like whispering dreams. The sea does not have the ability to surround me like an oceanic cloak. Sun is sun, stars are stars, sea is sea. My world has lost its magic. Everything is as it is, and that is a very difficult conversational point. I can't cross that bridge anymore, I can't be the last person standing in the bar, and I can't be the first person to arrive to have a drink. It's like I'm floating on the outskirts of the social evening.

I have had terrible pangs of loneliness, where sleep is by far the best option, to disappear inside myself, away from the constant feeling of social difficulty and all its trauma. The strangest thing is the realisation that I don't know myself very well and, as I don't know myself very well, I can't actually trust myself. Would anybody trust someone they don't know? Especially someone who has been pretending to know them for years?

I keep looking at my face in the mirror and try to weigh up whether it really looks like me or not. Then, the most scary thing

in the whole world, the "Movement of Truth"; my whole notion and understanding of truth itself has moved. It's shifted in a completely different direction and it keeps shifting. It keeps moving and I can't tie it down and this frightens me as everything feels slippery and untouchable.

White lie, black lie, shifting the boundaries slightly, keeping a bit of information back, relaying the story subtly. All of this fucking shit I never had to deal with when I went to bed half-cut and woke up half-cut. Truth just screamed out of my mouth, sometimes in the most horrid, abhorrent way and other times it would slide with enough wit and eloquence to grace a court.

Some people, when they drink, lie constantly. I have the opposite problem and now my level of truth shocks me, I even think it borders on the spiteful and those parts of me really are not very nice. So, when I'm sitting at the table on holiday in Kenya, next to an almost complete stranger, it's almost impossible to make polite conversation unless I lie. The lie is emotional, a veneer, an appearance to be socially acceptable and the reality is that I want to scream.

A few days ago I did scream, I screamed quite a few times, I embarrassed myself. I had flown up to a tiny place close to the Somali border, a place in the shape of a crescent moon, an idyll of palm trees, white surf and nothingness, a desert island cliché, heaven—turned into hell. I never knew I had a crab phobia until last week. Crabs the size of my hand, millions and millions and millions of them, a giant crab carpet, which most people found amusing and enchanting. My banda only 20 yards away from the water's edge, the serenity of the lapping of the waves and the fear of my high-pitched screams as I sat on the middle of my bed listening to them scuttle across the brush matting floor.

My fear was irrational, I shone my torch down on the sink as I went to brush my teeth and a crab, illuminated like an extra from hell in its own tiny spotlight, stared up to me pleading for deliverance from its porcelain cell. I lay in bed listening to its claws scratching away on the white china surface. Sleepless, riddled with guilt and unable to pick the damn thing up. I slooshed it with water

throughout the night. Even with all my fear and hatred for the thing, I really didn't want to wake up and find it dead.

Something really lovely came out of all this. Last week when Kenya as a nation appeared to be heading towards some kind of civil war, I had countless messages from people worried about me, some extraordinarily over the top. I had a very simple text message from my mum: "Tray love, thinking about you, love Mum." This week I received an email from her which read: "Dear Tray, are you with your friends out there? If you are on your own at least you are with your birth sign. Don't be scared, the crabs will be more scared of you. Enjoy the lovely sunshine and the sea. Lots of love, Mum."

Both these messages made me feel very loved and very understood by my mum. She knows my level of fear. She also knows my level of rationale, extremely levelheaded when it comes to it. Am I in any danger of being caught up in a civil war? No I am not—and if I was I wouldn't be here. But am I going to go into a total traumatic breakdown over a crab? Yes, I am. Sometimes in life you need your mum to tell you everything's going to be all right, even if it isn't. Today I need my mum.

18 January 2008

I lay in bed with the covers scrunched up in my hands, tightly pulled to me underneath my chin. I was trembling with fear, panicking that I had not made the right decision.

I looked around me and tried to make sense of the shapes in the darkness. A concrete room, part of a concrete house. I still wasn't sure that I had made the right decision. And then I heard the sound of the ocean and the mighty roar and I knew this was it. The two wooden doors were not going to hold back the wave. My heart was pounding uncontrollably. Did I have time to get to another room? At least if I was going to die, maybe I should die with someone else. Or was it better to die in a dignified way, alone in my singular concrete tomb?

I might not die—the wave might just carry on going. The concrete might withstand the power and the force. I just lay there and shook, knowing that it was coming nearer and nearer and nearer.

And then, of course, I woke up. Switching on the light next to me, I saw the shapes and apparitions of two giant crabs making their way up the mosquito net. A few days earlier I had given myself the choice of crabs or people, people or crabs. Due to my state of mind I wisely chose the crabs—and now, in the early hours of the morning, they scuttled on the net, resembling some kind of malevolent Victorian hand-crocheted curtain.

I wasn't quite as afraid as I had been before, because this time I regarded the crabs as more a nemesis than an enemy and the

reality of the situation was that the crabs were here a long time before me. I lay there thinking and thinking and thinking until my brain felt like it was going to explode. My right eye had the feeling that someone had placed a fork in it. I felt very uneasy about the dream and had somehow managed to get myself completely stressed out.

By the time daylight came I had managed to give myself an intense headache. I walked along the shoreline trying to shake it off. This place is incredibly beautiful. The ocean is so many different colours. Not just blues and greens but golds and oranges; tangerine light bouncing just beneath a flat, shallow wave, the millions of crabs scuttling along the shoreline daring to go in and out of the waves. Most of the crabs are pink and the water is generally an aquamarine blue.

So, as the light hits, I'm filled with nostalgia for my childhood, just the colours, the pink and the blue. I have done nothing for days, just walking and swimming. And thinking. Thinking with huge intensity.

Oh, I forgot to mention: I am the only guest here. A strange predicament, to be alone in paradise. But that is exactly how I wanted it. I wanted to be in a place where there's no confrontation, no idle gossip, and where I could be completely in control.

This place should be full right now. It's high season, it should be a honeymooner's delight. But it's empty. People are too afraid to come—and who can blame them? In parts of Kenya, babies are being raped and burnt alive. There's hysteria on the streets and a complete confusion of law and order.

I'm perched somewhere near the Somalian border. Not a place known for 100 per cent safety, but nevertheless a long, long way away from the effects of the recent elections. Even so, the economy of Kenya for the foreseeable future is well and truly fucked. A country that relies so heavily on tourism will take a long time to recover. And it is a sad fact that Kenya is well and truly stuck as a Third World country. And Kenya was one of Africa's great hopes.

Clearly I don't have much to say this week. I can go into long descriptions of the milky sandy beaches and the cute naughty monkeys and the beautiful puffy, purple twilight cumulus and pink stratus clouds that surround me—all of this stuff that I just see.

This last week has been strange. I feel that I am very solid and everything is just floating around me. Almost like it almost isn't really there, like this is all a dream. Which it very well could be. I am stuck alone on a desert island. My only salvation is chess. I have taken to playing with the proprietor. And it has made me very, very happy.

I haven't played chess since 1992. And that was against Carl Freedman's computer. It kept informing me that I was attempting to play the Sicilian Defence. The time before that, I was in Turkey, I was 23, wild, insane and madly in love. I was in love with someone who was as insane as me.

He's dead now; he was blown up by dynamite. Sometimes I dream of him; I dream we are on his fishing boat and we are sailing in the middle of a giant sea, and underneath us silently moves the hump of a giant wave and he explains to me that this is the beginning of something big. And he's right, it is. The dead are full of wise words.

25 January 2008

Kampala, Serena Hotel, Room 302. I am lying in bed. The linen is just as I like it, very soft. The pillows hold my head in a perfect way. I am very comfortable in my five-star hotel. I am neither too hot, nor too cold. Outside my open window the sound of Kampala rolls by—a city with faint colonial references, a mixture of ramshackle shantytown and art deco. A place that decades have missed. Businessmen wear ill-fitting pinstripes and drink Fanta through straws, and world clocks are set by hand—KAMPALA – JOBURG – BOMBAY – BEIJING.

I am positioned in a different part of the world that rotates on a different axis. I am very close to the equator and the people are very black from the sun. I have never been anywhere and felt so white. As we drive along the hand-carved muddy roads, far away from the city, amongst the lush green, green Ugandan flora and teeming fauna, tiny impoverished children in torn, dirty rags wave from their wattle and daub huts, shouting *mzungu* (whitey); their little eyes flash as they smile.

I lay there flicking through the channels, my mind's eye mixed with the million images of the day before and the screen in front of me. I go from BBC World to CNN to Al Jazeera, Sky, and back to BBC. They all say the same thing—Tracey, this world is a mess.

Through my TV, I am connected to every corner of the globe. Peter Hain has resigned. Heath Ledger is sadly still dead, and I have to wonder why the Palestinians don't just keep running through that

hole in the wall. I find the whole thing depressing and attempt to find something Ugandan. A woman with a really big bum fills up the whole of the screen.

I flick again and have the Kenyan crisis. Think of a country run by teenagers. My brain starts to plummet as I concentrate on war, humanity, fear, and hatred. My forehead starts to crunch in on itself as I try to fathom why the world is in such a mess. How did it get that way? Why can't this great ball of shit just stop rolling for five minutes and take a look at itself?

Some of us have the ability to see and observe everything, but we often numbly stand by, content to be the worst kind of witness—the kind who is totally aware, who knows but does nothing.

In life, it is so difficult to implement change. Rarely does change come without loss, death, or misery—or vast amounts of red tape. Even the good things are almost impossible to achieve. But yesterday, I did something good. In fact, something more than good; it was brilliant! I opened the Tracey Emin Library. I am still in a slight state of shock that a chance meeting, a chance conversation, could lead to so much.

I often feel dissatisfied or dislocated in my life, like I am not complete. I tire of seeing the spoils of my hard work constantly pouring into a vat of myself. People who know me are aware that I do a lot for charity. I enjoy it, it is rewarding, but I am always removed. I can't make decisions and be hands-on. For ages, I have wanted to do something that would be helping others but at the same time really helping me. I want to nurture something, see it grow.

By working with a small, small, tiny charity, and an investment company, I was fast-tracked. Within six months of a seed of an idea, now, in the middle of poverty-stricken rural Uganda, as part of the Forest High School, stands the Tracey Emin Library. In a place where nobody knows who I am, or what I do, miles and miles away from the galleries, collectors, good and bad reviews, stands my library. In a country where the infrastructure is weak but getting stronger, a country forcefully running from its cruel internal history, a place of devastating beauty, landlocked, holding in its belly giant crocodile-infested lakes, and the people are sweet.

Schools here don't have libraries. In fact, rural areas have very little. Most have no doctor, no clinic, no hospital; schools are few and far between. Education cannot afford to be a priority, but it should be.

When I was at junior school, every year there was a prize-giving—six or seven prizes—always going to the goody-goodies, the children who appeared to come from the least dysfunctional homes. Maria and I would sit cross-legged in the assembly hall and sneer as each goody-goody was presented with their award for being exactly how they should be. Then, in the third year, when I was about nine, the headmaster announced, "This year we have a special prize, a prize for someone who started a job and continued beyond what was expected." And my name was called out. My name was called again and I got up and made my way to the front.

In maths we had to make a paper house using a set square and ruler, measuring angles so the house could be cut out, folded, and stand. I made 10 houses, a church, garage, sweet shop, greengrocer's, butcher's. I painted them all, put them on a large sheet of cardboard, made trees, parks and a road; I made a whole village. I didn't do this in my maths class, on my school time, I did it in my play time. I did it because it made me happy. I think this library may be just the beginning.

I February 2008

Today feels like one of the most depressing days in the world. The greyness is sinking into my bones, so much so that I can't wait for twilight to appear. My whole day has been some kind of twilight zone, an emotional heel of nothingness. I want to bite into something, almost flesh, flesh and bone, and alive. I want it to be alive so it can react to the sharp coarseness of my teeth and the softness of my lips. I want to feel alive, but unfortunately today I don't have the energy to feel it through myself. Biting my own fingers is not going to be good enough.

This time last week, I was about to embark on what can only be described as a medieval adventure. I was lying next to the giant kidney-shaped pool at the Serena hotel in Kampala and my friend said to me, "You haven't actually left the hotel for 24 hours now." "Mmm," I said, congratulating myself on my new breakfast combination. "I'm really happy," I told him. "I could live here for years, maybe never leaving the grounds, occasionally maybe changing to different rooms and being experimental in the tropical gardens. On the whole I'm quite content and I'm the worst tourist in the world. My idea of seeing something is from a helicopter at least 150 feet above the ground. Why? Are you going to lay a helicopter on for me?"

"No, your Eminence," he said. "I'll give you a driver. You can go anywhere you want. No misbehaving or else you'll be under house arrest." (The vision of me falling asleep at a table during the

president's speech flashed back like a nightmare. *How to Misbehave in Uganda*, an epic novel by Miss Tracey Emin...)

One last word of advice from my friend: "Now, Eminence, no handbag, no purse, no telephone, no camera, no BlackBerry. You want to blend in as much as possible."

The next morning I marched down to the lobby wearing my bright red shirt, orange and red floral print skirt, and cowboy boots. My very nice driver, Baker, greeted me and asked where I would like to go. "The market," I told him. He looked at my outfit and said, "The craft market?"

"No, I don't want to go anywhere where tourists go. I want to go somewhere that only real people of Kampala would go." So we drove towards what he referred to as the local market, me all excited, clutching my bottle of water and staring out of the windows, like a 360-degree nodding dog.

Kampala is a strange city. For a start, it's a city with mud-track roads and giant billboard posters that say things like: "When you think of flying from Toronto to Dubai, there's only one airline..." Or, our next favourite poster, a giant billboard at a roundabout carrying the eloquent slogan: "When you think Uganda and you think basmati rice, you think..." Yes, they'd give Saatchi and Saatchi a run for their money. One week later and I haven't got the airline, but I'm thinking Tilda.

We pulled up in the Land Cruiser to a market district. There were lots of tiny wooden shops selling a mad assortment of things. The shop that got my attention was called Mummy Knows Best. Mummy Knows Best was selling hand-sewn university gowns—they puffed and billowed in the breeze, quite a contradiction to the mud and rubble and black soil that my cowboy boots were standing on.

Everything had a decaying, derelict air where you couldn't tell if it was half standing or half falling. A giant hole to my left looked like it was just full of mud and shit. A sign was scratched on a wall, saying "Toilets." As we walked further up the road, everything beneath my feet became a solid black. Huge piles of charcoal stood on either side of the street. Water gushed down, making everything black from the charcoal dust. To the sides of the stacks of charcoal

were even bigger stacks of tobacco. It was like some weird installation.

And then Baker took me through a gap in a small wooden fence—and it was at this moment that I went through my time-warp experience and realised that I had been sharply plunged into the twelfth century. Women sat around wearing assortments of rags tied together in different configurations to make clothes. In front of them, charcoal fires burned with different-sized cauldrons smouldering away. This was the epicentre. This was the food hall of the very poor.

Everything was black. The water that burned was black. The dirty muddy soil was black, and the fish that lay stretched out on banana leaves, and all the vegetables that were chopped in different piles, were either grey or black. In between the walls of this wooden shanty town I had to manoeuvre along thin planks of wood to prevent myself from being shin high in mud and God knows what else. Women shouted, "Give the whitey some food!" It was a playful interaction, and me being the polite time-traveller that I am, I smiled and graciously said no.

There were lots of people with sores and festering limbs, amputees with swollen, infected flesh that looked like something out of the Great Plague. And everybody, just about everybody, had bright red eyes. All of this took place under an umbrella of semi-darkness. I didn't want to be a tourist and I wanted to see something I had never seen before. What I saw was my ignorance and naivety. These people weren't the poor people, these were the ones making a living, this was commerce.

8 February 2008

Today, I feel utterly wounded. I'm not going to go into the reasons why, but just take my word for it.

What's incredible about the giant, grey, big, gaping emotional wound is how stuffed up with shit it gets. It's like living next door to the Clangers. Wooooo wooooh woo woaa wooooooa. All that stuff just floating around in space, aimlessly, with no trajectoral pattern, but today it's all coming crashing down into my heart. And I can't even swap it with the Soup Dragon.

I've always said that apathy leads to apathy. Energy leads to energy and sadness is simply sad. It's very difficult to make yourself happy. You have to wait until the sadness lifts, goes away, goes back to where it came from. But then if you've got a great, big, gaping wound problem, everything's messy and congealed and sticky.

Imagine lots and lots of cotton thread that's been released from a cotton reel. One moment clear, white, almost like a nest, suddenly being forced and rammed into your heart. And then you are told that the only way that you can get going again is to take the cotton out of your heart, untangle it, wash the blood out of it, thread it through a needle and sew the hole back up again. That's what I feel like I've got to do today.

Friendships work on all different levels. We need friends for different moment, different reasons, different times of our lives. To depend upon a friend for one moment and not another is in no way an act of betrayal, but a simple practicality. Some people don't see

it that way. People use the term "being dropped." Being dropped from someone's consciousness for a while is very different from being scrubbed out of their address book, taken off their mailing list and having them delete all your phone numbers from their phone. That, in my terms, is dropping someone. And I'm just on the verge of doing it to someone right now.

I've only ever done it to three people in my life. Actually, it's more than that, it's four. There are some people in your life that really have the ability to hurt. For some reason, they can touch you in a very sharp, spiteful way.

This can be quite funny for a while; you can accept it as part of their idiosyncratic behaviour, and you can make gracious amounts of space for them, because they need it. And then there's betrayal. That's when things get very difficult, because there are different levels of betrayal. There's the kind of betrayal without explanation, that one can only presume exists for ulterior motives, which can only be for the benefit of the betrayer as it shows no regard or feeling for the person being betrayed. Someone who does something for money, for example, or to make themselves look clever. Someone who deals in the tiniest piece of information without knowing the full story. I don't have to live like that. The reason why I don't have to live like that is because I never have. It's never a decision I've had to make. The last piece of art I made that was truly questionable on that level was *Everybody I have ever slept with 1963–1995*, a small igloo tent appliquéd with the names of everyone I'd ever slept with. But not once in that tent did it say the names of anybody I had ever had sex with; there was no differentiation, because the work was about intimacy.

Due to the vast amount of trouble I got into about that tent, I had people coming up to me at openings and shouting at me because I had put their names in the tent, and I had other people upset with me because their names weren't in the tent. (Jay Jopling, for one, as he fell asleep on the plane, but I didn't.)

When you're in the public eye, you have to be really careful what you say and what you don't say about other people, because it works as a giant echo effect. So if you say something mean, it comes

across doubly, doubly mean. I don't understand people who make a living by saying mean things. I don't understand people who do things that are intentionally cruel, because they understand the effect of what they do. Intelligent people who are supposed to be friends. YOU KNOW WHO YOU ARE. YOU CANNOT HIDE.

So, next week, my column might be a list of everybody who has ever fucked me over. Or maybe I just won't bother. Maybe I'll just have some really intimate, profound thoughts. Or maybe I'll make a painting that I fall in love with based on a story by Edgar Allen Poe. Or maybe I'll finish making my blanket *Contamination of the Soul*. Or maybe I'll just get in my car and drive up and down the motorway really fast. Or maybe I'll just get dressed up and have dinner with the Queen. I have a brilliant life and I have fought against every moment of it that isn't and I work exceptionally hard at making my life and the world I live in a better place. So, now, listen to me you fuckfaces out there that don't like my column, if you don't like it, you don't read it. You leave me and you leave my kind alone.

15 February 2008

I write this column on Thursday. Today is Valentine's Day. Ever since I was a child it's been a day of purgatory. A day of anticipation and a complete realisation of nothingness; more nothingness than any other day of the year, regarding love.

The most exciting thing that ever happened to me on Valentine's Day was being chased by a flasher at Euston underground station. I say exciting, but of course it wasn't exciting, it was petrifying. I had to jump down a flight of stairs and then threaten to smash his balls to pieces with my umbrella. I remember his dick quite clearly and his yellow, ill-looking face. I just felt so sorry for him. His lack of love and his isolation was so much greater than mine.

I remember going back to my rooms just off the Edgware Road and lying on a mattress on the floor. It was a basement flat, and I could hear the Tube trains rattling underneath. I remember my heart and chest heaving. I just cried and cried and cried.

Apart from that, every Valentine's Day for the past 44 years (or shall I say the 35 years since it's meant anything), has just drifted into the next day. The idea of actually receiving a card and being tickled, being excited, the promise of future love, is really quite beautiful. I often send my friends missives relating to love: wishing them love, wishing them passion, the ability to love freely.

It really is a painful time of year. It's cold and it's dark and if you are alone it's even colder and darker. The headspace closes in like barn doors on the light. The eyes close and the mind shuts down.

Curled up in bed, not even ignoring the winter sunlight, just not
believing that it's there. The pressure in this world to love and be
loved is extraordinary. Maybe some people are just put on this
planet to be singular units, to be fuelled by perpetual motion.

The spinster with the cat who lives at the end of the street.
She's always really friendly, every year she gives the newsagents a
Christmas card and they give her a Toblerone. She never expects
any Valentine's cards, but she'll give a cursory glance to the space
below the letterbox. But seriously, who's going to know that she's
there? One day in her sixties and she comes down the stairs, tea tray
in hand, ancient cat following behind, is she going to spy the large
pink envelope with the majestic handwritten script addressed to
"The beautiful woman with the dark brown eyes and the long grey
hair." And inside the words:

> For years I have watched you
> afar
> Sometimes I see you at your door,
> it's ajar
> You are, you are, you are, I
> wonder who you are?
> You, my grey-haired maiden
> who lives alone,
> If you would be my queen,
> I would place you on my throne
> Even though you don't know me
> and I don't know you
> There are so many things we
> can share
> So many things we can do.
> We are,
> Afar, afar, afar,
> But one day we shall be united,
> In our gilded lover's star.

The lonely spinster thinks, "Oh my God, I just hope I never meet the person who sent me this!" That evening she settles down to have a game of chess with her cat.

This Valentine's has been especially cruel to me, as the only thing I received in the post today was my accounts for the last tax year. I'm now going to go down to the Government, knock on their door, and say, "I've come to collect my Exocet missile. I don't actually want it, but as I've paid for it I feel obliged to pick it up. I gather I haven't quite paid for the warhead yet? Next installment should do it."

Why don't we all just stop paying tax and hold the Government to ransom and tell them what our taxes should be used for? It could all really work out nicely because there will be those out there who really believe, and in some cases rightly so, that defence is a priority, and people like me who believe education is the backbone of all civilisation. I would like to allocate my taxes to education. You might want to allocate yours to recycling, and your taxes can go towards paying for a new recycling plant. You might have grave concerns about the National Health Service, so your taxes can be allocated to providing a cleaner, safer, more efficient system. And then there's science, the arts, culture. All things have value— but the point is that we take responsibility for the world in which we want to live. The majority of people in this world are good; they are not born evil incarnate. Human nature usually only becomes dirty when it has to fight for survival.

When we are tired, we can't fight, we just curl up and give up. Shut down all our resources and just wish for the pain to go away. I have spent most of today trying to work out what could make my life happier, how I could be more content. I seem to spend so much time running away from things; occasionally I do a fast U-turn, screaming, mouth open wide. But it doesn't matter how loud I scream, it's almost what's expected of me. It appears to be my natural habitat. That's because people can't hear tears. At least I have that poem to look forward to... Valentine's is over.

22 February 2008

I shouldn't be writing this. I should be in my studio, painting. I should be wearing my really tight, stretchy shorts with my white apron and my legs splattered in acrylic pink and white and a Wall's vanilla colour.

I should be listening to really loud music, bouncing around in a drum, not knowing which way is up, but feeling spiritually free, pringling and pottering, excited by the fear of mark making. I can see myself there now, really clearly. I wonder if I've got another self, who has been astrally projected, who's doing what I actually want to be doing.

Painting and creating is not working. For me it is just being; it's me being me. I can drive around in my fast car, wearing my really nice clothes, with my beautiful diamond bracelet, celebrating the trinkets of my success, but they are all external to me. "Me" is how I feel naturally at home. Everything running through my veins properly. The ends of my fingertips being me, the joints of my knees being totally me. When I bend and crouch, resting on my haunches. That is a complete me.

Sitting at a desk, back slouched, chin in palms, eyelids closed, mouth down is me—but not the me I like, because that me is on the sickly side. She is vulnerable and easily damaged; repairable but slightly saggy, only the chair keeps her in place. Head could wobble off at any minute.

The only me I like at the moment is Backstroke Woman. She's

a mean machine; propelled by flippers, arms moving through the water like the sails of a windmill. The cobalt blue being sliced with grace and precision. Chest heaving high out of the water, head held back as far as possible. Sighs of release as the air escapes my lungs are the only times I feel alive. I stare up at the ceiling and I look down upon myself. I try to imagine myself as high as possible past the ceiling, past the roof of the bank, above the swimming pool, floating way above the cumulus clouds, up into the golden light of the sun. And there, down below, miles and miles below, is tiny Backstroke Woman—pulling herself through the water, praying that everything is going to be all right. Yes, this is the only way I like myself at the moment.

I don't like being an artist who isn't making art. I see it as a failing, mentally and physically. I am not waiting for the next great idea and I am certainly not looking for it. The great ideas are here, weighting me down, giving me migraine headaches, making me feel sick and bilious, swamping and suffocating me, due to my lack of time.

Time. All these people, half an hour of this, half an hour of that. Wednesday the 27th, Thursday the 29th, Wednesday the 5th, Sunday just for a couple of hours, 10 minutes around 6:30 p.m., 15 minutes on the phone, it will only take us half an hour to set up, we will be out of your hair within an hour—OUT OF MY HAIR, MY WHOLE BRAIN HAS BEEN CONTAMINATED BY YOUR FUCKING APPOINTMENT!

How much do I have to cancel which is for me? Those really nice personal things that I was really looking forward to. And how many meetings do I agree to, which facilitate other people? I don't think this just happens to me. I think that we are all victims of this evil mystery of where time disappears to.

I wake up really early, around 6 a.m., just so I can lie around thinking about whatever I want. Most of the time we have to think about what we are doing, what we have to do right now. I like to think about whether cats listen to music, and if they do, what kind of music do they like, and do they hum the kind of music that they like? What do cats hum like? How do cats hum? Do giraffes smile? Are they happy animals? At first we think they are slightly melancholy but,

then again, I would imagine they would have a wicked sense of humour, slightly all knowing, very secretive.

I want to spend time thinking about things like that—not about how to juggle my day. I don't want to be a juggler; dropping bits and pieces everywhere, feeling inadequate, never quite reaching the mark. I want to feel more complete, more happy with myself, not frozen, scared by the lack of time.

Yesterday, I walked through Threadneedle Street, tears streaming down my face, unashamed, just walking. I couldn't see the point of stopping and cowering in some Masonic stone doorway to wipe away the tears, knowing they would only start again. I didn't mind about the tears—I just wish I had been walking through fields or plains, somewhere open, somewhere with a 360-degree view. Somewhere I didn't feel trapped.

But emotional entrapment follows us to the end of the world. It is a fallacy that I make my best work on emotional trauma. When I am sad or unhappy I make nothing. I become frozen and locked inside myself. To be an artist we need all the ego, but we need to be able to step out of it. And sometimes in life, that stepping out is just too difficult—even for the likes of Backstroke Woman.

29 February 2008

I'm sitting here trying to see what I can write, and it's different from thinking, because I have my eyes open and I'm staring beyond everything in front of me. Further than the beef and horseradish sandwich in my hand, past the paperwork on the desk, past the scrawny handwritten word "Uganda" and a long, long way past the window in front of me.

I can see all these things but my eyes are pierced sharp into a loch; a deep, deep, beautiful, ice-cold loch. I'm in Scotland and I'm standing next to somebody I love and it's like a strange surreal dream. The water is icy still and the sun, a cold lemony winter yellow, shines across the loch like a Nordic pathway. Even though I am in Scotland I feel like I'm in Scandinavia. I feel like I'm standing in an Edvard Munch painting.

Everything is slow motion, I think of a title of the painting that I'm standing in. Maybe *The Lover's Conversation*, *The Reunion*, all sounds a little bit clichéd but it has to be in the early-1900s-Munch mode when great paintings were titled, such as *Three Girls on a Bridge*, *Jealousy*, *The Dance*, *The Sick Child*—paintings that had meaning for the person making them, which then transmitted meaning to the person viewing them. It was all done in a very simple alchemic referral.

Three times last weekend whilst in Scotland, I had the most incredible déjà vus. They scared me. It wasn't as simple as "I think I've been here before," it was as though I was retreading my footsteps.

We went past one loch, pitched deep between bleak, gargantuan hills and on top of the hills were even bleaker, jagged mountain ranges. As we drove past the loch I looked between the winter trees and I said, "God that place is really dark there." We both nodded in agreement. I said I imagined something from the dead rowing across the water.

These lochs, it really is as though they are gateways to another world. But this one loch in particular seemed so dark, as though light had never shone on it. The kind of place that makes me feel ill at ease just thinking about it. I should stop thinking about it.

All this week I've felt ill at ease, nervous, and slightly sleepless. Scotland is very romantic and very beautiful and very old, it seems so much older than England. Maybe it's because so much of it is unspoilt and it's easy to feel spiritually involved, to imagine ghosts and mystic worlds, when things are so natural and nature rules.

I wonder if as human beings we become physically ill when deprived of nature. I thrive in an urban landscape, I breathe bricks and stone, pavements, streetlamps, shops, and traffic lights. For years this has been my natural habitat. It's where I feel comfortable.

But in truth it's years since I felt comfortable. Sometimes I have small sleeps where upon waking I feel that my soul has been replenished and a certain degree of poison has left my body naturally to join the ether and slowly disappear.

I'm sure that we have strange stains of ourselves floating smeared but yet invisible, creating strange atmospheric patterns on the earth. That's the kind of thing that Edvard Munch painted. The kind of thing Ibsen wrote about. The invisible things that are there, that make themselves known within our daily existence.

Every night when I go up to bed I have a tray. Sometimes hot milk, sometimes herbal tea, but usually full with a book, telephone, BlackBerry, whatever usual paraphernalia I feel is necessary to sleep with. Docket will run ahead of me at each flight. I usually have the landing lights on due to the fact that I'm afraid of the dark. I know that my carbon emission trail is going to burn me in hell but my fear of the dark unfortunately far outweighs the decline of our planet. But this week, the night of the earthquake (just to keep

things low-key), as I came up the last flight of stairs to my bedroom the nightlight wasn't on.

As Docket ran ahead, I placed the tray at the top of the stairs and fumbled for the light of my bedroom. Just for a moment, as I stared across the room, I saw someone sitting on the end of my bed. Instead of being totally afraid I just stood there staring at this dark apparition. I thought to myself, imagine how frightening it would be if it was a real person sitting there! And at that, as I turned on the light, picked up my tray, a few quick meows from Docket, the apparition vanished.

I used to think that darkness came from fear, but now maybe, just sometimes, the dark comes to comfort us. As Friedrich Nietzsche once said to Munch, "The darkness has not come to take you away. It has come to embrace you." I just made that up. Hee hee.

I went to Edvard Munch's studio—a tiny wooden house on the edge of a fjord. The thing that really amazed me was the telephone by his bed. I remember picking up the receiver and saying in a deep Norwegian accent, "Allo, Edvard Munch here." I actually held the receiver—the earpiece to my ear, the mouthpiece to my mouth— that Edvard Munch held all those years ago. And for so many years I had studied Edvard Munch and his paintings but never in my wildest moments of my imagination did I ever imagine him lying in bed on the telephone. Yes, with a broken heart, surrounded by apparitions, but never attached to the world by a telephone line.

Tonight I will go to bed with my pot of tea and my cat, and no doubt after I have made peace with the ghost I will punch out a few poetic lines on my BlackBerry and send it out into the ether where all invisible things belong. Long live the darkness.

7 March 2008

Without sounding too puerile, you'll never guess where I am! For people who know me well, my guessing games will come as no surprise. Guess how much this cost? Guess how long it took me? Guess how many old socks I found in a drawer? Guess how long it took me to fly from London to Sydney? Oops, I've just given the game away!

I'm sitting in the Sydney suburbs. It's a beautiful, lush green, sunny day. A cool autumn breeze blows through the window. The blind gently clanks. I can hear a soft ringing noise from the fire station next door. There's the fire station, a school, and a very nice little church that has religious banners outside; grand, blasting statements that, whether you are religious or not, make you think.

Today's banner reads: "It's good to say sorry." Can't argue with that. I tend to say sorry about something almost every 10 minutes. All I have to do is start thinking and remembering and various degrees of sorryness fly through my mind. At times, I feel like I have been an utterly vile human being. When I've been drunk, I've said some of the most cruel, hurtful things; things that really seem to make no sense whatsoever. It makes me question truth to a really high degree. A screaming explanation of "that's how I felt at the time" or "I didn't mean it, I was drunk" or, the best one, "I don't remember." "I don't remember" doesn't mean that I wasn't there.

I refer to these situations as "the walking dead." The darkest bit of Hell having limbs, Beelzebub breathing through my voice box. I can't go back. I can't start writing millions of letters: "Dear Dylan,

I am so sorry I was so drunk in 2003, and nearly sabotaged the whole entire *GQ* Men of the Year Awards"; "Dear Melvyn Bragg and all organisers of the South Bank Show Awards and the Savoy Hotel, I'm really sorry I threw up on the carpet in public"; "To the cloakroom attendant in that club I don't remember somewhere in Mayfair, I'm really sorry I shouted at you when you couldn't find my bag that was hanging over my shoulder the whole time"; "To the mini-cab driver coming from North Finchley at some ungodly hour, who I insisted on letting me out of the car and leaving me exactly where I was because I didn't trust them ..." Oh, the list is endless.

But most of all, the people who are close to me, who are really close to me, the ones who love me and care about me, the ones who don't want things to get worse, who want things to get better, the people who don't want to hate me, but want to love me more. They're the people I really want to say sorry to so much. But the best way to do that is to create change, not to say sorry; to be different, to show new energy—and belief in a better way of going forward.

When I was young, there was someone in our lives who was very drunk. She was my mum's best friend, Margaret. She would come and stay with us for two or three weeks, and the first few days would be really good. Then things would get slightly sour, and finally they would be horrendous. Often with me screaming at Margaret, and with her shouting back saying the most cruel things. And sometimes my mum would send me to find her. She would be crumpled up on the floor in some pub, drunk, crying like a little girl. I would have to try and get her home. Margaret was Austrian. She was blonde and feisty, and would be very happy sitting on a stool, drinking her halves of draught lager, winking and saying skol in a very Teutonic fashion. She could be lovely and fun and had a sweetness about her, the ability to make Mum very happy.

But you couldn't trust her. Not emotionally, because it would be like sitting around a time-bomb. Towards the end of Margaret's life, I fell out with her quite badly. I made it up with her at the end, but Margaret definitely goes down as one of my biggest sorrys. Just recently I dreamt of her, and always in my dreams, she never says anything to me. She is often wearing white, like a mortuary gown,

and she just stands or sits bolt upright. Her facial features are of a photograph that I saw of her in her early thirties, a 1960s bombshell. But always in these dreams, there is silence. She just turns and stares at me. When I wake up, I always try to imagine what she may be thinking about me. I often suppose that she is telling me to look after my mum. But maybe that icy stare that fills me with some kind of strange guilt is telling me to look after myself. After all, the dream is mine.

So here I am in Sydney, trying to sneak just a few more weeks of sun into my life. And a chance to get my head really clear, before an onslaught of two years' solid work. I'm busy until the middle of 2010, but I guess most people are busy for the rest of their lives. I would really make a good dropout, if only I'd dropped in in the first place. I fantasise about disappearing into obscurity. While flying over here, the air steward, Simon, who was really lovely, asked how I felt about such long flights. I told him that I loved it. I loved the paradox: all safely cocooned in my first-class bed, being waited on hand and foot, no telephones, no emails, no one in the entire universe knowing exactly where I was. Cosy from the outside world, but at the same time being 36,000 feet in the air, with an outside temperature of 52 below freezing, and certain death if something was to go wrong. So, on one level, completely safe, and on another level, in a state of fear. The perfect environment for someone like me.

I wish I could be content to live in a classic, cosy world. A world of simplicity, without ego and ambition. Without the edge of it. I've been like this since I was a little girl, all my life. On one hand, wanting to be tucked up cosy in my nightie, going to bed early, and on the other hand, doing mad rock 'n' roll dancing at Birchington village disco. Even at the age of 12, everything was a huge contradiction. So I can blame it all on drink, I can blame it on my upbringing. I can throw the blame almost anywhere that suits me, but the blame falls firmly on myself. If I'm sorry for the things that I've done, then I have to live with that sorryness. For now, it's good being away from everything. It's good to have time to think, time to breathe, and maybe send a few letters. But you can't send letters to Heaven.

4 April 2008

Today I have a very strange headache. It's piercing. It feels like a skewer has been tucked behind my right eye, just above the corner of my brow—a very sharp, thin, flat skewer, the kind that has a ring at the end. I can almost mentally see it protruding out of my head. Sometimes it doesn't hurt, just looks weird, and other times its being gently twisted and the pain is excruciating as it scrapes along the nerve endings of my eye. This headache has been brought on by stress and grief. I have spent the last few days, in between every other waking thought, trying to understand and come to terms with death.

On Sunday morning I was happily staring out the window on the 53rd floor, idly plotting and planning my last days in New York, when I received a phone call telling me an old friend had been found dead, hanging from a tree, apparently a very beautiful tree. I was suddenly propelled mentally from the here and now to 15 years ago when everything, in comparison to now, was careless and free.

I have always liked to think of myself as philosophical when it comes to death. And I have been touched closely by the deaths of people who I love dearly. I have suffered excruciating pain thinking that I couldn't survive the feeling of grief but part of me has always known, or felt, that there must be another world, another world where we are light, where we become light. Part crystal, part sun, part raindrop, part rainbow, a beautiful place where we shine.

All of these beautiful thoughts, this beautiful place, which exists part reality and partly in my mind, doesn't really help at the

moment with the loss of a friend. All the things I didn't say, all the things I forgot to say. Why didn't I write a postcard saying that I thought his last show was good? I meant to. Why didn't I just be more of a friend? Why do we take people for granted, especially the good, kind, lovely people, the people that have never done anything wrong to anybody. How do you say goodbye to someone when you didn't know you were saying goodbye. Almost everybody I know is now connected by grief. Everybody's minds are going round in endless circles.

Death makes no sense when it happens, but of course it makes perfect sense. It's one of the few things in this world that we can rely on 100 per cent, no matter how it comes. It really shouldn't be a surprise. Sooner or later, or whichever way, it's coming.

Tonight I am in a show that's opening. It's a group show and all the works are based on some aspect of Edgar Allen Poe. Poe, a man who made a career out of death, but the darker side. I have only ever read one Edgar Allen Poe story and to be honest I'm actually scared to read another. Life is difficult enough as it is. There is darkness all around—pulling at us, punching, tripping us up, pinching, thumb and forefinger tightly biting into our sides. Darkness can be an angry place that we have to fight our way out of. My painting, which I made especially for the show, looks dark. In one way it appears to be a demonic self-portrait, skittish and psychotic, something heavy and malevolent to behold. On the other hand it could come across as being Gothic, cartoonish, something from the Hammer House of Horror. Not so unlike Poe himself.

There are lots of artists in the show. One of them is Angus Fairhurst. How will we look at his work? Will we see his work differently? I know some of us won't be able to look. Death transcends everything. Nothing can ever appear the same. I have been reading Angus's obituaries and I wonder how it is that people give so much thought after someone has died, and so little thought before. This doesn't just relate to Angus, this relates to all moments after someone has passed away. Every little drop, every moment, every ounce of someone's being is remembered, rethought and

sometimes reinvented. With Angus, nothing need be reinvented. Angus was good enough. More than good enough.

Now I'm sitting round trying to finish this column before I go to the opening. But instead of writing, I have been thinking, trying to weigh up the good souls against the bad souls. Which is the heavier? Am I being stupid, is there such a thing? This is not a thought I usually judge others by, but something I direct toward myself. Am I a good person? Have I got a good soul? How pure is my heart? I'm talking about the true essence of any being. The stuff that when you stare long enough into the mirror, appears, and then the image of yourself disappears. When we die, how much of us is left behind? At the moment the strange thing is that it feels like Angus hasn't even left. Maybe the thoughts and collective memories of him that all his friends share are a way in which to say goodbye.

18 April 2008

I've spent the past few days doing exactly what I wanted to do. I've been driving, driving round and round and round, not just aimlessly but with some intention, with an instructor. The idea was to become more confident, neater, more precise. So I bought myself the time and the teacher. After hours of reverse parking, parallel parking, windy country lanes, and motorway safety, I do feel a slightly better driver. But the whole point of driving is to get me somewhere. And today my driving has got me to Margate. It's got me back to exactly where I came from.

I'm like one of those people who sit in their car with a flask and a sandwich watching the tide roll in. It's so windy, the spring tides are rising high and a crest of white foam rides on top of almost every wave. The sea shelf is black in high contrast to the pale blue sky with puffy Cirrus clouds. There is a slight pinkness to them and a slight pinkness across the sea to give a vision of a strange nostalgia, like looking at an old tinted photograph. Seagulls flap around, dodging in and out of the wind, swooping and diving like a cliché from Jonathan Livingston Seagull.

As a child we had a plaque hanging up on the kitchen wall. It was blue with a white seagull flying high and below the seagull were the words, "If you love something, set it free. If it comes back, it's yours." At the age of 10 I always thought this quote from Jonathan Livingston Seagull was the most profound thing in the whole world, and I suppose to a certain extent it is.

Margate for me should be somewhere I rejoice to come back to. A sort of spiritual place bound up in childhood memories and the fecundity of the sea. It should be a place of passion mixed up with Edwardian charm. A place of kinky contradictions, that's how Margate always used to be. But now every time I approach the Golden Mile I am filled with dread and fear of what I may think.

Every time I come here something has gone, something is missing. This time it's the scenic railway. Another time it's the big wheel. After the storms of 1987 it was the pier. In the eighties it was the entire Lido complex. Every single time I come something has been burnt, destroyed, fire bombed, boarded up, demolished, or just completely forgotten about and left to fall into a tragic state of disrepair.

It's strange to witness the death of a town. In some ways there is a melancholy romance. It's like the tragic set of a film, but the sad thing is that the star is Margate. Margate has become Britain's tragic Norma Desmond from *Sunset Boulevard*, almost nothing can save her.

I never imagined in a million years that, at the age of 44, I would be sitting in my car, staring out of my window, thinking these thoughts. As a child Margate had magic. It had charisma. It had a sense of humour. But it also had incredible architecture, thousands of holidaymakers, daytrippers, beauty competitions, a thousand fish-and-chip shops, a harbour full of hundreds of brightly coloured fishing boats, and an incredible Victorian funfair.

All of this had the backdrop of some of the most beautiful sunsets in the world. And that is not an exaggeration. Turner painted enough of them. And if you study Turner's seascapes, in many of his miscellaneous seascapes, imaginary seascapes, the sunset you most definitely see sets in Margate. There is something about this place which is so shaggable. It lends itself to raunchy. It makes me feel sexy being here. Even with the depression of everything falling down, everything collapsing, the sexiness of Margate overrides any of that kind of depression. Kiss me quick is an understatement. I sit here feeling very, very sad.

I want someone who is a giant to come along and treat Margate like their very own special model village. I want them to return

Margate to its manmade majestic beauty. I want them to lovingly recreate the scenic railway and the big wheel. Make Dreamlands a place possible for teenage lovers to have dreams, the Teddy Boys to whirl on the Wurlitzer, and Mods to dodge with their girlfriends on the dodgems, the Victorian promenade to be graced with beautiful, wrought-iron railings.

I want the giant to flick the switch on the battery box and Margate's summer lights to twinkle and dance between every guesthouse and hotel. I want all the boarded-up hotels and guesthouses to be opened up and come alive again. Tiny figures to be placed at the Lido swimming pool. The giant bends down and nimbly, with thumb and forefinger, replaces the 30-foot diving board.

I am not complaining, I am just making a sad observation. An observation I'm sure many, especially those who live in Margate, have made. This tiny knuckle of England has truly been forgotten, left somewhere in the early eighties to just die and decay. What makes me very sad is that all that is lost of the better days, of the better times, of Margate are the things that have made Britain great. An inheritance lost that belongs to no other place in the world.

9 May 2008

I am lying on my bed. It's rock hard and slightly bumpy and the pillows are very flat and combobulated.

I don't know if that's the right word to describe the pillows, but when you lay your head on them they give the sensation of being made up of lots of individual bobbles, which are very hard. The whole experience is somehow very basic, yet strangely satisfying. I can hear the sea roaring, and if I sit up straight I can see the blue of the Mediterranean touch the blue of the Mediterranean sky.

I'm in Cyprus, an island that for years has been divided in two, and I would say, extremely unhappily. The first time I came here was 1984. The civil war was still fresh in people's memories, and everywhere had a very heavy military presence. But now, nearly a quarter of a century later, Northern Cyprus has been left in a confused, driftwood state of no-man's land.

Northern Cyprus, once untouched and unspoilt simply because nobody had the courage or the permission to invest, is now fast becoming a hideous world of cheap and tacky villas. An overrun and overbuilt sprawling mass of fake Mediterraneana. So much in this part of the world is not real. Breezeblocks are clad with fibreglass rocks, wooden doors are made of plastic, and brass is painted aluminium.

There is a certain amount of Cypriot culture in terms of taste, which has always been able to win me over, enchant me. The chintzy plastic tablecloths, plastic soup bowls with cherries on them,

fountains in the shape of dolphins, ad hoc gardens, which border on either the insane or genius. Grapevines stand next to bougainvillea, strawberries grow in the shadows of tomatoes, all these kind of things are in general a Mediterranean way of being. But sadly, in the last 15 years, Northern Cyprus has lost its way.

Tiny hotels double their room size overnight. They make more space on land by claiming the sea. They build, casting giant shadows where the sun should shine. Almost nothing is thought through. For miles and miles, signs say "Turtle Bay Villas," "Turtle Beach Villas," "Mediterranean Heights." Turtle this and Turtle that where once turtles used to live.

I want to feel the magic of Cyprus. I want to imagine Cleopatra bathing in her pool. I want to think of her and Mark Antony making love as they watch the sun set behind the copper mines; the mines which once incarcerated Pontius Pilate; the copper mines which now lie derelict and disused.

I have only ever been to the Greek side of Cyprus once and that was to visit the graves of my family—graves which were all well kept and neatly looked after in a tiny little cemetery.

My ancestral connection with Cyprus goes back a long, long way, but my now only real connection at the moment is my dad. He is 87 and he infuriates me. I can never see him without feeling angry. All the love in the world and all the forgiveness never stops me from asking him the same five words, "Why did you leave us?" This conversation always comes up. I always feel that we are two extras in a play.

The sun is an almighty spotlight and the Troodos Mountains are our stage. I feel like every word we are saying to each other is being recorded. My dad tells me that he is unlucky. I hear myself say back, "No Daddy, you are not unlucky. How did you ever think you would get away with it?

"You treated your wife cruelly, my mum badly, and one by one you let your children down." And the last line of the play is always the same: "Dad, why should I look after you when you have never looked after me?" Then the curtain falls and I walk away, always wondering if these are the last words I will ever say to him.

Sometimes, when my dad makes me angry, I just won't see him for six months and then I hope that when I see him I would have missed him so much that the anger would have gone, but in reality nothing gets resolved this way. Like the island of Cyprus being divided in two (just for the record my dad speaks better Greek then he does Turkish) for years and years, the separation has only cost the people of Cyprus dear.

Yesterday I drove through the Green Line—the line which divides southern Cyprus from Northern Cyprus, the Greeks from the Turks. A no-man's land of barbed wire, corrugated iron, and hundreds upon thousands of shelled-out derelict buildings. Miles and miles of something which looked like a strange set from an apocalyptic film. A void of terror and emptiness, the evidence of the futility of war.

Every time I think of Cyprus I always think of it as the perfect example of a disagreement unresolved. So much sad bitterness from the past that has only become magnified towards the reconstruction of the future.

As my dad becomes older, I feel Cyprus slipping away from me. When I was younger, my ability to always look for the positive, to rejoice in its idiosyncrasies becomes increasingly more difficult, as I see its natural beauty being eaten up by greed.

Every time I leave Cyprus, I have the same fear. When I board the plane I imagine that one day I will be boarding the plane with the body of my father and at the same time the door will close behind me.

A door to a Mediterranean island that will then always remain closed.

16 May 2008

Today, I am writing the column in a room where the column has never been written before. It's the ground floor of my house, which I always refer to as "the Freud Museum." It's an eclectic collection of odds and sods, furniture, knick-knacks and objets d'art that weirdly, happily, hang together, spanning from the 1600s to the present day. I rarely ever sit in these rooms alone, and it's the only part of the house which I feel is frequented by some spiritual presence from another world.

Not a permanent spirit—it's the kind of place where spirits like to pass through, or just hang out for a short while. It isn't just the rooms. And, when I say rooms, this is because the room itself is made up of two rooms with an opening connecting them. Maybe it's this central arch, which gives me the feeling of somewhere where sprits pass through, or it could simply be because it's on the ground floor, the place where you wait when you are expecting visitors, cautiously and apprehensively, occasionally staring out of the window. I don't want to use the word haunted, but there is most definitely something else that resides in these rooms.

It could possibly have something to do with the table. It is a table made up of four wooden boards, with two boards that can be lowered to make the table half its size, leaving a long, thin shape, perfect for a coffin. The table is over 300 years old, and that's exactly what it would have been used for. It had a dual purpose: coffin one day, dinner the next. When I first brought the table into the house, the

moment it crossed the threshold of the door, every wall and every stair and every floorboard and every window, every ounce of my house shook. At first, I wondered whether the house was a little bit jealous of the seniority of the table, or maybe the house was just afraid of what I had let into it.

Docket spent hours prowling and miaowing around the table legs until eventually he pounced and, like a Russian gymnast, rolled from one corner to the other. The table immediately felt warm, as though the wood was being heated from inside. What at first felt frightening, in my home became solid and comfortable, a port of rest for the elbows of my friends.

My collection of hand-blown, green Georgian glasses; my drawing by Peter Blake, which is a portrait of my feet; various little Victorian samplers with phrases such as "come unto me" and "with you I love"; Egyptian cats and Nefertiti memorabilia; my grandmother's rose-mirrored table standing with the ashes of Fleabite, an affectionate little stray; felt-covered top hats; photographs of myself and Sandra Esqulant dressed as Mother Teresa, blue-and-white tea towels round our heads; Regency cats dressed up in an Oriental style; miniature chairs; William Morris patchwork curtains and a Georgian settle, which many a coachman must have rested his head upon. Most of this is reflected in a large mirror that hangs in the wood-panelled hall.

I spend a lot of my time, today especially, wondering why my life is so complicated. Today, at one point, at the kitchen table, I thought I was going to spontaneously combust. My mum is staying with me, it's her birthday, but I'm not allowed to say how old she is. I just imagine her coming down the stairs and there, at the table, just a singed cuff of my blue shirt. My mum, after spending a couple of days with me, believes my headaches are simply because I don't drink anymore. It's got something to do with reality. My friend Gregor, his theory is that it's because I don't come enough. What gives him any kind of inside information is beyond me, but maybe he's only speaking from his own experience, I don't know.

One clear thought for today, in amongst all the clutter of my mind, all the clutter of my house, my collections, my past, the mirror that

reflects everything that surrounds me, which in turn doubly complicates everything, the one clear thought is, that I was born to drink and fuck.

What has gone so terribly wrong in my life? I'm weighing up all the pros and cons, the extremities of my own existence and really, really, really questioning what life is about. Everything that surrounds me one day feels like nothing, like I never needed it and I can live without it, and another day I cling to everything which is familiar, touched and loved and owned by me, as if these objects are part of who I actually am. As if part of my soul and being has seeped into them and remains there, even when I am not.

My home feels happier when I am in it. How should I know how it feels otherwise? But somehow I do. It's like I'm attached to this material world that I have created; a space where I don't rattle, I float. I clearly see myself in 100 years' time, sitting at my table, walking up and down my stairs, turning on and off the lights, leafing through my books, counting my roses from the second landing window, and always happily enjoying what is mine. Yes, I really think you can take it with you.

23 May 2008

I'm sitting here in silence, looking at all the mess that's around me. I'm in the mood today to be completely distracted. I'm open to the outside world coming in; slightly spangly, as though, if I could find a way to truly relax, almost anything could happen. I am open to suggestion and I feel warm and generous.

Today I have laughed much more than usual and I have had the clear ability to see and imagine friends in situations and unusual predicaments. In short, I spent quite a long time on the telephone, and with each conversation, part of me bounced around the world. Curtains in Moscow, jewels in Siberia, helicopters in Ireland, palazzos in New York, plantations in Uganda, and salmon in Scotland.

My world has become truly glamorous and international: every little girl's dream, which is odd, because, as a child I didn't have many dreams or aspirations. I never really wished for anything. I was too busy focusing on the here and now. I think, possibly, from the age of three I actually started to think not from moment to moment, but more externally. I always somehow saw myself from the outside. I never imagined myself as a child, surrounded by the pink and fluffy, but more of a granite-like darkened force; an atmosphere of anti-matter and negative ions constantly surrounding me—a darkened living hole.

As a child there is not much that you can do about it but as an adult you can mentally disperse the darkness. Or maybe just dig your

way out. That's what I've done today. I have allowed friends to come close to me, even by way of a telephone line it's somehow worked. Their affection has opened me up and made me feel less afraid. I left part of myself in bed today, part of me that I really didn't like very much. As I sit here now, I can see a strange sliver of myself smeared on the pillow and the sheets. It will still be there when I go back to bed tonight, this dead, irritable, tired, miserable self. But hopefully the brighter side of me will be able to overpower it, when we lie down and interlock.

By the time I was 11, I loved the idea of travel, and I desperately wanted to learn another language. The top stream for English at my school had the privilege of learning French. I was in the third stream. After my first year I was put up into the top set in English. I was so excited, not because I had gone up two grades, but because I was going to learn French. Margate was only 22 miles from the French coast, so to me it seemed to make perfect sense that the first language border I should cross should be *"Parlez-vous Francais?"*

I was the only person learning French who wasn't also in the top set for maths, and unfortunately the French lessons coincided with my maths classes. I was in maths set 3. So my school, to solve a simple problem, put me down a set in English. Hey presto—no French, problem solved. I went home and cried. I could see myself now 12 years old, skinny, bent over my mum's dressing table, shaking, tears streaming down my face. It's not like I could just go and get some French lessons, or even go and buy learn-to-speak French cassettes. That was my chance gone.

I always see this as a pivotal moment in my education, where, sadly, the cynicism began. By the time I was 13 I had a completely different attitude towards learning. I was more interested in the Springboard Effect. The Springboard Effect was a term that I had come up with for sleeping with people.

When I say sleeping, I mean sex. Full-blown penetrative sex. I felt that every time I slept with someone new, I was somehow sent to another place. At the age of 14 I wouldn't have known what metaphysical meant, as a word, but I understood it as a reality. I couldn't travel and I couldn't experience the exotic, but I could

experience the journey of passing through somebody else. I really believed that after sex with someone new I was in another place, a different destination.

I tried to explain this to my geography teacher when he was trying to persuade me to do O-level geography. He kept saying to me, "Tracey, you're naturally gifted, you have an intense interest in rock formation, map reading, continental drift, everything from volcanoes, tidal waves, deserts, tundras, and avalanches. You have a natural gift for these things." I remember just sitting there and saying, "But Sir, I love geography but I've found another way of learning about places. It's the Springboard Effect." I didn't go into all the graphic detail, but I said it was by knowing other people. He actually said it was my only chance of getting an O-level and I should do geography.

I often sit around wondering how my life would have turned out had I taken Mr. Hartley's advice instead of sleeping with half of Margate. The Queen of Contour Lines instead of just a plain, simple Margate Princess.

30 May 2008

What have I spent the last hour and 45 minutes doing? Cutting bits of wire, and bending them into tiny, square, frame-like shapes, to have a piece of canvas sewn on to them later. I'm doing it in a sort of moronic, addicted way. I have to cut off about 15 centimetres of wire with wire cutters, then I have to fold it into a square-like shape that's approximately two inches by two inches. The largest it can be is maybe two and a quarter inches by two and a quarter inches. Any bigger and the square of wire looks somehow ungainly and ugly. I then have to wrap the end pieces of wire around themselves to make a stand at the bottom of the square.

It sounds like a very simple task, but there is a certain kind of artistic knack or skill to it, somewhere between the completely naff and the genius. But most definitely, for anybody watching I would be considered a little bit insane, because until I explain what I am doing or why I am doing it, there is no reason on earth why I should be doing it. This is one of the odd things about making art. When you watch an artist working, a true artist, there is always a devout amount of strange intensity. Something quite feverish, hot; even if it's not on the outside, it's certainly bubbling up on the inside like a stirring volcano, a dormancy just resting in the cradles of the mind, and suddenly whoosh, a wild, mental, physical, artistic eruption. Ideas can lie around for years, resting somewhere, lying on the shelf of a soul, dusty but somehow just beating like a pulse waiting to be sprung into action; ideas in the brain go in and out

of fashion. Something, which seemed incredibly witty and funny one moment, can be corny and heavy-handed at another.

Sarah Lucas and I, back in the early nineties, when we had our shop, were constantly making things. We had to. It was the merchandise for our shop. Often we would stay late into the night making keyrings, badges, ashtrays, drinking cans of Guinness, chain-smoking Marlboro Lights in our tiny empire of the shop putting our world to rights. We had profound statements such as "I'm so fucky," and "Have you wanked over me yet?" Thirty-year-old women going on 15. We'd be prone to lots of private jokes that we didn't think were private and thought everybody would understand.

One night, after pints and pints of Guinness, we realised we had to have a name for the shop, and as if the doors of heaven had opened and a revelation been bestowed upon us both, the mini cassette recorder cranked out David Bowie's "Golden Years." In our drunkenness and our haste we unrolled some yellow sticky plastic and, bleary-eyed, proceeded to cut out the letters "Golden Years." I remember us saying, "Yeah, we've got it, that's it! These are the golden years!" About 1 a.m. we pulled the ladder, the dodgy ladder, up to the plate glass window and between us attempted to do a glorified balancing act. After a couple of attempts, and realising I had spelt "golden" wrong, we decided it would be safer to leave the putting up of the golden years and the grand unveiling until the morning.

The next day we both entered the shop and, without really saying anything, scraped up the yellow plastic letters and put them in the bin. I just remember checking out the relief on Sarah's face. Nobody knew about this minor event in our history and I am sure nobody would particularly care, but now when I think back on it I wish so much that this tiny little event had been filmed. Maybe a bit Gilbert and George, but nevertheless something innocent and magical. A time when an idea was just an idea and all that was wasted was time. No weight or preciousness, just the innocent passing of time.

Now, ideas are so immensely heavy it's like I weigh out the pros and cons, the aftereffects. I suffer a bout of side effects before I have

even started to make anything. I get physically affected by the knowledge of my own creativity. It's as though nothing is free anymore. Life is spiritually heavy. Ideas are concocted from a gluttonous, gloopy soup being stirred by a giant spoon, a cauldron of inactivity. Does a lightness of touch belong to a younger age? I sit around for ages procrastinating on the idea of truth and what is real and what should exist and what shouldn't exist, what I am allowed to let continue exist. Does destroying something mean that it doesn't exist anymore, or the fact that I had the idea mean that it goes back to the dormant shelf, ready to be picked up again and regenerated? As an artist your mind is a giant cave, void of everything apart from the stuff that it's made of. The stuff that can so easily become something beautiful. But life is not just made of the beautiful, the sincere, the worthy, the reformed. There has to be room for other stuff. So for now I think I'll just try to sit here and happily make my little wire...

6 June 2008

Today I awoke, stretched out my arms, and rejoiced in the fact that it is just an ordinary day. By that I mean I have to do everything that I usually have to do, like write this column, and a multitude of other tasks, but also that this is the first day in more than three weeks when I haven't had to go to the Royal Academy, or when the Academy hasn't completely absorbed my thoughts. Even now, I feel my soul is floating around Gallery VIII.

A few months ago, I was asked if I would like to curate a room at the Royal Academy Summer Exhibition. I was in Australia at the time, and the month of June seemed a long way away. And then, suddenly, a few weeks ago, the month of June came charging towards me, like a deranged elephant flapping its ears and making loud gestures with its trunk, and the daunting task of having to curate anything, let alone something so public, quite overwhelmed me as I suddenly realised I had never curated anything before.

I began by thinking about the Royal Academy: what it stands for, its history, what the summer show represents—and what I could possibly bring to it. The obvious would be what is expected of me. The title for this year's RA Summer Exhibition is *Man Made*, so I also began to think about what the term "man made" meant to me: Luddites, the age of mechanical reproduction, the desire of invention, science; it all seemed quite distant from me.

So I turned the expression on its head and thought about the emotions that humankind make, from fantasy to jealousy, pain

and fear. I thought about the mind and how it has to deal with everyday life's confusion and emotional instalments. I wanted to create a room that could show this, and at the same time I wanted to show work that could somehow excite and create discussion about art. Something that would entice the viewer, not just into the room, but maybe into the dialogue and opinions, and maybe a change of opinion once they had left the room. I wanted to create a room at the Royal Academy that would have a longer-lasting effect than the summer show.

I wrote down a list of artists and particular works of theirs that I liked. The artists ended up being multinational, their ages ranged from 27 to 97, and the works crossed over many different media. All of the works that I chose had to go through the official channels and be cleared by the RA Summer Exhibition Hanging Committee.

For people who don't know: the Summer Exhibition is an open submission. This year, there were more than 10,000 entries. It's a show where professional artists hang alongside amateurs and its reputation literally hangs on the fact that it is totally overhung, from floor to ceiling. This has always been the style, the salon hang. Personally I find it crazy, draconian, but somehow amazing. It doesn't mean to say I was going to hang Gallery VIII (my room) like that, but I have hung high into the gods and low to the ground, and I have world-renowned artists hung next to unknown artists.

I have also taken on the tradition of the shock of Varnishing Day. This is the day when the works are first unveiled: 200 years ago Turner would have been standing there touching up the last wave; Ruskin would have been strutting his stuff, removing any evidence of pubic hair (I like to imagine him on his knees with a little dustpan and brush).

In the olden days, every year, the Royal Academy was plagued with some kind of scandal or another; I am happily just returning to that tradition. There are some works in Gallery VIII that I feel viewers should be warned about in advance, simply because I don't want to have the blame of somebody having a visual heart attack because they have never seen a penis before, or a zebra mounting a woman from behind. These images are appearing in an art gallery. This is

a safe environment for them to take prominence on the stage, and for the audience to create discussion around them. This is what art is about, forcing us to exercise our minds and our visual capacity, but I will accept that maybe not everybody wants to.

I would love to write about all the works individually, but there isn't space and there isn't time. What I know is the pleasure I've had over the last few weeks in putting this room together: working closely with the other Royal Academicians; dressing up in all my finery and beautiful silver medal; feeling actually very proud to be a Royal Academician and having wonderful conversation with the likes of Adrian Berg RA—finding out inside information on Barbara Hepworth that you could never read about, the kind of stuff where you had to be there at the time. It's good fun seeing history, seeing it unravel, and understanding that you can play a part, if only minor, in its evolution.

If there are any elements in my room that shock, I'm very happy about this. Shock is a base word used to describe a response forced by certain emotions. I really want people to start feeling art, not just looking at it. Art is a wonderful, fantastic thing. It exists halfway between man and nature. It rests on a strange plane, somewhere else where we can take our minds, outside of the daily realm. A place of a heightened spirituality, a place where the mind can feel free to explore, mentally, emotionally and, if it wants, without even having to utter a word. As we say at the Royal Academy, with glasses raised high: "Honour and glory to the next exhibition."

13 June 2008

This week I have been driving up and down and around and all over the South Downs. I have decided that out of all of my miniscule driving experience, the road that heads from the M2 towards Dover, and then up and over to Folkestone, could possibly be one of the loveliest driving experiences in the world. The road, all smooth and creamy, winds around and up and down and you have a really good sense that you are going somewhere. I had the roof down, the music playing at a very high level, the sun was turning my forehead into a very hard piece of brown leather, but nevertheless the whole experience, as I made my way to Folkestone, felt extraordinarily brilliant.

The reason why I was going to Folkestone was to install my work. I'm one of the selected artists to take part in the 2008 Folkestone Sculpture Triennale. Folkestone really is very beautiful. It has totally seen better days, but it still retains a great element of beauty and nature that can't help but shine through in among the industrial leftovers of a once-vibrant port. I like this industrialness that's been left to be salvaged, and it has been salvaged—by the arts.

Folkestone has a benefactor who obviously passionately loves art. Many of the disused shops and other such places that would have been boarded up and left to go derelict have been turned into low-priced artists' studios. And there's a certain bohemian rinky-tinkiness to the place, which has pulled in artisans and interesting

little one-off independent businesses. It's now attracted a huge-scale international art exhibition, to be followed by a train line that means it will only take 35 minutes to get from Folkestone to London. It's always the same: wherever artists go, commerce follows.

Every weekend over the next few months, especially on hot sunny days, arty types in their droves will be pouring down to Folkestone for a day out. I wonder if the people from Folkestone will be pleased about this? I think, and hope, they will.

I like the idea of people trundling up and down around the hills of Folkestone, like a treasure hunt, looking for art. But even more so, I like the idea of a teenager from Folkestone who's never gone into an art gallery, who doesn't particularly care about art, stumbling across something and it making them think. All I had when I was a teenager was the resident Russian poet who had written the words "I scream ice cream" on a café window. He was a real dissident type with a big beard and a strong Russian accent. As a teenager I was always looking for something. The something I was looking for always transferred itself into sex. That was my way of living on the edge and exploring. If I couldn't have an intellectual adventure, I had a physical one. There are many girls like this. Everyone presumes girls who get pregnant when they are young are stupid, but I have often maintained that it can be those who are most advanced and most intelligent. And there are some girls out there who just don't want to be girls; they want to grow up—and they want to grow up as quickly as possible. They want to get away from their childhood as fast and directly as possible.

The southeast of England has an extremely high proportion of teenage mums. I think statistically it's higher than anywhere else in England. When I was doing my recce in Folkestone—trying to think about a site, what kind of work I would make—I noticed so many young girls with babies. Not a few but hundreds, and not girls in their twenties, but girls in their teens. I thought about making some art for them and about them. This nicely coincided with my ideas about public art in general being too big and macho for me. Always when I see discarded baby clothes—the odd little sock that's been lost, tiny mitten, baby shawl—I think about how clean and new

it was next to the baby, and where it's ended up, rolled around like a piece of tumbleweed amongst the urban mishmash of society. I always have to place these little leftovers: a sock is left on a kerb, a mitten is put on a spike, a jacket is hung over a railing. You can't just leave them to be rolling around in the dirt, these little time-capsules of innocence. So that's my work for Folkestone: found and lost baby things.

But one of the objects I didn't find is a crocheted booty that my grandma made. She made me a whole set of baby clothes not long before she died. She said she had made them for me now because by the time I had a baby she would be making clothes for angels. I placed the bronze cast of my Nan's little booty in a beautiful little garden with a pond and fountain; it's the sort of place where old people go, older people who understand about crochet, who understand about making something out of nothing, and older people who could hopefully enjoy a tiny little forlorn booty left by the side of a pond.

I had a lovely couple of days installing my work. The sea was really blue, France was just a blink away, and as I drove off up past the white cliffs, over the green hills, I thought about my little baby clothes I'd left behind, and tears rolled down my face.

20 June 2008

I'm in Florence, lying by a pool in the gardens of a hotel that used to be a palace. The pool is very beautiful with greeny, grey, bluey water that's fresh and soft to the skin. I'm surrounded by trees that have been planted in a man-made majestic way. Everything has a look of calm and serenity. The sun is hot and beating down on me.

I should be feeling secure and comfortable but instead I am filled with fear. As I lie out in the sun tears burn my eyes as I recount in my mind the last eight years of my life. Today I was given the news that Docket, my cat, has contracted feline AIDS (otherwise known as FIV). Docket is not just a pet to me. Without sounding too corny, he is really like my baby. I constantly say this. I love him more than anything else in the world. I love his yellow eyes, his big ears, his white paws with puffy pink pads, his fluffy white tummy, and soft grey fur. But most of all, I love his warmth, and I love his smell. When I cuddle him I rest my face on top of his head and remind myself of how much I love him.

The reason why I love him so much is because of all the love I have invested into him. To some people a cat is just a cat. It miaows, it has to be fed, and it has a tail. But for me cats are small animals which occupy a massive amount of my mind—especially Docket, who I live with. If I'm honest, I realise that I plan a lot of my life around my cat. And by this I don't mean small things, I mean where I live, who I live with, and my future plans.

Should I move to the country? Should I live by the sea? Every large-scale decision that I make involves Docket. The idea that he is seriously ill is making me feel confused and afraid. I don't expect people to understand, unless they feel the same way about animals. I can't imagine my life without my cat. It's as though it doesn't make sense. If someone asked me to truly describe myself in an abstract frame, next to me there would be small mark, like a smudge, and that small mark would be my cat. I know there are atrocities that are going on in the world, but personal fear and loss is often what defines our characters. Everything today has a very big shadow and nothing really feels real. At other times in my life when I have been afraid, it's like something is trembling inside of me, and as it trembles I can feel it when I walk, my voice shakes and my breathing doesn't feel right. I felt like this when I was pregnant. I feel like this when people close to me die. And now I feel like this because I'm afraid of the thing that I love most in the world leaving me.

I'm lying here trying to think about what makes me the person that I am. My voice, my look, my resilience, my art, my home, all the things that make Tracey Tracey. There is so much that I could really live without. We adapt ourselves to the world which surrounds us, but sometimes we are in a position to completely create that world. I never created Docket, but I had a large part in the love that I created. It's hard to write when you're crying.

The last few weeks have been a real slog one way or another. I just felt like I was getting to the top of a hill, I was just starting to feel that things were all right. But they are not. There's always something there to cast a shadow, to remind me that fate is cruel, to let me know that things will never be easy. In life it can sometimes be the smallest things that knock someone. The higher you walk the tightrope, it's so obvious, the more dangerous the fall.

I have such a strong desire for my world to feel safe and cosy, for a sense of calm and serenity. I often feel that instead of just going out, I'm going out to battle. Today my armour has taken the loss of a massive, massive chink.

This column isn't really any good. Really I shouldn't have written it. But I think it's important to be true, and it's not always good for

things to be consistent. I'm lying here, in these beautiful surroundings, seriously wondering what life is about. All the stuff in this world that makes us who we are can never add up to the amount of love that we can give. And that's what I'm really afraid of. That time will come when I'll have no place for my love to go.

27 June 2008

Today, the pressure was off. But now it's back on again. I never seem to have enough time, and I really feel that this is what affects my happiness: pleasure and time.

I can hear some people across the way making some kind of light conversation and occasionally an oooh-ahhh noise. I'm guessing they are watching the tennis. I went to Wimbledon once. I was 13 and it was some kind of special school treat. I was good at running, but never good at tennis. I had massive problems in concentrating on the ball. Nevertheless, somehow I had wangled a place on this extremely glamorous school trip. One minute you are doing cross-country through the cabbage fields, the next it's strawberries and cream on court No. 1.

I remember it clearly, we didn't have to wear our school uniform, but we were told that we had to wear a skirt. I wore a floral pleated skirt that was quite see-through, a collarless granddad shirt, a man's pinstripe waistcoat that I had altered to fit me quite tightly, some ankle socks and a pair of plastic jelly sandals. I thought I looked so cool. There was only one downer for me, the night before, during trampoline class, whilst attempting a backward somersault, I had managed to ram my knee right into my top lip, so along with the 1950s punky shades, I also had a very nice 1970s fat lip!

It was such a hot day. I remember sitting on the grass and dabbing ice cubes on my lip. These are my fondest memories of tennis. I now occasionally get invited by some fantastic corporate

entity to be one of their guests on Centre Court—and I always have a "plus-one." I have friends who are tennis mad, but I never go, and so I can never give away my "plus-one," because it's me plus one. The "plus-one" is a funny thing. I often wish it was "plus-two," then the plus two could go and I wouldn't have to.

It's strange, the memories and experiences from when we were young and how much they affect us. I really felt that day at Wimbledon (with my fat lip and jelly sandals) that I was going somewhere. And I was so grateful to the swollen lip because I had an excuse not to have to watch the tennis.

I roamed around, looking at other spectators, what they were wearing and how they carried themselves, and my obvious observation was that, like myself, there were a lot of people who weren't there for the tennis. If they were, they would have been watching it. I have always been sitting around pondering and thinking, but I think when I was young my main objective was to meet people.

I felt there was something exciting and glamorous about meeting somebody from somewhere else, not in a calculating way, but in the truest way. I think about that innocence and that liveliness and how free and easy everything felt—I had penpals stretching from John O'Groats to Land's End.

Now, as I sit here at the grand old age of nearly 45, the whole notion of meeting new people and taking on new friendships is completely daunting. How do we find room in our heads for everybody and everything? How do we have the strength to take everybody with us? I mean that as a human collective, I mean it in terms of the biggest ideas. Everybody you have ever known, in every way possible, they are still there, in your head, somewhere.

The artist Douglas Gordon made a work about this. You can see it on the stairwell of the Scottish National Gallery of Modern Art. It's a very simple work, listing the names of everybody he has ever met. In some ways, not so dissimilar from me listing the names of everybody I have ever slept with. Except Douglas Gordon's is very cool and conceptual, whereas mine was very passionate and expressive and ratty looking. But nevertheless, both works are like

a cleaver in the brain with the ability to push the memory and the thinking patterns much further than usual.

If you don't believe me, get a pen and paper now and write your own list. Everybody you can remember meeting, without exclusion. It's like cleaning out an old cupboard that you haven't looked in for years. Some people you will ponder on, evoking memories from the past in quite graphic detail. Other names will fill you with pride and emotion. And some will just be a callous whisper of the pen. What appears to be on the surface very, very simple, once it nears completion, is an obvious mental journey to extreme places.

I went on a bit of a journey today. For at least half an hour my mind went into an upset, jealous rage, full of imaginary graphic detail. My whole thinking process resembled an insane ball of dental floss. How I calmed myself down was to sit and write a list of all the people that I've never met, that I never wanted to. I'm only joking, but the idea did put a smile on my face. It also made me realise that I don't actually have any hatred or animosity towards anybody (except Robert Mugabe, who's a fantastic example for my list).

As a 13-year-old girl, sitting on the grass at Wimbledon, at least I was hungry enough to know there was a whole world out there— beyond tennis. Love All.

4 July 2008

It's my birthday today. It's one of those days when it doesn't feel like it's my birthday. Some days in the year you wake up and everything feels tingly and special. If I'm really honest, tingly and special are not two words I would use to describe myself today. Bleak and plump seem more appropriate.

But saying that, I was at a friend's party last night and a younger person did sidle up to me and say, "How come you are so thin and your tits are so big?" I then proceeded to take away any myth or illusion that they may have had by explaining the various lumps and bumps on my body that give me varying degrees of dissatisfaction. And as I stood there and minced and mused like a contemporary Oscar Wilde about the pros and cons of youth and age, the young person just cut through everything and said, "But you are sexy." I then asked them, if they had to have a bath with anyone in the room, who would it be? This then led on to a whole different topic of conversation, because both of us opted for the people who might give us the most intellectual stimulation. Blow the bubble factor, it's good conversation we want!

It is odd, this thing with age; if I think about the past 15 years and how fast it's gone. When I was 30, I felt so indestructible, Sarah Lucas and I had a party, titled: "Fantastic to Be 30 Party— Old Enough to Do Whatever She Fucking Wants." I remember that moment of waking up and being 30, the clarity, the relief, so happy to be away from my twenties, one of my most unhappy

331

decades. In my thirties, my life changed, my mind altered and I started to like myself. Then, on my 40th birthday, everything seemed to be about recovery and I was just happy to be alive. Everything seemed like a glorious bonus, due to the fact that I had almost died a few months before.

But now, five years later, I feel like I am rolling into the bleak and plumpy years. I feel that my young friend who referred to my sexiness was intelligently making reference to my lack of mumsiness (like a young boy from the Isle of Dogs, who pinned me to the bar in an East End pub once, saying, "I like you. Old bird, well seasoned!"). I deeply regretted at that point that my mind had no graphic limitations. As this young man tried to make further advances towards me, I just didn't want to think about it! But I do know as I get older I'm probably going to have more and more regret about not being more sexually promiscuous. And it's not like I don't know what I'm missing.

Tonight, I am having a dinner party, but what I really should be having is a giant Roman orgy. Everybody lying around spoiling themselves in the Turkish baths, the steam rising up, wine and grapes being passed around as the lions stand guard, roaring, at the entrance to my palace. A couple of senators are in the corner, arguing, while a group slope off for some extra activity after having an aggressive game of backgammon. A solo harpist plays naked in the corner and I happily lie in a pool of effervescent water, surrounded by rose petals, and my very closest friends, as we discuss the latest gods and sacrifices.

Every year I have some kind of party. And every year I think I'm actually too old for it. In a way I feel quite silly. I'd like to just be really cool and modest, and if people remember, it's just a charming part of the day. But instead, my birthday is always like a major astrological event, like some giant meteor flying through the heavens on a pathway to shake up every dimension known to man, fifth, sixth, and otherwise.

Maybe it's because I always had to share my birthday as a child. I do still share the date with my brother, Paul, but not a cake that's half pink and half blue. This is the last, spoilt, rich birthday I

remember having as a child. The cake was brought to school and it was the size of an entire table. I remember at the age of five feeling slightly disturbed by the whole situation.

But not now; Stargazy pie, perry jelly, my favourite chef—and even though I try to do it in a very mature way, I know it's still going to come across as 45 going on eight. There's still going to be some point this evening when I am going to stamp my foot! Life should be celebrated. I never thought I would get to 45. I never in a million years would have believed that my life would be so immensely gratifying, fun, generous, lucky, happy may be pushing it, but it really is very good. And that's why I like to have a party, it's a way of saying thank you for last year and never taking anything for granted. So thank you to all my friends, just help me get through another year and I hope I've behaved slightly better than I did last year; I'm working on it!

PS: If you stole my bird, Roman Standard, from Liverpool Oratory, or you know anybody who stole my bird, and even if you are a fan, please can you put it back or leave it in the Cathedral. Because you didn't steal from me, you stole it from the people of Liverpool, and if I were you, I would be very afraid!

TRACEY EMIN

25 July 2008

I'm up in Edinburgh. I'm installing my show at the Scottish National Gallery of Modern Art. It's a big show—a very big show. The title is *Tracey Emin: 20 Years*. I had a show at the Stedelijk Museum in Amsterdam six years ago, titled *10 Years*, so really my Edinburgh show could have been called *16 Years*.

Most people would try and lose years, I've just sort of gained a few, but in a conceptual way it's totally correct that it's 20 years because I feel that's the amount of time that I have been thinking about art seriously, and on a different level. Also I do have work in the show which spans the last 20 years.

It was around 1988 that I realised art wasn't about pictures; it was my newfound love at the time, of early Renaissance icons—I fell in love with the gold. I used to go to the National Gallery, down to the basement and spend hours mystified by the magic of the gold leaf and wooden panels. I loved the way that they were things, entities with presence, not pictures, not things which worked on a single plane but objects which could be held, that somehow seemed to have a soul, more like they possessed parts of people's souls, the people who had looked at them over the years.

It was having these kinds of ideas that made me realise art wasn't about surface, and it seemed from that point that everything became more difficult and more complicated. The disappointments surrounding my own creative process increased a thousandfold.

I remember having tutorials at the Royal College of Art, when

334

I would get very moody and upset while trying to explain the kind of art that I really wanted to make, and how I felt trapped in a process of mannerisms and gestures. I remember screaming at my professor, "Don't you understand? I want to make grown-up art!" I remember the tutors saying, "We would never have the heart to criticise you the way you criticise yourself." But it seemed to me that no matter how hard I worked, I was never going to get to where I wanted to be.

And now, walking around the gallery and looking at my past, my past adventures in the world of art and creativity, my tiny, personal Galileo moments, I've yet again become my hardest critic. All this stuff in all these rooms and I'm responsible for it. I don't just mean the bricks and mortar of it; I mean the responsibility for the idea. Two days ago I unpacked the bed. The museum was doing a condition report and, as methodical and mechanical as that was, for me it was extremely bizarre. To actually be unpacking my bed sheets from 10 years ago, the stains and detritus of my own being, from more than a decade ago, was like unpacking a ghost—a ghost with a smell, the smell of me that has gone.

To be treating my chair like a hallowed, sacred object, art handlers carrying it in white gloves, and for me to suddenly realise it can still be mine to sit on! All these objects, all these things, these priceless works of art, even though no longer literally belonging to me, are, and always will be, mine.

That's the wonderful thing about having a retrospective, my art feels like old friends coming to visit. And silly as this sounds, as I unpack works in different rooms, I feel the works give each other a nod and a wink, like they are happy to see one another; as though they resonate. Maybe this is a cross between my imagination and sentimentality because for me so much is loaded into the work. When I look at things, I remember what made me make them in the first place, what pushed and punched me into that line of creativity. I thought I would feel very low and confused installing my 20-year retrospective, old and somehow moping around in the past, but instead it's the complete opposite. I'm enjoying seeing my thought process over a long period of time, and no matter how hard

I try to stretch my imagination, there's no way I could project myself and imagine what I will be doing in 20 years' time. Just the same as 20 years ago, when I was a student at the Royal College of Art, literally banging my head against the wall, I could never have imagined in a million years that I would be doing what I am today. When an artist is good they create their own language; it's a language which they can pick up and drop whenever they wish, but it is 100 per cent theirs. This is what I've enjoyed about this installation period. I never realised how much Traceyness I actually make, and I'm very happy to spot and enjoy my influences, too. Munch, Picasso, Schiele, Giotto, Katie Kollwitz, Frida Kahlo, and even many other artists where the influence is totally subconscious. It's fun to see my own little route through art history, but I'm pleased there is still part of a student inside me. There is part of me that will never be satisfied, that will always look and question what I do. I feel good to be my hardest critic. I can see the ups and downs more honestly, more correctly, and with more authority than anyone else I know. And that's what keeps me going.

8 August 2008

The drone I can hear, that feels like it's living behind the backs of my eyes, is a cross between the fan in my bedroom and a hangover. Something which I haven't had for a long, long time. But last night I hit the town. I was smiling and happy—and I'm still smiling and happy. I'm really, really in love, passionately in love.

Something has come over me, which I never expected. The austere Georgian architecture, the mounds, the humps, and the vales, the stone, the moss, and the green of Edinburgh. I have fallen in love with the city. I keep having to check myself and ask, is it because I left all my work there, or is it because I had a really fantastic two weeks installing my show, or is it because I was treated like a duchess everywhere I went? (Not just in the true cockney sense!) Or is it because everyone is so friendly? My flight to London City Airport was delayed by nearly three hours, but I was just happy—happy sitting in Edinburgh Airport. I really didn't want to leave. And now I am lying in bed in London, all torn and pulled, because I am supposed to be going on holiday tomorrow, but what I really want to do is go back to Edinburgh, because it's where I felt happy.

I went to a Chinese astrologer once who told me that I had to live so many degrees above the line of the equator for my soul to feel complete. Everywhere from that point was cold, rainy, and Nordic. I never really considered that Scotland is a different country. It's brilliant we can just drive there; we can get on a train and just go

there. I was happy with my flight delay, it was like a really good, slow comedown. It made me realise why Hadrian's Wall was there, why it was ever built—and my boyfriend's Scottish!

Today, I feel extraordinarily lucky. My aches and pains are not really from the hangover, even though I did have a few drinks. They are from vast amounts of dancing: spinning, twisting, turning. It's so fantastic and extraordinary when you just allow your body to take over when there is an actual loss of gravity. Not floating, but like a strange connection with a centrifugal force; you can feel yourself leave the earth, but somehow still be connected to it. That's how I feel at the moment and this is happiness.

I'm happy when I forget who I am and I just exist being me. That sounds like a complete contradiction, but it is to do with the balance of the self. I might have to have a little snooze and resume this column later. I am really, really very, very tired.

My retrospective in Edinburgh has been like a massive mirror, and to be honest, there are parts of me that don't reflect that well. Like any middle-aged woman looking at herself, there are bits I would rather not see. I have read lots of reviews of the show and it's amazing how personal they are. Even the good ones are twisted with backhanded compliments that relate directly to my personality: to the Me. It would be great if one day I died and it turned out that all my work was made by a really thick-jawlined, 6-foot-2-inch Geordie guy and I was just a blink, a fragment of someone's imagination and I hardly even ever existed.

Just the idea of that brings me a massive relief: the idea of not really existing. For years, most of my life, I wished I hadn't been born. Being a twin and for months being in the womb and knowing that I wasn't wanted is something that has played on my mind continuously.

Of course, once I was born I was wanted, but given the choice, most of my life I would rather have not come here uninvited to this world, this planet, to everything I know. But luckily, this is why today I feel very lucky. Art came and got me. Art with its big ideas and its engulfing arms picked me up and swept me away to another world. A world where I exist coherently and purposefully as an artist. I exist

in this world, and everything I do makes sense because of that. Without art I am nothing and I am no one. I have just spent two weeks having one of the greatest love affairs of my life, and on that happy note I am going on holiday. See you in September.

Things to Do in Edinburgh:
 * Have afternoon tea in the Palm Court of the Balmoral Hotel. The best beef and horseradish sandwiches in the world!
 * Lie naked on Arthur's Seat reading *Sunbathing Naked and Other Miracle Cures* by Guy Kennaway.
 * Walk through the Botanical Gardens and listen to the squirrels' mating calls on the way to the Richard Hamilton show at Inverleith House. One of my favourite paintings in the whole world is there; a portrait of Bobby Sands looking like Jesus.
 * For dinner, the Kitchin in Leith, five minutes from the city centre. Amazing, fantastic, cool, delicate food.

And if anyone goes to see my show, if you walk behind the Scottish National Gallery of Modern Art there are the most beautiful woods and stream. It's like being in heaven—and heaven is a good place to be on this earth.

6 November 2008

I am lying in bed, my eyes are just peeping over the covers. I'm staring at the grey of Docket's fur against the grey of my fake fur blanket, against the grey of the sky that's coming through the window. The air looks heavy and saturated and the grey looks like a colour that's been mixed. Half a tube of zinc white with the tiniest drop of Payne's grey, a couple of splashes of water and that's the colour of my sky.

It seems like I've spent weeks in bed, but that's the problem with being unwell, days and nights just seem to fade into one another and early morning really is early morning. I wake at 5 a.m. wanting to be filled with zest and energy, but instead I just lie on my back, my neck propped up with a pillow, listening to Radio 3. It has only recently dawned on me how much I really love classical music, music I know absolutely nothing about. I find myself happily absorbed for hours in the dream-like tranquillity of its sound. It feels real and uncontaminated, two adjectives that I find almost impossible to apply to anything these days.

I started being unwell about two weeks ago. I found myself lying in bed, hot and cold and shivery, the nape of my neck saturated in sweat. I said to my boyfriend on a Sunday afternoon, "I think this is what it feels like when you're going to die." And in my shivering state I went into a kind of delirium. I dreamt that I had closed the door behind me, the door of the house that I had lived in when I was a child. But now I was a superfit adult wearing a black baseball cap

and running gear. My body was muscley and well formed. There was zero fat.

I jogged down the alleyway towards the Britannia pub, eventually arriving at Fort Hill. But everything was different, the road had gone and the car park had tumbled into the sea. Broken bits of asphalt with tufts of grass moved and rocked slightly beneath my feet. I clambered down towards the beach, climbing in between the jagged rocks and asphalt.

The beach was beautiful: golden sands soft under my feet but just the right consistency to run on, the colour of the sea an amazing aquamarine, and as I squinted towards the sun, I could see silhouettes of figures flying the most beautiful kites. As I ran, my eyes remained focused on the movements of the sails of the kites as they danced around in the wind. I was filled with an overwhelming sense of happiness and freedom, but as my eyes followed the darting shapes, I realised my trainers were getting wet. The tide had come in and I was blocked off in a bay. I couldn't go forward, I could only go back, back the way I had come. I looked at the kite-flying figures to realise that they weren't real, they were just shadows on the sands. I ran back toward the crumbling asphalt. The sea was becoming ferocious, spitting and licking at my thighs. Giant waves began to appear that at any second could just sweep me away. I clambered up onto the broken bits of tarmac, my hands grappling to hold on to whatever I could. I could feel my back getting wet and the sea spray covering my neck. I began to panic and cry as my nails were filled with the soft black tar, and my elevation seemed almost impossible. I panicked and looked for a stronger foothold. And then up above me, I saw my Nan. She said, "This way, come this way." She held out her hand and pulled me to the top, and just as I reached my destination of safety, she let go my hand and said, "I have to go now."

A few days later, I was in hospital with a temperature of 110. As I lay there, attached to my drip, I thought about my dream and I wondered whether it was a dream, or whether it was one of those near-death experiences. I wondered whether my Nan was saving my life, or whether she would have been leading me to another world.

It's so long since I have dreamt of her and to be honest, I don't think of her enough. I realise I should put time aside to think about the people who are dead that I love. To conjure their voice, their smell, the touch of their hair and their skin. To try and remember how someone truly was. I know there's another world out there. I can't prove it, but I know it. Since I was a child I have always known it.

This last couple of weeks I have been in and out of sleep, the twilight hours lasting longer than ever and the sleep patterns deeper than they have ever been before. It really feels like I have slipped into another world. Somewhere beautiful and peaceful, somewhere I can rest and sleep.

27 November 2008

I'm sitting in Malaga, in the middle of my installation. It's freezing cold outside. Icy droplets of rain spit on me from afar as I scurry along the palm-clad avenues of this southern Spanish city. I've never shown in Spain before, and it feels very strange and alien. I look at my work with its sprawled text, paintings that say:

I FELL IN LOVE WITH YOUR DRAWINGS WHEN I WAS FOURTEEN AND YOU KNOW, I STILL LOVE THE WAY YOU DRAW

I WANT TO FUCK THE WORLD. C**T INTERNATIONAL. THAT WAS YESTERDAY TODAY I JUST WANT TO DIE

WHEN I THINK ABOUT SEX I THINK ABOUT MEN – WOMEN, DOGS, LIONS, GROUP SEX (AND I LOVE YOU ALL)

VOLCANO CLOSED

AND I TOLD YOU NOT TO TRY AND FIND ME

I could fill up this whole column with my words, and lines and sentiments from my work in the show. Layer upon layer, from simple to complex meaning. I wonder how it's going to work for someone who doesn't speak English. I wonder if the vibrations of

my feelings will resonate beyond the language barrier. I'm not known as a text-based artist, but I should be really. Writing is the backbone of everything I do. The image can often be repeated, but the title is always new. And even though I consider myself some kind of hardcore expressionist, my writing factor can sometimes throw me into a mini conceptualist camp.

I'm sitting on a small camp bed with a duvet wrapped round me. I could very easily keel over and fall asleep. I feel a bit mentally pummelled. I should explain that the camp bed I'm sitting on and the duvet I have wrapped round me are two very convenient components from the work I'm installing at the moment: *Exorcism of the last painting I ever made*. In essence it's a fake studio. And after a day of climbing up and down ladders, hanging washing lines, pictures, drawings, paintings, throwing newspaper all over the floor, filling up buckets, knocking over brushes, unrolling countless homemade Yves Kleins, I transform a white-cube gallery space into a studio that looks like I have just finished working in it.

It's a brilliant, creative, timeless process which I really get a kick from but best of all, while installing big shows, it always gives me a cosy little room to run off and hide in, cocooned away from a big museum. The scary giant museum space that yesterday made me feel like everything I had done was worthless. My work looked weak and tired. I spent four hours frantically running around moving things, chancing things, pointing. I turned the whole space around, tweaking and sprigging until I felt it was good enough for me to go home back to my hotel.

I have a rule when installing a show that every evening when you leave, you must leave it as though you are never going to be able to come back. As though you would be judged on the last thing that you hung. That's the only way I can sleep. It's like being knocked down with dirty knickers on.

And then there is the strange thing about being in a strange city. All this work, all this of me, and I don't know a soul. It feels like I'm looking into a giant big vain mirror. My ego and enormity seem so ill-balanced with everything that's outside of the gallery. A genie stuck inside a bottle.

This will be another one of those classic occasions where I am resident in a city for a week and I see nothing of the city, just the A to B from the hotel to the gallery. My feet are swollen and ache as though I have walked a thousand miles when all I have done is endlessly pound the concrete of the gallery floor. Up and down, round and round, forcing square pegs into round holes. My show from Edinburgh is now here in Malaga. It was conceived to fit into a Scottish Georgian building with different shaped rooms offering varying levels of intimacy. And now I have a gargantuan white space in the shape of a horseshoe with ceilings seven metres high. At one point, my work looked like it was about to float away and never come back. The travelling show is a strategic nightmare, but one that forces all artists into a more knowledgeable position— the experience is incredible. Nobody can tell you how amazing your work can look in one place and a complete bucket of shit somewhere else. You have to see it for yourself. But with the tweaking, the pulling, the pacing, the perseverance, if the work is good, it can work in any space.

My show opens tomorrow night. I don't really know anybody in Spain, let alone Malaga. I don't know what kind of party or celebration it's going to be. I haven't chosen the restaurant, I haven't chosen the people who are going to be there. It's like I will be in some strange place where everybody knows me but I don't know anybody. But what I will know, and know so much better than before, is how much I love and care about my work.

4 December 2008

Strange to see the mountain mist roll away just to return again; shafts of light shine through the snow clouds. Everything is tinted with a mystic haze of electric blue. The lake shimmers like a silver mirror; tiny aluminium ripples let me know it's real. Two wooden jetties display themselves in an anthropomorphic fashion; the non-speaking stars of an Ingmar Bergman set, never trying to outdo the lake, but making the lake all the more human for their presence. Twilight time is almost descending. The silvery grey will become a dark Prussian blue. A chain of twinkly lights, golden and sparkly, will circle the lake, rimming like a mystic fairy chain. The last flocks of birds fly homeward and bedward to their cosy nests perched up high in the darkening glades of evergreens.

Dark is here, bringing a crooked crescent moon followed by some very low stars. They hang together in a huddled heap just above a mountain ridge. They look like something left over from an old pantomime. Strings still attached. I enjoy this feeling of nineteenth-century melancholia.

I'm in Austria: a strange country. Strange because it means so much to me, and yet I have no real connection. A place where, at the age of 10, there was almost the feeling of happiness: a ski trip to the Tyrol. My mum worked every hour she could to send us. Upward and downwards, clenching our thighs on our snow-turn edges, to be released downwards, to glide happily in our snowplough turns.

Everything was so good until I wet the bed. Then the fear set in. My bladder, always feeling weak and bruised, would run riot when I deeply slept. For four nights I had tiptoed around the other girls in the ski-chalet dorm, not really sleeping, always in pain, cystitis burning its way up inside of me, the tiredness and the chill of the ice-cladden air firmly getting to me.

I lay in bed, piss all around me. Early morning, hungry and anxious, but feigning illness as soon as my teacher arrived, I lay there until the room was vacated of every living soul. I was 10 and I had wet the bed. The point was, I always wet the bed, but now, sleeping in a room with five girls, I wondered why. Also, there was no one I could tell. Trust became a serious question. I felt ashamed, and who could I trust with my shame?

The chambermaids came and went. I lay motionless, like a tiny corpse in my piss-stinking coffin of a bed, wishing someone would just bury me. I realised, lying in that Austrian bed, that I was terribly unhappy. I had the immediate problem of how to deal with the mess, and the bigger problem of how to confront my life. Should I tell my mum that he touched me? And where he touched me? That he was always playing with himself?

First things first, I took the sheets and the blankets off the bed. I lay the top dry sheet where the wet sheet had been. I then made up the bed to look just like all the others: crisp, neat, turned back. My mum was a chambermaid and every Saturday morning I would help her lug the heavy baskets of linen from one floor to another floor. She would lay the sheets and I would turn the corners.

At the age of 10, I was a prodigy at making beds. I then took the damp, yellow, piss-stained sheet and hid it in the chest of drawers with an Aran jumper over the top. Then, every day for the rest of the trip, when the chance came, I sunk my teeth into the sheet to make a tear and then ripped it into strips. I would then wrap the strips around my body like a bandage or medieval cummerbund. Once, at the top or the bottom of the slope, anywhere where no one could see me, I would crouch down, undo my ski jacket and unravel the sheet as fast as possible. Frantically digging a hole, I would then bury the dead sheet.

Somewhere outside of Innsbruck, in the Tyrol, I can still see the ghost of this little girl in fear; in some mad, crazy panic. I see her face red, not really understanding the whole process but knowing that everything that was bad, unliveable, had to be hidden. The creative process, I suppose, had already begun. I think about the spring, the Tyrolean giant thaw, as the snow slowly melted away on dark green grass, alpine lawns and snowdrops appeared and baby marmosets bounced around. Hill-walkers with sticks and hiking boots muttering to each other as they prodded the limp balls of cotton rags: "Look, there's another one!"

When I got home, I had to lie to my mum. I had to say I had had a good time. I think that was the hardest thing: to keep lying, to pretend that everything is OK when it's not. And then there was the guilt. Why should a 10-year-old girl feel that she is to blame? I think it was the weird guilt that did the most damage. I feel deep regret for that little girl, almost as though she wasn't me, like I have jettisoned her to another place. A disconnection that I now feel needs to be reunited with the rightful owner of her soul.

That's me. I want that damaged little me back. I want to take care of her. I have come to Austria to purge my body and rejuvenate my soul. A lake of glassy water, fresh mountain air, a crystal-clear mirror for me to see whatever I want to see. The depths of the past have opened, are becoming clearer. Maybe it's time to write another book...

11 December 2008

The lake looks very different today. Staring past the long, dried-out reeds, my eyes travel to the jetty, and in the far distance, black ducks bob and dive, bottoms up, heads down, on the top of the strangely shimmery, pinky, peachy-coloured water. A swan with its mate in tow glides by; its reflection leaves a silver streak. Coloured houses stand tall, leaving pastel distortions on the far side of the lake.

The sky is blue and everything dazzles in the clear rays of the sun as they bounce and bring everything into hand-tinted, full-on Technicolor. A gentle, professional, touch—not too much green in the everglades, not too much yellow in the reeds; pinky, peachy whites are dappled on, and a silvery-blue wash is spread across to give an even account of this picturesque view.

Snow clouds hover far away with the threat of turning all in front of me into varying degrees of blue, white, and grey. It's nice to look at something, to pay attention to the shadows of the clouds, to have the time to indulge in such visuals. Often, even when we have the time, we don't look; we are too busy being consumed with all the festering that floats around in our minds: TV, magazines, phones, meetings, dates, times, measures, calculations, events, more times, more TV—image after image, a nonstop barrage of everyday minuscule hell floating on a nonstop train straight into our minds; the loss of nature and our internal faith: contamination of the soul.

The swans nestle by the water's edge, preening and pecking, their orange beaks nimbly going to work as they beauty themselves up

in the winter's sun. They are lovers and always will be. Simple, uncomplicated swan love, passive and beautiful right to the very end. I trudge through the forest, my trainers soaked up to my ankles in mud. I follow a leaf-drenched path, clumsily jump over an ice-cold babbling brook to see deer scamper among the trees. Weird little hoofprints sprinkle the snow, shafts of light glide in and out of the trees. I am so happy. Everything is crystal clear, my heart, my mind, loaded up with nature, my whole soul hungry, screaming out for more.

Have you ever been consumed from inside? Being the host to something utterly vile? That's why I'm here. To make sure it's gone. That giant parasite that took over my gut for so long—a worm maybe five times longer than my arm—living, moving, existing inside of me, taking over every ounce of good that I had—every vitamin, every mineral taken by my guest. The discomfort for so long; my blown-out, extended stomach; going to the loo 15 or 20 times a day; mapping out my social life and daily events around the distance of one public lavatory to the next—the worm having complete control.

When it was hungry, I was hungry. When it was tired, I was tired. When it was angry, I was angry. It didn't just take over my intestines; it took over my entire life. It started to eat away at my soul, a slow torture from within. How could I have been hostess to such an evil thing for so long? Because I was good to it. I gave it what it wanted. It gave me headaches, bad skin, diarrhoea, a swelling of my belly, and the grey puffy layer of what I refer to as dead skin. I wasn't me. My soul was getting more and more disturbed. I stopped touching life. In my case it was first the body, then the soul, but it can happen either way round once the contamination sets in.

Parasites. Millions of people have them. One of the main reasons I left home when I was 15 was because of the fleas. I would catch them in the top of my ankle socks and put them in a jar to try to convince the other members of the household of the discomfort I was going through. My legs were covered in red shiny scabs. I knew if my mum had been there she would have believed me, and if my mum had been there the fleas wouldn't have been there, and the

people I was showing the fleas to were not the kind of people a 15-year-old girl should show anything to.

And now all I keep wondering is how long I had that worm. After the colonic irrigation and the antibiotics, it came out of me forcefully in the middle of the night, reams of neat coils stacked up one upon the other. I wanted to pay more attention, but I just flushed it away. How many times had I wanted to hack away at my stomach, a giant swelling bulbous lump of fat, an ugly egg that needed to explode? How many times had my rotten bowels destroyed a really good night, or a beautiful day? How many times had I said no to the boat trip, no to the hot-air balloon?

Being a prisoner of a prisoner within is a terrible way to live. After every meal, my head would come crashing down upon the table, my brain no longer able to stay awake. Needing to sleep 12 to 14 hours a day. A constant stream of shit making my life a literal hell; the meanness, pinching and hoarding, finding it harder and harder to share; the disgusting advent of sugar and all things sweet—a lust and a craving for a taste that I had never had before. I felt like something was taking me over but I didn't know what. Now it's gone, physically dead, out of me. I can breathe and walk and laugh and love the beautiful world that surrounds me. Tracey is dead, long live Tracey!

8 January 2009

So I managed to survive another Christmas and another new year. But strangely, only just. All the dread and the anxiety that I had about being alone swiftly disappeared for a number of different reasons.

A few days before Christmas I was struck down by some mystery ailment. It was a cross between the worst cystitis in the world and the whole lower half of my body feeling like it was going to prolapse. It came in spasms and waves of inordinate amounts of pain that reduced my body to a human bellows.

I had gone to a lot of trouble to make my local church look more Christmassy. The minister had given me permission to enhance and grace our beautiful Hawksmoor-designed Christchurch Spitalfields with candelabras and holly wreaths. The plan was to make everything atmospheric. I was very excited, as I had invited a number of friends over for Christmas Eve drinks. I was going to light fires and make soup and take everyone to the church for a candlelit midnight mass.

I woke up at 9 p.m. with my doorbell ringing. I had gone to bed in the afternoon doubled up in pain and now I had to put on a brave face and bring out the Christmas spirit, which I did, I did very well. Everything looked festive and warm and cosy. The fires were burning and there was something innocent, almost childlike, in the air. That was from the outside. From the inside I was doubled up in pain and desperate for the vicar's last word, desperately waiting for

everyone to leave so I could just curl up in bed and get on with myself. Christmas Day I didn't wake up lonely. I woke up in slightly less pain. I made myself egg and bacon and took it back up to bed, turned on Radio 3 and nestled down to the soothing waves of Bach and comforting sips of Redbush tea. Docket snuggled up to me as I opened up the first page of Gregor Muir's book *Lucky Kunst: The Rise and Fall of Young British Art* which covers the period from 1990 to 2000.

Six hours later I was feverishly turning page after page after page, stamping mental Post-it notes all the way across the book. My mind had been pulled back into an almost black-and-white art world of Britain, of fish and chip papers, roll-up cigarettes, carpeted galleries with hessian wallpaper and tiny little glasses of white, acidic wine; the art world, but not as we know it now.

Riding around London on my bike—a darkened, dampened, derelict Brick Lane, a copy of *Time Out* in my bag with little rings marked over every single possible contemporary art space I could visit. The early nineties, everybody looking for something that wasn't there yet. Gregor's book describes those defining moments so well. I have been friends with Gregor for years, since 1991. I don't call him Gregor, I call him Boom Vision. Originally it came from Gregor Muir, as in Muirangi Boom, as in the song, as in Boom Vision.

Even all those years ago, I was insightful enough to know that Gregor could see things that other people couldn't see. And even if they could see them, Gregor was the person taking the time to note them down. Gregor and I have only fallen out big time once during our friendship and that's when I drunkenly miaowed too loudly and too much during his inaugural speech as director of Hauser & Wirth gallery, at the opening of a Louise Bourgeois exhibition. My friend Boomer really has gone a long way.

But what's really good about going a long way is when you come back to those people you love. And all during Christmas and New Year, as I turned those pages, I was filled with the most amazing memories, and to Gregor's credit, his fantastic accuracy. Without wanting to make the book sound too pompous, I think that Gregor's anecdotal journey of 10 years in the British art world is a fantastic historical document. It explains really clearly and accurately what

was happening at the time because Gregor was actually there. He's not an art historian looking back on events in art; he's recounting what he has actually witnessed. He also puts the YBAs into a very good global context, not just the media phenomenon but also the art that was actually being made at the time. My Christmas was spent full of melancholy, with lots of laughter and it really did help to take away some of the pain.

I've just come out of hospital after having keyhole surgery. I'm unable to move and I'm on some mind-blowing painkillers. My mental state is either high or asleep. I've emailed Gregor a few times to say, "Come on, hurry up, write another book." I also sent him a quote from Henry Miller, which goes something like this: "There were no appointments, no invitations, no parties to go to. There was no one to impress, we were young and free."

Here's one of Gregor's favourite extracts:

> Early one afternoon, just after the art fair opened its doors to the public, I spied Jay Jopling from afar walking down the central aisle with something slung over his shoulder. This something turned out to be Tracey Emin, who was so hungover she could hardly walk. As they got closer, Emin's arms started to flail and Jay put her down on the floor. On hands and knees, she proceeded to throw up into a corporate water feature directly opposite the Artforum stand, where a woman looked on in horror.

22 January 2009

Last night I went to bed crying. I had been thinking about my days at the Royal College of Art. I've always said the best thing about the Royal College of Art was receiving that letter saying that I got in, and after that it went downhill.

But, of course, that's not true. Twenty-two years on from receiving that letter I look back at my time there and realise how lucky and how honoured I was to get a place. I remember my interview as if it was yesterday. The year that I applied, more than 2,000 people had gone after 20 places, and almost everybody had done exceptionally well in their last art school. To even apply for a place on the painting course at the RCA, you had to have received either a First or a 2:1 for your degree.

I was doing something quite strange when I applied, as I had taken my Bachelor of Arts in printmaking, and my painting experience was almost nonexistent, apart from large panel paintings on board, done with screenprinting ink and very cheap household paintbrushes. It was unanimously agreed at the time of my interview that my paintings had something in terms of picture making, but as far as the art of painting was concerned, forget it.

I remember laughing and asking the six gentlemen (who included Professor Paul Huxley, painting tutors Alan Miller and Adrian Berg—who since that day I've always referred to as Bergy Baby—and Peter Allen, the painting school technician): if my painting was so crap, why had they bothered to give me an interview in the first

place? I remember one of them asking me if I thought my painting was bad. I said yes, because I had never been taught how to paint, that I knew I was technically quite incompetent and that I really, really wanted to spend two years learning how to paint.

Peter Allen told me that out of all the portfolios that they had looked at, I was one of the very few people who had comprehensive, complete sketchbooks which showed a system of thought, in so many ways a journey and that showed very positive student potential, which was why I had been given an interview. I remember Professor Huxley asking me how I thought I would be able to get on with the other students. I thought it could possibly be a trick question, but I gave a standard compromise answer, something along the lines of it being like a football team. The interview went very fast and there was a lot of laughing at my painting *The Day the Pub Burnt Down*. (Frank Auerbach's got nothing on me!)

Adrian Berg was doubled up, especially when I told him the pub hadn't actually burnt down, it was just that I spent so much time in there that sometimes I wish it had, and the orange flames added something to the mucky browns and greys. Adrian said it was possibly one of the worst paintings he had ever seen. I looked at it as it stood there on the easel and told Adrian not to be so nasty because he was making me feel really sorry for it, which was making me like it even more.

I left the room all smiles, thinking what a great interview it had been, but knowing in my heart that I hadn't got in.

So when that big, fat letter thudded through the letterbox I knew just by the weight of it that it was good news. The royal crest on the franked mail and that letter: "Congratulations..." I knew I had done so well to get in. Leaving school so young, no GCEs, no A-levels, no foundation course, and absolutely no painting skills whatsoever! To this day, when I see Adrian Berg at the Royal Academy, I point at him and say, "It's your fault, it's all your bloody fault!" and he says, "Don't give me all the credit, there were other people in the room at the time of your interview."

I was incredibly unhappy at the Royal College. The summer before I started I had lost my home and its entire contents, including

my three cats, which I had to give to a farmer to look after. I moved to London and became a lodger in a flat in Bell Street. My first year was filled with a lot of difficulty and tears. I did find it very hard to blend in and mix with the other students. I did feel very different from them.

All the teaching that I'd had at Maidstone College of Art, where I had done my BA, was guided by two trains of thought. On one level, a Marxist doctrine, so we were given the social and political skills with which to understand art history; and on another level, a passionate spiritual guidance through creativity. And believe me, this was not happening at the Royal College of Art in the late eighties, at the height of Thatcherism.

At the end of my first year I was told that if I didn't do a large oil painting, I might be asked to leave the course. I went into the office to see the secretary and said, "Tell Paul Huxley I'm bored, that if this place had no walls it wouldn't exist for me, and that I'm going down to Margate and I don't know when I'll be back." And I just walked out.

On my return the following week, there was a letter informing me that I would have to have a serious meeting with my tutors and professor to discuss my future on the course. I used to arrive at the college at around quarter to eleven in the morning and leave at ten o'clock at night. I would work every Saturday and in the spring and summer terms I would go in on Saturdays and Sundays. I had no money and I had no social life whatsoever. All I had was the soul-destroying act of trying to make a good painting. I remember literally banging my head against my studio wall and crying with frustration.

Each night I would walk around the studios looking at other people's work. There was very little that I could relate to. People would spend weeks painting Velasquez's cuff, 10 feet high. Meanwhile, I was just finding out who Velasquez was. I would spend at least three mornings a week at the National Gallery before going to college.

But it didn't matter how hard I worked, I could never get that mix of cerise pink that the girl got in studio B. Until one day, Rachel,

the girl who ran the paint shop, told me it was Series F. Series F cost £16 a tube—I was never going to get that cerise pink, no matter how hard I tried.

That summer term, I applied for a travel grant. But during the meeting when I was pulled up in front of my professor and the other tutors, I was told that the thing that would stop me from being thrown off the course was if I made a large painting in oils.

So instead of the Ritblat travel award, which I had in fact won, I would be given as much paint and as much canvas as I needed, any colours, any series. I was furious! The closest I was going to get to the Mediterranean was a turquoise cirrus sea. That evening, when I sat in my studio, Alan Miller came to see me. He was very kind and he said, "I'm going to show you a really good shortcut."

And for the next week after college had finished, between 5 p.m. and 10 p.m., he spent every evening showing me how to mix paints, what brushes to use, and most importantly, how to stretch canvas. He showed me the rudiments of how to be a painter. He did this out of the kindness of his heart, in his own time, and over that week we became really good friends and I realised within the RCA I had an ally—someone could practically really help me, no bullshit, no pressure, just really good advice that has helped me right until this day.

That summer I did a whole series of paintings, big oil paintings, and during the summer holidays Alan even popped in to see how I was getting on and I remember his great big smile and him saying, "You've done it, you've done it!"

It was Alan's funeral yesterday. I didn't go because I wanted this column to be a tribute to him and I thank him for the confidence he instilled in me and I will always be grateful for his selfless support, which I know he extended to many others and he will be really missed.

29 January 2009

I can't believe how fast the week has gone. It seems like there have only been two days this week, and they have both been Wednesday, joined back-to-back, colliding like two tectonic plates. Everything else in between squeezed and pulped into some gluey, blancmangey mess, a sort of dark-mauve, blueberry-coloured blancmange, with a few frozen moments.

I went to Tate Britain to see my drawings; a fleeting sense of glee filled my heart when I saw them hanging on the walls. I smiled and thought to myself, who would have ever thought my drawings would be hanging in the Tate? And immediately, my mind was thrown back to 1990, coming round from the anaesthetic after having my abortion, and that overwhelming sense of failure, failure as a human being and failure as an artist. If only I had known then that I would have my drawings hanging up in the Tate; not giant dominant works of art, but delicate, spindly line drawings that are so recognisably mine.

Everybody is trying to come up with the next big idea, fighting with the pressure of the weight of it, all the time there is something bubbling, something moving along on its own trajectory. In my case, it's my drawings. There are some days when I can draw, and some days when I can't draw. It's not that my hand doesn't work properly—it's my whole arm, my whole body, everything that is connected to the finished result on the paper.

Most mornings, I wake up at about 6 a.m. These days, I have a

flask of hot tea by my bed; I turn on Radio 3, crush three pillows underneath my neck, and lean my head back at a 45-degree angle. I roll my eyes into the back of my skull, as far as possible. I then stretch out my hand, knowing that I should pick up my book but I always pick up my BlackBerry. I have this thing called the 6 a.m. club. There are a handful of people whom I can text or email at 6 a.m., and they will reply to me immediately. Their thoughts will not be minor; they will be weighty, profound, and somewhat philosophical. This is the morning time when the darkness is outside, but we still have the fantastic feeling of being alert in our womb-like nests. It's a safe place from which to send out these deep thoughts.

This morning, my friend emailed me, saying, "I met a 58-year-old woman who was very happy, really genuinely deep-rootedly happy, and I said to her, 'Why?' And she said, 'Because I have never had an abortion, that's why I can live without having children.' She said she had tried to have kids but had never got pregnant."

I emailed him back, saying, "My Dad said I must never have another abortion, because after three you start going mad. I've had two and I'm borderline. As it is, no one has ever wanted to have a child with me.

"Makes me feel cynical when I think about making love, and I sometimes have to ask: what is love? I would have been so much happier had I not had the abortions, but I truly believe that I would have been so much unhappier if I had had the children."

These are the kinds of conversations I have before dawn has broken. These are the kinds of thoughts that fill my mind before daylight comes. I'd never have believed that I would say or think this, but as I get older, it's becoming more and more obvious that my children are hanging on the Tate Britain walls.

When I first started becoming successful, I was filled with strange guilt and misunderstanding of myself. I felt that my abortions had somehow been a Faustian pact, and in return for my children's souls, I had been given my success. I am not a Catholic, but I have a profound belief in the soul. It's only now, now that I know that it will never be possible for me to have children, that the guilt has finally lifted. I give a lot out into the world, and I care and love for

all that I create. It's a really big endeavour that extends much further than just the ego of myself.

I'm very lucky and very happy to have reached the point in my life that I have. There will never come a time that I will have to live with the fear of burying my children. We have only had to witness the atrocities that have happened in Palestine over the last few weeks, so many children being buried every day. With these images, I felt so grateful not to be the kind of mother who gave birth to a human being, but the kind of mother who gives birth to a creative notion, a creative idea, something that isn't evil and could never have that capacity. The man that pulled that trigger is somebody's child. Sometimes, when I reach for my BlackBerry, I don't email anyone, I just roll on to BrickBreaker and try to get a better score.

26 February 2009

Something very sweet happened today: my mum made pancakes for me and everyone at my studio. My mum will be 81 soon and to see her with a bowl and fork in hand whisking away, with the eager eyes of my Japanese assistant following her every move, and then the tossing—it all worked very well. And the no-recipe formula, the all-knowing I've-been-making-pancakes-for-70-years attitude filled me with a strange, glowing pride for my mum, a real mum doing a real mum thing.

I don't often feel like this. And the reason I don't feel like this is because since the age of 15 I've been swamped with an abundance of independence. I have a distance between myself and my family; a distance that I keep in place to protect myself. It has nothing to do with love or a desire to be free from them, it's just the way things are and always have been.

I've just got used to going to myself for help. I often get niggled by the proximity of love—an irritable hereditary clash of being too close. But today I really love my mum and I'm very happy that she's here, sitting in the studio, quietly reading a book. I feel good that I have a mum that's so adaptable and someone who seems so much younger than their years.

Today is my dad's birthday. He's 88. I've tried to call him but there's no answer on the end of the line. Unlike some people who would worry, I don't. I know he's in Cyprus digging around in his garden. I can go weeks without speaking to my dad. My dad has gone

years without speaking to my brother, and vice versa. We are dysfunctional in the truest sense of the word.

I often imagine what it must be like to be in what you'd term a normal family. Not a family where there is always harmony and a fake 2.2 syndrome, but a family which shows solidarity and commitment, constantly.

The last few weeks my column has been quite sombre. And over the last few weeks I have been watching my friend slowly die of cancer. On Sunday night I kissed him goodbye on the forehead. I could feel the breeze from Commercial Street blowing through the window as I walked out the room and waved goodbye.

He's not just my friend, he's the father of my friends, and the husband of one of my closest, dearest friends. I'm connected to the whole family. It really, really hurts to see your friends suffer. Somehow within your own suffering there is the excruciating pain that you have to deal with, but when you witness others suffer so immensely it's as though the pain bounces to and fro like waves of shock, and you want to make things better for them. And you can't. All you can do is to try to help with practicalities.

This week I am very, very confused about death. Where does it come from? I do really feel like it's an entity, like the Grim Reaper. Something that you have to watch out for at the times when you are most happy and when you are gently asleep in the dark, no moment is safe. All I could say to my friends is nothing will ever be the same again. Coming into the world, leaving the world, these big, big, big events. Without sounding too crass: we all do it. I walked around Liverpool Street train station today. It was the commuter hour and like some improvised play my character kept saying, "Everybody's going to die, we're all going to go." Now I really want to know where.

What I know about my friend is that he looked very much in peace. In fact, he had a smile on his face. That I found very comforting. But I would still like to know where he's gone, and where we all go. I have a general sense of dissatisfaction about this planet that we're on. I really can't believe this is it. And if it is, then all the suffering is even worse. When I was young, before I started having

sex, I really believed that if you never had children you would leave this planet when you died. You would never be reincarnated and, unless you were a ghost, not one single part of your soul would be able to return. Not having children would be a good shortcut to the next world. I've never been one of those people who thought I could possibly come back as a tree or a dragonfly.

Part of me has always thought that my soul has reentered the earth's atmosphere on quite a few occasions now, but always as something human. And as wonderful as life can be, there is always part of me that's feeling here we go again.

I have never been afraid of my own death, but as I get older my fear of losing those that I love becomes immensely greater. This week has been an incredibly sad week.

I've watched a family deal with pain and I've seen how much they love each other, how close they are. Their love is a strong, good, positive thing and it's made me question my own situation again, and my own beliefs.

So I write this column in loving memory of my friend Dennis Esqulant, landlord of the Golden Heart for 30 years.

5 March 2009

Today I am emotionally burnt out. Grief is a terrible state to be in. The tears, the drinking, the tears, the more drinking—it eats you up and consumes you. And at the same time it makes everything spacey and unreal. I can't stand seeing those I love suffer. It's torturous. I know with all pain, one day when you are least expecting it, it arises. And instead of gnawing away and eating at you it becomes a strange little cloud that floats around directly above you, and sometimes it rains. It rains when it's not raining anywhere else. From where you stand you can see the blue of the sky and the sun shining, but inside everything is cold. Warmth doesn't have a home in you any more.

Love, passion, and loss. To live broken-hearted for many feels like a living death. I really do think that some people feel things more than other people. I also believe that there is a hierarchy of emotions. When I was younger I used to think that I was jealous. That I suffered jealousy. It was one of the reasons why I fell in love with the paintings of Edvard Munch, because he made a painting called *Jealousy* that was about himself. I thought it was an incredibly open, self-effacing, and defiant thing for a man in the early twentieth century to do. By openly displaying his weakness it empowered him and gave him strength. It's only recently in the last few years that I understand that I was confused about the meaning of jealousy. I never envy or covet, and with the success of others my reaction is to celebrate. I have always been a believer in the Midas touch. But

in terms of love, what I thought was jealousy was the correct reaction to somebody stealing love away from me. I have often joked and said the only times I have ever been jealous is when my boyfriend is sleeping with someone else. But this isn't jealousy, this is a passionate reaction to a situation, just like tears are the passionate response to loss. Being human is very difficult. We would like to have complete control over every aspect of our lives but when we lose something or when we lose our grip we realise just how tiny we are.

When I was 21 I was in so much emotional pain that I really didn't want to live anymore. I attempted to slash my wrists, but after one small abrasion I knew it wasn't the way I wanted to go. I bought a half bottle of whisky and drank it on the train down to Margate and arrived at night. Drunkenly I walked along the sea front, past the neon, round to the harbour wall. I remember thinking of my childhood at the time, some of my happier times: catching crabs on a hook and line, and a piece of bread for bait; being chased by Tubby, the fat harbour master and hurling ourselves off the end of the jetty wall—we could then swim to the other side of the harbour in fits of giggles as we saw his perspiring, round shape breathlessly wobbling with his attempt to catch us. Now I walked along the jetty; with my clothes on I threw myself into the blackened night sea. As I felt myself go beneath the water I could then feel my feet touch the sand. I bounced back up like a piece of cork. If I wanted to die, I realised I would have to swim out to sea. It was then that I felt stupid and lonely. But the biggest feeling as I climbed out was just how tiny I was, and majorly insignificant to myself. I compared myself at that moment to the sea and all its greatness. I was the sea as one big entity. I also saw the sky as another big thing that surrounded the sea. And in the sky the millions of stars that were already dead but yet still shining. They still give light, and subconsciously I realised, at that moment, that that's what I should do. And even though my heart had felt completely pounded and trampled on, like a star that had died, part of me was still shining. I took on the responsibility of that being my existence. My little light could be useful somewhere in the world. And now when I look back

at being 21 I realise what an incredible loss it would have been had I died. I don't mean that in an egotistical way, but just on a simple level—of a loss to myself. Me knowing me, getting to know me.

I love my passion for life, the ups and the downs. Sometimes they come from outside, and other times they just manifest themselves within me. But today's sadness is from the outside. And there's nothing I can do about it apart from try and understand life and its complexities. I know that it always rains on the other side of the mountain.